MW01482295

Advance pra

"In *Fragment by Fragment*, the reader is pushed to really think about the meanings of both the false memory movement and the sexual abuse of children in patriarchal cultures. The powerful threads of social, political, and philosophical contexts that have informed the feminist discussion on memory and trauma are brilliantly illuminated here. A genuine addition to the library of anyone who takes this topic seriously."

— *Laura S. Brown, Ph.D, Psychologist*
in Private Practice, Seattle WA

"*Fragment By Fragment* represents a substantial contribution to the discussion about child sexual abuse and society's response to its disclosure at a time when women's memories of their abuse are under relentless seige. For anyone concerned with being well informed about these issues, and particularly, those working in close proximity to them, this is a must-read book. Here are intelligent and authoritative voices that resonate with integrity and resolve. The sound and fury of the current anti-woman, abuse-denying rhetoric is confronted head-on in what is an unflinching examination of a challenging subject. Justice for women and children requires that we take account of, and apply to our understanding, the material offered in this impressive and timely publication."

— *Anne S. Derrick, Feminist Lawyer, Halifax, NS*

"*Fragment by Fragment* is an impressive testimony to the fact that survivors of child sexual abuse — and therapists, academics and activists working with them — will not be silenced by organized campaigns which use the 'false memory' argument as their main weapon. Through personal accounts and multi-disciplinary scientific contributions, this courageous book shows how this 'false memory' war is being waged and what is wrong with it."

— *Onno van der Hart, Ph.D, Professor in the Department of*
Clinical Psychology, Utrecht University, The Netherlands

"Margo Rivera's book is the perfect answer to those sceptics who do not believe that children really are sexually abused by adults who are trusted to care for them. In a calm and scholarly way, advocates and professionals document the political, scientific and clinical issues that arise when adult women report their own sexual abuse. If this book is carefully read, the public can no longer be mislead by those who don't want the truth known."

— *Lenore E. Walker, Ed.D, Professor of Psychology,*
Nova Southeastern University & Executive Director,
Domestic Violence Institute, Ft. Lauderdale, FL

FRAGMENT

by

FRAGMENT

Feminist Perspectives on
Memory and Child Sexual Abuse

Edited by
MARGO RIVERA

gynergy
books

Technical editing by: Sibyl Frei and Sarah Swartz
Cover illustration (detail) by: Marilyn McAvoy
Printed and bound in Canada

*gynergy books acknowledges the generous support of
The Canada Council for the Arts and the
Department of Canadian Heritage.*

Published by:
gynergy books
P.O. Box 2023
Charlottetown, PEI
Canada C1A 7N7

Jennifer Hoult's "Silencing the Victim: The Politics of Discrediting Child Abuse Survivors" and Anna C. Salter's "Confessions of a Whistle-Blower: Lessons Learned" were originally published in *Ethics and Behaviour* 8, 2 (1998) and are reprinted with the kind permission of Lawrence Erlbaum Associates, Inc.

Canadian Cataloguing in Publication Data

Main entry under title:

Fragment by fragment

 1st ed.

 Includes bibliographical references
ISBN 0-921881-50-9

1. Recovered memory. 2. Adult child sexual abuse victims.
3. Child sexual abuse. I. Rivera, Margo, 1945-

RC569.5.A28F72 1999 616.85'8369C99-950096-1

For my parents Dorothy and Tommy Tuckey
who gave me the blessing of a childhood
I enjoy remembering.

Acknowledgements

My family: Raquel Rivera, my lovely daughter, and her creative husband, Kim Chua, who are living with me and awaiting their first child; Kate Coon, child of my heart, and Rachael Coon, my goddess child; and my brothers, John, Tom and Steven Tuckey, with whom I spent last spring and summer, sharing the final months of our mother's life.

My colleagues at the Chrysalis Day Program, Martha Dickens, Karen Gagnon, Pierre Leichner, Steve McNevin, Joyce Patterson, Kathy Southmayde, Luce Scott, Marg Taylor and Barbara Wetherington: We share precious adventures every day, fostering the growth of our clients, and our own growth as well.

Sarah Swartz, freelance editor: Her considerable skill with word and phrase, and an ability to keep the lens of a general trade readership on this project, were of great help during the editorial process.

Sibyl Frei of gynergy books: This book would not have come into being had Sibyl not been involved every step of the way. Sibyl and her partner Louise Fleming envisioned the collection, and Sibyl midwifed its birth with both tenacity and gentleness, supporting my strengths and filling in where I am not strong. In the last stage of the labour, we were exchanging e-mails back and forth daily about everything from authors' contracts to sentence structure. In true feminist fashion, we always made time to fill each other in on the joys and stresses of our lives before and after we got down to work.

Table of Contents

PART THREE: Memory in Culture

PREFACE

Elly Danica

Child sexual abuse does not exist in a vacuum. It has a social and political context we need to understand before we can appropriately support victims and survivors, before we can change fundamental attitudes and structures in our society, and before we can eradicate child abuse. Informed by my own past experiences as a victim of child sexual abuse and now as a survivor, I have written two books on this subject and, during the past decade, have spoken to groups and individuals in many communities in North America and Europe. The huge shift in public reaction to my story since I first began to speak publicly about child sexual abuse has been disappointing. What began as movement toward awareness and compassion has taken a backwards turn: more questions and doubts, less support and understanding for victims of sexual abuse.

This shift in public focus, led by the media, took place in less than three years. Early interviews after the publication of my first book, *Don't: A Woman's Word*, in the late 1980s concentrated on what happened,

10 Elly Danica

although there was a media fascination with the lurid details of my experience. (What exactly did he do to you?) During public readings and speaking engagements in this early period, audiences voiced their belief in my experience and recognized the importance of my speaking publicly about abuse. Women and men who had experienced child sexual abuse found my public disclosure both moving and useful in their own healing. For a short time, there was a window of belief and generous compassion for those survivors able to make child abuse disclosures.

As more survivors began to reveal their stories of childhood abuse, it became evident that a significant segment of society behaves in a predatory and vile manner toward children. Parental nurturing, far from being the norm we would all wish for, is too often merely an ideal many children never receive from their families. We uncovered the troubling reality that the most vulnerable among us are not safe in their families.

The sheer volume of the disclosures that followed and their accompanying pain and discomfort brought a backlash from a frightened public: disbelief, attempts to discredit personal testimony, media features on so-called "false memories" and pleas for the re-instatement of so-called "family values." The public perceived the growing awareness of abuse as an avalanche, a crack in the walls of silence that became a chasm, so frightening to the public that it seemed to threaten civilization, or certainly family life as we knew it.

Surely, the media proposed, the notion that fathers and other male authority figures could be predators is not true. No, it must be a feminist plot to misinterpret the actions of loving fathers. Or worse, a plan to remove children from the affection of their fathers during a vindictive divorce.

The False Memory Syndrome Foundation (FMSF), a group founded mainly by parents who had been accused (and found guilty) of abuse of their children, managed to shift public attention to the credibility of memory and away from who was doing what to whom. Backed by large donations, this group is well organized and has good access to the media as well as the legal system. Although the FMSF couldn't find specific fault with me or my disclosures (I never "forgot" and didn't have the benefits of therapy), they did make attempts to hijack my message of belief in and compassion for the pain of victims and my hopes for resolution. Media interviews now inevitably began by questioning the credibility of my memory. I was constantly asked whether I had "recovered" my memory with the help of a therapist. When I explained that I did my healing work

alone, interviewers were often disconcerted and quickly moved the discussion from my experience (which was no longer interesting, perhaps because it could not easily be dismissed) to that of unnamed others who "recovered" their memories in the now problematized context of therapy. As far as the media was concerned, there were genuine victims — few in number and special in circumstance — and then there were all the others with their faulty memories.

The media, with its preference for glib reporting, for reducing complexity to the most simplistic terms, is out of its depth dealing with child abuse as a social, political and gender issue. This isn't an issue which lends itself to dramatic television footage. Instead of educating itself and the broader public, the media retreated, hiding behind stories about women and children who had allegedly made it all up. The focus had somehow shifted to sympathy for accused perpetrators as victims of false allegations. The media went from ambulance-chasing mode — as it eagerly sought the juicy details of yet another victimization — to complete dismissal in one leap.

I am no less silenced today than most other victims and survivors of child abuse. While I try to keep the focus on the social ill of child sexual abuse, the media still portrays faulty memories. Media coverage from the victim's perspective is now nearly impossible to obtain. Fewer books by abuse survivors are now published than a decade ago, and film projects on the topic can not find funding. Disclosures by children and adult survivors are not more successful in the court systems. In fact, they are doing worse, as the FMSF has helped to foster an atmosphere of disbelief that makes it easier to dismiss allegations of abuse.

The road to indifference to the pain of others is paved with small betrayals. Every time we, as a community, fail to protest court rulings detrimental to the safety and well-being of children and women, every time we ignore the implications of government policies and actions that enforce the poverty of women and children, every time we ignore media portrayals that objectify women and "sexualize" images of children, we give tacit and clear permission for the abuse of children.

In order for survivors and caring people to demand the political changes in our society that will stop child abuse, we need a broader understanding of the social and political underpinnings of child abuse. Once personal healing is under way, we can begin to search for solutions to the large social problem of child abuse. *Fragment by Fragment: Feminist Perspectives on Memory and Child Sexual Abuse* is the base from

which we can begin this exploration. These essays of careful and considered scholarship in several disciplines are a vital link in the process of understanding that underlies social change. I have long wished for one publication to recommend that contains an overview and analysis of the issues in psychology, justice and philosophy, a compilation of what some sharp minds among us have learned so far. *Fragment by Fragment* is that book.

Fragment by Fragment is an important resource for survivors and professionals, as well as anyone interested in a clear analysis of the complexities of memory and abuse. This compilation is a tool for social and political change in the best sense. I trust it will provoke deeper thinking, animated discussion and eventually concerted political action. And, with time, we will use what we have learned in the process of personal healing and growing political awareness to make the changes I first envisioned as an abused child: a time when nobody will ever again have to endure what I did.

INTRODUCTION

Margo Rivera

I saw my first psychotherapy client in 1970. I was also in the midst of my own psychotherapy/training analysis. My colleagues and I did not think of our clients as all that different from ourselves. We did not think that the Delphic injunction to "know thyself" meant remembering everything that happened in our childhood, nor did we think we or our clients needed to go back and dredge up everything we experienced as children. We thought we all needed to know who we were, what our values were and how we lived them out, how we deceived ourselves and others, how we covered our vulnerabilities by lashing out at other people or withdrawing from them, the ways in which we exaggerated our power or discounted it altogether. Memory was always a part of this process, and we all understood our early socialization to be central to our development. We explored our memories as part of finding out who we were, and of changing how we might be in the future.

I still think this is basically a sensible way to approach the issue of memory and self-exploration. But it was a more innocent time, or we thought it was anyway. A number of my clients in the 1970s were sexually

abused in childhood, but we did not know how many children had been subjected to the extremes of maltreatment, combinations of physical and sexual abuse, often on a daily basis for long portions of their childhoods. And we knew very little about the psychological mechanisms they could develop to block out their awareness of these negative experiences so that they could still relate to the people who hurt them, frequently the same people who were charged with their care and upbringing.

When, in the 1980s, the veil began to be lifted on the phenomenon of the widespread sexual abuse of children, and the survivors of abuse began to speak — not only about their childhood torment but about forgetting it for years — memory moved into a much more central and complex place in the process of understanding, exploring and eventually changing the way people lived their lives.

For many abuse survivors, having had no memory, or more frequently, fragmented memory for such significant formative experiences, recovering memories often became central to their recovery. And with the recovery came empowerment. Individuals who had been silenced for the bulk of their lives found themselves able to speak, and they did speak in great numbers and with powerful effect. For a decade, society listened to them, and they were sometimes accorded respect and validation.

And then the breaking of their silence began to affect others, and some of the perpetrators of the abuse and their supporters did not like this challenge to their power to define reality. The target of their outrage became the source of the empowerment. They attacked memory:

> To the survivor: *You think you remembered I had sex with you? You remember no such thing. You say you remember your father abused you after forgetting about it for so long? Your therapist put those thoughts in your head.*

> And to the therapist: *You think you are helping people recover events from their sexually abusive backgrounds? People never forget important things like that. The research demonstrates there is no such thing as a recovered memory.*

It was not the mental health profession that exposed the cultural corruption of widespread child sexual abuse. Our social awareness about the millions of children who have been oppressed in this way emerged from the consciousness-raising efforts of the women's liberation movement of the 1960s and '70s. Social action programs, particularly battered women's shelters and rape crisis centres, responding to the needs of

violated adult women, began to hear about the ways in which these women had been socialized into their roles as victims by a childhood of sexual abuse. The workers listened to these women as they told them about their experiences of childhood sexual assault, and they believed them rather than reframing their reports as fantasy, as mental health professionals had tended to do.

Research focusing on child sexual abuse emerged from the context of feminist social activism and combined a social and political perspective with an awareness of both the psychological effects of childhood abuse and the vast numbers of children who were forced to experience it.[1] By the early 1980s, an awareness of the high incidence of child sexual abuse had begun to extend beyond the feminist community. What began as a grassroots movement to create a milieu to remember and to speak — for those who have had to forget and be silent to survive — became part of the provision of services in medical clinics, therapists' offices, child welfare settings and courtrooms. By the end of the 1980s, it was becoming apparent that victimized women and children, and eventually men similarly assaulted in childhood, were making some headway into eroding the power of those who had previously been free to harm vulnerable youngsters with very little chance of legal or social consequences.

By the early 1990s, the forces of opposition to the kind of liberation created in the 1980s became marshalled. I guess it should not have come as a surprise. Adults had been sexually abusing children for years, centuries, millennia. And now those children and the parents of those children and their supporters from all walks of life were saying NO in great numbers. We won't let you get away with it. I guess we should have expected the counter response that eventually emerged. The consensus that developed in the 1980s about the prevalence and harmfulness of childhood sexual abuse turned into a fierce political fight about what can be spoken in public and who gets to say what really happened. The focus of this power struggle became the issue of memory. Memory became, as Ian Hacking, a philosophy professor at the University of Toronto, put it, "a surrogate for the soul." [2] What individuals could remember became profoundly connected to whom they could claim to be. The fight was on to recapture these souls who had begun to escape from their mental prisons, in which they remembered little and recounted less, and to put them back into solitary confinement where they could no longer challenge the status and the power of those who had harmed them.

This is not the first time that the issue of child sexual abuse has been opened up and closed down in the fashion of the past 25 years. Though we often think of ourselves as revolutionary in recognizing how large the problem of childhood sexual abuse is, the social phenomenon of unearthing widespread sexual abuse and then covering it up again has happened before in this very century. Between 1880 and 1930, many woman and suffrage organizations campaigned to protect children from sexual abuse by men.[3] Through their efforts, the issue of the sexual abuse of children had, by the 1920s and '30s, become a topic of acknowledged social importance. Laws were passed for the first time criminalizing incest and establishing age of consent guidelines. The issue of sexual abuse was then appropriated by the medical establishment, who appointed themselves the experts on this behaviour, which they labelled "deviant." The extent of the problem was minimized and the few offenders who were apprehended were treated as sick exceptions that had little relevance to male socialization and oppressive social structures in general.

When the doors are slamming shut in this way, those who try to hold them open — even open them further — tend not to be very popular. So, when Sibyl Frei of gynergy books asked me to edit a book about sexual abuse and memory, my first response was to cringe. At this point, it seemed to me like one of those topics in which everyone who got involved, at least publicly, got hurt. I had just escaped from a couple of professional situations in which I had been hurt. Hurt and scared. I had been tricked into participating in a documentary that was presented to me as a project to bring more light on the topic of abuse and dissociation. I was shocked when the promotional blurb, "Therapists Create Multiple Personality," began to appear daily on television during the week before the program was screened.

Only 18 months before, in the fall of 1993, I was involved in putting the finishing touches on an exciting project put together by the Ontario Ministry of Health as a response to the consensus that child sexual abuse was widespread and had lifelong effects on its victims. This assessment, treatment and education program — which would have offered therapeutic services to dissociative abuse survivors throughout Ontario — was on the verge of receiving final approval when it was dropped like the proverbial hot potato under intense pressure from those who believe that most sexual abuse memories are false and that the therapists who work with survivors of such abuse are irresponsible charlatans.

Shortly thereafter, I found a niche in the department of psychiatry at Queen's University in Kingston, where my main responsibility is creating

and maintaining an intensive treatment program for people who are labelled as suffering from "severe personality disorders." Many of my current clients hurt themselves badly, attempt or at least think about suicide a lot, have trouble maintaining stable relationships, have serious eating problems, and suffer from a range of disabling fears and compulsions. About a third of them are severely dissociative and another third are much more dissociative than the average citizen. Many of them have spent months, and sometimes years, in psychiatric facilities when they have been unable to cope in the community. They all report a great deal of trauma in their lives, including sexual abuse in many cases. In other words, I am working with many of the same people I had been working with previously.

What a relief! For the previous five years I had been depending on government grants to work with extremely disturbed individuals who could never afford private therapy. Grants had been much more available in the 1980s than they were as the political and fiscal climate changed in the 1990s. And here I was now, funded by a university to treat many of the same population.

I love my work. Many of the people who need the kind of help I can provide are extremely poor, and they can afford only publicly funded treatment. I have always wanted to work with them and have done so most of my professional life. I am not burned out from working with these clients, but I was beginning to be very tired of the politics that came with the territory. I do not mind explaining, describing or even defending the theoretical, research and clinical basis of the work I do. But I intensely dislike personalized, ideologically driven conflict, and that was beginning to be an inevitable part of my work being funded by the government to specialize in the area of child abuse and dissociation. So I was ambivalent when Sibyl presented her idea for a book about the current debate on recovered memories of sexual abuse. I did not want to step back into the fray. It had been such a peaceful year.

Sibyl and her partner Louise Fleming, who own a feminist publishing house in Prince Edward Island, thought that gathering together a collection of articles by feminists on various aspects of the recovered memory issue, not just therapy, might make a useful contribution to the discussion. Sibyl emphasized that they had in mind a book for members of the general public who want more than the sensationalized sound bites they get in media presentations about memory and child sexual abuse. It should also be substantial enough to be useful to professionals from a range of disciplines.

I thought it was a worthwhile, even an exciting project, I told Sibyl, but I was not likely the kind of feminist they wanted. I told her that I didn't see the debate as two-sided, between the angels who believed everything they were told by women about their lives and the demons who dared to challenge this point of view. I said it was much more complicated than that, and in fact, I've been occasionally excoriated by other feminists because I insist on considering each case on its merits. Sometimes I have reported that I could see no evidence of abuse in particular cases I was asked to assess. I told Sibyl that I thought that those of us who did the early work with sexual abuse survivors had no idea how complicated the issues — therapeutic and political — would get when we rallied behind the slogan "Believe the Child" in the early 1980s. Far from being discouraged that this was a viable project and I was a suitable editor, Sibyl became even more enthusiastic, and I agreed to give it a try.

I have not found it easy, and the project has taken longer to finish than we imagined when we first met and talked over lobster dinner in Charlottetown in May of 1996. My original belief that this was a complex topic and that many aspects of it remain to be investigated has been confirmed by the clinical advances and solid research on the subject of trauma and memory that have emerged in the three years since our discussion. Though the immediate response to the backlash against widespread belief in the reality and prevalence of child sexual abuse seemed, at that time, to fall into two clearly defined camps — popularly framed as "true believers" and "sceptics" — many responsible researchers and clinicians, including some prominent feminist professionals, have since refused to be positioned in either camp. For example, both Laura Brown and Christine Courtois have called for moderation and thoughtful, thorough research to study the important points that the debate has raised. Their books on the topic have made a solid contribution to the discussion.[4] Though the media delights in depicting the debate as crude and frenzied (and, unfortunately, it is not difficult for them to find spokespeople who see only two positions: believe all or believe nothing), a middle ground is emerging. This middle ground acknowledges the prevalence and toxicity of child sexual abuse while recognizing the importance of assessing each case individually, rather than reflexively assuming validity or invalidity depending on whether or not the allegations resonate with one's ideological biases.

The project of putting together this collection of articles has been a worthwhile endeavour, both professionally and personally. I have met people I would not have gotten to know otherwise, people who are doing

groundbreaking work to make these issues more clear. And I think that the book is an important contribution to the discussion, just as Sibyl had envisioned. That is important to me. Much as I would like to retreat into a protected place and concentrate on creating a healing milieu for a couple of dozen people in pain, all the work I have been doing in this field has shown me that we can not do therapy out of context. Abuse survivors do not have that luxury. They must struggle within a society that consistently denies their reality. And therapists don't have that luxury either — even if, every once in a while, I put my hands over my eyes and ears and pretend that I can escape detection myself. I know, in life, that the social context doesn't disappear because you ignore it. I have been swinging on society's pendulum of disbelief/belief/disbelief for 20 years.

My first work with clients who had experienced the more severe forms of physical and sexual abuse in their childhood and held those experiences in their minds in a very fragmentary way was in a child welfare context. First there were one or two cases, and by the mid-'80s there were many more. I did not discount their reports. After all, there were lots of records documenting various forms of maltreatment that these people had endured as children. And when they began to recount previously unreported, and sometimes previously unrecalled, incidents of sexual abuse, it did not seem strange to me. I was observing how erratic their memory processes were day-to-day. Why should there not be impairments in their capacity to hold continuously in their recollection experiences that were fraught with terror and rage?

I had to learn more about memory as I began to see increasing numbers of clients whose memory processes were in the foreground of their psychotherapy, rather than in the background where they usually reside unnoticed. I also had to learn more about how the brain processes memories, as it became clear in my work that memory was not a unitary process and that a memory of any event can be encoded, stored and retrieved by different parts of the brain. The hippocampus and other parts of the midbrain, for example, consolidate explicit (or declarative and episodic) memory, memories that are available to conscious, verbal recall. Implicit memories embedded within a conditioned non-verbal emotional response, however, are processed in the amygdala and other neocortical and subcortical brain systems. A sudden rush of terror — seemingly unattached to anything in the present or in response to a situation or person in the present that does not appear to be particularly frightening — may represent an implicit memory of an event that is not available to conscious recall, at least at that moment.

The memories for a given event involve both explicit and implicit components, and they can be dissociated from each other. This means they can be held separately in consciousness and not connected in the way memories are ordinarily meant to be. For example, when I remember putting my baby to bed, I can recall the sequence of actions — bathing her, putting on her sleeper, rocking her for few minutes, laying her in her crib and watching as her eyes flutter as she falls asleep. I experience a warm, contented feeling, my breathing slows down, and a peaceful smile drifts across my face. That is an integrated memory of a deeply satisfying experience.

Traumatic events are rarely experienced in a way that connects all of their elements in this way, and the more often and more severely an individual is traumatized the less capable she will be of holding all the elements of her recollection of these experiences together. Sometimes she will be able to sequester her explicit recall of the certain traumatizing experiences for days, weeks or even years on end and only remember them explicitly later in the day, later in the week, or years later in life. In this way, she will not be overwhelmed with what she cannot understand or bear to feel. Implicit memories can be stored in this way also. A traumatized individual may feel fine or numb or even joyous, and then suddenly be swamped with fear or sadness or rage, seemingly out of the blue. Occasionally these surges of feeling memory will be connected to an explicit memory of a harmful experience, and suddenly they make some sense, though they are hard to bear. More often the feelings and the narrative recollections happen separately, and the traumatized person does not connect them, at least at first. She feels disturbed, often thinks she is going crazy. It is this form of mental self-protection that has been the source of the delayed memory controversy.

Some traumatic experiences are forgotten in this way, and some are remembered relatively continuously, but disconnected from an appropriate emotional response. An effective therapy can eventually enable individuals to bring together all the elements of their life experiences in a way that offers a sense of integrated awareness and self-knowledge that can be extremely empowering. E. B. Brownlie's description, in her article in this book, "Lies, Secrets and Silences," of the ways in which her awareness and memories of her abuse came and went, in her thoughts, her feelings and her bodily responses, illustrates the complexity of which the pressured brain is capable, as it processes, stores and retrieves traumatic experiences.

The accuracy of memories forgotten in this fashion and then recovered at a later date, and particularly those remembered in therapy, is the

central question of the current recovered memory debate. For more than 100 years, researchers and clinicians have been commenting on the paradoxical nature of traumatic memory. Pierre Janet developed a comprehensive theory about traumatic memory that anticipates much of contemporary neuroscience.[5] Other researchers in the early days of modern psychiatry and psychology were equally fascinated with the study of consciousness and how traumatic experiences disrupt the laying down, storage and retrieval of normal memories.

On the one hand, traumatic experiences appear to be utterly unforgettable, persistent and rigid, certain details playing themselves over and over when they are accessible to consciousness. On the other hand, they are not easily slotted into existing mental schema and can be stored in a dissociated fashion, outside of general awareness, to return unbidden, often in fragments. Though such memories have often been documented to be accurate as to the central details, there is no guarantee of their accuracy. Nor do vividness, emotionality and an individual's certainty about the truth of her recollections provide any such guarantee. Though false memory syndrome advocates point to long-forgotten memories as problematic, continuous memory, traumatic or not, does not necessarily mean accurate and complete memory. What has been highlighted by this debate about memory is the complexity of the issue and the need for a great deal more collaborative research by clinicians and cognitive scientists as to what constitutes an accurate and complete memory.

When I was treating my first severely dissociative clients, I never assumed that each detail of their recall was accurate or that the stories they told about their upbringings were complete or that they were offering the only possible perspective about the ways in which their families functioned. At that time, my focus was not on accuracy or on corroboration; they were not taking anyone to court. I was more anxious to help them than interested in documenting the veridicality of their recall. Helping them gradually ease out of the grip in which their traumatic childhood experiences held them, helping them build a life for themselves and their children that was different from the life that had been perpetrated on them — this took all my energy.

So I worked hard for 10 years in session after session, group after group. And I saw disturbed and distraught children grow into confident teenagers and frightened, sullen teenagers and young adults create lives that made them (and me) proud. I saw parents who had been shocked by their child's disclosure of sexual abuse remembering — or mentioning for

the first time — frightening experiences in their own childhood. And I watched these same parents recognize the ways in which they were unable to see what was happening to their own children, and therefore unable to protect them. When they *did* see, they often grew into fierce fighters for their children's safety and well-being through the painful exploration of their own earlier traumas and the ways in which they had adapted to being used and humiliated and silenced as children themselves.

This was an exhausting decade — the 1980s — but intensely satisfying as well. I saw the social systems that are constructed to safeguard the rights of vulnerable citizens change and expand in light of a growing awareness that children were being sexually assaulted in their homes, in their places of worship, in their schools, in the institutions to which they were sent when their families could not care for them — in short, in every setting in which children are supposed to be nurtured, educated and protected. It was painful, this growing awareness, for everyone involved. Most therapists I knew paid an emotional price for opening up to a visceral knowledge of what we, and everyone around us, had not known about in an earlier time. It was, and continues to be, a price well worth paying for the privilege of accompanying courageous people on their journeys of transformation.

There was always some resistance to these changes, even while a consensus about the reality and prevalence of child sexual abuse was growing in the 1980s. And in the 1990s this resistance began to grow increasingly powerful and influential. The focus of this opposition became an organization called the False Memory Syndrome Foundation (FMSF).

This FMSF was founded in 1992 by Pamela Freyd in what has become a very public response to her daughter's private allegation of incest by her father. The False Memory Syndrome Foundation started as an advocacy group for parents who were accused of sexually abusing their children. Although no one can state this with certainty, some of its members have probably been mistakenly or falsely accused. Some of its members *did* abuse their children; certainly some of them have been convicted in a court of law of sexually abusing their children. As well as parents and other relatives of people claiming to have been sexually abused in childhood, the FMSF has drawn a number of influential academics — psychiatrists, psychologists, and sociologists — as members and/or advisors.

The aim of the FMSF is to undermine the social awareness that took place in the 1980s, which led people to accept the possibility that children can be sexually exploited by those who are charged with their care. Their principal target is the community of psychotherapists who, in their view,

has influenced people (and particularly women) to believe that they were sexually abused in childhood. It is a testament to the effectiveness of therapy in turning frightened victims into rebellious survivors that the FMSF attacks psychotherapists so ferociously with the long-range goal, according to its newsletter, of shutting down the business of sexual abuse treatment altogether.

The FMSF's most common tactic is to attribute to clinicians a view of memory as a storage of exact replications of historical incidents that call be called up and played at will. Many false memory syndrome advocates assume that most clinicians who work with trauma survivors think of memory as a sort of video library of their personal histories, and think of remembering as akin to playing a video of the past "... that memory is perfect and complete, requiring only the proper cues to allow people to retrieve accurate records of past experiences." [6] They presume a credulous psychotherapist who does not have the wits to realize that every image or every ostensible memory retrieved in therapy may not be an accurate and infallible reflection of historical reality.

Elizabeth Loftus, one of the most voluble FMSF advocates, is a psychologist with a distinguished 20-year career in memory research. Her research shows that individuals can be suggestible enough to be persuaded to describe unpleasant events that never happened, but were suggested to them by a researcher. Her research also documents that when people do remember things, their memories are often faulty about some of the details, particularly some of the peripheral details and that, in fact, memory experiences are always subjected to some degree of cognitive distortion.[7] None of this undermines the credibility of sound psychotherapy that involves the recovery of some memories that were inaccessible to the client before the therapy process was initiated, as Dr. Loftus seems to assume in recent publications and public addresses on the topic. In fact, some of Loftus' most famous studies attesting to human suggestibility — the shopping mall study, for example, in which a boy was persuaded by his parents that he had experienced an unpleasant event in his childhood that had never happened, getting lost in a shopping mall — are more persuasive as an explanation of the retraction phenomenon, in which relatives, who have an obvious stake in affecting the suggestion, persuade survivors, who desperately want a loving family who never hurt them, to believe their abuses never happened.

Loftus insists that "this is not a debate about the reality or the horror of sexual abuse, incest, or violence against children. This is a debate about

memory." [8] However, the language of the FMSF apologists — framing women as "blank canvases on which the therapist paints" and victims in training who "discover that playing a sexual abuse victim is both a demanding and engaging role" [9] — makes a joke of the claim that this is a disinterested scholarly debate. The scholarship of the more extreme FMSF advocates ignores or discounts all professional research and literature on dissociation and memory, except their own. For example, despite more than 40 studies documenting the reality of dissociated memories of childhood sexual abuse being recalled and often corroborated,[10] Loftus and her colleagues argue that "repressed memories do not exist, until someone goes looking for them." [11]

Anna Salter, in her article in this collection, "Confessions of a Whistle-Blower," which documents the years of harassment she endured as a result of preparing a report on the accuracy of expert testimony in child sexual abuse cases, notes that we keep producing more studies, arguing logically, expecting fair play and assuming that others share our desire to discover the truth. But this is not an academic debate, she declares, "it is a political fight." [12] It is a fight to return us to a time when many people in power — fathers, clergy, teachers, all sorts of formidable people — did not have to worry about being called to account for their sexually abusive behaviour. Our social tolerance for facing the widespread cultural corruption of child sexual abuse seems to have peaked, and it is common for news stories, television programs, and even some scholarly articles, to characterize abuse investigations as witch hunts and to assume that thousands of innocent adults are being victimized by what is sometimes termed in the media as the "sexual abuse industry."

What is the reality in terms of our efforts to protect children in the 1990s from adult sexual exploitation? A thorough documentation of reported and investigated incidents of sexual abuse, conducted by Ontario Children's Aid Society and Police in 1993 in the province of Ontario, found that five cases of sexual abuse were reported and investigated per thousand children, and 1.57 (29 percent of them) were substantiated. These Canadian statistics are not significantly different from U.S. figures in which 1.65 cases of sexual abuse are substantiated per 1,000 children in the general population each year.[13] If, based on incident studies that have been replicated repeatedly, a minimum of 25 out of 100 children, male and female, are sexually abused before they are 18 years of age, our child protection efforts appear to be picking up only a tiny percentage of child sexual abuse activity for intervention of any kind.

This is not to say that some investigations are not undertaken with more enthusiasm than skill, or that there are no ideologically driven and/or ham-handed psychotherapists who make assumptions and suggestions about their clients' childhood experiences. It is certainly not to say that there are no examples of mistaken allegations or even malicious accusations. There have indeed been excesses, and some people would like to see things as more simple than they are. Unfortunately, some clinicians working with individuals who claim a childhood history of sexual abuse or think they might have been abused, find it difficult to give each situation the thorough and rational exploration that it needs. They may feel pressured to arrive at a place of pseudo-certainty before all the information is in, rushing to interpret material prematurely or validating a client's own interpretations without sufficient evidence to do so. Simple propositions, like "believe everything a woman tells you" or "always validate a woman's interpretation of her own experience" can be comforting in their simplicity and their universality, but they are not reality-based, given what we know about the complexity of human functioning.

Although I do not respect the tactics of many of the proponents of the False Memory Syndrome Foundation, I do think the debate that they have initiated has made a contribution to the field of trauma. Issues about memory have been raised in a way that has compelled professionals and survivors alike to look hard at its complexities. And a great deal of thoughtful dialogue and rigorous research have emerged as a result. Unfortunately, the extremists on either side, who hold to a one-dimensional view of the issue of recovered memory, are still more frequently featured in the media, but the efforts of thoughtful people on both sides of the issue are producing results.

Recent research about recovered memory of trauma has corrected many of the methodological flaws of earlier studies,[14] and the overgeneralization of laboratory findings to clinical settings has been challenged by many scientists. Most professional organizations representing clinicians and researchers have impanelled a group of experts from their discipline to study issues related to recovered memory of traumas in treatment, and though there are some differences in their reports shaped by the allegiances of their members to one side of the debate or the other, they have delineated preliminary points of agreement and raised some important issues and cautions. They are in unanimous agreement that some recovered memories of abuse are true and that pseudomemories can be implanted by suggestion. All the reports agree that it is early days for certainty and that many

questions remain unanswered. They urge clinicians, researchers and foren-
sic experts to practise conservatively and not to allow their opinions to
outstrip the scientific data. Significantly, they all urge that the current
controversy not obscure the importance of treating and preventing the
serious effects of widespread child abuse.[15]

I agree with Anna Salter that this is a political fight, and a vicious one
at that. There are times when it is hard to be moderate, when false memory
advocates are engaging in the most scurrilous of tactics to harass those they
see as their opponents. Often those "opponents" are professionals working
industriously to find a place of integrity and balance and to look at all sides
of the issue fairly. When I was in Seattle attending the annual conference
of the International Society for the Study of Dissociation in November
1998, whenever I left the hotel, I had to walk past a van parked outside,
covered with posters libelling some of the presenters in the most extreme
terms. Many professionals who once treated abuse survivors are not
willing to subject themselves to this kind of harassment, and they no longer
practise in this field. It is difficult to maintain perspective in this frequently
personalized and emotional debate. However, we *have* reaped benefits
from this contentious dialogue about memory and abuse, and we will reap
more as psychological studies, careful clinical work and applied neuro-
science combine to enrich our capacity to understand the life experience
of survivors of the trauma of child sexual abuse and enable us to reach out
to them from a place of increasingly grounded empathy for the complexity
of the challenges they face.

Though my own day-to-day work with trauma survivors inclines me
to see therapy in the foreground of the issue of sexual abuse and memory,
Fragment by Fragment is not a book about therapy or a book about
memory research, though these topics are addressed in many of its articles.
It is a book written by women tackling the topic of child sexual abuse and
memory from a range of perspectives. This range exists because the issues
are so broad. The topic should be examined through many lenses. It is
personal, philosophical, cultural, legal and political. It requires hard
science, it requires social science, and it requires literature and personal
narrative to explore its many nuances. The issues are certainly not just
about therapy, as you might infer from most of the criticisms of the FMSF
or even from much of the professional literature on the topic.

In organizing this book, it was not easy to decide which section should
claim which articles. Why should E.B. Brownlie's chapter be in the
therapy section and Cindy Veldhuis and Jennifer Freyd's in the culture

section? Why not the other way around? Is Gail Fisher-Taylor's article about social structures or about therapy? Are not the legal articles about our social systems, and doesn't the topic of therapy come up in most of them? The intersection of all these categories, and the difficulties I had in deciding which article goes where, illustrate just how committed feminists are to the proposition that the personal is political. Though I think we need these compartments to create some sense of structure in a book that presents such a range of perspectives on the central issue of child sexual abuse and memory, the divisions are pretty artificial.

This book is multi-disciplinary. It has three sections — Memory in Therapy, Memory on Trial and Memory in Culture — and a wide range of perspectives, some very different from others. It is unlikely that any reader will agree with every point in every article or even every point of view. I certainly can't say that I do. But I can say that I am proud to be part of the ongoing discussion and debate that is so wide-ranging and so quintessentially feminist that it highlights the convergence of the personal and the political, acknowledges complexity and difference, encourages disagreement and dialogue, and assumes that the struggle to create grounded and lasting social change needs all of us.

Margo Rivera

April 1999

Endnotes

1. Florence Rush, "The Sexual Abuse of Children: A Feminist Point of View," in N. Cornell & C. Wilson (eds.), *Rape: A Sourcebook for Women* (New York: New American Library, 1974); Louise Armstrong, *Kiss Daddy Goodnight* (New York: Hawthorn, 1978); Sandra Butler, *Conspiracy of Silence: The Trauma of Incest* (New York: Bantam, 1978); Judith L. Herman, *Father-Daughter Incest* (Cambridge, MA: Harvard University Press, 1981); and Diana E.H. Russell, *The Secret Trauma: Incest in the Lives of Girls and Women* (New York: Basic Books, 1986).

2. Ian Hacking, *Rewriting the Soul: Multiple Personality and the Sciences of Memory* (Princeton, NJ: Princeton University Press, 1995), p. 4.

3. Sheila Jefferies, *The Spinster and Her Enemies: Feminism and Sexuality, 1880-1930* (London: Pandora, 1985).

4. Kenneth S. Pope & Laura S. Brown, *Recovered Memories of Abuse: Assessment, Therapy, Forensics* (Washington, D.C.: American Psychological Association, 1996); and Christine A. Courtois, *Recollections of Sexual Abuse Treatment Principles and Guidelines* (New York: W W Norton, 1999).

5. Pierre Janet, *Psychologique l'automatisme* (Paris: Felix Alcan, 1889).

6. D. Lindsay & J. Read, "Psychotherapy and Memories of Childhood Sexual Abuse: A Cognitive Perspective," *Applied Cognitive Psychology* 8 (1994), pp. 281-338.

7. Elizabeth Loftus & Katherine Ketcham, *The Myth of Repressed Memory: False Memories and Allegations of Sexual Abuse* (New York: St. Martin's, 1994).

8. Ibid, p. xi.

9. Richard Ofshe & Ethan Watters, "Making Monsters," *Society* 30, 3 (1993), pp. 4-16.

10. Daniel Brown, Alan W. Scheflin & D. Corydon Hammond, *Memory, Trauma Treatment and the Law: An Essential Reference on Memory for Clinicians, Researchers, Attorneys and Judges* (New York: W W Norton, 1998).

11. Loftus & Ketcham (1994), p. 141.

12. Anna C. Salter, "Confessions of a Whistle-Blower: Lessons Learned," *Ethics & Behaviour* 8, 2 (1998), p. 122.

13. Nico Trocme, *Ontario Incidence Study of Reported Child Abuse and Neglect* (Toronto: Ontario Institute for the Prevention of Child Abuse, 1994).

14. Alan Sheflin, Daniel Brown & Cory Hammond (1998).

15. Courtois (1999).

PART ONE

Memory
in
Therapy

INTRODUCTION TO PART ONE

Memory in Therapy

Margo Rivera

When I worked at the Children's Aid Society, I watched parent after parent respond with intense emotion to their children's disclosures of abuse. Sometimes they directed their reactions at the child: "Why didn't you tell me before?" "Why did you let him do that to you?" Sometimes they focused on the perpetrator: "Wait till I get my hands on him. I'll kill him." Sometimes they vehemently refused to believe: "I would never bring anyone into our home who would hurt you." "You never like any of my boyfriends."

There was nothing abnormal about their reactions. They did not indicate that these were bad parents. Of course, people want to deny or to attack when their world collapses around them. Some of them were able to re-focus on their child's needs quickly; others never budged from that self-absorbed initial stance. But those first reactions often silenced the child, at least for a while. It was bad enough to have to talk about such gross things; to make mommy so upset was worse. It confirmed the children's suspicions that, no matter what the nice lady

said about it, it was a mistake to talk. A few children, in fact, never talked about the abuse again.

As an effective therapist, listening without immediately imposing one's own reactions is part of the discipline of helping abuse survivors claim their lives as their own. There are always limits on this process; our own interpretations will necessarily influence our responses. I have never forgotten one of my first lessons on viewing sceptically my own beliefs about my clients' childhood experiences. A woman was telling me about disclosing paternal sexual abuse. "They put me in juvenile detention," she said, "and then I had to stand trial for what I did."

Poor child, I thought, the court process was so frightening and hostile she felt she was the one on trial. I don't think I replied in any way except with a murmur and a nod, but I remember clearly how sure I was about my interpretation. A year later, I was working with new clients at the Children's Aid Society, and I came upon the records of this case on microfiche in the course of a current investigation. Indeed, this young girl had been arrested as a result of telling her health teacher about the sexual abuse she'd been enduring at home each day. She had just made the connection between what her father was doing to her and the possibility of getting pregnant, and the shock released her inhibitions against speaking about her home life. Her parents were notified about her allegations, and they countered by declaring that she was meeting a boyfriend for sex and they could not control her. The girl was tried and convicted in family court for "sexual immorality," and her parents were the only witnesses against her.

This taught me the dangers of making assumptions about events I did not witness. Obviously, it can go the other way as well. I can be entirely persuaded of a person's story happening exactly as she recounts it, but if I was not present, it is important that I recognize the limits of my ability to know anything for sure. There might be situations in which it is important for me as a therapist to try to tease out the reality as best I can (in forensic or child welfare situations, for example), and then I must make an educated judgement based on an analysis of all the data that is available. But my responsibility as an individual's therapist is to help her create a meaningful narrative about her own life as part of the process of making the most out of her life. I must resist the temptation to do the interpreting for her, even if she begs me to do so when her own confusions overwhelm her.

The caution we must exercise in claiming to know what we cannot know becomes an important part of the psychotherapy process. No matter

how much a client might want her therapist to tell her what is real as she struggles to make sense of painful images — dreams and physical sensations that at one moment seem like a memory and the next like a horror movie — the more implacably must the therapist insist that it is the client's life and only she has the right and the responsibility to decide what happened and what it meant. This message, offered with empathy and compassion for her struggle and an understanding that what she knows and how she interprets what she knows may change over time, reiterates the basic message of good therapy geared to the empowerment of the client: that your life is your own, and no one, with the best intentions or the worst intentions, has a right to take that life away from you.

Becoming aware of how complicated the process of remembering is and of how much about it we do not know yet is something professionals have learned, as we see more clients with more complicated sets of problems. We have also expanded our ideas about how to understand those problems and have developed more sophisticated ways of facilitating the healing process.

In 1980, when three new diagnostic categories that reflect our professional and cultural awareness that trauma affects people's mental health — Posttraumatic Stress Disorder, Multiple Personality Disorder, and Atypical Dissociative Disorder — were incorporated into the *Diagnostic and Statistical Manual of Mental Disorders (3rd Edition)* (DSM-III), fairly straightforward lines were drawn between event(s) and effects. It is now clear that it is not so simple. The category Posttraumatic Stress Disorder (PTSD), for example, reflects the belief that traumatic experiences cause symptoms. Yet, many people are exposed to traumatic events; only a quarter of them subsequently develop PTSD.[1] The notion that an effective therapy process for sexual abuse survivors essentially involves unearthing (if they are partly buried) and re-living memories of the trauma, in what is basically de-sensitization, stems from this model — stressful events create posttraumatic stress symptoms. Most therapists could see that there were many intervening variables that make the treatment of a individual who had been abused and neglected throughout childhood different, and much more complicated, than helping a mentally healthy person deal with the psychological aftermath of a recent severe car accident.

The articles in this section of the book, "Memory In Therapy," point to some of the complexities that need to be taken into consideration if psychotherapy for sexual abuse survivors is to be helpful rather than

harmful, if it is to be the vehicle it ought to be for helping people face the complexity of their life experience, the myriad ways in which they became the people they are today, and the changes they will need to make if they want to be more peaceful, more productive, more responsible, and even, possibly, happier.

There are no mental health issues that can be treated properly without an awareness of the social context, past and present, of the individual who is experiencing her particular problems. The articles in the "Memory In Therapy" section of this book demonstrate how especially true this is in the treatment of a survivor of childhood sexual abuse, whose life experience includes events that carry such powerful social messages.

E. B. Brownlie's article, "Lies, Secrets and Silences: Substantiated Memories of Child Sexual Abuse," places a young girl in the midst of a set of systems — family, social service and criminal justice systems — in which she believes her life to be in danger if she speaks. She is offered by the authorities only words that make a lie of her disclosure, and she is refused the protection she requests from the daily assaults that terrify her. She is told not to talk about the abuse and has to carry one more significant secret: the counselling she needs and must access without parental permission. She argues that, though she always remembered that the abuse happened (and official records substantiate that memory), there are more similarities than differences between her experience — for example, the complexity of the way she remembers and of the distortions to which her story was subjected when she tried to break the socially sanctioned silence — and the experience of the woman who recovers her memory of abuse as an adult after forgetting it for years. She suggests that the notion of "substantiation," separating "true victims" of child sexual abuse from their suggestible false memory counterparts, is a political artifact rather than a reflection of any reality she recognizes.

Merideth Kimball's "Acknowledging Truth and Fantasy: Freud and the Recovered Memory Debate" points to the similarity in the major shifts within Freud's body of work — first framing abuse memories as unambiguous truth and later as sheer fantasy — to the recovered memory debate that is occurring today. She argues that we can learn from history that simple and fevered propositions about memories — as being either completely and utterly accurate or completely and utterly fantastical — are never a solid basis for sound psychotherapy. Though it is particularly difficult to bear the ambiguities so often associated with memories of child

sexual abuse, our knowledge will stand on firmer ground if it encompasses the complexity of the human mind, and we do not overstate what it is we think we know for sure.

Mary Gail Frawley-O'Dea draws a parallel between the defensive fluctuations ("it's all true"/"nothing is true") commonly encountered in the individual therapy of the sexual abuse survivor and the more extreme positions taken by the combatants in the recovered memory debate. In "Society, Politics, Psychotherapy and the Search for 'Truth' in the Memory Debate," she notes that most survivors of sexual abuse, whether they have always remembered their experiences or remember later in life, bring to their therapy a sense of chronic doubt. How can this have happened? Ultimately, Frawley-O'Dea claims, both the individual and the social discourse will be enriched by developing a tolerance for the ambiguities and complexities that are a part of every person's construction of her personal narrative.

In her article, "In the Presence of Ghosts: Transforming Realities," Gail Fisher-Taylor juxtaposes her own experience of being cut off from her family, particularly from her mother, when she disclosed her experience of being sexually abused by her father, with the alternative way in which disclosures of intrafamilial abuse are handled in the Objiway First Nation community in Manitoba. She argues that our mainstream institutional interventions in response to a child's disclosure of sexual abuse usually involve many losses for everyone involved and few gains. She points to alternative community programs in which there is a general social acknowledgement that each criminal act of child sexual abuse spreads from one relationship to another, touching many people, all of whom should be incorporated respectfully into the process of accountability and healing.

Each of these articles, coming from very different perspectives, includes an important similar point. They all highlight the necessity of giving up, within the therapy context, the comfort of ideological simplicities when coming face to face with the struggle to revisit, reclaim and integrate memories of childhood sexual abuse. Survivors need therapists who continue to expand their knowledge about the ways in which the human mind operates and the wide range of influences that affect how people take in, encode and retrieve information. They need therapists who recognize that human beings are deeply embedded in their social contexts and that treatment is not an isolated phenomenon. They need therapists who are open to more than one way of approaching the healing process and

who can creatively consider many ways to reach out and to reach in. And, above all, they need therapists who can bear the uncertainties and ambiguities that come, at least at this point, with the territory of memory and who can support their clients in maintaining a steady life course as they explore this rich and fruitful terrain.

Endnotes

1. Marilyn Laura Bowman, "Individual Differences in Posttraumatic Distress: Problems with the DSM-IV Model," *Canadian Journal of Psychiatry* 44 1999, pp. 21-33.

LIES, SECRETS AND SILENCES

Substantiated Memories of Child Sexual Abuse

E. B. Brownlie

I was 16 the first time I saw anything in print about child sexual abuse. It was 1983. In a public library, I came across a book entitled *The Best Kept Secret* by Florence Rush. My heart pounding, I took it off the shelf and saw that I had guessed correctly what the book was about. I didn't read it, couldn't really bear to, but I remember thinking that maybe now that sexual abuse was being publicly addressed, something would be done to prevent it. Maybe now those who came forward to tell that they had been abused would be heard and protected.

Since then, I have watched the silence covering up child sexual abuse slowly lift. Today sexual abuse is frequently discussed in the media and elsewhere. But increasingly, the focus of public concern and discussion has shifted from the reality of child sexual abuse to issues of verifiability and proof. People rarely deny the existence of child sexual abuse any more. However, public discourse often highlights the fraught, complicated nature of unsubstantiated abuse memories. Substantiated memories of abuse,

if they are discussed at all, are assumed to be unproblematic and transparent. But substantiated memories do not provide a standard of certainty and clarity — often they too are complicated and fraught. Memories of a secret, even substantiated memories, are not straightforward.

By the time I came across that library book, I had already discovered that telling the truth about sexual abuse was difficult, and that, for me, speaking out did not result in safety or any kind of resolution. I was a little girl who was sexually abused at a time when the very existence of sexual abuse was still virtually hidden in silence, and, as I became all too aware, before adequate interventions to deal with it were in place. I was sexually and physically assaulted for several years before I was 12. There were two perpetrators, both male. One of them instigated the abuse and had a position of trust within my family, and the other was an older kid from my neighbourhood who was initiated into the abuse by the main perpetrator. For a number of personal and legal reasons, even after 20 years I still do not feel safe revealing exactly who they were. What is important for this story is that although the abusers were not my parents, they had power over me and had frequent access to me when I was alone.

By the time I was eight, the abuse was occurring almost daily, usually after school, but sometimes at other times too. I didn't tell anyone, and it continued for three more years, becoming progressively more methodical and cruel. When I was 11, the main perpetrator moved out of town for reasons unrelated to the abuse. A year and a half later, he returned. I was at summer camp just before he was due back, and I told a camp counsellor and then wrote to my parents to tell them what had been happening. After I disclosed the abuse, the Children's Aid Society and the police were involved, but they did little to ensure my safety. During my adolescence, the abuse did not continue in the same way it had when I was younger, but I was still subjected to menacing reminders and threats. Starting in Grade Eight, I arranged whatever counselling I could find for myself, but it was not enough to do more than keep me functioning. I left home when I was 20 and soon found therapy that held the promise of healing.

Now, more than a decade later, I'm in graduate school in the research stream of psychology. The topic of abuse and memory comes up often at conferences and lectures, in casual conversations, and in the media. I often find that an attitude of general scepticism toward unsubstantiated abuse allegations prevails, especially when recovered memories are involved.

Much of that attitude is due to the False Memory Syndrome (FMS) movement, whose portrayal of the adult making unsubstantiated sexual

abuse allegations has permeated public imagination. The prototypical complainant is a well educated, white, middle-class woman in her 20s or 30s. She often accuses family members; in most cases she accuses her father. She seems to have had a relatively normal childhood. In fact it is astonishing that, if her claims are true, no one noticed that anything was wrong. She has personal problems as an adult, and comes to therapy for some reason other than abuse. She blames her own difficulties on childhood sexual abuse, in what has been termed the "ultimate crybaby therapy." [1] While in therapy, she performs what are described as unlikely feats of memory, such as remembering events from 20 years before. Eventually she harms her family by ending contact with family members, especially those who do not believe her accusations of abuse.

When I hear these accounts of "false" memories of abuse, what strikes me most is that the complainants sound very much like me. I am a well educated, white, middle-class woman in my 30s. I came to therapy in my 20s after a relationship break-up and ended up working more on my childhood abuse history than on the issue that brought me to therapy. As a child, I did very well in school and in other activities and no one noticed that anything was wrong, or, if they did, nothing was done about it. During my therapy, I temporarily cut off contact with my family, and permanently ended all contact with both of my abusers. The main reason for these separations was my memories of abuse from 20 or more years ago. Although I have since reconciled with my parents, my family is still divided because of the abuse.

Although I sound a lot like the typical "false" memory syndrome sufferer, I have always remembered the abuse, and my abuse history is substantiated. The substantiation includes police records, Children's Aid Society records, and an admission of guilt by one of the perpetrators. So why the close correspondence between my experiences and the story that is used to discredit survivors with unsubstantiated memories of abuse? Maybe the description of a person with "false" memories of abuse is better viewed as a description of any survivor of child sexual abuse in the current political climate.

The commonalities between my experiences and the prototypical FMS story made me notice that I have been affected by the FMS movement, even though my abuse history is substantiated. I began to recognize the ways that the FMS movement is detrimental to all survivors of abuse, whether the abuse has been substantiated or not. First, FMS proponents promote a habit of disbelief in response to reports of abuse, whatever the

circumstances. As a result, allegations of abuse are often met with disbelief and hostility, without a careful reckoning of what evidence might or might not be available. As well, FMS rhetoric blames daughters for disrupting families either by lying about the abuse, if the allegations are false, or by insisting on speaking out about something that happened a long time ago, if the allegations are true.

In addition to themes of disbelief and blame that apply to all abuse survivors, FMS discourse maintains rigid criteria based on substantiation and proof. By arguing that abuse happens, but not unless you can prove it, FMS uses the ideal of the "true" complainant with substantiated memories as a foil to dismiss and deny unsubstantiated memories of abuse. I want to interrupt that process, and that's why I decided to write this article.

The fact that I have substantiation is one part of my story. However, having proof has never rendered my story straightforward or unambiguous, either in the ways I have thought about it or in the ways that people have responded to it. It is the lack of clarity and the layers of contradiction in the context of a substantiated abuse history that I want to explore. Having substantiated memories helped me to understand my own life by forming a kind of bridge to the past. Nevertheless, my own beliefs about what happened to me and the ways that I remembered the abuse were complicated and conflicted. Further, the content of the substantiation itself was not only partial and incomplete, but a distortion of the events it would supposedly confirm. Finally, my disclosure of the abuse, which led to my having substantiation, did not grant me safety, nor did it provide a space to speak the truth or a permanent end to secrecy or silence. Substantiation did not result in an easy relationship with the truth.

Despite the similarities between my experiences and those of survivors with unsubstantiated memories of abuse, I did derive some comfort and validation from having substantiation. I was believed. No one suggested to me that the abuse did not happen, that I had imagined it, that it was mere fantasy. When I was in therapy confronting the events of my childhood, having substantiation simplified dealing with the abuse. Since I knew that the abuse happened, and that I had evidence in addition to my own memories, I did not feel I had to concentrate on defending my own assertions, while doing the painful work of reliving those childhood years. Knowing I had substantiation limited the extent to which I felt I had to censor or interrogate the memories that made it hard to sleep, hard to eat, and rendered me terrified much of the time. I found it comforting and grounding to have something in the world that validated the painful stories

I revisited again and again in therapy. It meant that the focus of therapy could be on my own experiences.

Having substantiated memories encouraged me to believe myself. However, it did not prevent me from disbelieving at times that the abuse had happened. For me, the question of belief was often ambiguous and divided. I believed parts of it and not other parts. I believed it sometimes and not other times. Part of me believed it and part of me didn't believe it. It rarely reduced to true or false. Nevertheless, being able to believe myself was emotionally important to me. I had always feared that people might not believe me if I told them what had happened. The same sorts of meanings attached to my own disbelief. For me, to disbelieve that it happened represented a denial of the pain I was feeling and the reasons for it. It also seemed to be a betrayal and abandonment of the girl I had been. Yet at the same time, disbelief represented a retrospective, futile hope for safety, for a different life for that girl. Believing my memories required me to abandon that hope. Learning to believe myself brought with it both clarity and grief.

My belief that it happened also compelled me to develop different coping strategies from the ones I had used since the time I was being abused. Coping with the abuse was particularly complicated, because of the context of contradictions in which child sexual abuse occurs. It's happening, but it's not supposed to be happening. At the same time, it is imperative to act as though it's not happening. I truly believed that my life would be in danger if anyone found out, especially if it appeared that they found out because of something I said or did. Sometimes I could convince myself, with partial success, that it wasn't happening and had never happened, creating a fleeting illusion of safety that made it easier to get by.

As an adult, I still wanted to believe that it hadn't happened, even while I knew that it had. Imagine trying to gain strength, confidence, and a feeling of safety in the world, while continually being acutely aware of times when you were most vulnerable, powerless and in danger. My healing was made easier by a temporary, unrealizable alternative, a possibility that it didn't happen, which I harbored for a while, separate and protected, until I was ready to transform it into a possibility for a different life as an adult. The transformation to believing difficult truths was painful, but strengthening. During this struggle, I would often forget for months at a time that I had any sort of corroboration. Struggling internally with my own beliefs, external sources of validation did not occur to me. However, in time, the fact that I did have substantiation acted as a centering

force, like a rudder, pulling me back to reality. Believing that reality was essential for me to find my own voice of protest and resistance.

Although the existence of substantiation helped me to come to terms with my own truths about my experiences of abuse, I have never been able to construct a complete or coherent account of what did or did not happen. I was assaulted many times over a number of years, but I do not believe I have remembered every incident that happened, nor the order in which they occurred. I am sure that some of my memories are composites of many incidents, rather than single experiences. When I have remembered particular incidents, I have usually only guessed how old I must have been at the time, and I rarely, if ever, have placed them on a particular day. At the same time, I have always remembered the abuse, and this has had a centering effect, just as substantiation has had. But how could such an unclear set of memories provide a basis for my own clarity?

In thinking about this question, I have tried to unravel what it means to remember childhood abuse. The characterization of memory as delayed or continuous suggests that memory of trauma is singular — either present or absent over long periods of time. It does not speak to different ways of remembering. I experienced qualitatively different kinds of memory at different points in time. I had memories *of* the abuse (recollections of the experiences) from the time the abuse stopped happening. However the content and quality of those memories changed over time. Some memories I had all along; others I remembered only in adulthood. Others I remembered at first only partially, then more completely later on. In addition, I had memory *that* I was abused (knowledge that it happened) which stayed relatively constant over time. Finally, the more day-to-day memories of myself as a young girl, living under the stress of daily attack, I thought little about until adulthood. These three facets of memory remained separate for a long time, and I forged connections between them only after years of therapy as an adult.

I have never forgotten that I was abused. Yet, as a child and an adolescent, a good day at school was a day in which I did not remember. My memories of the abuse were debilitating. They were violent flashes — images, sounds, sensations, terrors, fragmented and out of context. They were flashbacks to the past, usually triggered by present-day reminders of the abuse, and I experienced them as though they were happening in the present. The memories seemed unreal because they were dreamlike, and because they made me feel as if I had been transported back to a time and place where I was still experiencing the abuse. However, they seemed

extremely real in that they were vivid, terrifying, and seemed to capture what the experiences were like. My memories of the abuse motivated my healing, because they were disruptive and painful and I wanted to be free of them. Much of the process of healing involved facing these memories and staying with them long enough to see what happened next, so that they became less fragmented and more integrated and complete. When I doubted whether the abuse happened, they served as distressing and powerful reminders.

Given the fragmented quality of many of my memories of the abuse, it is not clear how to interpret them even after years of working them through in therapy. It is possible that no single memory is precisely accurate, yet, taken together, the whole set of memories is not far from the truth. I am least sure about the most violent memories, but I am sure that they represent the level of terror I felt as a child. They have an emotional truth, and they say something about the sadistic, structured aspects of the abuse. But they are also the memories that even now I have trouble recalling calmly, so my uncertainty stems in part from the difficulty in focusing on them. And they are the memories from which I would have most wanted to protect my younger self, the ones that should not have been, most of all.

To the extent that memory is reconstructive, I cannot recapture the incomprehension with which I faced these events, nor can I recall the strange normality that infused them in the way I coped with them, the everydayness of it. The memories that come easiest are the ones that do not involve the abuse itself but the minutes before. I remember watching the clock on school days in the afternoon, and my stomach aching as the minutes passed and finally the bell rang. I remember leaving school at the end of the day and walking home as slowly as I could, but never considering that there might be somewhere else I could go. But other than these moments, which are strongly associated with the abuse that followed, I find it hard to remember myself as a young girl, what it was like for me then and how I felt. Even with all the work I have done in therapy focusing on the years of my childhood, it is a rare and painful thing when I do connect to that time in my life. Sometimes I find other forms of corroboration, other ways of knowing. I look at photographs of myself at the time, and I see something in my eyes, and the bright red burning of a stress rash on my skin. My mother says I became heavy on my feet around the time the abuse started — that all of a sudden I couldn't dance.

In contrast to my memories of the abuse, and of myself as a young girl, my memory that the abuse occurred was relatively detached. It was an

available awareness, so that if I thought about it I would know that it happened. When I did think about it, I remembered little or no specific content. It was as if I did not remember what happened, while I was remembering that it happened. I would feel apprehensive but, aware of the panic lurking beneath the surface, I usually kept stronger feelings at bay. This controlled way of remembering seemed unreal in that it was very separate from my experiences of the abuse and of living with recurrent abuse. However, it seemed very real in other ways, as it was the most accessible, rational way of remembering. It was always accurate, and it did not make me feel as though events from the past were happening in the present. Although my awareness that it happened was disconnected from my emotions and experiences, it provided a continuous thread of memory. Further, my awareness that it happened served a survival function. Separate from the paralyzing effects of specific memories, my calmer knowledge of what had happened enabled me to try to protect myself as an adolescent. It enabled me to strategize ways not to be left alone with my abusers and to plan escape routes if I was. It was the reason I gave to agencies when I tried to arrange emotional support and counselling.

My own belief and memories of the abuse, while painful, were empowering because they were ways of telling myself truths. However, telling these truths to others proved difficult; maintaining my own truths became impossible given the power of agencies and individuals to distort, stifle, and ignore these truths into lies, secrets and silences.

One reason for these distortions was my own limitations when I first reported the abuse as a 12-year-old. Just as I lacked the physical size and strength to defend myself effectively, I lacked the knowledge and language to name my experiences for what they were. I did not have the ability to say words like "rape," "torture," even to myself. All I had were pre-teen words for sexual exploration and physical attack, and those are the words that I used to come forward to tell what happened to me. He made me make out. He beat me up. He made me do things. I knew at the time that they did not describe what had transpired very well, but I knew no other way to convey what I had experienced.

My initial disclosure led to the involvement of the Children's Aid Society and the police, and for that reason I have substantiation. However, the content of the substantiation, including the information I provided, was determined in many ways by the practices of police and child protection institutions in cases of childhood sexual abuse at the time. When I made my statement to the police, the abuse was talked about using terms usually

reserved for consensual sexual activity. Before the interview, I was given the definitions of two words that I was told to use to describe what happened: petting and intercourse. These words were horrible for me to say aloud to adults. They also radically minimized the experiences I wanted protection from. Neither word acknowledged coercion or violence, nor did the questions I was asked. But I knew no words to describe what went on in my house almost every afternoon after school, and I probably could not have said such words even if they had been in my vocabulary. I was interviewed by two male uniformed police officers with my parents present. No one was there to advocate for me or to help me say what I remembered or to provide support afterwards. No one spoke to me about my experiences alone, without my parents present. No one provided me with any assurances about my safety, given what I was divulging, although I felt very much in danger. I was alone, frightened and ashamed, and had little experience talking about sex or violence.

During the police interview, I lied about what had happened to me. I tried to say as little as possible because I did not want to have to describe any details of the abuse. A police officer suggested that what happened had been mostly limited to petting, with only a few instances of intercourse, and I agreed. I felt that if I alluded to anything else that had happened, I would have had to elaborate on it, and I was not at all willing to do that. I also lied about who did it. I named only the older, main perpetrator, mostly in order to avoid the demand to describe more of the abuse, but partly to ensure that blame was not diverted from the one who was most responsible.

Given how difficult it was for me, my disclosure had little effect. What was supposed to have been a leap to safety was greeted with deep silences and inaction. It is true that neither my parents nor the authorities knew the extent of the abuse. However, I made it clear that I had not told sooner because I was afraid for my own safety, and that I continued to be afraid. That did not protect me from unsupervised contact with my abusers either at home or at school. Further, the only opportunity I had to protest to the Children's Aid authorities that the main perpetrator had continued access to me was in his presence. With much trepidation I did so, only to be told by child protection workers that I had no right either to sanctuary at home or to a different living situation, and that it was up to me to change schools if I was afraid to be there. The abuse was considered to be a family problem, and the idea that the child protection workers had a right, much less a responsibility, to intervene was not reflected in any of my dealings with the Children's Aid Society.

Despite my attempts to speak, the secrecy I resisted was reinstated almost immediately after I disclosed. I was quickly instructed not to tell anyone what had happened. Further, my parents promised to arrange therapy for me, but never did so, and never mentioned it again. As an adolescent, I tried repeatedly to find therapy for myself. Most therapists and counselling agencies would see me only if I had parental permission, because I was legally a minor. Given the silences that followed my last plea for help, this was not a topic I wanted to bring up at home. Eventually I found different sources of emotional support, and convinced those in authority to allow me access to services without parental permission. My use of counselling services was now another secret that I had to keep hidden from my parents. I found out as an adult that a social worker told my parents that I did not need counselling, and that they should never discuss the abuse with me.

The reason I have any substantiation at all is that I reported the abuse. A combination of events led to my disclosure. When I was 11, the abuse stopped and I had no intention of telling anyone about it. It was no longer happening, and I certainly was not in a home or school where anything related to sex could be easily discussed. I was afraid of my abusers, afraid they would harm me if I told anyone. I was also afraid that I would be blamed or held responsible for the abuse, or for not having told earlier. More than a year passed; then two events happened that precipitated my disclosure: the unexpected return of the main perpetrator, and the onset of menstruation. I knew that I would not be able to prevent myself from being left alone with him. I told because my fear of pregnancy outweighed my other fears.

I can imagine a few scenarios in which I might not have told anyone and therefore would have had completely unsubstantiated memories of abuse. If the main perpetrator had not returned, I might have said nothing, which is what I had been doing, and had been planning to continue, before I found out that he was coming back. If he had not left, I might have remained too terrorized to act. If he had returned before I reached puberty, and the abuse resumed, I also might have felt too threatened to disclose. The events that led to my having substantiated rather than unsubstantiated memories are unrelated to the early abuse and so it is partly coincidence that I have substantiation. The same story could have had either ending.

Given that my memories are substantiated, though partially, I decided to explore what tangible evidence actually exists. Perhaps most compelling has been the admission of guilt by the perpetrator I identified. Soon

after I disclosed, I was told that he had admitted it, though "it" was only spoken euphemistically, so I do not know the content of what he admitted to, or how specific it was. In addition to his admission, I have always believed that there were police records and Children's Aid Society documents that would record in some way what happened. When I began writing this article, I realized that I have never seen any police records, and I do not know if any exist. I thought there were police records because I was told that my abuser had received a warning at a police station, and I assumed that the police would have had to record the information. Finally, I have never seen any documents from the Children's Aid Society about me or the abuse that I experienced. When I was in therapy, I contacted the agency to try to obtain any relevant records they had, as I thought seeing them would help me in my healing. I was told that I needed the perpetrator's permission to get access to the documents, as my reading them would violate his privacy. The substantiation I have always believed I had may not exist, and has never been in any way mine.

So where does that leave me? Are my memories completely unsubstantiated? Probably not. The Children's Aid Society documents may well allude to or explicitly reference the abuse, even though I do not have access to them. Social workers, police officers and family members witnessed the police interview or the Children's Aid Society meetings in which I raised my concerns about the abuse. Many others listened to me talk about what happened as counsellors or as friends. But I have less substantiation than I thought I had. If substantiation is understood as a matter of degree, as a continuum rather than as something that is present or absent, then where am I on that continuum? Do I have enough substantiation? The question requires a context. Do I have enough to know myself, enough to confront a sceptical family member, enough to convict my abusers in a court of law?

Is there such a thing as enough substantiation, and what would it entail? Substantiation is always partial, always incomplete. Even in their most truthful telling of their most clear recollections, an abuser and an abuse survivor would probably remember the same events differently. A third person might discover the abuse while it is going on, but would provide no substantiation about events that transpired in the minutes, hours, days or months before the interruption. A video camera, perhaps several cameras covering every viewing angle, would provide images of what went on. But such images would miss subjective experiences, and sometimes external observations do not tell the whole story. In the intense relational environment of secretive abuse, meanings can be communicated

in ways that the perpetrator and victim fully understand, but that others would miss. An example is the tug of a phone cord that my abuser would wrap around my neck as I talked on the phone as a teenager. This subtle gesture that might look like an accident or even a joke would send a chill through me, and I would receive a message loud and clear. What exactly could be substantiated in what I just described, "fooling around" or something more deadly?

Largely as a result of the FMS lobby, legal issues have become central to understanding and dealing with adults' memories of abuse, whether or not the legal system is involved. In some cases, the possibility of legal repercussions results in legal contexts drifting into non-legal settings. For instance, in response to very real concerns about litigation, some therapists advocate that all statements about childhood abuse that are made during therapy sessions be documented as a precaution in case of legal actions, which could arise at any time. Under these circumstances, therapy for child sexual abuse survivors might well shift into a context of evidence gathering or deposition.

For most people, therapy is a setting that allows a number of possibilities to be freely explored, a place where contradictions are allowed to exist. I think I would have found it much more difficult to say things I was unsure about in therapy and to explore my own beliefs and doubts, if I thought that everything I said about abuse would be permanently recorded. Given the difficulties I had in coming to believe myself, I probably would have avoided admitting that I no longer thought something I said some weeks ago was true, if I knew it would be on record that I had taken it back. I wonder how often I would have garnered the courage to say something that I thought was a possibility, but not a certainty, or to cast doubt on something that I had been certain about before. Ironically, a possible consequence of these legal constraints in the context of therapy is that they may inadvertently encourage a premature certainty of abuse, the very thing that strategies of documentation are intended to avoid.

Like most survivors of child sexual abuse, I have never pressed charges against a perpetrator, nor do I plan to do so. Yet the trial is the unspoken metaphor informing the ways that adults' recollections of sexual abuse tend to be viewed and discussed. Consequently, substantiation has come to be perceived as a necessity in order to even talk about abuse. Naming my experiences of abuse can quickly elicit responses of interrogation and cross-examination in others. I think this happens because many people feel at some level that not to do so would be fundamentally unjust.

The perpetrator's right to presumed innocence is implicitly invoked, even in what can be thought or said. Conscious legal concerns may constrain practices of therapy, so that abuse survivors automatically trigger a different protocol for recording information than other clients. In the same way, unconscious legal sentiments can constrain informal discussions of abuse, so that only statements with "enough" substantiation are admissible.

The implicit legal discourse around child sexual abuse and the resulting focus on proof has made it more difficult for me to speak about my own experiences. Although the topic of sexual abuse is frequently raised, I often feel hesitant to express my thoughts, based on what I know from my own life, because I expect that at some level the veracity of what I say may be challenged. Other life events, unwitnessed, illegal or traumatic, are not held to the same standards of verification as are adults' accounts of child sexual abuse. More extreme attitudes of blanket scepticism toward adults' memories of abuse, with their insatiable demands for more substantiation, more proof, have certainly caused me pain. They have also discouraged me as I have painstakingly tried to understand my own complicated history.

As long as the legal anxieties FMS raises continue to shape the ways that abuse can be talked about, those complicated layers will not be incorporated into discussions of abuse and memory. If only unambiguous evidence can be considered, conclusions will remain simple. But to understand the truths about memories of abuse, space is needed for complexity, ambiguity and contradiction. Only then can the lies begin to be untangled, the secrets begin to be told, and the silences begin to be broken.

Endnotes

1. John Hochman, at <http://www.sceptic.com/02.3.hochman-fms.html>.

ACKNOWLEDGING TRUTH AND FANTASY

Freud and the Recovered Memory Debate

Meredith Kimball

The modern debate over recovered memories of childhood sexual abuse is too often presented as a simple dichotomy between "believers," who argue that recovered memories of childhood sexual abuse are true, and "deniers," who argue that these memories are fantasy. This debate has a long history. More than a hundred years ago, when confronted with evidence of childhood sexual abuse, some medical doctors accepted the child's accusations as true. Others argued that the children's stories were only fantasies designed to ruin the reputation of innocent men.

Sigmund Freud entered this debate initially to support the truth of his adult patients' memories of childhood abuse. However, he soon retracted this view and proposed instead that all adult memories of childhood sexual abuse were infantile sexual fantasies. Freud's retraction had a powerful effect on clinicians and most followed his latter view that these memories were fantasies. However, a few continued to argue that the memories of abuse were true. The debate has continued to the present day where

believers, most often feminists, are pitted against deniers, advocates of the False Memory Syndrome movement.

I have two purposes in writing this article. The first is to describe the historical debate in which Freud played a major role. The second is to argue against dividing memories of abuse into only two choices: truth or fantasy. All memories are ambiguous. Even memories for simple events are often changed, distorted or reorganized.

In writing this article, I have become more attentive to my own memories. Two strike me as noteworthy in this context. The first is a childhood memory for which I have disconfirming evidence, that is, a false memory. From the time I was two and a half until I was four years old, I lived with my parents in the upstairs of a house that was described to me as being on a specific corner. Until several years ago, I was certain that a rather elegant old house on that corner with an outside staircase to the second floor was the house in which I had lived. Then one day, while driving by the house with my mother, I mentioned the house and she corrected me. It turns out we lived in the upstairs of a rather unremarkable house across the street. I assume that I must have formed a clear image of the other house through looking out of our windows and that later it appealed to me as more attractive and certainly more romantic than the house where I had lived.

The second is a childhood memory that I have been told, but have never recovered for myself. My mother told me this story. When I was in elementary school, there was a tornado warning one day. Many of the parents came to take children home, but evidently my mother did not, as she knew there was a basement in the school and I would be safe. I was not the only child left at school during the warning, but I was very upset and angry with both my mother and father at the time for not coming to get me and evidently let them know how angry I was. I find this particularly interesting, because I was angry at the time and anger was a rare emotion in our household. Even though it made a big impression on me at the time, I have no recollection of the event. Furthermore, I now reconstruct my past in such a way that abandonment issues played a significant emotional role in my childhood. Thus, it is of particular interest to me that I should not have access to a memory of an experience in which I felt both abandoned and angry. However, if it had remained an active part of my memory, it would have challenged my family's myth of independence and strength.

Traumatic memories are often more ambiguous than more neutral everyday memories. Victims of traumatic events often experience both an

inability to shut out traumatic memories and an inability to remember the trauma. This frightening lack of control over memories and emotions increases uncertainty and creates confusion. However, even the most fragmented and confused memories contain elements of truth. The essence of past events often remains or can be recovered, even if all the details are not remembered exactly as they happened.[1]

Stories of one's own personal past help individuals understand the present and help them act in the future. Similarly, Freud's story, which is part of the Western cultural past, can help us understand the present and create a future more responsive to feminist values and visions. In Freud's world, as in the present, the debate around childhood sexual abuse was highly polarized. Instead of challenging this polarization, Freud accepted it, advocating both extremes at different times. He moved from the position of "believer" in the total truth of his patients' memories to that of a "denier" who saw only fantasies in what they told him. In doing so, he contributed to the dichotomous thinking that continues to this day. His story can serve as a warning against dividing ourselves and the world into believers and deniers, memories into truths and fantasies. It can also help point the way to an understanding of memories of childhood sexual abuse that includes the truth of people's experiences and the complexities of their memories.

The Recovered Memory Debate in Historical Perspective

In this section I begin with Freud's seduction theory followed by a description of his retraction. In the modern debate, Freud's retraction is often assumed to have been the final word in psychoanalysis on the subject of traumatic sexual memories. However, a few psychoanalysts continued to believe in the reality of sexual abuse memories. Many more advocated the reality of memories of childhood trauma more generally.

Freud's Seduction Theory

When Sigmund Freud finished his medical studies in October 1885, he received a grant for further study. He used this grant to go to Paris and study with Jean Martin Charcot, a medical doctor who was known for his theories of hysteria. Freud remained in Paris until February 1886. During this time, he was exposed to two prominent themes in the French medical

literature. One attested to the reality and prevalence of child sexual and physical abuse, whereas the other claimed that a large percentage of these cases were actually simulations designed to entrap innocent men. It is also probable that Freud witnessed one or more autopsies of children who had died from the results of physical and sexual abuse.

From 1857 to 1878 Ambroise Auguste Tardieu, who was a professor of legal medicine at the University of Paris, published a number of studies emphasizing the frequency with which children were raped. He estimated that between 1858 and 1869, of the 11,576 accusations of rape, 9,125 were rape or attempted rape of children. Other authors supported these high numbers, claiming that between 1827 and 1870 there were 36,176 reported cases of rape and assaults on children 15 and under. In addition to documenting the frequency of child sexual abuse, Tardieu noted that parents were often the abusers and specifically rejected arguments that the victims he examined had simulated the abuse. In supporting the reality of abuse, he argued that the anatomical evidence was clear and that children who accused their fathers did so with reluctance and fear.[2]

A contrasting body of medical writing in France at the same period emphasized the importance and frequency of simulations or fantasies of sexual abuse. It was assumed that these fantasies were either made up by the child or by the child's parents in order to bring false accusations against innocent men. These authors agreed that some young children were sexually abused; however, a significant minority or even a majority of the cases involved simulated abuse which victimized innocent men.

Alfred Fournier, a prominent Parisian doctor, argued that it was often impossible to tell, even in a medical exam, the difference between actual rape and other causes. He claimed that masturbation alone could cause inflammations that looked similar to those caused by assault. Furthermore, he argued that spontaneous discharges were common and often mistaken by medical doctors as proof of assault. The motivations behind these simulations were primarily extortion or blackmail-rape and a desire for revenge. His emotional concern was with the innocent men falsely accused. He reported with pride how he had violated the Hippocratic oath in order to intimidate and bribe an eight-year- old girl into recanting her story. He justified this action by claiming that the protection of an innocent man was a higher duty than his duty to his patient.[3]

This French medical literature forms part of the social context for understanding both Freud's proposal and his later retraction of his seduction theory. The German medical literature of the last half of the 19th

century reflected similar ideas, although it was primarily supportive of Fournier's focus on simulations, rather than Tardieu's focus on abuse. What Freud added to this debate in three papers he published in 1896 was the idea that sexual experiences in childhood had important consequences for adult mental health, a view that contrasted with the prevailing assumption that mental illness was a result of poor heredity.[4]

Freud developed his theory of sexuality as an experiential cause of neuroses in three papers published in 1896. In the first paper,[5] he began with his view that far too much emphasis had been placed on heredity as the cause of neuroses and developed his ideas about environmental causes. He pointed out that just because two people in the same family became neurotic, that did not point to a common heredity any more than a common environment. Furthermore, one needed to explain why some, but not all, people in any one family became ill. He reduced heredity to a precondition for neurosis and elevated sexual experience to a necessary cause. That is, one might be predisposed to become neurotic, but this hereditary potential was realized only as a result of present or past sexual experiences. He then outlined two main groups of neuroses and proposed specific sexual causes for each. The first group, neurasthenia and anxiety neuroses, had sexual causes in the patient's contemporary life. Neurasthenia was the result of an overindulgence in masturbation, and anxiety neurosis was the result of sexual frustration, such as enforced abstinence. The second category, neuro-psychoses of defence, included hysteria and obsessional neuroses. These were caused by childhood sexual experiences for which the patient retained an unconscious memory. In the case of hysteria, this was a memory of "a precocious experience of sexual relations with actual excitement of the genitals, resulting from sexual abuse committed by another person." [6] The emphasis here was on a passive sexual experience. In contrast, for obsessional neurosis, the emphasis was on active sexual experiences. A child who had been seduced might later seduce other children and repressed memories of this sexual aggression would cause obsessional neuroses.

These diagnostic terms used by Freud were common in the medical literature of Germany, France, England and the United States in the late 19th century. All of them were applied to patient populations in highly inconsistent ways. For example, similar symptoms were attributed to hysteria and neurasthenia to the extent that even specialists often could not distinguish between the two. The differences in diagnoses depended on a combination of the symptoms and the person being diagnosed. Hysteria

was most commonly associated with the feminine as both signified extremes of emotionality. Thus, although men were sometimes diagnosed with hysteria, the label carried a feminine meaning. Neurasthenia, on the other hand, was associated with masculinity. As with hysteria, both men and women were diagnosed as having neurasthenia. In the United States, middle- and upper-class men diagnosed with neurasthenia were thought to be suffering from the consequences of overwork, ambition and financial success. Women of a similar class who were diagnosed with neurasthenia were assumed to be suffering from an attempt to compete with men for public success.[7] Instead of neurasthenia as the masculine contrast to hysteria, Freud used obsessional neurosis. Thus hysteria was caused by childhood sexual victimization, whereas obsessional neurosis was caused by childhood sexual aggression.

In the other two papers Freud published in 1896, he focused on psycho-neuroses in general[8] and more specifically on hysteria.[9] These are wonderful papers. I recommend that anyone interested in the area of child sexual abuse and recovered memory read them. Freud's clinical skills, his sensitivity to his patients' experiences and his logic are compelling. Many issues he discussed reverberate in modern debates, and both similarities and differences between his thinking and that of the late 20th century are instructive. In both of these papers, the reality of childhood sexual abuse as told in his patients' reconstructions is vivid. He used the metaphor of an archeologist to describe the painstaking search for a past that had been forgotten and disguised in the form of adult symptoms, but was nonetheless present in fragments of memory. He likened the tracing of symptoms and experiences backwards in time to a genealogical tree, a pattern that branches and comes together in complicated ways. He was clearly upset by the details of his patients' stories. For example, he described all the traumas that analysis uncovered "as grave sexual injuries; some of them were positively revolting." [10] He claimed that "the idea of these infantile sexual scenes is very repellent ... they include all the abuses known to debauched and impotent persons, among whom the buccal cavity and the rectum are misused for sexual purposes." [11]

The foundation of Freud's theory was repressed memory. He believed the childhood sexual experience had very little effect at the time of occurrence; however, a memory of that experience was repressed. Later, on the basis of a mature sexual experience or cue, the memory was revived and expressed as a symptom. He did not acknowledge the traumatic effects of childhood sexual abuse at the time of the event. He also did not consider

the possibility that hysteria could result from a continuous memory of abuse. This repressed memory of the event had a much stronger effect than the event itself. The reason for this was a puzzle to Freud, and he never did develop a clear explanation for this "inversion of relative effectiveness." [12] At the same time, he was horrified by the events he uncovered in his patients' lives. One possible explanation for his failure to incorporate the traumatic impact of abuse on children is that at this time he assumed sexuality began at puberty. Therefore, sexual events in childhood could only develop psychic meaning later through the memories of a sexually mature person.

Freud was clearly aware that his theories would arouse controversy and disbelief. He tackled this problem directly, particularly in the last of these three papers. He expected objections on several counts. First, he assumed that proponents of hereditary theories would object to his promotion of environmental causes of mental illness. To this, he responded that their different underlying assumptions meant that neither side would be convinced by evidence or argument. Secondly, he assumed that his critics would argue either that the patients had made up these memories (they were imagined or invented) or the physician had forced the scenes of childhood sexual trauma on his patients. He provided several lines of evidence supporting the truthfulness of his patients' memories: (1) their distress upon recalling the events, (2) the patients' disbelief of their own memories, (3) the uniformity of detail among different patients' stories, (4) the specific fit between the content of infantile scenes and adult symptoms, which he described as a jigsaw puzzle where each piece fits into one, and only one, place, (5) therapeutic success, and (6) confirmation by other people in two of his 18 cases. Thirdly, he addressed the objection that some people remember such scenes and do not become hysterics. He answered with a medical analogy to tuberculosis. Many people are exposed to the bacteria causing TB and do not develop the disease, yet all people who get TB have been exposed to the bacteria. What was critical was that all hysterics had been exposed to sexual abuse, not that all people exposed became hysterics. [13]

Freud's theory of seduction was clear. Although heredity and other factors might contribute, the causes and reasons for the disease required a childhood sexual trauma, the memory of which was repressed and later re-emerged as hysterical symptoms. According to Freud's theory of seduction, the events his patients described to him were real scenes, and relief from the distress of their symptoms required the recovery of the memories of these childhood events.

Freud's Retraction

The story of Freud's retraction of his seduction theory is important, because it reflects some of the problems encountered when dealing with ambiguous memories of traumatic sexual experiences that are culturally taboo. I want to examine three questions in this section: (1) When did Freud retract his seduction theory? (2) What exactly did he retract? and (3) Why did he retract?

The timing of Freud's retraction is very different in his private writings than in his published work. The first private statement of a retraction occurred in a letter to Wilhelm Fliess, a friend and medical colleague of Freud, on September 21, 1897, exactly 17 months after he delivered his "Aetiology of Hysteria" paper. However, in several unpublished letters written to Fliess later in 1897, he returned to his earlier beliefs in the reality of sexual abuse and of the father as the most common perpetrator. In a letter of December 22, 1897, he used a metaphor of censorship to describe an adult's memories of childhood abuse: "Have you ever seen a foreign newspaper which went through Russian censorship at the border? Words, entire phrases and sentences obliterated in black, so that the rest becomes unintelligible. Such Russian censorship occurs in psychoses and produces the apparently meaningless deliria." [14] Although the September 21 letter is usually cited as his retraction, the later letters show that he continued to believe in the seduction theory.

The published record of his retraction stretches out over many years, indicating that it took him some time to change his ideas. In 1898, he published another paper that, far from retracting, actually reiterated his ideas of the causes or reasons for hysteria.[15] In a sense, this paper completed the cycle begun in his 1896 papers by returning to neurasthenia and anxiety neurosis, which he had introduced briefly in his earlier work, and reiterating the importance of sexual causes of neuroses based on more than 200 cases. In letters to Fliess at the time, Freud trivialized this paper, but added that it was "designed to cause trouble — which it will succeed in doing." [16] It is a puzzle why he should have published a paper he both thought trivial and knew would cause trouble. Writing about adult causes of neurasthenia and anxiety neurosis may have seemed trivial, given the importance childhood was taking on in his work. By this time, he was beginning to define psychoanalysis as a method of explaining ailments of the present by referring to something in the past. He also was preoccupied at this time with his own childhood as a part of his self-analysis. I would

argue that his decision to publish reflected his ambivalence about retracting the seduction theory. He doubted it, but was not yet ready to publicly abandon it. His expectation that the paper would "cause trouble" was undoubtedly based on the reception of his earlier papers.

The first full account of Freud's retraction in his own words was published in a book by Leopold Löwenfeld 10 years after the original proposal of the seduction theory.[17] Löwenfeld, a medical researcher, was both a critic of Freud's work and a personal friend. They corresponded from 1900 with each other and Löwenfeld referred in a 1904 publication to Freud's idea that it was not sexual experiences but sexual fantasies that led to neurosis. He then convinced Freud to contribute his ideas in his own words two years later.[18] In later autobiographical essays written in 1914 and 1925, Freud gave two further accounts of his retraction of the seduction theory.[19]

What Freud retracted is clear. In his 1906 paper he stated that "infantile sexual traumas" were replaced in his theory by "infantilism of sexuality." The importance of sexuality and of early childhood remained constant. What changed was that sexual traumas were replaced by sexual instincts. Furthermore, repression of memories of actual events was replaced by repression of infantile sexual fantasies.[20] He reiterated these points in both of his later reconstructions.

Why Freud retracted is a much more complicated story, and as is the case with retracted memories of abuse, several possible reasons need to be considered. Freud's own explanation was that his theory was wrong. In his letter to Fliess, he gave as reasons for his doubt: (1) the absence of success in analyses, (2) his surprise at the frequency with which fathers, including his own, were implicated, (3) that in the unconscious it was impossible to distinguish between truth and fiction, and (4) that sometimes the secrets of childhood were never revealed.[21] Psychologist Carolyn Enns and her colleagues have pointed out that these were not reasons to abandon the seduction theory; rather, they were issues that needed further exploration. The difficulty of working with the long-term impact of childhood sexual abuse, the problems of telling fantasy from reality and the fact that it is sometimes impossible to recover memories from the past are difficult issues that offer no easy answers.[22] The frequency of male relatives named as perpetrators has repeatedly been documented. None of Freud's reasons supports a belief that childhood memories are fantasies.

In his 1906 retraction, Freud cited as critical evidence the fact that many normal people had childhood experiences that were not different

from neurotics, including experiences of seduction. What is most interesting about this reason is that he had already argued persuasively against it in his proposal of the seduction theory. In an analogy to tuberculosis, he argued that one would expect some people to be exposed to the critical causal factor without getting the disease. What would be critical disconfirming evidence would be neurotic people who had not been seduced as children. In his later retellings of his retraction, he even more simply stated that the theory had broken down "under the weight of its own improbability and contradiction," [23] and that he had drawn the correct conclusion that fantasy was more important than reality in the psychoanalytic setting.

Freud did not present compelling evidence for retracting his seduction theory. Although he did not deny that seductions occurred or that sexual experiences might play a part in the development of neuroses, he demoted them to incidental rather than crucial causes. In a reversal of his earlier position, he argued for the primacy of hereditary over environmental causes of neurosis. He shifted from questions of immediate causation to a study of the essential nature of psychoneuroses, which was to be found in sexual instincts. This was a shift in assumptions that according to Freud did not require evidence. Unfortunately, Freud had the power to assert that his old theory was wrong and his new one the truth and to suppress critical questioning. For far too long, his retraction was taken as proof that his earlier theory had been false.

A number of other motivations for Freud's retraction have been offered. The first of these is the isolation and professional rejection he experienced as a result of his seduction theory. Freud himself anticipated some of this when he addressed himself to objections others would raise. He later described how he had sacrificed his growing popularity as a doctor by presenting his seduction theory. He had hoped that his findings would be treated as ordinary scientific contributions, "But the silence which my communication met with, the void which formed itself about me, the hints that were conveyed to me, gradually made me realize that assertions on the part played by sexuality in the aetiology of the neuroses cannot count upon meeting with the same kind of treatment as other communications." [24] Although with hindsight he could later romanticize this period as one of "splendid isolation" in which he had the luxury of unpressured exploration,[25] the actuality of this isolation must have been painful and frightening. He was unable to convince his close colleague and confirmed hereditarian, Josef Breuer, of his views. His seduction theory went against two prevailing views in the German medical literature: (1) that reports of

sexual abuse of children were largely simulations, and (2) that heredity was the primary cause of physical and mental diseases. Although Freud's early work on hysteria was favourably received in medical communities in France and England and widely successful in literary circles, the German medical community was offended and some reviews of his work scathing.[26] "Studies on Hysteria," [27] which he published with Josef Breuer the year before his 1896 papers, tentatively explored issues of sexuality. One review of this book dismissed it with the following words:

> "I cannot believe that an experienced psychiatrist can read this paper without experiencing genuine outrage. The reason for this outrage is to be found in the fact that Freud takes very seriously what is nothing but paranoid drivel with a sexual content — purely chance events — which are entirely insignificant or entirely invented. All of this can lead to nothing other than a simply deplorable 'old wives' psychiatry." [28]

A second possible motivation was Freud's discovery through his own self-analysis, begun in the summer of 1897, that his own father may have been sexually abusive towards him or his siblings. He denied this to himself and generalized his denial by retracting the seduction theory. Freud's father died in 1896, the same year Freud published his seduction theory. It was partly his emotional response to his father's death that led to his self-analysis. During this analysis, he discovered sexual memories that he concluded were fantasy, and on which he based his emerging theory of the Oedipus complex.[29]

A third possible motivation may have been personal exhaustion from working so intensively with abuse survivors. Therapists today, who have much more social and political support for their work, nevertheless report feelings of self-doubt, isolation and vulnerability. It is possible that Freud, working in the climate of denial described above, had similar doubts that contributed to his retraction.[30] Although there is certainly no direct evidence for this, some of Freud's writings convey a strong emotional response to this work. At various places, as I describe above, he expressed his disgust for what he was hearing. At one point, he gave a very accurate and heart-felt description of the power imbalance between adult and child:

> "... on the one hand the adult, who cannot escape his share in the mutual dependence necessarily entailed by a sexual relationship, and who is yet armed with complete authority and the right to punish, and can exchange the one role for the other to the uninhibited

satisfaction of his moods, and on the other hand the child, who in his helplessness is at the mercy of this arbitrary will, who is prematurely aroused to every kind of sensibility and exposed to every sort of disappointment, and whose performance of the sexual activities assigned to him is often interrupted by his imperfect control of his natural needs — all these grotesque and yet tragic incongruities reveal themselves as stamped upon the later development of the individual and of his neurosis, in countless permanent effects which deserve to be traced in the greatest detail." [31]

He also described his therapy as consisting of laborious individual examination of the 18 patients on which he based his theory of seduction, in most cases involving more than 100 hours of work, and two years later he claimed to have examined more than 200 patients.[32]

No one will ever be able to tell what really happened in Freud's retraction of the seduction theory, just as no one can know exactly what has happened in any individual's personal past. However, in both cases evidence limits possible interpretations. It is clear that a number of factors converged on Freud at the time of his retraction. He was isolated and rejected by his colleagues, including Josef Breuer. Most of the medical research and theory he could draw on challenged his views on the importance of sexual experience. He was engaged in the reconstruction of his own personal past, which was emotionally challenging. And he was involved in working with patients in a process of discovery that was painful for them and challenging for him.

Refusing to give up the importance of sexuality, especially infantile sexuality, he sacrificed the essential truths in his patients' stories by devaluing the actual traumas that happened to them and inflating the role of sexual instincts. Through this retraction, he both held to his belief in the importance of sexuality and came closer to the central assumptions of the intellectual community whose recognition he most desired.

The Continued Debate Between Truth and Fantasy

Although Freud's retraction became a central tenet of psychoanalysis, the debate between truth and fantasy continued within the field. The dominant view was that adult memories of sexual abuse were fantasies, which undoubtably caused further harm to many patients, most of whom were

women who had experienced some recall of abuse. But the domination was not total. The view that memories of sexual and other traumas contained important elements of truth found expression in the writings of a few mainstream analysts and in the therapy setting with their patients. Though no therapist is likely to argue that a client's story as told in therapy is an exact or totally accurate recounting of the past, there is variation in how much historical accuracy is considered a critical component of the therapeutic process. Therapists who focus on narrative truth emphasize the client's present reconstructions or stories and the interactions between the therapist and client as the only crucial components of therapy. How the present interpretations and feelings relate to the past is irrelevant. It does not matter whether the client's story is fiction, fact or some combination of the two. What is critical are the emotions and interpersonal dynamics as they are experienced in the present. In contrast, therapists who focus on historical truth as an important component of therapy argue that some validation of what has happened in the client's past is required for successful therapy.

Obviously there are many positions between these two extremes and many different ways therapists and clients combine a search for historical and narrative truths. At this point, I want to look briefly at this ongoing debate to show: (1) how ideas about the effect of trauma on people's lives did continue in spite of Freud's denial, and (2) how the debate can facilitate understanding the ambiguities and truths that memories of abuse contain.

Although there was very little outright acknowledgement of child sexual abuse and its psychological consequences within psychoanalysis, there was considerable debate about the relative importance of truth and fantasy in therapy. Although Freudian orthodoxy dictated that sexual abuse memories be defined as fantasy, the truth of many other kinds of remembered trauma was acknowledged and seen to have a detrimental effect on adult mental health.

After Freud's retraction, only two analysts before the 1980s took public stands validating the importance of sexual abuse histories in therapy, and both were men. Sándor Ferenczi, a psychoanalyst and one of Freud's closest friends for more than two decades, was the first. In 1932, a year before his death, he presented a paper, "Confusion of Tongues Between the Adult and the Child," at the International Psycho-Analytic Congress in Wiesbaden. In this paper, he argued that his lack of therapeutic success had led him to the view that the "professional hypocrisy" common to analysis tended to repeat in therapy the original trauma the patient had

experienced as a child. The adult, who had been psychologically confused and damaged by sexual abuse as a child, experienced the distance, lack of caring and withholding of belief in the analytic session as a repeat of the abuse and therefore kept repeating the trauma over and over with no long lasting relief.

Ferenzi argued that sexual abuse by parents and other caretakers was prevalent and included the rape of girls barely beyond infancy, the abuse of boys by adult women and homosexual abuse. He claimed corroborative evidence in the confessions of adults in therapy who admitted to abusing children. He argued that the playful sexual attitudes of the child were mistaken by adults for mature passionate sexuality with debilitating consequences for the child. Often the perpetrator behaved as if nothing had happened, and assumed that the child knew nothing and would forget the abusive event.[33]

The other voice that spoke out for the reality of sexual abuse of children and its pathological consequences was Robert Fliess, a psychoanalyst and the son of Wilhelm Fliess. Particularly in his last book, *Symbol, Dream, and Psychosis*, which was published after his death, he specifically discussed the effects of abuse and the ways in which one could distinguish memory from fantasy in therapy. He stated that he was prepared to "contradict him [Freud] head on: *no one is ever made sick by his* [sic] *fantasies*. Only traumatic *memories* in repression can cause the neurosis … Fantasies, in particular compulsive ones, *are a symptom of the disease*, never its cause." [34] Memories can be distinguished from fantasies by the details associated with memories, the repetition of apparently meaningless associations, the quality of the memories and the feeling of continuity of self in the patient. Therapy was only effective through the removal of amnesia.

Sigmund Freud retained an interest in the historical truth of what his clients told him, in spite of making childhood fantasies central to his retraction of the seduction theory. One psychoanalyst described a chronology of Freud's intellectual journey from 1896 to the end of his life in 1939 as follows: "Freud started with the assumption that the analyst was unearthing unconscious memories of actual events, then only fantasies, then a psychical reality inherited from prehistoric events, and finally, back to individual experiences that 'did really happen.'" [35] It was in some of his very last work that Freud returned to the importance of historical truth in analysis.

In 1937 he returned to the metaphor of an archeologist to describe the

work of analysis.[36] As he had done more than 40 years earlier, he described the work of the analyst as a search for memories of real events that were never totally destroyed or lost. What was found in the analytic excavation contained fragments of historical truth. He went on to argue that delusions and hallucinations contained a fragment of experience from earliest childhood and that they derived their strength from the presence of this element of truth.

He also wrote about the reality of early childhood traumas. Defining trauma as "either experiences on the subject's own body or sense perceptions," [37] he discussed the effects of early childhood trauma as either positive fixations in which the trauma was brought into operation over and over again, or a negative fixation in which nothing of the trauma was remembered or repeated, while the patient engaged in avoidance behaviours, defensive reactions, inhibitions and phobias. Whether positive or negative, the effects of trauma were compulsive, involved great emotional intensity and were qualitatively different from other mental processes.

The debate in Freud's work between remembered traumas as fantasy or reality continued in the wider psychoanalytic community. The debate was about what was necessary for a successful therapeutic outcome. Analysts who focused on narrative truth argued that successful therapy was based on interpreting and understanding present emotions and interpersonal dynamics. Whether these present stories related to actual past events or not was irrelevant. The distinction between fantasies about the past and past realities was not useful or important to the therapeutic outcome. Validation of actual events in the client's past was not an important part of therapy. Because it did not matter whether memories were fantasies or based in reality, attempts to distinguish between the two were impossible and a waste of time.

Another group of analysts argued against this point of view. They argued that historical truth was crucial to therapeutic success. By historical truth they meant what had actually happened in the client's past. Therefore, making a distinction between truth and fantasy was a vital therapeutic goal. They argued that vast differences existed among real trauma, real experiences interacting with fantasies and fantasies. Just as fantasies and realities had different impacts on children, so also did adult memories of each. True memories, compared with fantasies, were thought to have more significant effects on the mental functioning of the client. It was sometimes exceedingly difficult to differentiate fantasy elements from actual memories, but one owed it to one's patients to engage in this exercise as a part of therapy.

This was particularly important if, as a child, the patient had been lied to by parents or other authorities about traumatic events, or if the child had tried to make adults aware of the trauma and had not been believed. In some case studies, relief and therapeutic improvement were reported to follow acknowledgment on the part of the analyst of the reality of the client's memories.[38] Thus therapy was thought to be more effective if elements of important past events were included and validated as actually happening. This was particularly important when the memories were of traumatic events.

As this brief review shows, the debate between truth and fantasy has never been foreclosed. In emphasizing this continuing diversity, I am not attempting to minimize the harm that has been done to victims of sexual abuse whose memories have been distorted as fantasies. But I am pointing out that the conversion of reality into fantasy was never total in Freud's work or in psychoanalysis. There were cracks in the dominant discourses, sometimes fairly large ones in that opposing views were published in mainstream psychoanalytic journals. Although it is not a story that we will ever be able to reconstruct, it is to be hoped that some of those cracks have provided validation for some survivors of childhood traumas, including sexual abuse.

Lessons for the Present

What can we learn from the story of Freud's retraction and the wider debate around the importance of truth and fantasy in therapy? The most important lesson is that memories are neither reality nor fantasy, but rather ambiguous combinations of both. There is no copy of the past. All memories contain ambiguity. Even the metaphor of a videotape of the past breaks down on closer inspection. Videotapes are subject to deterioration, can be edited, and, most important, do not provide a copy of what happened but rather a construction recorded from a particular vantage point, by a person who selected what to include and from what angle.[39] At the same time, the truth that is present in memories is essential to a person's sense of history. It is the truth in memory that allows a continuous sense of self as a unique being who has been, is and will continue to be. Therefore, it is vital to acknowledge both the ambiguity and the truth of adult memories of childhood sexual abuse.

Even though all memories are ambiguous, the process associated with traumatic memories make the ambiguities more difficult and painful. Both

intrusion and amnesia for traumatic events are common experiences. Some survivors of trauma continuously remember. Others have periods of time for which the trauma is partially or completely unavailable for retrieval. And presumably some never remember. Surveys of survivors of childhood sexual abuse consistently report that a significant minority experience some period of forgetting, followed by recovery of memories of abuse.[40] There is some evidence that those who forget for a period of time have experienced abuse at a younger age, abuse with a close relative compared with a stranger, more than one type of abuse or very violent abuse.[41]

Accusations of abuse have shattering effects on the individuals involved, family members, friends and to a lesser extent the public who hear many accusations filtered through the media. A desire to say, "Yes, this happened" or "No, it never did" is natural. In therapy, the desire to arrive at either yes or no is reflected in the improper use of symptom checklists to make diagnoses of abuse. Many researchers and therapists working with adult memories of childhood sexual abuse have argued that these checklists should be used as a basis for seeking further information and as an investigative tool, but never for a diagnosis.[42] It is also important to resist the desire for clarity and assume that what people report is what they remember. Although this is often the case, there are many reasons why people may remember something that they choose to omit or change in the telling. Everyone has had the experience of compromising memories to please or not hurt others. Retractions of memories of abuse may reflect uncertain memories, but they also may reflect fear, intimidation or deliberate silencing.

In certain legal settings, the law requires juries or judges to make decisions involving two very different alternatives. However, the tendency to think in terms of either true or false memories and either factual reality or fantasy is a tempting simplicity that can cut short adequate reflection and judgements about memories and allegations of abuse. Even in legal settings, if not in the actual decisions, ambiguity can and should be acknowledged. Psychologists who serve as expert witnesses in such cases have a responsibility to know and present the research that addresses trauma and memory, acknowledging both the strengths and the limitations of current knowledge.[43]

Ambiguous memories are not false memories. They may be confused, inaccurate in detail and displaced. However, autobiographical memory retains essential truths, and respecting these truths is as important as acknowledging ambiguities. Studies of the accuracy of autobiographical

memory reveal that adults' memories of childhood events that occurred when they were old enough and had access to relevant information are reasonably accurate. In general, parents' memories of their adult children's childhoods tend to be less accurate than those of the adult children and their siblings.[44] In a number of studies, victims of childhood abuse have found corroborative evidence of the abuse, and those with recovered memories are not less likely to find corroboration or to have less accurate memories than those with continuous memories.[45]

In a patriarchal society one barrier to respecting essential truths is the failure of psychoanalysis and the wider society to name the father as a perpetrator. From the medical literature of France and Germany in the late 19th century to the current False Memory Syndrome Foundation (FMSF), naming the father has stimulated disbelief and denial.

Although Freud never denied the historical reality of sexual seduction of children in his retraction or in his later work, he consistently denied the father as perpetrator. When seduction did happen, it was at the hands of a woman or older children. Although his patients consistently told him that their father or other male relative was the seducer, he revealed this information only privately. In his published work, fathers' seductions were fantasy seductions. Mothers, nursemaids, governesses, tutors, domestic servants and older children were the perpetrators of real seductions.[46]

In contemporary society, the political context of the recovered memory debate also contributes to the denial of essential truths, especially the truth of women's testimonies of abuse by male relatives. The typical focus of the FMSF literature is to claim false the accusations against fathers by their daughters whose memories, according to FMSF proponents, have been manipulated by feminist or female therapists. Even though men have brought charges of abuse, women have been charged with abuse and many male therapists work with abuse survivors, these cases have attracted less attention from the FMSF. The denial that is heard most loudly is the denial of privileged men who have begun to be held accountable for their behaviour. A major dichotomy exists: retractions are considered unquestioned evidence of false memories, or symptoms become unquestioned evidence of abuse. All the space in between is left unexamined, dismissing ambiguous memories and denying essential truths.

In people's lives, truth and fantasy are tangled in ways that are hard and sometimes impossible to separate. Memories and fantasies are often difficult to distinguish. This distinction is even more difficult when the memories include childhood traumas, including sexual abuse. These

ambiguities make it more important not to succumb to the temptations of labelling memories true and false, and to struggle to increase understanding and empathy. In the end, our knowledge will stand on firmer ground if it acknowledges the complexities of the human mind, the realities of abuse and the possibilities of reconstructions of the past that can be accurate in their essentials and useful guides to the future.

Freud's failure to consider the ambiguity of trauma memories was part of what led to his retracting the essential truth of his seduction theory, when he might have modified it instead. He began with the belief that all hysterics had experienced childhood sexual abuse that operated in adulthood through repressed memories. He argued that there was a one-to-one correspondence between the childhood trauma and the adult symptom and that recovering this connection was necessary for recovering health. Having overstated the causal connections, he dismissed the essential truth of his theory on the basis of the ambiguities and difficulties he uncovered in therapy. Instead, he might have seen these ambiguities and difficulties as problems needing further investigation.

At the end of his life, Freud proposed an analogy between therapeutic interpretations and psychotic delusions that would have been useful in his earlier evaluation of the seduction theory. He argued that both were "attempts at explanation and cure" and both were effective because they recovered a fragment of lost experience.[47] Had he viewed the stories his patients told him as ambiguous constructions with a fragment of lost experience, rather than as copies of their childhood experiences, he might have been in a better position to modify rather than retract his theory of seduction. In order to retain the essential truth he had discovered, he would have had to acknowledge the ambiguity of both memories and fantasies, rather than replacing reality with fantasy. He also would have had to have the courage to name the father as a frequent perpetrator. By the end of his life, he was able to acknowledge the possibility that truths can be embedded in fantasies. He was never able to name the father.

Endnotes

1. Carolyn Z. Enns, Cheryl L. McNeilly & Mary S. Gilbert, "The Debate about Delayed Memories of Child Sexual Abuse: A Feminist Perspective," *The Counselling Psychologist* 23 (1995), pp. 181-279; Kenneth S. Pope & Laura S. Brown, *Recovered Memories of Abuse: Assessment, Therapy, Forensics* (Washington, DC: American Psychological Association, 1996), pp. 52-66; and Elizabeth Waites, *Memory Quest: Trauma and*

the Search for Personal History (New York: W.W. Norton, 1997), pp. 106-133.

2. Jeffrey M. Masson, *The Assault on Truth: Freud's Suppression of the Seduction Theory* (New York: Farrar, Straus & Giroux, 1984), pp. 15-27.

3. Ibid., pp. 40-51; and Alfred Fournier, "Simulation of Sexual Attacks on Young Children," in Jeffrey M. Masson (ed.), *A Dark Science: Women, Sexuality, and Psychiatry in the Nineteenth Century* (New York: Farrar, Straus & Giroux, 1880/1986), pp. 106-127.

4. Masson (1984), pp. 136-137.

5. Sigmund Freud, "Heredity and the Aetiology of the Neuroses," in James Strachey (ed.), *The Standard Edition of the Complete Psychological Works of Sigmund Freud*, Vol. 3 (London, UK: Hogarth Press, 1896a/1962), pp. 141-156.

6. Ibid., p. 152.

7. Elaine Showalter, *The Female Malady: Women, Madness, and English Culture, 1830-1980* (New York: Pantheon Books, 1985), pp. 121-144; and Elaine Showalter, "Hysteria, Feminism, and Gender," in Sander L. Gilman, Helen King, Roy Porter, G. S. Rousseau & Elaine Showalter, *Hysteria Beyond Freud* (Berkeley, CA: University of California Press, 1993), pp. 286-397.

8. Sigmund Freud, "Further Remarks on the Neuro-psychoses of Defence," in James Strachey (ed.), (1896b/1962), pp. 159-185.

9. Sigmund Freud, "The Aetiology of Hysteria," in James Strachey (ed.), (1896c/1962), pp. 189-221.

10. Freud (1896b/1962), p. 164.

11. Freud (1896c/1962), p. 214.

12. Freud (1896b/1962), p. 167.

13. Freud (1896c/1962), pp. 204-209.

14. Masson (1984), p. 117.

15. Sigmund Freud, "Sexuality in the Aetiology of the Neuroses," in James Strachey (ed.), (1898/1962), pp. 259-285.

16. Ibid., p. 261.

17. Sigmund Freud, "My Views on the Part Played by Sexuality in the Aetiology of the Neuroses," in James Strachey (ed.), *The Standard Edition of the Complete Psychological Works of Sigmund Freud*, Vol. 7 (London, UK: Hogarth Press, 1906/1953), pp. 269-279.

18. Masson (1984), pp. 119-122.

19. Sigmund Freud, "On the History of the Psycho-analytic Movement," in James Strachey (ed.), *The Standard Edition of the Complete Psychological Works of Sigmund Freud*, Vol. 14 (London, UK: Hogarth Press, 1914/1957), pp. 1-66; and Sigmund Freud, "An Autobiographical Study," in James Strachey (ed.), *The Standard Edition of the Complete Psychological Works of Sigmund Freud*, Vol. 20 (London, UK: Hogarth Press, 1925/1959), pp. 1-74.

20. Freud (1906/1953), pp. 275-278.

21. Sigmund Freud, *The Origins of Psycho-analysis: Letters to Wilhelm Fliess, Drafts and*

Notes: 1887-1902 (London, UK: Imago, 1954), pp. 215-216; and Masson (1984), pp. 108-109.

22. Enns et al. (1995), p. 188.

23. Freud (1914/1957), p. 17.

24. Ibid., p. 21.

25. Ibid., p. 22.

26. Henri F. Ellenberger, *The Discovery of the Unconscious: The History and Evolution of Dynamic Psychology* (New York: Basic Books, 1970), p. 771; Masson (1984), pp. 134-138; and James Strachey (ed.), "Editor's Introduction," in *The Standard Edition of the Complete Psychological Works of Sigmund Freud*, Vol. 2 (London, UK: Hogarth Press, 1955), pp. xiv-xv.

27. Sigmund Freud & Josef Breuer, "Studies on Hysteria," in James Strachey (ed.), (1895/1955).

28. Masson (1984), p. 26.

29. Enns et al. (1995), p. 189; Florence Rush, *The Best Kept Secret: Sexual Abuse of Children* (Englewood Cliffs, NJ: Prentice-Hall, 1980), pp. 80-104; and Elaine Westerlund, "Freud on Sexual Trauma: A Historical Review of Seduction and Betrayal," *Psychology of Women Quarterly* 10 (1986), pp. 297-310.

30. Enns et al. (1995), p. 189.

31. Freud (1896c/1962), p. 215.

32. Ibid., p. 220; and Freud (1898/1962), p. 272.

33. Masson (1984), pp. 145-187; and Sándor Ferenczi, "Confusion of Tongues Between the Adult and the Child," *The International Journal of Psycho-Analysis* 30 (1949), pp. 225-230.

34. Robert Fliess, *Symbol, Dream, and Psychosis* (New York: International Universities Press, 1973), p. 212 [italics in the original].

35. J.G. Schimek, "The Interpretations of the Past: Childhood Trauma, Psychical Reality, and Historical Truth," *International Journal of Psycho-Analysis* 23 (1975), p. 858.

36. Sigmund Freud, "Constructions in Analysis," in James Strachey (ed.), *The Standard Edition of the Complete Psychological Works of Sigmund Freud*, Vol. 23 (London, UK: Hogarth Press, 1937/1964), pp. 255-269.

37. Sigmund Freud, "Moses and Monotheism," in James Strachey (ed.), (1939/1964), p. 74.

38. Harold P. Blum, "The Value of Reconstruction in Adult Psychoanalysis," *International Journal of Psycho-Analysis* 61 (1980), pp. 39-52; Phyllis Greenacre, "Re-evaluation of the Process of Working Through," *International Journal of Psycho-Analysis* 37 (1956), pp. 439-444; Oscar Sachs, "Distinctions Between Fantasy and Reality Elements in Memory and Reconstruction," *International Journal of Psycho-Analysis* 48 (1967), pp. 416-423; and Scott Wetzler, "The Historical Truth of Psychoanalytic Reconstructions," *International Review of Psycho-Analysis* 12 (1985), pp. 187-197.

39. Shelley M. Park, "False Memory Syndrome: A Feminist Philosophical Approach," *Hypatia* 12, 2 (Spring 1997), pp. 1-50.

40. Alan W. Scheflin & Daniel Brown, "Repressed Memory or Dissociative Amnesia: What the Science Says," *The Journal of Psychiatry & Law* 24 (1996), pp. 143-188.

41. Shirley Feldman-Summers & Kenneth S. Pope, "The Experience of 'Forgetting' Childhood Abuse: A National Survey of Psychologists," *Journal of Consulting and Clinical Psychology* 62 (1994), pp. 636-639; and Linda M. Williams, "Recall of Childhood Trauma: A Prospective Study of Women's Memories of Child Sexual Abuse," *Journal of Consulting and Clinical Psychology* 62 (1994), pp. 1167-1176.

42. Pope & Brown (1996), p. 130; and Waites (1997), pp. 231-236.

43. Sharon Crozier & Jean Pettifor, *Guidelines for Psychologists Addressing Recovered Memories* (Ottawa, ON: Canadian Psychological Association, 1996); and Pope & Brown (1996), pp. 207-237.

44. Chris R. Brewin, Bernice Andrews & Ian H. Gotlib, "Psychopathology and Early Experience: A Reappraisal of Retrospective Reports," *Psychological Bulletin* 113 (1993), pp. 82-98.

45. Feldman-Summers & Pope (1994); and Linda M. Williams, "What Does it Mean to Forget Child Sexual Abuse? A Reply to Loftus, Garry, and Feldman," *Journal of Consulting and Clinical Psychology* 62 (1994), pp. 1182-1186.

46. Freud (1896b/1962), p. 164; Freud (1896c/1962), p. 208; Sigmund Freud, "Female Sexuality," in James Strachey (ed.), *The Standard Edition of the Complete Psychological Works of Sigmund Freud*, Vol. 21 (London, UK: Hogarth Press, 1931/1961), p. 238; and Sigmund Freud, "Femininity," in James Strachey (ed.), *The Standard Edition of the Complete Psychological Works of Sigmund Freud*, Vol. 22 (London, UK: Hogarth Press, 1933/1964), p. 120.

47. Freud (1937/1964), p. 268.

SOCIETY, POLITICS, PSYCHOTHERAPY AND THE SEARCH FOR "TRUTH" IN THE MEMORY DEBATE

Mary Gail Frawley-O'Dea

Introduction

It was primarily the Women's Movement of the 1970s that dragged child abuse and domestic violence in all forms out of society's closet and insisted that they be examined and given validation. Over the past 25 years, attempts have been made world-wide to contextualize incest and childhood sexual abuse; to give content and language to the previously unthought and unspoken known.

In fall 1991, the *Journal of Psychohistory* produced a special issue devoted to the sexual abuse of children throughout the world. Research from countries as diverse as Canada, Egypt, England, Germany, India, Italy, Japan, Mexico, Puerto Rico, Thailand and the United States made apparent the universality of incest and sexual abuse. In one article an Indian researcher, S.N. Rampal, said, "For a girl to be a virgin at 10 years old, she must have neither brothers nor cousins nor father." In India, both

girls and boys are used as sexual objects by family members across castes. In Japan, recent studies suggest that at least one-third of Japanese women have been abused sexually as children. In addition, there appears to be a startlingly high incidence of mother-son incest in Japan. During a boy's adolescence, the mother not infrequently tells her son that he will not study well unless he begins having regular sex and offers herself as a partner. A recent survey of Thai men revealed that 75 percent of them acknowledged engaging in sexual activities with child prostitutes, 20 to 40 percent of them HIV positive. In Arab nations, mothers regularly provide their sons to older men for sexual use and fathers trade sons with each other for sexual favours. Arab physician Nawal El Saadwi reports that it is the norm for little girls to be assaulted sexually by brothers, uncles, cousins, grandfathers and fathers.[1]

This issue of the *Journal of Psychohistory* also looked at sexual abuse in the Western Hemisphere. There are only a few good studies that have been conducted on sexual abuse in European and Latin American countries. Indications, however, show that incest and childhood sexual abuse are prevalent in England, Italy, Canada, Germany, Mexico and the U.S. For instance, of 2,530 listeners responding to a British Broadcasting Company call-in show on sexual abuse, albeit a biased sample, 62 percent reported having been abused as children, with the sexual activities inclusive of intercourse. Official German estimates are that 300,000 children in that country are abused or raped each year. An Italian hotline established in 1989 scandalized that nation with reports of paedophile networks engaging in widespread sexual abuse of both boys and girls. J.M. Carrier reported a large proportion of Mexican men having sexual relations with nephews, cousins, and neighbours who are minors, while Romon Fernandez-Marina writes of Puerto Rican men regularly masturbating their sons to impress friends with their progeny's maleness. Finally, a large, methodologically excellent, government-sponsored study in Canada generated incident rates similar to those found in the United States.[2]

Methodologically sophisticated epidemiological studies of childhood sexual abuse in the United States like those conducted by Diana Russell and Gail Wyatt converge at essentially the same numbers. Specifically, approximately 35 percent of all women have been sexually abused before the age of 18. Of these, about 45 percent were raped or molested by a member of their own family; in other words, the abuse was incestuous. Approximately another 45 percent were violated by perpetrators outside the family, but well known to them — priests, teachers, bus drivers,

neighbours, etc. About 10 percent of the abuse was committed by strangers.[3]

In concrete numbers this means that 40 million American women and girls have been or will be sexually abused before they reach 18 years of age, more than 20 million of them by a loved and trusted relative. And, while the research on male victims is not as advanced as that on females, most efforts conclude that more than 20 percent of all men are sexually abused before they turn 18. That translates into more than 25 million men and boys in the United States.

In evaluating these startling and staggering numbers, and in placing them in context, especially in terms of the false memory syndrome movement and the debate about whether recovered memory is instilled by therapeutic intervention, it is vitally important to emphasize that most of these statistics were generated through studies conducted by scientists and researchers who had no particular investment in a specific construction of childhood sexual abuse. Most studies were executed exclusive of hypnosis, suggestion, or any intense transference relationship that might elicit one response or another. In a number of the studies, interviewers were, in fact, blind to the purpose of the study.

The Double Impacts of Society and Politics

If these numbers are correct, why does our society have so much trouble believing the reports of sexual abuse victims — children and adult survivors? What fuels the false memory syndrome movement's success? As suggested earlier, part of the answer lies in the unresolved dichotomy between the reality and prevalence of childhood sexual abuse and powerful, longstanding, organizing cultural dictates, such as the universal acceptance of the incest taboo.

Lloyd Demause, in the 1991 issue of *Journal of Psychohistory*, points out that virtually all social scientists and anthropologists cite incest taboo as one of very few, if not the only, cultural universals. Claude Levi-Strauss stated that "the prohibition of incest can be found at the dawn of culture ... (It) is culture itself." [4] The incest taboo is a worldwide cultural given that has persisted in being unquestioningly accepted as a fundamental organizing principle of all social structure despite decades of evidence that it is, in fact, also universally violated. It survives so tenaciously, in part, because it is what we want to believe. The incest taboo

denotes the way things should be and protects us from looking more closely at how things are.

Postmodernist thinking invites us to examine the linguistic expression of cultures in order to understand how we think and what we think about. In postmodernist terms, the language of the incest taboo has been privileged and has kept us from speaking about the reality of child abuse. As psychoanalyst and educator Michelle Price states, incest and sexual abuse have been "local knowledges ... excluded by the culture's dominant, master narratives," [5] one of the most dominant and masterful of which is the narrative regarding the universality of the incest taboo.

Existing alongside the master narrative of the universality of the incest taboo is an equally important cultural narrative regarding the sacredness of the nuclear family and the patriarchal and paternalistic organization of that family. In most societies throughout time, the family has been privileged. Laws are constructed to protect the privacy and integrity of the family. What goes on within a family is the business of the family, and the culture dictates that, with few exceptions, what goes on within a home is exempt from governance. In addition, there is among many people a deeply held belief that most families are organized in the best interests of their members. While the neighbourhood, schoolyard, city, or nation may be a dangerous place, one is safe within one's family. It is to the home and the family one returns for acceptance, support, and security. Although we have accumulated ample evidence that families are much too often far from idealized wellsprings of safety, sense, and security, the cultural myth of the good family prevails. Threats that challenge that myth and, thus, the integrity of the family, are offensive to many members of the populace.

Within the family, it has been traditionally the father, the man, who has been accorded leadership, power and protection. Women and children are to honour their men; this has been another privileged narrative within our culture. Women's rights and children's rights are relatively recent arrivals on the cultural scene and are shakily ensconced, at best. Perhaps not coincidentally, given that sexual abuse is a misuse and appropriation of power even more than a sex crime, it is mostly men that abuse both little girls and little boys. While we are beginning to learn that some women do sexually abuse their children, it remains clear that most abuse is perpetrated by men.

If we acknowledge that the statistics regarding sexual abuse are correct and early sexual trauma is profoundly disruptive to healthy devel-

opment, what does child abuse then imply about our functioning — as a species, as a society, as family members? What is the impact of sexual abuse on our families, friends, workplaces, academic institutions and political parties? Where does it leave the incest taboo, the unconscious but deeply held belief that permeates our social fabric? What does it say about the safety and sanctity of the family? What implications does it hold for the continuation of patriarchically organized and paternally executed conceptualizations of and attitudes towards the family?

The backlash against our awareness about the prevalence of child sexual abuse in our society is designed to restore order — to reestablish the dominant cultural narratives regarding the incest taboo, to protect the strength and untouchability of the family and the value of patriarchy and paternalism. The False Memory Syndrome movement represents one enactment of the backlash.

In addition, we are confronted by a genuine horror and wish to disavow the reality of abuse. For to allow the pervasiveness of childhood sexual abuse and the psychic, social, economic, intellectual, health care and criminal justice costs of that pervasiveness is traumatizing in and of itself. Trauma's hallmark is that it overwhelms the ego and the traumatic material is dissociated, disavowed by everyday states of consciousness. False memory syndrome advocates, in their extreme, represent the redissociation and renewed disavowal of the reality of childhood sexual abuse and its consequences from everyday social consciousness and discourse. They have found a way to live with the contradictions encapsulated in the universality of the incest taboo, the sanctity of the family, and the power of fathers existing alongside the sexual abuse of millions of citizens, often within their own families, that even gives some voice to the occurrence of sexual abuse. This is accomplished through, in Michelle Price's words, marginalized discourse,[6] which is offset by preservation of the master narratives of the culture.

In addition to marginalizing discourse about childhood sexual abuse, many advocates of false memory syndrome reconstruct the fundamental meaning of the discourse. This is not a debate about the horrifying prevalence and damage of child abuse, they assert. Rather, it is a controversy about repression and therapeutic efforts to uncover repressed memories or to suggest false ones. Suddenly, we are very far away from the mind-bending reality of little girls and little boys being physically and psychically violated by adults they love. Instead of looking carefully at the families we have structured and noticing the extent to which they too often

are chaotic constellations of violence and neglect, new villains, located safely outside the historically sacrosanct family, are found. In this scenario, sons and daughters and the adults who raised them are victims of misguided or malignant therapeutic efforts. The family has a common enemy and remains intact.

Extreme True Memory advocates — those who say that all recovered memories are true — on the other hand, can resemble a survivor whose very identity seems to be organized around persistent and unflagging attention to every conceivable trauma in herself, in others, in society. This survivor's capacity to believe herself, to trust her own perceptions about anything, is so vulnerable that to entertain the possibility of any fiction or fantasy in any construction of sexual abuse is to dismantle all belief. Either you believe everything or you believe nothing. True Memory proponents, such as this, may give false or suggested memories passing attention, acknowledging that such phenomena, of course, exist and can be hurtful to the wrongly accused. However, they generally persist in believing that recovered memories of abuse are always true. Like the traumatized survivor, whose tolerance for doubt and ambiguity was destroyed by her abuse, the capacity of extreme true memory advocates to believe in the reality of widespread child sexual abuse is so sensitive that the elucidation of one false memory will lead to the collapse of all belief. Once again, discourse is marginalized, now with the complexities of fact, fantasy, and fiction excised from the central discourse of this group.

It is important to recognize that the players on the "two sides" of the memory debate are engaged in a cultural enactment of all the roles central to the incestuous family. It is as though the whole society has entered into an intricate and intense transference/counter-transference paradigm around sexual abuse. In general psychological terms, transference includes all relationally mediated reactions of the client to the therapist including the working alliance, the dynamically derived imposition onto the therapist of internalized expectations and fantasies, and the client's conscious and unconscious perceptions of the therapist's character and dynamics. Similarly, countertransferance denotes the clinician's side of the working alliance, real feelings, expectations and fantasies the therapist develops in response to the client's transference, and reactions to the client primarily embedded in the therapist's own character.

Transference and counter-transference occur in the therapist-client relationship. In the individual treatment of an adult survivor of childhood sexual abuse, several types of transference/counter-transference positions

may come into play during therapy. Included here are the unseeing, neglectful parent and the unseen child; the abuser and the victim; the seducer and the seduced; the rescuer and the entitled child demanding to be rescued; and the "certain believer" and the chronic doubter. In treatment, these relational positions volley back and forth between therapist and client with each, at some point, taking on all roles until they are clearly stated by the client and therapist. One goal of treatment is to allow each of the elements of the relational matrix to unfold, to be enacted, and, ultimately, to be verbally identified within the therapy.

In the true/false memory debate, it is my belief that we see the same relational configurations at play at the level of culture and politics.

- *We have victims:* victims of early sexual trauma, victims of false allegations, therapists who are victims of spurious lawsuits, and perpetrators who experience themselves as victimized by their victims who now come forward to confront them about the abuse.

- *We have abusers:* perpetrators of long-ago abuse who re-abuse by denying their deeds and/or by launching lawsuits against therapists; individuals who abuse by knowingly making false allegations; misguided or ill-trained therapists who irresponsibly suggest or insist to their clients that they have been abused sexually, prematurely foreclosing on alternative explanations of the client's symptoms and suffering; false memory advocates who abuse by selectively reporting only on research that supports their views or who construe dubious research through which it would be difficult not to find confirmation of their views.

- *We have rescuers:* therapists who may offer inappropriate encouragement to ill-considered legal adventures of clients seeking revenge rather than healing; talk-show hosts who attempt to rescue one side of the memory debate from representatives of the other side; researchers who unscientifically design or cite research in order to particularly help one viewpoint or the other.

- *We have entitled children demanding to be saved:* clients who want to sue rather than work through the mourning of unrecoverable childhoods; therapists who insist that the privacy of the therapy relationship should protect poor training or irresponsible overzealousness; abusers who feel that their status as parents should hold them unassailable for their past behaviours.

* *We have seducers:* so-called "experts" from the fields of memory, trauma, sexual abuse treatment, cognitive psychology and neuropsychology who put into the public discourse — through published works, legal testimony and public presentations — conclusions that go far beyond what their research can actually demonstrate; therapists who, on the basis of too few dreams, symptoms or memories, make suggestions to clients about what happened to them years ago; perpetrators who, with wide-eyed innocence, plead in court for their families to be restored.

* *We have the seduced:* clients who believe that what they are told by therapists happened to them; therapists who believe they have engaged with a client on a journey of healing when, in fact, what the client wants is testimony in court; judges and juries who believe that studies and expert testimony really can clarify what happened to someone 25 years ago; the public that is swayed by popular media to believe that childhood sexual abuse rarely happens, or happens every time anyone says so.

* *We have neglectful, unseeing others:* partners of perpetrators who know what happened but maintain silence; therapists who, frightened of lawsuits, fail to see what is patently obvious in their consultation rooms; experts and professionals who are so dominated by their own agendas and theories that they turn a blind eye to contradictory data.

* *We have the unseen:* unseen victims whose narratives are disregarded or testified about in ways that destroy meaning; responsible, careful, well-trained therapists who work competently and, for the most part, anonymously; adult survivors who do not come forward, perhaps because of a renewed fear of being disbelieved; children who are bearing sexual abuse silently today.

* *We have certain believers:* experts who "know" their opinions are correct and entertain no differing opinions; perpetrators who "know" they never abused even when they have done so; therapists who impose certainty on a therapeutic process that, inherently, is infused with ongoing doubt and ambiguity.

* *We have chronic doubters:* clients for whom one result of early abuse is an ongoing inability to trust their own minds; non-abusing parents who cannot bring themselves to believe in the reality of their children's victimization; a general public who cannot deal with the reality of widespread early sexual trauma.

Truth and Doubt in the Therapeutic Relationship

In 1955, when I was five years old, my family spent two months in Europe and, during that time, we visited a concentration camp. I remember that the day was gray; the buildings were gray; even the land seemed gray. I remember touring barracks and then walking down some stairs and looking into rooms in which medical experiments had been conducted. I also remember a room or rooms in which were displayed instruments of torture. I remember standing with my parents and another couple that we travelled with; I was small surrounded by bigger adults. I do not know what I was told about that place but I remember feeling awestruck and scared. I recall the experience well and mark it as profoundly influential in my life. In late adolescence and early adulthood, I read everything I could about the Holocaust, not the typical pursuit of a young woman raised in what was, in essence, an Irish Catholic ghetto. Over the years, I always said I had visited a concentration camp in Belgium because that is where my family was for much of that trip. Only within the past year have I learned that there *were* no concentration camps in Belgium. My memory is false. Isn't it? Does my geographical misplacement of the camp denigrate the trustworthiness of the entire memory?

In the past, therapy was viewed as a one-person paradigm of treatment in which a neutral, abstinent therapist interpreted for the client the contents of his or her mind. The therapist, however, was not considered a contributor to the therapeutic process beyond this role of neutral interpreter. For most of the hundred-year history of psychoanalysis, the therapeutic relationship remained a one-person model centred on the client, despite some theoretical return to emphasis on the harmful effects of real events and real people in the person's life.

As the 20th century continued and we entered into the age of postmodernist thinking, philosophers, artists, literary figures, critics and psychotherapists began to highlight the inherently elusive and constructed nature of reality. Reality is relative, so this thinking goes, and the best any one of us can hope for is some construction of reality that is based as much on its meaning for us as on actual events or interactions. In psychoanalysis, this has led to increasing acceptance of a constructivist, two-person model in which therapist and client enter into a relationship through which they co-construct the meaning of the client's life. It is assumed in this model that any memory of the past or report about current events, including those transpiring in the treatment room between the members of the therapeutic

dyad, represents a compromise between what actually happened filtered through the fantasies, expectations, affects, and defensive structure of the client and of the therapist as well.

From this perspective, as psychotherapists, we live and work amidst a need to tolerate the ambiguity of historic and narrative truths and the tension between them. Historic truth can be thought of as events that actually occurred. Narrative truth, on the other hand, can be described as psychic truth or the remembrances of an individual.

In this contemporary model of psychoanalytic therapy, treatment becomes an exploration of, and co-operative construction of, the meaning of events and interactions for the individual client working with an individual therapist. It is assumed and accepted that the life narrative co-constructed by each therapeutic pair will be unique, representing their particular interpretation and understanding of the client's life and his or her approach to life. Further, this model accepts as inevitable the therapist's influence on the particular constructions of meaning that emerge for the client. It recognizes that traditionally defined neutrality and abstinence are, in fact, unattainable illusions. The questions we ask, the theories through which we filter data given to us by the client, our verbal and nonverbal responses to clients, our own personalities and predilections as professionals and as people cannot help but contribute to the client's eventual understanding of herself. The goal, therefore, is not to withhold influence but, rather, to help make explicit to the client the part we are playing in the therapeutic journey.

It is into this contemporary understanding of the principles underlying the therapeutic process that the issue of the reality of childhood sexual abuse and its harmful impact have once again become a focus of psychoanalytic thinking. Therapists must weave an integrated tapestry of theory and practice in which what may have really happened to our clients as children is threaded with a co-operative and jointly constructed understanding of what happened then and what is happening now. We must be aware of and accept the inevitability of our contributing to what any client ends up believing about herself or himself.

Whatever relative emphasis any one of us places on historic versus narrative truth, every therapy includes gestures to both the historicity and the meaning of a client's life and psychic organization. In the treatment of non-traumatized individuals, the dialectic between narrative and historic truth often remains as background, perhaps never addressed directly by either party. When one's mind has not been bent by the overwhelming

relational betrayal and assault encapsulated within sexual abuse, the search for absolute — and thus unattainable — truth is not so important. There is more tolerance for the uncertainty and ambiguity inherent in any memory of the past or perception of current events. Therapeutic work with a sexual abuse survivor — whose sense of reality, ability to trust her own mind, and tolerance for uncertainty have been brutally attacked and dismantled, not just by the abuse itself but by her life in home that engendered and turned a blind eye to sexual abuse — drags the issue of what "really" happened into the foreground of the therapeutic encounter.

The internal world of the adult survivor of childhood sexual abuse and her perceptions and experience of the external world are fragmented, discontinuous, and often frightening. In them are reflected a multitude of contradictory experiences that frequently elude logical cohesion and organization. The survivor is caught in the cross-currents of incompatible perspectives on her life, torn apart by the inability to integrate mutually exclusive experiences of reality, and driven by opposing needs to obscure actual experience while maintaining vigilance to the ever-present danger of repeated abuse. She often feels crazy and out of control. This mimics her childhood experience in which reality offered neither gratification of developmentally appropriate needs nor the avoidance of danger. Needs could be met and danger sidestepped only through dissociation, denial and escape.

Adult survivors of childhood sexual abuse begin treatment with dramatically different degrees of access to and confidence in their own childhood memories. Some begin with vivid memories of the abuse they suffered as children, along with a high degree of confidence in the reliability of those memories. Others enter therapy with no memories at all, or with only an uneasy sense that all was not right. Where memories begin as inaccessible or vague, and emerge clearly for the first time only during therapy, the client's confidence in the reliability of such memories is subject to the most intense doubting. This is to be expected.

Of enormous interest, however, is that, even when a client begins treatment with clear and accessible incest or sexual abuse memories, and even solid corroboration of her own memories, a sense of chronic doubting and questions about the accuracy of those recollections inevitably plague the therapeutic process. Chronic doubts about what did and did not happen, along with a persistent inability to trust one's perceptions of reality, are perhaps the most permanent and damaging long-term effects of childhood sexual abuse. Such doubts make it extremely difficult for the client to

arrive at a point at which she believes her own life narrative. It would be hard to exaggerate the pain a survivor feels as she fights to regain confidence in the integrity of her own mind. And the client's ongoing doubts often evoke in the therapist an intense pressure to either confirm or disconfirm the client's questions about the reality of her own abuse as well as the accuracy of current perceptions.

One transference/counter-transference constellation that accompanies treatment of an adult survivor of childhood sexual abuse, in fact, is that of a "certain believer" pitted against a chronic doubter. In one enactment of this paradigm, the client, a "chronic doubter" relentlessly questions the accuracy of any memory of the past and of her perceptions of current experiences, including those occurring in the treatment room. She ruminates and ruminates, endlessly replaying events in her mind to try to land on an interpretation of them in which she can have some confidence. Inevitably, however, as soon as she relaxes into acceptance of a memory or perception, a new doubt emerges and the process begins anew.

At the centre of the morass of uncertainty is an unspoken, desperate yearning for "truth," and a belief that truth, defined as *the* factually and interpretively accurate rendition of an experience, can be discovered, if only one gathers enough data and analyzes it sufficiently. There is no room for ambiguity; there are only the true and the false. The client craves the "truth" and the "real."

Unable to tolerate uncertainty and utterly mistrustful of the capacity of her own mind to assess accurately memories and perceptions, the client beseeches the therapist to offer a benign arbitration of truth and reality. This plea is particularly powerful and poignant when it applies to abuse memories. The client needs to know whether her memories are true, and she wants the therapist to tell her one way or the other. The temptation to comply in order to relieve the client's very real suffering may exert a potent pull on the therapist.

It is of note, however, that this kind of validation from the therapist, even if it is offered, seldom magically or permanently quells the client's deeply embedded distrust of her own mind. Rather, the process of reclaiming her own mind is one that ebbs and flows throughout treatment.

When the relational paradigm in play is that of an endlessly doubting client seeking the "truth," the therapist walks the line between unnecessary and ultimately retraumatizing withholding and overzealous, transferentially reinforced suggestion. If overzealousness prevails, the resulting transference/counter-transference constellation can be expressed in two

ways. In the first, the client prematurely accepts the therapist's views regarding the reality of the abuse and begins to construct incest "memories" to please the therapist. More often, however, the client becomes uncomfortable exploring her own trauma-related images and memories because the therapist's certainty about their meaning forecloses on the client's own psychic elaboration of these mental contents. Here, the therapist treads dangerously close to that of the perpetrator, who superimposed his views of reality onto the child during the original abuse.

It can also happen, of course, that the client becomes the "certain believer," while the therapist is beset by searing doubts about almost everything the client says and about much that occurs between them. Here, the client insists not only that her memories are photographically accurate but also that her current perceptions, including those about the therapeutic relationship, are absolutely true. There is no room here either for doubt or for the simple perceptual disagreements that mark all human relationships. In this case, the client defensively clings to certainty, lest she have to question any aspect of her perceptual world. Belief is fragile; if one memory or perception is shown to be flawed, then her capacity to believe anything collapses. The therapist, in this scenario, may feel forced to accede to the client's translation of reality in order to preserve relational bonds.

In some treatment relationships with adult survivors, therapist and client will each enact all permutations of changing doubt and certainty. Each will feel consumed with doubts and each, at other times, will be frozen in the certainty of her own perceptions.

How then should we, as therapists, deal with our client's and our own kaleidoscopic shifts in the capacity to know what we know, while we tolerate ambiguity, in prior abuse and in current events, including those taking place in the consultation room? If we hold to a belief that the client's history essentially will repeat itself within the relational matrix co-constructed between therapist and client, we can relax in an assurance that transference and counter-transference enactments occurring throughout the course of treatment will guide our grasp of the past as well as of the present. Indeed, within such a model, the client's and the therapist's very real doubts about the accuracy of abusive images will serve to underscore, rather than undermine, their basis in truth, not always a truth that can be proven "beyond a reasonable doubt" in a courtroom but a workable basis for a stable life. In other words, it is the *process* of doubt, uncertainty and denial, offset by certainty and unambivalent belief, and played out in the

relational configurations enacted by client and therapist, as much as it is memories themselves that validate the abusive history of the client from a treatment perspective. For the volleying back and forth of doubt and belief itself reenacts the invasion of body, mind and sense of perceptual accuracy that is embodied in childhood sexual abuse. Here, as much as anywhere in therapy, process speaks as loud, if not louder, than content.

Therefore, all issues related to the client's and the therapist's opposing views of reality, particularly those that infuse the therapeutic relationship, should be carefully attended to. As client and therapist together explore their versions of the therapeutic interaction, differences in perception will be unavoidable. As these are viewed and negotiated, the client's reality-testing skills will be called into service. There will be points of agreement, points of continued disagreement and compromises that feel unsatisfactory to both parties. It is not the specific content of what is in dispute that is essential, but the way in which client and therapist, together, create an environment in which agreement, disagreement, compromise and ambiguity can intermingle. If these states are reached and tolerated without a loss of integrity on either side, the process of negotiation itself will be reparative. To give in on a point without losing oneself; to hold onto one's view without shutting out the other person's experience; to hold vigorously to what one believes beyond doubt, without undo aggression and devaluation — these are capacities the survivor of child sexual abuse needs to develop in order to build mature, satisfying relationships.

One cannot emphasize enough that, ultimately, it is the client who must come to know and believe in the reality of her own life experiences. It is the client who must be free to choose the words with which to give voice to her own internal states. The difficulties with reality-testing common to adult survivors are related not to the recoverability of discrete sexual abuse memories but rather to the ongoing mental invasion inherent in such abuse. Therefore the most valuable repair occurs as clients reclaim faith in the workings of their own minds as opposed to belief in the precise historicity of given memories.

It is when therapists succumb, sometimes unconsciously, to the intense pressure to know that is exerted through the transference with these clients that the excesses cited by false memory advocates can occur. For instance, a colleague reports the case of Anna, who was told by one therapist, based on one dream, that she must have been abused sexually as a child. In situations like this, therapists have been precipitous in diagnosing sexual abuse or, worse, in providing narratives of abuse. The latter is

exemplified by one therapist who told a client, based on a few dreams and her aversion to sex with her husband, that the client must have been sexually abused quite often by her father when her mother, who worked evenings as a nurse, was out of the house.

Such an intervention by a therapist constitutes an abuse in itself. It usurps the client's own powers of discernment, emplacing the therapist as the arbiter of truth and reality. For survivors of childhood sexual abuse, it repeats the invasion of the child's mind, body and experience perpetrated by the abuser. For non-traumatized clients who may be seeking an identifiable answer to their seemingly mysterious lives, it divests them of a much needed opportunity to discover and demystify themselves, for themselves. As therapists, we are mandated not to foreclose prematurely on what is known about and to our patients. Rather, we must allow all possibilities to remain open, until clients arrive at their own conclusions about their lives.

There is another counter-transference danger that emanates from our reaction to the threatening and litigious stance assumed by some false memory advocates. As parents, abusing and not, fear the intrusion of unexpected accusations of prior abuse into their home and family, so too we, as clinicians, dread the invasion of our consultation rooms by sheriffs' deputies serving subpoenas in lawsuits launched by clients or third-party suits filed by parents.

If clinicians are threatened excessively by potential lawsuits and accusations of incompetence, we may want to protect ourselves, consciously or not, by refusing to know about our clients' abuse. Here, in our defensive tentativeness, we may fail them by enacting the position of the neglectful parent who remains blind to her child's victimizations, often to sustain a relationship or lifestyle she is too fearful to jeopardize. This unseeing parent says, "What if I lose my spouse or my home?" We, in turn, may say, "What if I lose my professional standing or my practice?" To protect ourselves, we might turn a self-defensively blind eye to the possibility of previous sexual trauma.

There is yet another issue to consider in discussing the implications for psychotherapy of the False Memory Syndrome movement. Advocates of false memory did not appear until adult survivors began to sue parents for damages related to early sexual trauma. Too often, these suits have been launched at the overt or covert suggestion of therapists. There are two dangers here, one relating to the process of psychotherapy with adult survivors and one concerning the incompatible rules of discourse in the arenas of therapy and the courts.

One common transference and counter-transference dynamic that emerges in work with adult survivors of childhood sexual abuse involves a rescuer and an entitled child. Almost inevitably, after a survivor, with great courage and persistence, accepts the fact that she was physically, psychologically and relationally betrayed by a loved and trusted adult, there is a yearning for compensation. The client, now stripped of long-held compensatory fantasies that her childhood was not really that bad and/or that her parents did not really betray her, is bereft and lost. One client said, "This is too much. I can deal with the abuse ... I think ... maybe I can. But the idea that this is all there will ever be, that when I think of being little, all I will ever feel is pain and terror and aloneness ... that's too much ... I can't live with that. I can't stand knowing I never was and never will be a child." [7]

There is tremendous poignancy to this phase of treatment. It challenges the therapist's capacity to withstand the client's despair and the limitations of the therapist's own capacity to alleviate suffering. During this phase, the compulsion for the therapist to rescue or to provide some of the concretized compensation for the forever-lost ideal childhood is incredibly strong. It is here, I suspect, that some therapeutic dyads arrive at the idea of launching a lawsuit.

While some lawsuits are well considered and reparative, I believe that many are not. Rather, they represent an avoidance of genuine mourning for what can never be retrieved that is enacted through a manic and vengeful pursuit of "justice." In this scenario, perhaps with the collusion of the therapists who may unconsciously also want to avoid the pain involved in a full grieving process for the client, the adult survivor seeks to wring from the perpetrator restitution for a wrecked childhood. Fantasies of satisfaction in the present for what was irretrievably lost in the past abound here even if they remain unarticulated and even unconscious. In fact, the irretrievability of the past itself is denied in an omnipotent and magical insistence on reparation.

Further, if the client attempts to draw the therapist into court proceedings — or the courts draw them in — it may well represent an attempt to repair the neglect of the nonabusive parent, who did not and would not intervene in the client's victimizations. The entire process removes the therapeutic dyad from the realm of symbolism and immerses it instead in concretely re-enacting past relationships that can only damage therapy. The outcome for both therapist and client must be hollow, even in the unlikely event that a large financial award is made.

In addition to these relational considerations, lawsuits and therapeutic endeavours are inherently incompatible because of the different rules of discourse that pertain in each arena. Therapists must appreciate and tolerate the differences between historic and narrative truths. They must know and live with uncertainty, doubt and the essential ambiguity of almost everything as they co-construct the lives of their clients. In court, on the other hand, every construction of the client's life is subject to rules of evidence which demand a precision and certainty that can rarely provided. Frustration and dissatisfaction for everyone concerned are the most predictable results.

Let us consider my memory of visiting a concentration camp in Belgium. For the purposes of my therapy, it was enough to "know" I visited a concentration camp when I was a very little girl and that it had an enormous impact on me, threads of which followed me throughout my life and could be illuminated in my own treatment.

I remain certain that I indeed visited a camp somewhere during our European trip, and its meaning for my life is clear enough for me. Were I to be questioned in court about the memory, however, it would be easily dismantled as wholly lacking in credibility. In a courtroom fantasy, I can hear the defendant's lawyers sarcastically leading me through a series of questions about my visit to a concentration camp, after which they triumphantly declare that my entire story is meaningless, since there were no concentration camps in Belgium. In the eyes of the law, my story is meaningless. In my eyes, that visit was one of the most meaningful experiences of my life, and it is the geographic mislocation of the camp that is meaningless.

Endnotes

1. Lloyd Demause, "The Universality of Incest," *Journal of Psychohistory* 19 (1991), pp. 123-164. Unless otherwise stated, the statistics cited are derived from Lloyd Demause's article in this issue.

2. R.F. Badgley, *Sexual Offenses Against Children*, Vols. 1 & 2 (Ottawa: Canadian Government Publishing Centre, 1984).

3. Diana E.H. Russell, *The Secret Trauma: Incest in the Lives of Girls and Women* (New York: Basic Books, 1986); and Gail Wyatt, "The Sexual Abuse of Afro-American and White Women in Childhood," *Child Abuse & Neglect* 9 (1985), pp. 507-519.

4. Claude Levi-Strauss, in Lloyd Demause (1991), p. 124.

5. Michelle Price, "Knowing and Not Knowing: Paradox in the Construction of

Historical Narratives," in Richard Gartner (ed.), *Memories of Sexual Betrayal: Truth, Fantasy, Repression and Dissociation* (Northvale, NJ: Jason Aronson, 1997), pp. 129-148.

6. Ibid.

7. Jody Messler Davies & Mary Gail Frawley, *Treating the Adult Survivor of Childhood Sexual Abuse* (New York: Basic Books, 1994), p. 179.

IN THE PRESENCE OF GHOSTS

Transforming Realities

Gail Fisher-Taylor

Once, a long time ago, I was a photographic magician, extracting little rectangles from the world at large, fixing into permanency split-second events grabbed from the ongoing flow of life, transforming the lively colours of day and night into varying shades of grays and blacks. I realized how easy it was to shift and change photographic reality: by moving the camera slightly, a gangly sapling once standing beside a woman in new spring garb could wondrously begin to sprout out of her fashionable hat, looking like an odd kind of Dr. Seuss decoration. By eliminating power lines and discarded candy wrappers from the photographic frame, I could transform a city park into an idyllic country-like scene, or by focusing on the wires and litter in the same setting I could create a picture of ugliness and despair. Two people walking in opposite directions might be beside each other only once in their lives for a fraction of a second, yet with a quick click of a shutter I could commit them to eternal photographic proximity. Using chemistry, light and a little magic, I was creating my own worlds. Eventually I became aware that this

photographic extraction and imposition was just a visual representation of a process in which all of us engage: we are constantly creating our own individual realities out of who we are and what we experience. Most of the time we do this without consciousness.

We are born. We experience. We respond with feelings, actions and thoughts. The world responds back to us. We form concepts of ourselves and the world out of our perceptions of the atmospheric conditions which envelop us: responsive or unresponsive, accepting or rejecting, loving or hostile, safe or dangerous, predictable or chaotic (the list goes on). If we grow up in a responsive, accepting, loving, safe and predictable atmosphere, our beliefs about ourselves and the formation of our realities will be very different from those formed in an unresponsive, rejecting, hostile, danger-ous and chaotic environment. Of course it is mostly the people around us who create the atmosphere, and it is our interactions with them which will affect what we feel and don't feel, how we act and don't act, what we believe and disbelieve. And it is their relationships (past and present) with their families, peers, community and world at large which will influence their interactions with us. As we move out into the world, and as the world moves in on us (for example, through television, radio and other electronic media, or through natural disasters or war), we are bombarded with more informa-tion and experience. And always, as responsive social organisms, we struggle for homeostasis. We keep trying to fit information and experience into our own realities because the faith we keep in our own renditions of reality can be essential for maintaining our equilibrium.

While growth and change are dependent on the redefinition of aspects of our reality, that redefinition must not be too radical or threatening. Otherwise the interpretive structure we use to define our world and maintain our equilibrium is shaken to the core. It disintegrates (dis-inte-grates); order implodes and there is chaos. Living is hard when the earth that holds us is constantly quaking.

It makes sense we would evolve a variety of mechanisms to protect ourselves from such terrifying chaos, structures that allow us to maintain the stability of a consistent definition of reality: individually, socially, politically and culturally. By definition, disintegration threatens existence; the integrity of whatever has disintegrated is destroyed. That's why people often are willing to go to war to defend the beliefs that define and determine their realities. The protection of those realities can be perceived as a matter of life and death. And sometimes that perception is transformed into a reality.

It was late in the evening on November 21, 1997, when the phone rang, and a disembodied voice gently informed me that my mother had died. The news had traveled through the grapevine, and the details were missing, but it was clear, at the moment of my discovery, she was deep in the ground, and the sound waves from any formal parting words and music were well dispersed into the universe.

Wanting some sort of contact with the life and death of this woman who had carried me in her womb, pushed me onto the earth and offered me sustenance, I called my mother's closest friend. The last time we had spoken was when she was younger than I am now. I entered a time warp and a reality shift. Her description of my mother was of someone I had never met, but would have liked to have known, a woman who fought against my father's wishes so she could die at home, who faced pain and death with courage and dignity. She had wanted to die, my mother's friend said.

Her reality had become painfully intolerable. Several people, including myself, had disclosed childhood abuse by members of our family, including my father. His and her response was to take a trip around the world and to write a letter that declared their intention to sever all contact for the rest of their lives with anyone who made such accusations.

Our realities had collided. I yearned for something I could never have: a mother who could listen with compassion and empathy to what had happened to me. She yearned for something she could never have: a daughter who would recant. I wasn't willing to live in a lie with her; she wasn't willing to hear what I had to say. I became the daughter in exile. She became ill.

Born in 1920, my mother lived the first 24 years of her life with her parents, and the last 53 with my father. The only time she was ever without him for more than the duration of a short business trip was when I was 12 years old. Fired from his job, my father found employment a thousand kilometres away, and my mother stayed with my brother, sister and me to sell the house and hold down the fort while we completed the school year. My mother didn't do well. I'd walk in the door, home from school, and find her unconscious on the kitchen floor, impossible to revive. Too ashamed to admit she was trying to drink away her overwhelming feelings, she told

me she had a rare form of epilepsy. I believed her, but knew something else was wrong.

When we finally moved that summer, she spent hours each day sitting in a lawn chair in our back garden, staring off into space. I liked to think she was looking over the fields at the lush tree-covered hills, but her eyes were vacant; she was out of reach, off in a deep internal place. I will never know the full story of that time, but it felt as if something had shattered, and she was searching inside for the lost and scattered pieces. Years later, she told me she had been thinking of leaving my father then. Her decision to stay became the cement that glued her old reality back together.

It is May 9, 1997, her birthday. Her words are accusatory, enraged, attacking. I haven't talked to her for four years, not since the last explosion in the mine field of our relationship when we tried to renew contact in a few calls and one visit. Before that we had had seven years of silence between us. I know that blaming, shouting voice; it is the same one that holds me responsible for her 45 years of arthritis because at the age of three I stepped in melted tar, and she cleaned my new patent leather shoes with carbon tetrachloride in an unventilated room and has been in pain ever since. Today I have called because I know she is dying of lung cancer and cirrhosis of the liver, and I hope we can talk. But of course we can't. I hear the tone of her voice and recognize the familiar explosions which have destroyed any possibility of conversation between us: to my mother it is not her smoking, her drinking or abuse by my father that is responsible for her dying. It is my telling.

That was the last time we spoke.

As a responsive organism, I have struggled for homeostasis. I have found a cognitive framework which, for now, helps to integrate the raw pain of experience into understanding.

Of course my mother refused to hear any disclosures; they posed an immediate threat to her familiar existence. If she listened, she increased the

possibility of believing, and she couldn't take that chance. If she believed, the consequences would have been too great: imploding order, chaos and disintegration of reality as she knew it. She would have been forced into a choice between living in the wasp's nest of my father's betrayal, or facing her terror of a marriage break-up and living alone, something she had never done. If she had chosen to separate from him, she would have been confronted with the financial struggles of a 65- to 77-year-old woman who had never supported herself. And she would have been met with the cruelty of humiliating small-town gossip and stigmatization.

Her refusal to hear the disclosures was one of the many mechanisms she used to protect herself from the dire consequences of believing, one of the structures that temporarily allowed her to maintain the stability of a consistent definition of reality. Because my presence was a reminder of the intolerable, she also needed to protect herself from me. I became the scapegoat. First she withdrew by severing contact; then she attacked. Both strategies kept me at the necessary distance.

There was one exception. It was the only visit we had in the last 12 years of her life, and the only time we got to talk without my father. We sat outside, just the two of us, with the stars popping out of the country-dark sky above us. We chatted, argued and sobbed. And then she said, "I could never live with myself if I knew I hadn't protected you."

As a child it was vital that someone hear me so the abuse would stop, but no one did. As an adult, speaking my truth to those who would listen with compassion was essential for the release of my trapped reality. It had been trapped in a dissociative haze which had settled around me like dense cloud, transforming incomprehensible horrors into ghosts of experience. My history lay dormant and out of reach, but influencing all aspects of my life. It was shapeless, formless and nameless, ominous and omnipresent, but I could no longer afford to recognize and identify it. As an adult who lived far away in time and space from those original abusive events, I could allow the cloud cover to break and the ghosts to emerge and transform, but even then, consciousness and recognition shook my ground, shattered my definition of reality and forever altered my relationships with every member of my nuclear and extended family.

I yearned for validation and acknowledgement from those who hurt me. I realized the denial by the adults in my childhood was in some ways

as injurious as the sexual abuse. It was crazy-making, causing me to doubt my own experience, perceptions and beliefs, creating a core mistrust in myself. While the sexual abuse was in the past, the denial was ongoing, a continuing abuse. I wanted it to stop. I wanted those who hurt me to say, "Yes, this is what I did, and I'm sorry," and I wanted them to try to understand the impact of their choices on my life and being and on the lives of those who are close to me. I knew if that happened we could begin to heal the festering wounds that separated us. We could begin to heal the relationships and ourselves in relationship, which is important because sexual abuse is an assault not only on individuals, but on relationships.

While I received validation that released me from any temptation to revert to a more comfortable version of my childhood, that acknowledgement did not come from anyone who hurt me. Because of the ongoing denial, I have had to accept the likelihood that those relationships will not be repaired. For me the integrity of close relationship is based on the shared acknowledgement of core experience which allows the weft and warp of individual experience to create the cloth of our interpersonal weave. When my mother died, a very important relationship ended with the weft and warp too tangled to create cloth.

Without the possibility of repairing the fabric of those relationships, I have been drawn to situations in which people are able to have the communication, acknowledgement and healing in relationship which have been unavailable to me. I am soothed by the knowledge that what I wanted is possible, if not for me, for others, and I have become interested in the personal and social looms that create those possibilities. In this way I nourish my hope and optimism.

Recognition. I have been given a gift: someone is telling me about the Community Holistic Circle Healing programme as described in *Returning to the Teachings: Exploring Aboriginal Justice* by Rupert Ross.[1] And then I am reading, hungrily, because this is one of those stories of possibility.

The place is the Objiway First Nation of Hollow Water, Manitoba, a community of 600 residents on the eastern shore of Lake Winnipeg. The

year is 1984, and people gather to discuss the vandalism, truancy, substance abuse, violence and suicide haunting the youth in their community. Exploring these issues is a mixed group: there are many community women as well as a number of social service providers including the Native Alcohol and Drug Addiction worker, a community health representative, a child protection worker from Manitoba Children's Aid, and representatives from community churches, the RCMP and the Frontier School Division of the Manitoba Department of Education. The formation of this group is the first step in a continuing journey.

It begins with the children, but leads to the vortex of family violence and drug and alcohol abuse which has created chaos in the children's homes and lives. With further exploration the team members face the disturbing possibility that at the centre of the vortex is the legacy of generations of child sexual abuse.

The team is wise. They realize the need for consolidation. They challenge the structures that have kept each of them working in isolation. They start to share information and training drawn from Western models of intervention and healing as well as from the exploration of traditional ways and teachings from Aboriginal communities. And in the process, they recognize the importance of confronting their own troubled histories. Many of the team members face for the first time in their lives the reality of how they too had been sexually victimized. Then, individually and together, they learn how to navigate through their own pain, terror, rage, shame, self-loathing, alienation and despair. Their knowledge of the territory becomes intimate and real, and out of it they develop the protocol for the Community Holistic Circle Healing (CHCH) programme at Hollow Water.

From their own experience, they realize that when a child discloses sexual abuse by a parent, many people are affected, and all of them need support. This becomes an important part of the protocol they develop: After the CHCH assessment team establishes that the disclosure of sexual abuse seems valid, two team members approach the person who has been accused, while others offer support to the child who has been victimized, his or her siblings, non-offending parent, grandparents, aunts and uncles. Close relatives of the person accused also receive support. Team members talk about the disclosure, explain the protocol and provide assistance.

The person who is accused is approached at a time and place the team members feel will be most conducive to honesty and openness. They explain the disclosure, and from previous experience, expect that the initial

response from the person accused is likely to be one which abdicates responsibility by denying, victim-blaming, minimizing and/or manipulating with anger. The team members say that criminal charges are going to be laid, and they offer a choice. If the person accused is willing to make a sincere attempt to accept responsibility and go through the healing process, the team will support him or her through the entire criminal justice process. If the person accused is not willing, the team will leave, and the person is left alone.

If he or she agrees to participate in the programme, the offender is accompanied to the police station, where a statement is taken and charges are laid. In court, a guilty plea is entered, but the CHCH team members request that the sentencing be delayed in order to give them as much time as possible to work with the child who was victimized, the offender, both their families and the larger community. Ideally, the CHCH team likes to delay sentencing until after a Healing Contract is produced, but this is usually not possible. Evolving out of a complex and time-consuming exploration, mediation and consensus-building process, the Healing Contract is put together by everyone involved in and affected by the abuse. It is an agreement that will take years to fulfill, due to the complexity of the healing challenges that need to be met in order to restore balance to the child who was victimized, the offender, their families, friends and community. Although the creation and implementation of the Healing Contract takes place outside of the criminal justice system, the process has a significant impact on the criminal justice process.

Court is held in a local community hall. The CHCH sentencing protocol involves two circles, one inside the other. The inner circle is for those who wish to speak; the outer circle for those who want to observe and listen. After traditional Aboriginal opening ceremonies, there is a confirmation of the guilty plea and the judge proceeds with other court technicalities. These are followed by four go-rounds in which each member of the inner circle addresses a particular person and/or issue. In the first round, the topic is why each circle member is in court on that day. In the second round each one talks to the person who was victimized. In the third round, the participants speak to the offender about the effect of his or her abuse on them individually, on their families and community, and in the final go-round, circle members address the offender again, but this time about their expectations of him or her and about what they feel needs to be done to restore balance. Based on what has been said in the go-rounds, the judge sentences the offender, not to incarceration, but

instead to a demanding journey on the "teaching and healing" path. There is a closing prayer followed by a debriefing for anyone who wishes to stay.

The Community Holistic Circle Healing programme has an enviable record: in the nine years reported in Rupert Ross' *Returning to the Teachings: Exploring Aboriginal Justice* there were 48 offenders in Hollow Water. Only five went to jail, and that was because they decided not to fully participate in the CHCH programme. Among the 43 who did participate, only two offenders have repeated their crimes: one early in his process, before sentencing; the other early in the CHCH programme's evolution. The second offender, after completing his Healing Contract, has become a valued team member who knows a lot about the ways victimizers attempt to avoid responsibility.

It is January 18, 1999. I want to know more. I talk by phone to Burma Bushie of the CHCH programme in Hollow Water. She roots our conversation in history by referring to the harmful effects of colonialism, particularly the removal of children from their families and traditions, and the abuses of the residential schools. She uses the word "semi-conquered" when talking about her people.

She speaks about the work of the Community Holistic Circle Healing programme, about "bringing back our children as gifts of the Creator," about "restoring our women to our place of value." She asks, "What is the role of mother and of grandmother?" She talks about nurturing: "When you nurture, you don't label. You don't say this child is bad." Instead you guide, you teach — and you listen.

Listening. Breaking silence. Repairing, reforming, restitution. Now, with more than 50 participating offenders, the recidivism rate remains at only two. These days there is a core group of about 20 people who are on the CHCH team. But there are new challenges. The children often are not willing to disclose outside their community to the criminal justice system, and of course, they don't have to. The challenge for the community is to be able to protect the children who have disclosed without involving the criminal justice system. Many children do not want to talk to therapists; instead, they want to do their healing in the community and in relationship with the people who have abused them, not with outsiders. This raises concerns about protection and contravenes provincial policies, but Burma Bushie says, "Youth know when it's time to change," and she encourages

listening to them. "We will know our community is restored the day our children are heard."

At the core of this programme and other similar ones elsewhere (such as across Canada, in New Zealand, Australia, South Africa, Sweden, Great Britain) are a series of beliefs and values which come out of Aboriginal traditions and teachings. There is an emphasis on balance, interconnection and relationship, responsibility, teaching and healing. There is acknowledgement of how each criminal act affects a large number of relationships which need to be restored. If they are not, "the original pain continues to spread from one relationship to another in an ever-expanding ring of disharmonies, touching, ultimately, many hundreds of people." [2] Those who violate others are seen as out of balance, needing help; their violations are placed in the context of their lives and histories. As people, they are respected and valued while at the same time their abusive acts are condemned and shamed. To move towards balance, anyone who violates must become accountable for his or her behaviour, while at the same time receptive to support, teaching and healing.

Instead of hiding in a jail cell far away from the scene of his or her crimes, the offender must face the whole community on a daily basis, knowing that family, friends and neighbours have heard his or her promises and expect those promises to be kept. The perpetrator must get close enough to experience some of the resulting pain, sorrow, betrayal, self-hate, grief and rage he or she has caused others to feel. When that occurs the offender can truly begin to take responsibility.

When all people are valued and denial by the offender is expected, but not accepted, the person who was sexually abused gets heard, understood and validated. When the community response to the admission of sexual abuse is to condemn those acts, but to support the abuser in healing him or herself (and in relationship to family, friends and community), the consequences of taking responsibility — as humiliating and painful as they may be — often become more acceptable than the punitive and isolating alternatives. As a result, the abuse survivor is empowered by having spoken the words that ended the abuse and became the catalyst to long-term personal, familial and communal healing. In order for this to happen, the community must become responsible to the person who was victimized.

Community commitment is vital to this approach. It is the community which listens to and believes the disclosure, protects and supports the child who was victimized, confronts the abuser and refuses to be manipulated by his or her denial. It is the community which offers the abuser respect, support, teaching and healing in exchange for the assumption of responsibility, but also holds the abuser accountable for his or her actions in the past, present and future. It is the community which recognizes the importance of healing the familial and communal relationships and oversees that process.

This, of course, is not what happens in our society.

I am now a psychotherapist, consultant and educator. My specialization is in the field of trauma, dissociation and abuse. In the past decade, I've had contact with hundreds of adult survivors of child sexual abuse, yet, unlike the experience in Hollow Water, very rarely have I heard of abusers who have freely admitted their violations. My experience is not unique. A. Nicholas Groth, former director of the sex offender programme at the Connecticut Correctional Institution at Somers, reported that in his 12 years of working with child molesters, not one had referred himself for treatment.[3]

Our communities, big and small, are structured to support collusion with the silence that surrounds child sexual abuse. That means we are colluding with the abusers to allow them to continue sexually abusing children without interference. Florence Rush explains how it works:

> "More than one devoted parent has vowed, 'If anyone so much as lays a finger on my little girl, I'll kill him.' But when a mother or father, let us say, discovers that it was their good friend Jack (who just lent them money and took Mary to the hospital when the baby arrived two weeks ahead of schedule), who, their child reports, 'touched me all over' rather than some 'degenerate' stranger, they will have difficulty acting upon their anticipated rage. They will calm down. They will be more reasonable. Exposure might cost Jack his job. Sally might leave him. How will she manage? How will the families act if they meet in church or the supermarket? Could the

children still play together? Problem is heaped upon problem and it is soon agreed that the whole thing is best ignored."[4]

Convicted child molester Russell George was caught in the act of molesting his six-year-old niece at a family gathering, but the child's parents seemed too embarrassed to confront him. He interpreted the lack of confrontation as permission to continue molesting little girls at other family gatherings, with the understanding that "it's not easy for people to start making accusations."[5] He's right.

The media is full of horrifying stories of lots of children being sexually abused by the same pedophile — a choirmaster, sports coach, scout leader, camp counselor, teacher, priest or minister. For a long time no one tells. Finally, when a child does tell, the community response is outrage — not at the abuser — but at the child and his or her parents, because the disclosure, if believed, will shatter the comforting illusion of how well they know that person, how he or she can be trusted with their children and how safe their community is.

A frequent response to an adult who discloses childhood incest (especially by a parent) is for the rest of the family of origin to band together in opposition and to cast the accuser out of the family constellation, often scornfully describing the outcast's painful accusations as "crazy" and "delusional." Because of the likelihood of the family's vital need to maintain its less frightening picture of reality, I now, in my therapeutic work with clients, ask them to carefully explore their desire to disclose to their families in light of the possible ramifications. My professional experience has reinforced the personal: it often is easier for the family to sacrifice the connection with the disclosing family member than to allow for the disintegration of an important interpretive structure that defines and protects their world.

We know from the studies that child sexual abuse is epidemic.[6] That's not really the taboo. The taboo in our society is against shattering people's comfortable realities by *talking about* sexual abuse when it occurs too close to — or in — the home.[7]

In my work with individual clients, I approach denial as a signpost. It holds information, and signals something that lies ahead or behind. I don't want to ignore it or knock it down; what I want to do is understand why it's there because that knowledge is important to have.

Stop. Do not enter. No exit. Dangerous curve ahead. Caution. Falling rocks. The denial usually signals risks or dangers. In our society it *is* risky — not just for the victimizer — but for the sexually abused child, siblings and the non-offending parent, once incestuous child abuse has been exposed. Even if the family is sensitive to the feelings of the child who is being abused, the consequences of facing the sexual abuse can be perceived as far worse than the consequences of denial. In other words, there are many social structures that reinforce the denial, and very few that support telling.

If the family believes the child's disclosure, everyone will be thrown into crisis, chaos and the unknown. They are likely to experience a cacophony of emotion: anger, hate, betrayal, grief, guilt, shame, fear — probably mixed with love and confusion. Although there will be the involvement of police, a child protection worker and possibly other social service providers, it is unlikely there will be the co-ordinated support offered in Hollow Water. Instead, structures will be in place which isolate the workers from each other, and the non-offending parent, in the middle of this crisis, will have to coordinate the disjointed services. Without support, she or he will have to attend to the children's emotional and physical needs, while coping with her or his own distress.

If the abuser is the father, it is not just his behaviour which will be condemned, but he will probably be viewed as if he is *only* an abuser, nothing else, and society will scorn him and distance itself from him, as if he has no other history. If he is successfully prosecuted, he will go to jail, and any rehabilitation offered will be limited in its effectiveness.

The child who has disclosed might or might not get help. Perhaps she just wanted the abuse to stop, rather than have her father leave, so his departure could be difficult for her; she may feel terribly guilty. Her siblings, and possibly even her mother, may be blaming her, either covertly or overtly. And at the same time, she is probably trying to cope with the impact of the abuse. Even if supportive, her mother will be troubled and may have more difficulty than usual helping the child through such a distressing time. If the child is feeling too overwhelmed, she might become so distanced she feels emotionally dead. Or perhaps she feels such a whirl of emotion that it seems like her world is falling apart and her whole being is disintegrating.

If the father doesn't plea guilty, there will be a trial, and the daughter — with or without her mother's support — will be pitted against him. As a fact-finding expedition, the cross-examination may

be hellishly revictimizing, revivifying memories of the sexual abuse, as well as escalating the antagonism between members of the family.

Then, if the child is truly supported by the mother, there is the likelihood of a messy divorce, and if the father is not successfully prosecuted, the possibility of vindictive child custody and/or access litigation. But once the days in court are over, the fractured family will continue to live in the aftershock. There will be new financial stresses, the possible loss of a family home. It is not a pretty picture, and I've described just a small part of it.

In our society protecting a child from sexual abuse by a parent requires an exceptional amount of courage because there are so many losses and little or no support. Often the child's well-being is sacrificed instead. This is the story one woman tells about her niece:

> "Jill, my sister's daughter, is fourteen. Her stepfather has been feeling her up and going into her bedroom at night for the past six months. I know she's telling the truth because he did the same to me when I lived with them. Jill couldn't stand it and finally told her teacher. The teacher told the school psychologist, who said that either the child was lying and very sick or the family was in great trouble. The father could go to jail.

> "When confronted, the stepfather said Jill lied. Jill's mother believed her husband. Wringing her hands, she pleaded with her daughter to 'confess.' Otherwise who would support them and her younger brothers? Jill tried to stick to her story, but with persistent pressure and increased guilt at depriving the family of support, she finally 'confessed' that she lied. She was denied a request to live with me and placed under psychiatric care." [8]

With so few places for children to speak, to get heard, to get help, it is no surprise that child sexual abuse ends up as one of society's ghosts, haunting us, hiding in the shadows behind closed doors — elusive, but always present — shape-shifting into depression, substance abuse, vandalism, violence, suicide. When we turn on the lights, open the doors, listen to our children and face what is really there, we no longer see ghosts. We find real people, real violations and real personal and social injury.

We need change. We need to put the taboo where it belongs. Our society must find the social structures which support telling — and listening — and

stop the collusion with the abusers of the smallest and most vulnerable among us. The ever-expanding, overlapping rings of disharmonies surround us and we need restoration, reparation, resolution.

We need to find our way to Hollow Water, where there are clues.[9]

Endnotes

1. Rupert Ross, *Returning to the Teachings: Exploring Aboriginal Justice* (Toronto: Penguin Canada, 1996).

2. Ibid., p. 172.

3. A. Nicholas Groth, "Guidelines for the Assessment and Management of the Offender," in Ann Wolbert Burgess, A. Nicholas Groth, Lynda Lytle Holmstrom & Suzanne M. Sgroi, *Sexual Assault of Children and Adolescents* (Toronto: Lexington, 1986), p. 32.

4. Florence Rush, *The Best Kept Secret: Sexual Abuse of Children* (New York: McGraw-Hill, 1981), p. 3.

5. Tony Parker, *The Hidden World of Sexual Offenders* (New York: Bobbs-Merrill, 1969), p. 23.

6. Robin F. Badgley, Herbert A. Allard, Norma McCormick, Patricia M. Proudfoot, Denyse Fortin, Doris Ogilvie, Quentin Rae-Grant, Paul-Marcel Gelinas, Lucie Pepin & Sylvia Sutherland [Committee on Sexual Offences Against Children and Youth], *Sexual Offences Against Children*, Vol. 1 (Ottawa: Canadian Government Publishing Centre, 1984); and Diana E.H. Russell, *The Secret Trauma: Incest in the Lives of Girls and Women* (New York: Basic Books, 1986).

7. Rush (1981), p. 134.

8. Ibid., pp. 3-4.

9. With thanks to the client who introduced me to *Returning to the Teachings: Exploring Aboriginal Justice*, to Rupert Ross for writing it, to Burma Bushie of the Community Holistic Circle Healing programme and Vicki Kelman of the Toronto District School Board for their insights, and to all of my greatest teachers: my children, Kerr, who teaches me about the richness of relationship without words, and Skye, who teaches me about the richness of relationship with words; those clients, past and present, who have allowed me to accompany them on their journeys into the deepest parts of themselves; and with special thanks to my partner, who by giving me the gift of time made this writing possible.

PART TWO

Memory
on
Trial

INTRODUCTION TO PART TWO

Memory on Trial

Margo Rivera

One of the reasons for the adversarial and essentially anti-scientific atmosphere surrounding so many discussions about memories of childhood sexual abuse recovered in psychotherapy is the shift of the arena of investigation from the laboratory, the library and the treatment room into the courtroom. The rules of evidence and the conventions of communication are quite different in the legal context, and the need to prove one's point based on rules and precedence often outweighs one's inclination to consider all sides of an issue in a curious and an open-minded fashion. The increase in successful criminal and civil cases against perpetrators of child sexual abuse, which followed law reform in the area of sexual assault in the past 15 years, is one of the most obvious causes for growing resistance against the proposition that forgotten memories of child sexual abuse can be recalled with a substantial degree of accuracy many years later. Many a frightened defendant is looking for an effective defence to accusations that two decades ago would never have seen the inside of a courtroom.

The criminalization of child sexual abuse offences which were once considered a private matter has been a goal and a gain of the women's movement. Feminists have taken sexual violence against women and children out of the home and into public and political arenas. This sort of legal accountability is a blessing, but it is a blessing with a cost. Now that the courts are more open to hearing allegations of child sexual abuse, the stakes are much higher and everyone — victims, accused and professionals alike — are frequently compelled to play by the rules of the judicial system. This is rarely the framework most conducive to revealing the multi-leveled reality of life experiences, much less facilitative of the deep healing desired by many survivors of childhood sexual abuse.

I have been personally involved in a number of sexual assault trials, most often as an expert witness, but once as a prosecution witness against a man who had been a friend. He was the principal of an alternative school I had been instrumental in establishing and supporting. Years later, he was charged with sexually abusing the only two students who would testify against him, though they reported that there were other victims as well. I found out about the assaults, I reported him to the police, and I experienced three grueling weeks of trial, during which his lawyer did everything she could to undermine the credibility of the victims, their families and every other witness, including me. The experience of finding out about his betrayal of those children and then being part of the effort to hold him accountable for his actions was one of the most painful experiences in my life.

The young victim witnesses stood up under days of vigorous cross-examination and told their stories to the judge and jury with courage and dignity. When the lawyer tried to confuse them with complicated questions containing multiple parts, they told her that they could not answer all those questions at once. Could she please ask each of them separately? When she accused them, again and again, of lying, they simply repeated that they were telling the truth; they had no reason to lie.

The jury deliberated for quite a while. I tried to apply to myself, while I was waiting for them to return to the courtroom, the advice I had offered to so many clients, adults and children, who were involved in trial proceedings: that their job was to tell the truth and how the verdict turned out was not their problem. I found out the hard way that it was a farce to even think that I could dismiss the outcome so easily. At that moment, it meant everything to me that the jury believe those children. I thought that they would never trust again, if the perpetrator were freed to gloat about

his power over them. I didn't know how I could keep working in the child welfare system, if I felt we were unable to protect our children, even when the facts were so clear and the guilt so apparent. The jury came into the courtroom, after many long hours. The perpetrator was convicted, and he was sentenced to three years in a federal penitentiary. Those girls took some important steps, during that trial, on the journey of mending what he had broken in them.

The articles in the section of the book entitled "Memory On Trial" make it clear that sometimes there are similar outcomes when adults are charged with child sexual abuse offences, but failure to convict or receive compensation is a more likely result, and for many reasons. This section of the book focuses on the positive ways in which the courts have played a part, both in the opening up of the issue of child sexual abuse as a crime and promoting the credibility of the abuse survivor as a witness to her own experiences. It also discusses the negative ways in which the courts have been influential in re-enforcing social stereotypes that discount the abuse survivor's experiences and her testimony.

Even when recovered memories of child sexual abuse are corroborated and allegations are upheld in a court of law, some perpetrators, often supported by professionals associated with the False Memory Syndrome Foundation, still make vigorous attempts to discredit abuse survivors. Jennifer Hoult, in "Silencing the Victim: The Politics of Discrediting Child Abuse Survivors," recounts her experience of remembering incest, suing her father in civil court and winning, and then being subjected, for years, to harassment and defamation from a range of sources. Though the costs of reporting her father have been high, she declares that the results are commensurate to both her and her family. The intergenerational cycle of violence has been stopped, and her own life continues to get stronger, safer and happier.

Susan Vella, a civil litigator who specializes in cases of childhood sexual assault, exposes six myths she identifies as part of the False Memory Syndrome Foundation literature that are currently being used by defence attorneys to undermine the reliability of an abuse survivor as a witness in court. In her article "Credibility on Trial: Recovered Traumatic Memory in Child Sexual Abuse Cases," Vella emphasizes the fact that judges and juries face the same — not greater or particularly different — challenges in assessing the testimony of a sexual abuse survivor as they do in assessing the reliability of any other witness to an event for which there is no corroboration. She proposes a set of guidelines that would ensure that

such an assessment of credibility would not be biased against the abuse survivor.

"When memory is on trial, so too are the sociopolitical values embedded in the debate." Katharine Kelly, Connie Kristiansen and Susan Haslip, in "Memory on Trial: The Use of False Memory Syndrome in Court," argue that the reform of the sexual assault laws in Canada, the United States, Great Britain and Australia has been undermined by the resurgence of the use of rape myths as a credible defence under the rubric of pseudo-scientific evidence on the prevalence of false memories of childhood sexual abuse. They suggest that, for the court to uphold its own standards of objectivity and fairness, it should admit a False Memory Syndrome defence only after unbiased pretrial scrutiny, and that the use of rape myths as part of a defence should be grounds for appeal.

"Why Convictions are Difficult to Obtain in Sexual Violence Prosecutions" by Karen Busby creates a path through the maze of criminal law as it relates to sexual violence prosecutions, to help survivors who are grappling with the implications of laying a criminal charge. It is the combination of the foundational rules governing all criminal prosecutions, which are biased in the defendant's favour and often prevent the whole story from being told, and the laws specific to sexual violence offences, which have always perpetuated the inequality of women and children, that presents the most significant obstacles in securing a conviction. Busby does not argue that sexual abuse survivors should not make criminal complaints, but that they should be fully informed regarding the therapeutic, social and legal difficulties that they will encounter, if they decide to seek judicial redress for the harm that has been done to them.

In 1988, Anna Salter, as part of a study about the accuracy of expert testimony in child sexual abuse cases, reviewed a book by Ralph Underwager and Hollida Wakefield which claimed that most accusations of child sexual abuse were the result of suggestion. She pointed out the systematic misrepresentations of the research they used to support their central point. Her article "Confessions of a Whistle-Blower: Lessons Learned" describes the subsequent campaign of intimidation, including multiple bogus lawsuits, frivolous ethics complaints, and slanderous accusations of criminal behaviour, all eventually dismissed as groundless. She counsels everyone involved in the field of child sexual abuse against projecting our own moral sense onto others without discernment. Though it may be distressing and disillusioning to acknowledge the malevolence that is a very real part of the memory wars, naïveté, though comforting, can be dangerous.

Whether the details of an individual case of child sexual abuse are ever presented in a courtroom (and, of course, the vast, vast majority never are), the disposition of the tiny minority that are litigated isimportant to every person who has been sexually abused in childhood and everyone who cares about what kind of a society we live in. The courts are one significant place where we create and disseminate our social values. One of the most salient of these values is the responsibility of the social safety net, which includes the judicial system, to provide protection for those who cannot protect themselves. Each case must, of course, be judged on its own merits, and safeguarding the rights of the truly innocent — whether the innocent be the victim of child sexual abuse or the innocent person falsely accused of this crime — is, or ought to be, the goal of a healthy judiciary.

SILENCING THE VICTIM

The Politics of Discrediting Child Abuse Survivors

Jennifer Hoult

I am a victim of child abuse who proved my claims in a landmark civil suit [in the United States], and there have been many attempts to silence and discredit me. During my childhood several factors ensured my silence. I loved my father and blamed myself for the abuse. I was ashamed and humiliated: While sexually abusing me, he told me that I liked it. I believed his threats of further violence. Ultimately, my repression of awareness of the abuse ensured my silence, protected my father, and protected me from having to face his betrayal.[1]

Although I had no conscious recollection of sexual abuse until adulthood, I had myriad symptoms of abuse dating back to my childhood. Because they were habitual, I never perceived them as symptoms until much later.[2]

There are many things I have always remembered. I grew up in an upper middle-class, suburban home, the eldest of four children. My father taught at Massachussetts Institute of Technology (MIT) and my mother at Wellesley College. As a child I was my father's favourite: He taught me gourmet cooking, built model airplanes with me, and spent time discussing history and

mathematics with me. I treasured these special times with him.[3]

I always believed that I was a light sleeper, and I remember, at about age 10, often lying awake in my bed at night, fearful that a man would come to murder me with a knife and trying to decide whether I should lie facing the window or the door to be best prepared for him.

I remember my father leaving Playboy magazines in the magazine rack by the sofa in our den when I was in elementary school. I remember an evening in my teens when I approached my parents to tell them I was leaving for a party, and my father, looking at my chest, said, "That really gets the semen running." I remember thinking, "What does my shirt have to do with sailors?" My memories of my father include both positive behaviours and, in my opinion, extremely cruel and sadistic behaviours that he routinely directed toward me and others in my family. Testimony about this was presented at trial.[4] I binged on food, and there are photos in my high school years that show my face covered with self-inflicted wounds. I had few friends and fewer boyfriends. In sleep, I had long, "epic" dreams, in which I was sexually tortured, but although I usually remembered them, I had no emotional reaction to them. My self-esteem and body image were extremely poor.

I began to study the harp at about age seven, and at age 16 gave my solo debut with the Boston Symphony as a result of winning their Youth In Concert Competition. My grades were predominately As and Bs, except in gym. In three years, I completed my high school requirements, graduating at 16 with several awards. I went to Barnard College and Manhattan School of Music, earning degrees in Harp, Computer Science and Religion. After graduating, I pursued a career in Artificial Intelligence Software Engineering. Later, I returned to a full-time career in music.

My impression was that my parents' relationship was never good. I recall, and there was testimony from my father's sister and my mother during the trial,[5] that there was heavy drinking in my family. My parents were separated once during my combined junior-senior year of high school. There were allegations that my father had an affair, but, at the time, I believed his denials. In the spring of 1984, they decided to divorce. I supported their decision. My siblings cut off their relationships with my father shortly thereafter. I was the only one to maintain a relationship with him, which he made difficult because he did not provide me with a home phone or address.[6]

At age 23, I entered psychotherapy primarily to deal with communication issues with a serious boyfriend with whom I was contemplating marriage. Things were not going well, and I wanted our relationship to

succeed and not end up like my parents'. Although I had been sexually promiscuous during college, during this period I was experiencing increasing difficulty sexually, becoming extremely scared while making love. My boyfriend would ask what I was afraid of, and when I would try to focus on the fear, I would feel that men with knives were coming to kill me, and then I would shut down, becoming completely numb. However, this was not my reason for entering psychotherapy. In fact, I consciously believed that I did not have any sexual problems. My therapy dealt with general family, work, relationship and self-esteem issues. It never involved suggestions of sexual abuse, hypnosis, drugs, leading questions, or diagnoses of Postraumatic Stress Disorder or sexual abuse.[7]

As my self-esteem began to improve, I began to have a more integrated emotional response to and awareness of my fears. The routine fear I lived with became less bearable. As my awareness and emotions became more integrated, and as I sought to understand what I was afraid of, I began to feel the full force of what I had anaesthetized.

The fear that had always been a part of my life continued. Because this was a normal part of my life, I had never considered it to be a symptom of anything. It was only in adulthood that I realized that my routine nighttime fears, panic, hypersensitivity to sounds and sleeplessness were not mere "light sleeping."

In college, I remember a colleague describing his "panic attacks." He described what I experienced almost nightly. Until that time, I had considered it to be part of my light sleeping. Both on the street and in my home, I was afraid someone would come and kill me or sexually torture me. I was afraid that no one would help me. I did not connect the fact that my dreams during sleep paralleled my waking fears, with men with knives coming after me and torturing me, and no one protecting or helping me. Although I numbed myself to it, fear was an ordinary component of my life.

I began to realize that my epic dreams were extremely sadistic in content. Although I remembered their sadistic content, I had no emotional reaction to them. During the summer of 1985, my response to these dreams became more integrated and emotionally connected, and I responded to them as the nightmares they were.

In October 1985, at age 24, while focusing on my fear in a therapy session, I had my first flashback of sexual abuse by my father. I testified about it at trial:

> "... I was feeling really afraid, and so I started the same thing of shutting my eyes and just trying to feel the feelings and not let them go away really fast.

"And it was the same thing. I — at the time like I just felt really, really scared, and I felt like someone was coming to get me, like with a knife. And my psychotherapist just said, 'Can you see anything?'

"And at first it was the same thing, I couldn't see anything, just sort of a shadowy cut-out thing, figure, and then all of a sudden, I saw this carved bed post from my room when I was a child ...

"I could see the two bed posts from the end of the bed. And then I was like, back there in that room. And I could feel myself against the head board, pushed way back, being all kind of pulling away.

"And then I saw my father, and I could feel him sitting on the bed next to me, and he was pushing me down, and I was saying, 'No.' And he started pushing up my night gown and — and then he was touching me with his hands on my breast, and then between my legs, and then he was touching me with his mouth, like with his lips on down my body, and then — and then it just all like went away. It was like — it was like, like on TV if there is all static or if you shut your eyes in the dark sort of white static. It was all of a sudden it was plusssh, all stopped. And then I — I slowly opened my eyes in the session, and I said, 'I never knew that happened to me.' " [8]

After the first flashback, I was relieved to know what had made me afraid. I also felt extremely sad that my father, whom I loved so much, had sexually abused me. I believed I had been sexually abused one time and did not consider anything else might have happened.

Several months later, I had another flashback during a therapy session. I described at trial:

"... I had been feeling really scared, and we had talked about the evening I was telling you about when I was home with dad and everyone else was away skiing, and he was talking to me about my mom in front of the fire.

"And I couldn't ever remember anything that happened after, just sitting, talking by the fire, and I had been feeling really scared again, and so I — the same thing, I shut my eyes and tried to just feel how scared I was, and then when I was just feeling it to see if I can see anything, and then I could feel him.

"I was in my parent's bedroom in Wellesley, and I could feel his hands on my throat choking me. And my father was sitting on the end of their bed, and he pushed me — I was standing first in front of him, and he was pushing me down so I was kneeling in front of him, and he was wearing pajamas, like those men's pajamas with two pieces, like a top and a bottom, and he — he — he pushed me down.

"And I was kneeling in front of him, and he was choking me, and then he took one of his hands and — and — through his pajamas, took out his penis that was erect and started pushing it in my mouth and choking me, and I couldn't breathe, and I thought I wouldn't be able to breathe, and I was trying to pull away from him.

"And he pulled up my nightgown and was touching my breast and saying in this angry voice about how women were all whores and talking almost like I wasn't there. And saying bad words about — about women, like — like he said, 'Cunt,' and then I remember — I don't remember exactly him stopping, but then I remember he was lying in his bed, and I really wanted to know that he loved me, and I wanted to sleep next to him, and he made me go away and — and I went down the hall to my room and got in my bed, and I remember just feeling like I wanted to be dead, and that I was so bad that he didn't even love me." [9]

After remembering it, I thought I had been abused two times.

Over time I began to process the grief, shame, humiliation, anger and fear of the abuse. No one ever suggested that I had been abused, and my therapist never asked me if I had been abused. During flashbacks in her office, I would sometimes stop talking as I was reliving the events; she would say things like "Tell me what's going on." She never asked leading questions and never gave me any opinion about whether my memories were accurate.[10] Neither did the expert at trial.[11] I was never hypnotized or given drugs. In 1985 child abuse was rarely in the media. I knew little about it, and nothing about dissociative amnesia. After each flashback, I clung to the belief that I had remembered the full extent of the abuse. I never sought further memories or in any way attempted to "develop" my memory. The memories simply emerged of their own accord, usually triggered by something in my daily life.[12]

As I began to tell my family, they were universally supportive. In late 1986 I confronted my father, and he denied having abused me. I learned that there were other allegations of abuse. For example, apparently my father had molested a baby-sitter, and my mother had insisted he go to counselling. The former baby-sitter claimed in a 1989 affidavit and subsequent deposition that when she was approximately 10 or 11, my father had come up from behind her and fondled her breasts.

At the trial, my father admitted he had "goosed" the baby-sitter and testified about the counselling he received as a result. He claimed that during that counselling he had learned he could not "lose control" again.[13]

In addition, my mother testified to discovering him on top of my then-teen-age sister in her bed in her darkened bedroom. She testified that my father claimed he was "tucking her in." [14]

Beginning in 1987, I had more flashbacks, mostly occurring outside of therapy, but always in the company of someone I trusted. Ultimately, I had some 20 flashbacks of incidents of abuse, most of them complete incidents and a few fragmentary ones. They spanned from the time when I was about four until I was in college. As I look back at that period, I realize that the memories emerged not in historical order but generally in the order of less traumatic to more traumatic. At trial I claimed and testified to incidents of repeated vaginal rape. I also alleged and testified that my father threatened to murder me with carving knives and other sharp objects. I testified that I remembered he told me no one could stop him, that he controlled my life. [15]

As I remembered more and more incidents of abuse, I could no longer cling to the idea that the sexual abuse had been a few isolated incidents. This made me grieve deeply, because it meant my father's betrayal was far greater than I had originally allowed myself to comprehend. I struggled to understand why he had sexually abused me. I preferred to blame myself, as I had always done, than to blame him. I never sought new memories; in fact, after each one, I thought I knew the extent of the abuse. However, as I remembered more and more incidents, I could no longer cling to the idea that the abuse had been a few isolated events. Slowly, I realized that my fears were not about what might happen but what had already happened, and my lifelong symptoms began to abate.

Part of my experience with dissociative amnesia has been of connection and integration. My perception of different parts of my life was so compartmentalized that I did not connect the pieces into an integrated comprehension of my life and experience. The process of integration continues even now. Only recently, I realized that the "white-out," or numbing, experience that I had in several flashbacks was the same as what I experienced with my boyfriend when I tried to focus on the fear I had while lovemaking. It was a form of instant numbing or anaesthetizing. It is only recently that I realized that my fears during sleep paralleled my fears while I was awake and the fears I had while lovemaking. In a sense the same information was redolent in every part of my life, but my consciousness was so fractured that I did not integrate the information from disparate parts of my life to see a pattern. As I look back, it is amazing to me how I was actually having the same experience in myriad ways but

never allowed myself to realize it.

After telling my family about my memories, having numerous flash-backs and hearing of other allegations of abuse, I still blamed myself for the abuse and continued to feel extremely loathsome and isolated.[16] At that point, I connected with groups for sexual abuse survivors, attending meetings for several months. Meeting with other survivors was enor-mously helpful in breaking this sense of isolation and in developing compassion for myself. I began to realize that the abuse had not been my fault, and I began to forgive myself. I began to realize how profoundly my father had betrayed me. I read about child abuse, but not in an organized way. For example, the only part of *The Courage to Heal* that I have ever read was the section of how to deal with being suicidal, because I had been suicidal twice and wanted to protect myself. I began to exercise; took ballet, judo, and self-defence; and began to have a better view of my body. Over time, I developed an increased sense of physical empowerment and began to live without fear. I began to feel less a victim and more a survivor of abuse.

As I emerged from the isolation of silence, I became more aware of the larger social context of violence against women and children. Wanting to help others, I wrote a legal column for a national victim's organization between 1989 and 1991.[17] I trained and then volunteered as a rape crisis counsellor at a local hospital emergency room, work for which I received a volunteerism award from Chemical Bank in January 1989. I began lobbying for legislative reform to hold abusers accountable for their crimes. (My efforts, in conjunction with those of many others, have helped see passage of important legislation in Massachusetts, New York and Washington, DC.)

Becoming aware of recidivism issues, I spoke with people who provided psychological treatment for sex offenders and became increas-ingly concerned that my father constituted a risk to the community. I talked to the district attorney's office about criminal prosecution, and I was told that the statute of limitations protected my father from prosecution. (One of the pieces of legislation I recently helped pass was an extension of the criminal statute of limitations on rape in Massachusetts. Had the new statute been in effect in 1988, criminal charges might have been brought against my father.)

In 1988, I pursued the only legal option available to me: I filed a civil suit.[18] My father countersued me for defamation (he later dropped this counterclaim).

In preparing for the trial, I realized that, given the general social denial of child abuse, to prove my case I had to first prove that child abuse exists, then prove it had happened to me and that I repressed the memory of it. The original case went to trial in 1993. At trial, testimony in support of my allegations was presented by me; my mother; my father's sister; my therapist; an expert witness; and my former boyfriend, who had been with me during a number of flashbacks. After a week-long trial, the 10-person jury found unanimously in my favour and awarded me $500,000. To prove my case, I had to place the most humiliating experiences of my life under the scrutiny of numerous strangers for many years of discovery and at trial. I found the experience of testifying and cross-examination to be extremely punishing, and it took me over a year to recover from that trauma.

Then came the media coverage. The day after the verdict, the *Boston Globe* ran a front page article covering the case and identifying me as a rape victim.[19] The reporter interviewed my father, his attorneys, and my attorneys, but made no attempt to contact me, my family or the baby-sitter. Without consent, my and my sister's names were printed. A few months later, New York Newsday printed my photo without my prior knowledge or consent.[20]

Two years later, the *Boston Globe* ran a profile piece about accused child sex abuser Mark Pendergrast. The article quoted several alleged abusers but contained no comments from any of their alleged victims. The reporter quoted my father but made no attempt to interview me, my family or the baby-sitter. Meanwhile, Dr. Elizabeth Loftus' unproved allegation of having been molested during her childhood was reported as if it were a proven fact, with no comment from her alleged perpetrator. Coverage that presents one-sided and unproved allegations as fact is not balanced. This is true whether an allegation comes from an alleged victim or an alleged perpetrator.[21]

I began to learn that victims of sex crimes are held to a public standard that says no amount of proof is enough. Having gone through the humiliation and rigors of proving my claims and having had the jurors unanimously decide in my favour, I found this lesson particularly harsh. I have since found that people often reduce sex crimes to a "he said-she said" paradigm and claim they cannot know what happened. In reality almost all crimes tried in U.S. courts, even white-collar crimes, involve one person's word against another.

Despite the fact that I won the case, the slant in the press favoured my father. Many reporters never attempted to contact me or my family for comment, but they interviewed and quoted my father. Nonetheless, I found my name and photo used without my consent and the evidence

misrepresented to cast doubt on my credibility. My father's name has not always been used, and I have never seen his photo used in any coverage of the case. I learned that I had no right to privacy, or even the right to have the facts portrayed accurately. I also learned that the idea that the press only prints sexual abuse victims' names with their permission is, in fact, untrue. Perhaps unwittingly, the media thus plays a role in silencing victims. All this was an extremely painful replay of my father's attempts to discredit and silence me.

I respect the difficulties faced by journalists reporting sexual abuse cases. However, I believe that fair coverage should involve treating victims with respect and accurately reporting facts. The abuse taught me that I had no right to privacy or ownership of my body or reality. The experience was one of profound disenfranchisement. When the media fails to contact both sides for comment, "he said-she said" becomes simply "he said." Coverage should scrupulously report what was actually said. Using victims' names and photos without permission, misrepresenting the facts of proven cases, and using such misrepresentations to effectively retry and ridicule victims who have proven their charges in court or to titillate readers is, in my opinion, extremely cruel, unnecessary and has no place in responsible journalism.

In trying to collect the judgement, we discovered evidence that supported a claim that my father and his second wife began to transfer his assets within a few weeks of my filing the original suit in 1988. Based on this evidence, my attorneys filed a complaint for fraudulent conveyance, alleging that my father has made numerous illegal transfers of his substantial interests in real estate and has attempted to hide large sums of money and inheritances he received both before and after the judgement. A nonjury trial on these claims took place in January 1996. The judge has not made a decision in that case.[22]

After all the appeals my father pursued in the original case were either decided in my favour or dismissed, I thought the portion of my life spent dealing with holding my father accountable was over. My life continued to improve, and my symptoms were no longer interfering with my daily life. I slept normally and I was no longer hypervigilant. I no longer had the epic dreams and rarely had panic attacks or fear. I made love without having flashbacks. I picked at my skin less and binged less. I developed a sense of humour (something my family claims I never had before). Friends and family described me as "transformed." I learned what it is to feel happy and safe.

I became more confident in my work, and my career began to blossom. I won an international competition and was presented to a capacity house in my 1995 solo debut at Carnegie Recital Hall. I toured as a soloist. I began appearing in orchestras on Broadway and was appointed Principal Harpist of several small orchestras.

I began having healthier dating relationships with men, no longer feeling I had to sleep with anyone who wanted me to, no longer feeling I was property belonging to others. I began to value myself and my body.

I found myself increasingly well liked and surrounded by a supportive and loving network of family, friends, neighbours, colleagues, former boyfriends and, since the trial, other people who have won similar cases.

By age 33, I had transformed my life from one of victim to one of survivor. Little did I know that my personal life was about to intersect with a brewing public maelstrom.

In 1992, a year before I won my case in court, the False Memory Syndrome Foundation (FMSF) was founded. The organization advocated for people who claim they are falsely accused and who want to be reunited with their children. While bemoaning the problem of child sex abuse, the FMSF has never publicly identified even one living victim of real child sex abuse. The people they refer to as "victims" are accused and, in some cases, proven child abusers. FMSF cofounder, accused child abuser and University of Pennsylvania math professor Dr. Peter Freyd uses the University of Pennsylvania's computer resources to publish various FMSF mailings and raise money for his organization by advertising for membership dues.[23]

The FMSF has filed amicus briefs stating that there exists no scientific evidence that memories of childhood sexual abuse can be repressed and that such testimony should be inadmissible in court.[24] When alleged victims' memories of abuse are ruled inadmissible, it generally means that legal action cannot proceed, and alleged abusers may escape the scrutiny of the courts. Such FMSF claims are contradicted by the fact that amnesia for childhood sexual abuse is a robust finding across more than 24 studies, and research regarding the accuracy of recovered memories of abuse indicated that recovered memories are no more or less accurate than continuous memories.[25] The FMSF has never produced or identified a single piece of research demonstrating any of the following claims: Memories of child sex abuse can be successfully implanted, false memory syndrome exists, or recovered memories are any less reliable than other memories.

Some members of the FMSF have lobbied against legislation that would hold proven child abusers accountable (e.g., the Child Abuse

Accountability Act). FMSF leadership has informed their members that they "may take the legal position that the accusing child is incompetent and seek guardianship proceedings." [26]

The FMSF appears to support the concept of third-party lawsuits against therapists, writing, "The courts may be an appropriate arena for litigation when a small minority of the profession persists in practices that scientific evidence and professional judgement have deemed obsolete." [27] The organization has published statements supporting accused child abuser Chuck Noah's picketing and harassment of Seattle therapists. Mr. Noah has been criminally convicted several times of violating restraining orders and of physically assaulting a clinic employee. In January 1995, it published a letter to the editor from two criminally convicted child abusers describing accused sex abuser Chuck Noah as a "precious commodity," an "example of what true friendship is," "an example of unconditional love" and a "hero." [28] An organization that appears to condone Mr. Noah's actions leaves victims, therapists and legal professionals with the impression that other acts of violence may be similarly lauded.[29]

A decade ago, Operation Rescue used picketing, lawsuits and harassment to pressure doctors to stop performing abortions. Some Operation Rescue members applauded the murder of a Florida physician who performed abortions. In the late 1990s, the threat of picketing, lawsuits and harassment may pressure therapists to stop treating trauma victims.

After spending a year studying the issue of recovered memory, Mike Stanton, who shared a 1994 Pulitzer Prize for investigating reporting, wrote the following about the FMSF:

> "The foundation (FMSF) is an aggressive, well-financed P.R. machine adept at manipulating the press, harassing its critics, and mobilizing a diverse army of psychiatrists, outspoken academics, expert defense witnesses, litigious lawyers, Freud bashers, critics of psychotherapy, and devastated parents. With a budget of $750,000 a year from members and outside supporters, the foundation's reach far exceeds its actual membership of about 3,000." [30]

In effect, the activities of the FMSF, when successful, protect accused abusers from the scrutiny of the courts; discredit victims of real abuse, isolating them from treatment and legal recourse; and frighten victims, therapists and legal professionals into silence.

After the trial, we learned that my father and his second wife pay membership dues to the FMSF. Apparently, the jury verdict in my case and his admission about the baby-sitter incident did not disqualify him as an

FMSF member. Both before and after the trial, my family received anonymous mailings of false memory materials.

During the year after I won my case in court, Dr. Jonathan Harris, one of my father's MIT colleagues, began using MIT's computer resources to run an Internet mailing list call WITCHHNT.[31] At the end of December 1997, the webmaster address for Witchhunt changed to seharris@mind-spring.com, the address for Jonathan and his wife Susan Harris. On the webmaster page, Dr. Harris still claims that he "is an associate professor of chemical engineering" at MIT, despite the fact that, according to both Dr. Harris and the chemical Engineering Department, Dr. Harris left MIT in July 1996. Although the webmaster address is no longer an MIT address, Witchhunt is still located at the MIT address and is run using MIT's Athena system. MIT's *Athena Rules of Use* states that access to the Athena system is "restricted to authorized members of the MIT commu-nity" [32] and that the intended use of MIT's computing system and facilities is "to support research, education, and MIT administrative activities." [33] Witchhunt was linked to the Chemical Engineering liquid-2-sun.mit.edu pages, which deal with materials and liquids research. It is unclear to me how the topic of child sex abuse relates to these topics. Athena rules prohibit system use "for private financial gain." [34] Dr. Harris has used Witchhunt to solicit legal and fiscal support for convicted felons and to advertise membership in the FMSF (which requires payment of member-ship dues). It is unclear to me how Dr. Harris's use of the MIT Athena system is permissible given the *Athena Rules of Use.*

In early 1995, Dr. Elizabeth Loftus, an FMSF Board member, wrote an article discussing my case in the *Sceptical Inquirer*.[35] In my opinion, the article seriously misrepresented my case. Dr. Harris immediately published and internationally disseminated the portion of the article that dealt with my case, using MIT's Witchhunt. Dr. Peter Freyd internation-ally disseminated it using University of Pennsylvania computer facilities. The article appears on numerous websites, including CSICOP's and Dr. Loftus' University of Washington homes pages.

In an attempt to defend myself, I filed a 30-page professional ethics complaint against Dr. Loftus, accompanied by nearly 400 pages of cor-roborative materials. The complaint was received by the American Psy-chological Association (APA) on December 18, 1995.[36] The rules of the APA Ethics Committee bar members from resigning while an ethics complaint is being investigated.[37] The APA Ethics Office staff claim that, before an investigation was begun, Dr. Loftus resigned in a letter transmitted

electronically on January 16, 1996. As a result, the APA never actually investigated the complaint. The APA has since changed their procedures to ensure that other members cannot resign electronically in the interim between the filing and investigation of an ethics complaint.

In a letter to APA Chief Executive Officer Dr. Raymond Fowler dated February 22, 1996 and circulated on the Internet, Dr. Loftus asked that the APA Board of Directors investigate the complaint. She claimed the article was "based on material from actual court transcripts" and characterized it as a "scholarly article." Dr. Loftus cited the entire trial transcript as a source for her article.[38] But in 1998, Dr. Loftus testified that she did not obtain or read the entire trial transcript before writing this article.[39] The APA Board informed her that only the Ethics Committee is empowered to investigate ethics complaints and that she must reinstate herself to be within APA jurisdiction. She did not reinstate herself.

It is my opinion that in her article Dr. Loftus altered or ignored the facts of my case to support her thesis. The following are a few examples.

Altering the historical sequence of facts, she created the appearance of suggestive factors that did not actually exist. Describing the period after my parents' divorce, she wrote: "Over the next year or so she (Jennifer) experienced recurring nightmares with violent themes, and waking terrors." [40] She omitted all reference to the fact that I had lifelong symptoms.[41]

Dr. Loftus wrote, "During the course of her memory development, Jennifer joined numerous sexual-abuse survivor groups. She read books about sexual abuse. She wrote columns. She contacted legislators." [42] She omitted the fact that I had both memories of abuse and knowledge of other allegations of abuse before I joined any group, read books on abuse, or became politically active.[43]

She associated my therapy with a case involving a person who posed as a patient and allegedly was seen by a therapist who diagnosed her in her second session as having been sexually abused.[44] Such treatment has no similarity at all with my own.[45]

She wrote, "Jennifer's mother testified that she had seen the father lying on top of Jennifer's 14-year-old sister and that he had once fondled a baby-sitter in her early teens." [46] She omitted my father's admission of the baby-sitter incident and his testimony regarding the counselling he received as a result of that incident. She omitted all evidence that showed my father's lack of credibility.[47]

She claimed, "(Jennifer) had 'experts' to say they believed her memories were real." [48] Despite defence attorneys' repeated attempts to elicit

such testimony, Dr. Renee Brant, the expert who testified on my behalf, refused to provide such a statement.[49] The court described Dr. Brant's qualifications as follows:

> "With respect to her qualifications as an expert in the areas of general psychiatry, child psychiatry, and childhood sexual abuse, Dr. Renee Brant testified that she is a graduate of Harvard Medical School; has a private psychiatric practice; was founder of the sexual abuse unit at Children's Hospital; holds a joint appointment as an instructor of medical students at Children's Hospital and Harvard Medical School; serves as a consultant on the treatment of children who have been sexually abused; has lectured widely on the issue of the treatment and diagnosis of children who have suffered sexual abuse and has served as an expert witness in several other actions." [50]

Note that Dr. Loftus has no credentials in child psychology, sexual abuse, child sexual abuse, trauma, traumatic memory, or any clinical field of psychology. Her expertise is limited to research psychology.

At trial, I described one incident as follows:

> "... I had been in the children's bathroom, and I don't remember having a bath but my hair was still all wet, and my father had been there. I don't remember exactly, and I remember pulling a towel around me, and running down the stairs to sort of the archway doorway that went into the kitchen. And mom was making dinner, cooking something, and I think (my sister) was at the kitchen table or doing something, playing with something. And the water was running off me onto the floor, and I could feel blood sort of between my legs, not running exactly, but like sticky." [51]

Dr. Loftus reported the incident as follows: "She remembered one time when she was raped in the bathroom and went to her mother wrapped in a towel with blood dripping." [52] There is no "towel with blood dripping" in this incident in my testimony or in my memory.

Regarding my memories of childhood abuse, Dr. Loftus wrote: "(Jennifer) paid her therapist $19,329.59 ... to acquire that knowledge." [53] She omitted mention of the fact that I had most of the flashbacks outside of therapy sessions.[54]

She called "repression folklore" a "fairy tale" [55] and omitted mention of her own research that found a 19% rate of repression among women who had been victims of sexual abuse.[56] Such presentations of real abuse cases under the auspices of "scholarship" have become a common means used by false memory proponents to discredit victims of real abuse. Such

presentations are experienced by real victims as public ridicule, which further humiliates and often silences them.

In early 1996 I learned that Dr. Loftus planned to give a talk (also called "Remembering Dangerously") at the Southwestern Psychological Association conference. On March 13, 1996, I contacted their President, Roger Kirck, who told me that, as a person without credentials in the field of psychology, I would not be allowed to attend the conference. I later learned that that information was incorrect. I sent him a copy of the APA complaint and its documentation so he could make corrections if Dr. Loftus misrepresented the facts of my case.

Of the many prestigious organizations in which Dr. Loftus then held membership, only one, the British Psychological Society (BPS), would investigate allegations of ethical misconduct by its members. After I filed the ethics complaint with them, the BPS Investigatory Committee concluded that "Elizabeth Loftus's conduct was not such as to amount to professional misconduct." [57]

In response to the APA complaint, members and supporters of the FMSF published numerous statements about me, which they distributed internationally. They claimed I was suicidal, unemployed, estranged from my family, and a victim of therapy, and they insinuated that I was malicious and a liar.

A *Psychology Today* reporter who had never seen the ethics complaint wrote "... the complaint, when studied, (is) baseless." She described it as "... the sound and fury (of a woman) ... enmeshed in pain and anger ..." [58] Dr. Peter Freyd disseminated her article internationally, using University of Pennsylvania Internet facilities.

Despite the fact that the APA had never investigated the complaint, the Associated Press wrote that the APA complaint was "found to be baseless." [59] Once again, I was not contacted for comment. The alleged sources for this statement were Dr. Raymond Fowler and Dr. Michael Beecher (head of the department where Dr. Loftus works). Both men denied making such a statement. A correction was run by the Associated Press wire on August 29, 1996. I found five newspapers that ran the original article. Not one published the correction when it ran on the Associated Press wire. I spent several months contacting the papers directly, and ultimately all five ran the correction.

As a routine part of their investigation, the BPS sent a copy of the complaint to Dr. Loftus on April 30, 1996. The BPS claimed that they did not provide a copy of the complaint to anyone else. Nine days later on May 9, 1996, my father filed a new libel suit against me, based on and citing the

three ethics complaints against Dr. Loftus and claiming I defamed him by saying he had raped me. In this most recent claim against me, my father's most recent attorney, Witchhunt subscriber Ed Collins, wrote:

> "As part of an effort to halt Loftus from appearing as an invited presenter on the program of at least one meeting of a professional society, by filing purported claims of ethical violations against Loftus with professional organizations, in efforts to halt publication of an article relating to Loftus in at least one widely circulated magazine, and in statements to the press has, with malicious intent, uttered knowingly false, untruthful, and defamatory statements concerning her father, David P. Hoult." [60]

Given my father's conduct, I had kept my home address a secret from him. Whoever provided him with copies of the three ethics complaints knowingly gave him my home address, which was on the complaints. Notice of the new libel suit was sent to my home.

One June 30, 1996 a psychologist who specializes in trauma wrote to me the following: "I just got back from [an international conference], where Elizabeth Loftus took me aside to ask me personally to stop defending you ... on the Internet. She told me that your father had filed suit against you." [61]

In June 1997, the judge dismissed the libel suit on the grounds that the issue of rape had already been decided by the first jury. My father has appealed this decision. My father also unsuccessfully attempted to sue Dr. Renee Brant and Boston's Children's Hospital for malpractice and negligence. (Boston Children's Hospital employed Dr. Brant part-time but had no involvement with either my treatment or my legal actions against my father.) He is also appealing that decision. To date, in every case that has been decided, my father has lost.

In 1996, I learned that SIRS Publishing was using my name and photo on commercial promotion posters entitled "False Memory Syndrome: Exposing the most shocking mental health issue of our time." These posters were intended for "display in libraries, book stores, churches, and other public places." [62] They were also distributed at FMSF conferences, where SIRS' chief executive officer Eleanor Goldstein appears regularly. In a letter dated September 24, 1996, SIRS agreed to cease distributing them after my attorneys intervened. My attorneys asserted that it is illegal to use a person's name or photo without their consent to promote commercial sales and that associating cases of real abuse with false memory syndrome and false accusations is defamatory.

In 1998, Dr. Loftus' article was republished in a larger volume. The editor described it as an "article on the dangers of uncritical acceptance of recovered memories and the filing of false charges based upon them." [63]

Such continued attempts to discredit me are demeaning, insulting and painful. Ultimately, these efforts to intimidate and silence me have failed to destroy my quality of life. In 1996, while people around the world read the aforementioned claims published by false memory proponents about me, I gave over 200 performances nationwide, toured nationally as a concert soloist, taught music to some 3,000 children, performed on radio and TV, recorded music for a major motion picture, saw the release of two albums I recorded with major artists, lobbied for better legislation, spent holidays and vacations with my family and friends, dated, and even found time to learn the macarena.

Since 1995 I have become aware of the parallel between the intimidation and silencing in the microcosm of the abusive family and in the macrocosm of a society that is ill at ease in dealing with the abuse of children. During my childhood my father protected himself from being held accountable by threatening me into silence. I believe that published documents demonstrate how some members and supporters of false memory groups publish false statements that defame and intimidate victims of proven violence and their supporters. Some professionals publish personal attacks and deliberately alter facts to misrepresent the evidence in proven cases of abuse. Such altered accounts are used to discredit other victims in court and in the press. Supporters of false memory groups picket, harass and sue therapists. Their intimidation is made all the more frightening by the fact that many of these individuals are persons alleged to have histories of violence. They also have money and media power. Their publicity campaign has been so successful that the term they coined, false memory syndrome, has been added to the Random House dictionary, despite the fact that there is no scientific evidence that such a syndrome exists.

I have been contacted by both treatment professionals and alleged victims who have seen how I have been treated and who fear similar treatment if they speak out. The treatment they have observed has frightened them into silence. Understandably, people who have survived the humiliation of sexual assault are not eager to be further, and publicly, humiliated. The long-term effect of this concerns me. If victims do not report violence and professionals do not support them in court, perpetrators will commit violent crimes with impunity, and the cycle of violence will continue.

Discrediting and silencing victims, both on a personal and political level, is the means by which perpetrators escape being held accountable. Within the family, and in society, the only way to stop this sort of domestic terrorism is by breaking the silence of fear. In such a situation, silence is not neutral.

It is true that I was victimized during my childhood, but I am no longer a victim. My life continues to get happier, safer and stronger. It is true that the cost of reporting has been high for me and for my family. The continued attacks on my credibility and attempts to silence me are hard to deal with. However, my family and I have become closer than ever before, and we agree that, as a result of my reporting, the cycle of violence in our family has been stopped. As a result of my case, other victims may have their day in court and other cycles of domestic violence may be stopped.

Endnotes

1. *J. Hoult* v. *D.P. Hoult*, U.S. District Court, District of Massachusetts, Civil Action No. 96-10970 (1993).

2. Ibid.

3. *J. Hoult* v. *D.P. Hoult* (1993), testimony of Jennifer Hoult, pp. 70-73, 160.

4. *J. Hoult* v. *D.P. Hoult* (1993).

5. Ibid.

6. *J. Hoult* v. *D.P. Hoult* (1993), testimony of Jennifer Hoult, pp. 38-44, 252-260.

7. *J. Hoult* v. *D.P. Hoult* (1993), see especially testimony of Jennifer Hoult, E. Jacobson & Dr. Renee Brant.

8. *J. Hoult* v. *D.P. Hoult* (1993), testimony of Jennifer Hoult, pp. 58-59.

9. *J. Hoult* v. *D.P. Hoult* (1993), testimony of Jennifer Hoult, pp. 91-92.

10. *J. Hoult* v. *D.P. Hoult* (1993), see testimony of E. Jacobson.

11. *J. Hoult* v. *D.P. Hoult* (1993), see testimony of Renee Brant, MD.

12. *J. Hoult* v. *D.P. Hoult* (1993), testimony of Renee Brant, MD, pp. 12-13, 61-132.

13. *J. Hoult* v. *D.P. Hoult* (1993), testimony of David P. Hoult.

14. *J. Hoult* v. *D.P. Hoult* (1993).

15. *J. Hoult* v. *D.P. Hoult* (1993), testimony of Jennifer Hoult.

16. *J. Hoult* v. *D.P. Hoult* (1993), testimony of Jennifer Hoult, pp. 44, 56-67, 91-97, 101-105, 107-115, 122-127, 281-284, 285-286.

17. See: "Legal Forum," *VOICES In Action Newsletter* (1989-1991), available at e-mail: voices@voices-action.org.

18. *J. Hoult* v. *D.P. Hoult* (1993).

19. M. Brelis, "Man must pay $500,000 for raping daughter," *Boston Globe* (July 2, 1993), p. 1.

20. G. Kessler, "Hidden Horrors," *New York Newsday* (November 28, 1993), p. 7.

21. J. P. Kahn, "Trial by Memory," *Boston Globe* (December 14, 1994), p. 75.

22. *J. Hoult* v. *D.P. Hoult*, U.S. Court of Appeals for the First Circuit (May 1996).

23. Using: FMS-News@saul.cis.upenn.edu; or FMS-RESEARCH @saul.cis.upenn.edu; see also FMSF website: http://advicom.net/fitz/fmsf/).

24. For example, see: *State of New Hampshire* v. *Hungerford*, No. 95-429 (Supreme Court of New Hampshire, 1997 NH Lexis 64).

25. Alan W. Scheflin & Daniel Brown, "Repressed Memory or Dissociative Amnesia: What the Science Says," *Journal of Psychiatry and Law* 24 (1996), pp. 143-188.

26. False Memory Syndrome Foundation, *Legal Aspects of False Memory Syndrome* (Philadelphia: FMSF, 1992), p. 3.

27. False Memory Syndrome Foundation, *Legal Aspects of False Memory Syndrome* (Philadelphia: FMSF, 1997).

28. False Memory Syndrome Foundation, *A Message to Professionals* (Philadelphia: FMSF, 1995a); and False Memory Syndrome Foundation, *Letter from Ray and Shirley Souza* (Philadelphia: FMSF, 1995b).

29. For more information, see: David Calof, "Notes from a Practice Under Seige: Harrassment, Defamation and Intimidation in the Name of Science," *Ethics and Behaviour* 8, 2 (1998), pp. 161-188.

30. M. Stanton, "U-turn on Memory Lane," *Columbia Journalism Review* 3 (July-August 1997), p. 45.

31. Using: WITCHHNT@MITVMA.MIT.EDU; http://web.mit.edu/harris/ www/witchhunt.html; http://www.mit.edu:8001/people/harris/homepage. html; former link: liquid-2-sun.mit.edu; former e-mail: harris@mit.edu.

32. Massachusetts Institute of Technology, *Athena Rules of Use* (AC-01), Section 6, "Don't overload the communication servers ..." (AC-01), available at: http://www.mit.edu/afs/athena.mit.edu/astaff/project/olh/Welcome/rules.html

33. *Athena Rules of Use*, Section 1, "Don't violate the intended use ..."

34. Ibid.

35. Elizabeth Loftus, "Remembering Dangerously," *Sceptical Inquirer* 19, 2 (March/April 1995), pp. 20-29.

36. APA, Office of Ethics (personal communication, January 5, 1996).

37. Ethics Committee of the American Psychological Association, *Rules and Procedures*, Part II, 5.4 & Part V.1 (Washington: Ethics Committee of APA, 1992).

38. Loftus (1995), p. 29.

39. *Seiguious and Seiguious* v. *Fair and the Alliance for Counselling and Therapeutic Services*, Superior Court of Fulton County, Georgia, Civil Action No. E-56169, deposiyion of Elizabeth Loftus, Seattle Deposition Reporters, Seattle, Washington, Min-U-Script File ID No. 2804944620 (January 22, 1998), pp. 155, 159.

40. Loftus (1995), p. 26.

41. *J. Hoult* v. *D.P. Hoult* (1993), testimony of Jennifer Hoult, pp. 38-44, 162-174, 212-217, 252-260.

42. Loftus (1995), p. 27.

43. *J. Hoult* v. *D.P. Hoult* (1993), testimony of Renee Brant, MD, pp. 113-119, testimony of Jennifer Hoult, pp. 4-20, 44-67, 91-97, 128-136, 261-262.

44. Loftus (1995), pp. 22-24, 28. (Note that there is no way to corroborate this story, as Dr. Loftus provided no citation that can be independently verified.)

45. Loftus (1995), p. 28; compare with *J. Hoult* v. *D.P. Hoult* (1993), testimony of Jennifer Hoult, pp. 44-67, 56-67, 91-99, 101-105, 107-115, 122-127, 285-286; also testimony by E. Jacobson & Renee Brant, MD.

46. Loftus (1995), p. 26.

47. *J. Hoult* v. *D.P. Hoult* (1993), testimony by David P. Hoult, my mother and my father's sister.

48. Loftus (1995), p. 27.

49. *J. Hoult* v. *D.P. Hoult* (1993), testimony of Renee Brant, MD, especially pp. 142-148, 159-160, 172-174, 197-198, 207-211.

50. *J. Hoult* v. *D.P. Hoult* (1993), p. 5.

51. *J. Hoult* v. *D.P. Hoult* (1993), testimony of Jennifer Hoult, pp. 150-151.

52. Loftus (1995), p. 27.

53. Ibid.

54. *J. Hoult* v. *D.P. Hoult* (1993), testimony of Jennifer Hoult, pp. 44, 56-67, 91-97, 101-105, 107-115, 122-127, 281-286.

55. Loftus (1995), p. 26.

56. Elizabeth Loftus, Sara Polonsky & Mindy T. Fullilove, "Memories of Childhood Sexual Abuse, Remembering and Repressing," *Psychology of Women Quarterly* 18 (1994), pp. 67-84.

57. British Psychological Society (personal communication, 1996).

58. J. Niemark, "Dispatch from the Memory War," *Psychology Today* 29, 3 (March/April 1996), p. 8.

59. T. Klass, "Memory Wars," Associated Press wire, Seattle Bureau (August 1996).

60. *David P. Hoult* v. *Jennifer Hoult*, complaint, p. 14.

61. Personal communication (June 30, 1996).

62. SIRS Publications, promotional material signed by Eleanor Goldstein (1996).

63. Robert A. Baker (ed.), *Child Sexual Abuse and False Memory Syndrome* (Amherst, NY: Prometheus, 1998), pp. 29-48.

CREDIBILITY ON TRIAL

Recovered Traumatic Memory Evidence in Sexual Abuse Cases

Susan M. Vella

As a litigator who specializes in sexual assault cases,[1] I am noticing the alarming frequency with which the memories of sexual abuse survivors are being attacked by defence counsel in cases involving childhood sexual assault. Though the reliability of memory is often a question in many different kinds of cases, this focus has not been as major an issue in non-sexual assault cases. The pleading of faulty memory as a defence has become a common practice in childhood sexual assault cases, and is usually levied against female complainants by defence lawyers. This practice represents, in my view, a backlash against women who, after years of silence, are finally achieving a measure of success in bringing their claims of sexual abuse before the courts.

Though this backlash is occurring in both civil and criminal cases, my article will concentrate mostly on civil judgements in Canada, since this is my area of expertise. In a civil proceeding, the victim of sexual abuse (called the "plaintiff") sues her/his perpetrator and, sometimes, institutions or government (called the "defendant") for compensation for

harms suffered. In a criminal proceeding, the Crown prosecutes the victim's perpetrator for committing a crime (the victim is called the "complainant"). If convicted, the perpetrator will either go to jail or have to pay a fine, or will receive some other non-custodial sentence. The main difference between civil and criminal proceedings for purposes of this chapter is the differing degrees of burden of proof. In a criminal proceeding, the Crown must prove its case at the high "beyond a reasonable doubt" standard. In a civil proceeding, the victim must prove her/his case on the lower "balance of probabilities" standard.[2]

The banner under which this new sexual assault defence strategy is developing is commonly referred to as "false memory syndrome." In fact, false memory syndrome (FMS) is nothing more than a phrase that has been coined by a private American non-profit corporation, the False Memory Syndrome Foundation (FMSF). FMS purports to describe a condition in which a patient (generally female) has been influenced, through suggestions made by her therapist, into genuinely believing that she has been the victim of historical childhood sexual abuse, when the alleged sexual abuse in fact never occurred. Women, FMS proponents suggest, are the targets of overzealous feminist therapists who are carrying forward an agenda of breaking up families.[3]

If the courts, in Canada and elsewhere, recognize the scientific validity of the "false memory syndrome," as they are being urged to do by FMS proponents, justice systems will be lending to this highly speculative theory an element of truth — a "legally constructed" truth — in the absence of any significant body of medically credible opinion.[4] More important, the courts risk losing sight of the fact that, historically, they have already had to assess, and will continue to assess on an individual basis, the vulnerabilities of each testimony based on the reconstructive process of memory.[5]

The proponents of FMS have challenged the reliability of recovered traumatic memory in order to discourage the courts from using their traditional multi-factorial assessment of who is most likely telling the truth. They seek to make sexual assault cases involving female complainants and male defendants "one-issue" cases, focusing entirely on the reliability of the complainant's memory and, therefore, attacking her credibility. Such an approach is neither fair nor balanced and, I suggest, unlikely to produce a just result.

This article exposes and refutes six myths that I have identified from FMS literature as underlying FMS and FMS-related strategies. "Myth" is

defined by the *Concise Oxford Dictionary* as "a traditional narrative, usually involving supernatural or fancied persons and embodying popular ideas on natural or social phenomena." In our everyday lives, myths are popular ideas that are false. Our courts of law have acknowledged that myths about women and their behaviour abound in the field of sexual assault.

The six myths underlying FMS that this article refutes are:

(1) FMS is a medically recognized memory disorder.

(2) Survivors of childhood sexual abuse can never forget the traumatic events of their abuse.

(3) Sexual abuse rarely happens in "traditional" families.

(4) FMS is a valid defence to the charge of childhood sexual assault (in which the real "perpetrator" is the complainant's therapist).

(5) Therapists are capable of brainwashing women (who are inherently more suggestible than men) into believing false and "preposterous" speculations.

(6) Testimony based on recovered traumatic memory is inherently unreliable and, therefore, can never support a finding of liability or guilt in a court of law.

The last section will suggest strategies on how to expose the myths underlying FMS and false memory-related attacks in a trial setting. I will propose a set of guidelines for the assessment of the reliability of recovered traumatic memory.

Myth #1: False Memory Syndrome is a medically recognized memory disorder.

The use of the term "syndrome" in the coined phrase "false memory syndrome" is misleading; FMS is *not* a recognized medical condition. In fact, the alleged phenomenon of "false memory syndrome" has not even been classified as a mental disorder by the recently revised *Diagnostic and Statistical Manual of Mental Disorders (4th Edition)* (DSM-IV).[6] (DSM-IV is the authoritative source for North American psychiatrists and psychologists identifying medically recognized mental disorders and their diagnostic requirements.) The DSM-IV defines "syndrome" as "a grouping of signs and symptoms based on their frequent co-occurrence that may suggest a common underlying pathogenesis, course, familial pattern or

treatment selection." [7] None of the medical literature exploring FMS has assigned any such grouping of signs and symptoms to that concept.[8]

In fact, the term "FMS" was created by its namesake, the False Memory Syndrome Foundation. One of the Foundation's major goals is to ensure that FMS will, through legal recognition, take on the appearance of "truth." [9] The FMSF claims to be documenting the alleged spread of FMS throughout North America based on the stories told to it by its members, some of whom have been found guilty of abuse of their own children.

In the FMSF's literature, the "ideal" victim of FMS is invariably female.[10] This gender-biased stereotype is reminiscent of an earlier era in which false stereotypical psychiatric notions of women were used to influence our laws and to cause our justice system to require evidence from another source before a sexual assault complainant would be permitted to take her case against a male perpetrator to court. The justification behind this former requirement for corroboration in North American courts was described by Professor John Wigmore, a leading American academic in the 1940s, who said that "young girls" were "contriving false charges of sexual offences by men." [11]

This statement demonstrates the past role that psychiatry, and its attachment of "mental disorders" to women, has played in undermining the credibility of women who claim to have been sexually assaulted. Women's mental health has long been pathologized, with the effect of labelling women as inherently not credible, and has served at times to place virtually insurmountable obstacles (which men rarely face) in the way of a woman's pursuit of justice in the legal system.[12]

Proponents of FMS, including defence counsel, use the guise of a "scientific" mental disorder to undermine the credibility of women in their sexual assault claims against men. FMS is based on the assumption that, psychologically, women are peculiarly vulnerable and suggestible, thereby making them the perfect subjects for "programming," through mere suggestion, by therapists, into subconsciously adopting their therapists' belief that they have been sexually abused by a trusted or loved one.[13] However, neither the FMSF nor proponents of FMS provide any data, scientific or otherwise, which demonstrate that women are more inherently hypnotizable or suggestible than men. The use of pseudo-medical theory by FMS advocates to undermine the credibility of women is dangerous given its "common sense" appeal, which queries how any individual could possibly "forget" having been sexually abused.[14] The FMSF offers no scientific data to support its theory that memories of

traumatic childhood sexual abuse can never be lost. Rather, the FMSF offers anecdotes based on stories told by its membership and admits that it does not even attempt to verify these stories.[15] This "factual basis" is suspect, especially when one considers that FMSF is comprised mainly of parents accused of child abuse who have a clear self-interest in advancing the theory of FMS.[16] The FMSF also fails to explain documented cases in which survivors who have lost their memories of abuse have had their abuse corroborated by independent sources.[17]

Myth #2: Survivors of childhood sexual abuse can never forget the traumatic events of their abuse.

It is well recognized that persons who suffer traumatizing sexual abuse may experience a loss of memory of that abuse. The DSM-IV specifically recognizes this medical reality, known as dissociative amnesia. Dissociative amnesia is a medical condition in the family of dissociative disorders commonly experienced by victims of severe trauma.[18] A dissociative disorder is a coping mechanism commonly used by victims of traumatic sexual abuse to help them survive the horror of the abuse experienced.

Proponents of FMS contend that memory loss of traumatic events can *never* occur because the events in question, namely that of repeated childhood sexual abuse, are so traumatic that they could never be "forgotten." However, they fail to account for the fact that dissociative disorders are caused by severe trauma. Accordingly, the fundamental premise of FMS — that it is impossible for survivors to experience memory loss of childhood sexual abuse for any extended period of time — is fundamentally unsound, and is contradicted by medical authorities, including the DSM-IV, and by many Canadian court decisions.[19]

FMS proponents have also failed to note that there are at least two types of memory systems which work in different ways — *explicit* and *implicit* memory systems. FMS proponents have placed the focus on the explicit memory system and ignored the implicit memory system. The explicit memory system is visual memory, whereby a person has conscious recollection of historical events. However, our implicit memory system continues to operate in the face of trauma, and is manifested in a person's instinctive bodily reactions. The implicit memory system has been described by specialists in the field as a "more primitive brain system that controls conditioned emotional responses such as fear, skills and habits like riding a bicycle or driving a car." [20]

Survivors who have suffered memory loss have reported that they automatically vomit when they smell a certain scent or become frightened when confronted by a certain sight, and yet do not understand, initially, why they suffer this reaction. After recovering visual memories of abuse, these survivors have realized that the smell or sight has an association with the traumatic abuse and that the vomiting or fear is their conditioned emotional response to the traumatic event.[21]

The recognition of an implicit memory system is important to the recovered traumatic memory debate because implicit memory has not been accounted for by the proponents of FMS. Further, the conditioned emotional responses of the implicit memory system usually exist before the survivor enters therapy. Therefore, these responses associated with implicit memory may be used as one piece of evidence against which to assess the reliability of recovered traumatic memory.

Expert evidence explaining the operation of the two memory systems in the face of trauma would likely be of assistance to the judge or jury where the complainant has disclosed instinctive body reactions to certain stimuli. This may, in turn, confirm the validity of her subsequently recovered traumatic memory.

The courts are now prepared to accept the explanation provided by expert psychologists that children often do not disclose their abuse until adulthood, because the dynamics of childhood sexual abuse often lead to a conspiracy of silence between the perpetrator and the victim of abuse.[22] As a result, the lack of corroboration of the alleged abuse by a third party is the rule, not the exception, in cases involving historical childhood sexual abuse, whether or not recovered traumatic memory is a factor. Judges and juries have, and will continue, in appropriate cases, to decide in favour of complainants in the absence of such evidence.

Myth #3: Sexual abuse rarely happens in "traditional" families.

Childhood sexual assault occurs in the privacy of families of all social classes, races and ethnicities with an alarming frequency. There is no standard profile of a "typical" sexual offender.[23] However, there is an abundance of clinical literature and studies documenting the nature and prevalence of childhood sexual assault. For example, the 1984 Canadian Badgley Report on Sexual Offenses against Children states that "at some time during their lives, about one in two females and one in three males

have been the victims of one or more sexual acts." [24] More recently, the 1990 Canadian Rix Rogers Report notes that a national population survey found that just over one-half of the females and one-third of the males of the 2,000 people surveyed reported that they have been victims of at least one unwanted sexual act.[25] Over four-fifths of these incidents occurred before the victim reached adulthood. In addition, the consensus of researchers in the field is that false complaints by children are in the two percent to eight percent range of reported cases.[26]

The distressingly high percentage of persons reporting sexual assault resoundingly refutes the myth that sexual abuse does not happen as frequently as claimed or in the context of "traditional" families or other relationships characterized by trust.[27]

Myth #4: FMS is a valid legal defence to the charge of childhood sexual assault.

Though FMS proponents have tried to make it seem otherwise, FMS is not a valid defence to allegations of sexual assault in Canadian civil or criminal court. Rather, it is an attack on the credibility of women who must rely on their memories of abuse to support their testimony. Defences that have expressly centred on FMS have been treated with scepticism in most of the legal decisions to date.

Since the theory behind FMS has yet to meet the minimum requisite legal standard of reliability,[28] the expert evidence supporting this theory fails to meet the test of legal relevance as set out by the Supreme Court of Canada. This is because the highly speculative nature of the proposed expert evidence would likely confuse the fact-finding process, and therefore its prejudicial value outweighs any potential as proof or evidence.

Most Canadian cases to date dealing with "false memory syndrome" have refused to recognize FMS as a credible medical theory refuting either the validity of memory loss or the reliability of recovered traumatic memory. This is because FMS has not been recognized as a medical condition. Contrary to the position of FMS proponents, it is the evidence surrounding FMS that is too unreliable to be admitted into evidence, as opposed to the testimony based on recovered traumatic memories that they seek to undermine.[29]

The 1994 civil case of *Colquhoun* v. *Colquhoun* illustrates how earlier cases have upheld the decision that "false memory syndrome" *per se* lacks

scientific validity as a syndrome and is therefore insufficiently reliable as a basis for attacking the plaintiff's credibility.[30]

Madam Justice Corbett determined that FMS lacked scientific validity as a "syndrome." The plaintiff, in this lawsuit for damages, alleged that she was the victim of continual sexual abuse during her teenage years at the hands of her father. The pattern of sexual abuse consisted of nude backrubs and touching of genitals. These memories were always held and therefore not subjected to an attack of false memory by the defence. However, the plaintiff claimed that one particular memory of an isolated incident of rape had been lost and then subsequently recovered as a fragmented memory, a memory that was not yet complete at the date of trial. Justice Corbett found that the fact that this one particular memory had been revived with the assistance of therapeutic intervention, which included an element of suggestion by the therapist, was a relevant factor in assessing its reliability. However, the trial judge underscored that therapeutic intervention was only *one* factor in the context of many in assessing the reliability of the complainant's recovered memory. She held that therapeutically revived memory was neither inherently unreliable nor suspect as a matter of course.[31]

Justice Corbett stated that the particular recovered memory of rape testified to by the complainant in *Colquhoun* was insufficiently reliable. She did not state, however, that the memory was false. Rather, she placed considerable weight on the complainant's own testimony that she was intoxicated to the point of unconsciousness immediately prior to this alleged assault.[32] She embarked on an assessment of the reliability of the complainant's memory that reflects a balanced approach to the matter and stated:

"All witnesses rely on memory when giving evidence. Giving evidence necessarily involves recounting or memory retrieval. It is common knowledge that memory involves a reconstructive process and the capacity to recollect may vary with physical capacity, age, conditions at the time of the original event, and the length of time between the original event and the remembering ... There is a popular trend whereby some seek to characterize memories revived by a therapist as inherently unreliable or as a part of a false memory syndrome (as Dr. Côté notes, there is no scientific basis to refer to therapy-revived memory as a 'syndrome'). Such an approach is neither appropriate nor helpful. The existing techniques for assessing credibility at trial continue to be apt to determine the reliability of memory." [33]

Ultimately, Justice Corbett held that the plaintiff's memory of this one isolated rape was insufficiently reliable to support a finding of liability on the basis of factors which have traditionally been used to challenge the integrity of a memory, and *not* on the basis of FMS. The plaintiff's other allegations of sexual abuse were, however, found to be credible, as contrasted with the utter lack of credibility on the part of the defendant, resulting in judgement in her favour.

At least two important points can be drawn from *Colquhoun*. First, the finding that FMS lacks scientific validity as a "syndrome," and does not assist the court as an approach to the assessment of the reliability of recovered memories, is an important one. Second, Justice Corbett's assessment of recovered traumatic memory included a consideration of a number of factors: the lapse of time between the historical event and trial, and the state of the witness at the time she experienced the event in question. These are factors which our courts have traditionally considered when assessing the reliability and accuracy of memory always held.

Myth #5: Therapists are capable of brainwashing inherently suggestible women into believing false and "preposterous" speculations.

At the heart of FMS theory is the sexist proposition that women are more suggestible than men, and because of this psychiatric flaw, therapists can brainwash women into subconsciously adopting information that is both false and preposterous.

Proponents of FMS suggest that hypnosis or mind-altering drugs are the most likely modes used to facilitate this transfer of false information by therapists. The use of hypnosis or repeated suggestions by a therapist has been the focus of FMS-driven legal challenges in Canada.

However, what FMS proponents fail to highlight is that only a small percentage of people — men and women alike — can actually be hypnotized to the extent of adopting outside information as their own. Hypnosis is a psychological technique that attempts to achieve a mind-altered state in its subject.[34] On the other hand, hypnotizability (suggestibility in this context) refers to the degree to which subjects of hypnosis will subconsciously adopt the information presented by the hypnotist as her or his own information. If subjects are not sufficiently hypnotizable, then they are unlikely to subconsciously adopt the suggested information as their own.[35] The consensus in the forensic hypnosis field is that approximately 10 percent of the

general population is sufficiently hypnotizable to be programmed into adopting the information provided to them by the hypnotist during this mind-altered state.[36] Hence, I would suggest that the percentage of the population that is suggestible enough to adopt false information as a recovered memory should be in the 10 percent range; 90 percent can not be hypnotized.

The FMSF offers no studies that conclude that women are inherently more suggestible or hypnotizable than men. In fact, gender does not appear to be a factor in identifying individuals who are hypnotizable at all. Finally, inducing a person into a trance or mind-altered state and then successfully transferring false information into that person's mind is a process that would require great skill and a concerted effort by the hypnotist.[37]

The standard guidelines for assessing the reliability of hypnotically recovered memory were formulated by the Alberta Court of Queen's Bench decision in *Regina* v. *Clark*.38 They include a statement of professional qualifications and standards for conducting hypnosis, as well as for the recording of hypnosis sessions.

The *Clark* guidelines are intended to serve two purposes. First, they are directed at minimizing the danger that a potential witness' testimony will have been tainted by the intentional or inadvertent suggestion of false information acquired under hypnosis. Secondly, if the session is recorded in the manner suggested, there will be a complete record to facilitate subsequent review of the quality of the hypnotic interview.

A direct application of the *Clark* guidelines to assess other forms of therapy that assist recovered memory retrieval is impractical. The *Clark* guidelines were designed with a view to scrutinizing only hypnotic assessment. There are alternative ways of providing the Court with an outline of the therapeutic technique employed by a therapist who uses neither hypnosis nor mind-altering drugs, assuming such a review is relevant and necessary in the first place. For example, it may become important to assess the degree of "suggestibility" employed by the therapist in her or his therapeutic technique, and whether that degree might have unduly influenced the client. Further, it must be determined whether the client is sufficiently hypnotizable in the first place.

It should be noted that, in some provinces in Canada, the practice of hypnosis is strictly regulated and restricted to the practice of registered psychologists and psychiatrists.[39] Hence, the opportunity given to unregulated therapists and support workers to implant false information with the aid of hypnosis is severely reduced, if not eliminated, in these provinces.

Myth #6: Testimony based on recovered traumatic memory is inherently unreliable and can never support a finding of liability or guilt in a court of law.

As demonstrated by the previous section, the courts have held that testimony in non-sexual assault cases that is based on hypnotically recovered memory is sufficiently reliable to support a finding of guilt or liability. The following review of cases reveals that courts have similarly found recovered traumatic memory testimony, which is unaided by hypnosis, to be sufficiently reliable to support a finding of liability or guilt in historical childhood sexual assault cases. A credibility assessment which is based, in part, on the reliability of recovered memory testimony is approached in much the same way as the courts approach their assessment of testimony based on memories that have always been held (i.e. never lost or blocked). Fundamentally, the assessment of the reliability of a witness' memory is one factor among many to be taken into consideration by the judge or jury in determining what weight to attach to a witness' testimony. The ultimate findings of fact are then based on a number of factors, including, but not restricted to, assessment of the credibility of the other witnesses, including the defendant.

Credibility, of course, is a question of fact. The determination of credibility is decided only by the trier of fact, be it judge or jury. The Canadian judiciary has accepted as a general proposition that the memory of a victim of childhood sexual abuse may have been blocked as a coping mechanism or tool of survival, and then recovered several years later. Perhaps the most obvious example of this judicial acceptance is found in the Supreme Court of Canada's landmark civil sexual assault decision in *M.(K.)* v. *M.(H.)*.[40] In that decision, Mr. Justice LaForest, writing for the majority, reviewed American case law in which the commencement of the limitation period was postponed to a point in time, *subsequent* to the recovery of the survivor's memory of sexual abuse, when the survivor has gained substantial awareness of the harm and that the cause of the harm is the sexual abuse. Furthermore, Justice LaForest concluded that therapeutic intervention is often essential to a survivor's discovery of the link between the abuse and her injuries. He also found that the complainant in *M.(K.)* v. *M.(H.)* suffered from a dissociative disorder that explained her memory loss, and that a dissociative disorder is a defensive mechanism experienced by many incest survivors.[41]

Since this landmark decision by the Supreme Court of Canada, several appellate courts across the country have similarly acknowledged that

traumatic memory can be lost and then subsequently recovered in a reliable manner.[42] Courts have demonstrated their general willingness to convict or find liability against persons accused of sexual assault where the survivor's testimony is based on recovered traumatic memory.

In *R. v. Francois*, the accused was criminally charged with sexually assaulting the complainant, who was 13 years old at the time of the numerous sexual assaults.[43] At the time of trial, the complainant was approximately 26 years old. The complainant testified that when she was 13 years old she was often required by her family to go to her next-door neighbour (the accused) to use his telephone because her family did not have one. She testified that when she went to the accused's house for that purpose, the accused raped her. This occurred approximately 10 to 20 times over the course of 12 months. The assaults ended after the complainant's family moved away from the neighbourhood.

The complainant testified that she had suffered a memory loss and that this explained an apparent inconsistent statement made by her in an affidavit sworn in earlier unrelated wardship proceedings. In that earlier affidavit, she stated that the first person with whom she had had intercourse was her son's father. At trial, the complainant testified that her memory of abuse returned to her in 1990 in the form of a flashback when she was being interviewed by the police in connection with wardship proceedings concerning her son, but subsequent to having sworn the affidavit. In finding the accused guilty, the jury was apparently satisfied with the complainant's explanation of her prior inconsistent statement, which was that she had blocked her memory of abuse.

The accused in *R. v. Francois* appealed his conviction to the Court of Appeal for Ontario. One of the grounds the accused raised on appeal was that the complainant's explanation of memory loss and subsequent recovery was not credible. In upholding the conviction, however, the Court of Appeal made several important observations. First, it confirmed that it is not uncommon for the only evidence against an accused in a childhood sexual assault case to be the uncorroborated evidence of the complainant with respect to events that allegedly took place many years earlier. Second, it recognized that it is quite possible for a survivor to block her memory of childhood abuse, and then subsequently recover that memory by way of a flashback that is triggered by an external stimulus. The Court of Appeal held that this particular complainant's evidence concerning her memory loss and subsequent flashback was credible, and further, underscored how "the mental blocking of traumatic experience, such as sexual

abuse suffered as a child, from memory, and the later incremental recollection of the abuse through flashbacks are widely recognized psychological processes." [44] The accused then appealed to the Supreme Court of Canada, which also dismissed his appeal.

Reviewing past cases, it appears that the appellate and trial courts are increasingly recognizing that there are legitimate psychological factors explaining how and why survivors of childhood sexual abuse lose their memories of abuse and then recover these memories many years later.[45] In addition, the courts are prepared to accept the general proposition that a witness' recovered traumatic memory can be sufficiently reliable to support a positive finding of credibility of that witness. The courts are also careful in determining what weight to accord expert testimony tendered to explain the concept of recovered traumatic memory and processes by which lost memories of sexual abuse may be subsequently recovered.

Expert evidence appears to be accepted by the courts only when the opinion is supported by a body of credible scientific research and when it sets out to educate the court in a general manner about the concepts and principles in issue. The courts will not rely on expert evidence to corroborate or refute the veracity of a witness' testimony that is based on recovered memory — that is the job of the judge or jury. The courts also appear to be acknowledging that, at the end of the day, they must rely on their traditional legal tools for assessing credibility and determining whether the Crown or complainant has in fact discharged the appropriate burden of proof.

Guidelines for Assessing the Reliability of Recovered Memory in a Legal Context

The courts are in the process of working out how to assess the reliability of recovered traumatic memory. Importantly, they do not appear to doubt the existence of lost memory of childhood trauma. Nor do the courts doubt the existence of a legitimate and reliable form of recall of that memory through flashbacks and triggering events which may take place either outside or during the course of a therapeutic process.

The current challenge for advocates and courts alike is to develop a set of guidelines that will allow triers of fact — judge or jury — to assess the reliability of a witness' testimony based on her or his recovered memory. In this connection, one must remember that historical childhood sexual assault cases present the same key issues as other cases in which

corroborative evidence does not exist — that is, one of credibility. Assessment of a witness' credibility is, in turn, a multi-factorial analysis that includes, among other things, the assessment of the reliability of the witness' memory. The courts have always accepted that no memory, whether it be a recovered memory or a sustained memory, will ever be entirely historically accurate. The process of remembering is reconstructive. However, when memory has been lost and then subsequently recovered with the assistance of therapeutic intervention, it has been the subject of particularly close judicial scrutiny.

When faced with a case of historical childhood sexual abuse involving recovered traumatic memory, I suggest the following guidelines which I have developed based on the case law, the psychological literature and my experience in litigating these types of cases. They are meant to ensure that an assessment of credibility is not biased against a survivor by consideration of or reliance on any of the above-mentioned myths.

1. Were all or just some of the survivor's explicit (visual) memories lost?

 In certain cases, some memories of the survivor's abuse have always been sustained, but perhaps only the most traumatic of those events have been lost or blocked.

2. Were any of the survivor's disclosures of abuse, where predicated on recovered traumatic memory, made prior to therapy? If so, what was the extent of these disclosures?

 This is an important question because proponents of "false memory syndrome" claim that the alleged survivor has been the subject of programming through therapeutic intervention. Therefore, if any disclosures were made prior to therapeutic intervention which centred around the issue of sexual abuse, it is unlikely that false seeds of memory could have been implanted by the therapist.

3. Did the survivor have any form of implicit memory that pre-dates the therapeutic intervention?

 If the survivor has experienced certain forms of implicit memory that were manifested in adverse reactions to a specific smell or sight, and this smell or sight can be tied to an experience of sexual abuse subsequently remembered, such evidence would confirm the validity of the recovered traumatic memories.

4. Where explicit visual memory is recovered with the assistance of therapeutic intervention:

(a) Does the survivor fall into the minority of the population that is hypnotizable or suggestible enough to adopt information provided by a therapist during a mind-altered or trance state?

(b) Was any hypnosis used and, if so, were any or all of the *Clark* guidelines followed?

(c) Were any mind-altering drugs used that could explain an impairment of memory?

(d) Assuming that the survivor is hypnotizable, did the therapist use a therapeutic technique capable of intentionally or inadvertently providing false information to the survivor, who has adopted that information by way of a false recovered memory? If yes, is there nonetheless other evidence that tends to confirm or refute the survivor's credibility as per the balance of these guidelines, given that there is no consensus in the scientific community concerning the method of recovering traumatic memories?

5. Does the survivor exhibit behavioural traits and/or symptoms — such as eating disorders, self-abusive behaviour, low self-esteem, a lack of ability to trust individuals in authority, or an inability to become sexually intimate — commonly associated with or exhibited by adult survivors of childhood sexual abuse? If yes, were there traumatic events aside from the alleged sexual abuse that occurred at the relevant time during the survivor's childhood that might have traumatized the survivor and that could therefore explain the existence of those behavioural traits and symptoms?

 This is an important question because it is very unlikely that a survivor will develop such a collection of behavioural traits or symptoms without there being a precipitating cause.

6. Does the survivor suffer from any physical disorders that can be attributed to the sexual abuse or the stress arising therefrom?

 For example, some survivors report experiencing somatic pain: physical pain in the area in which the abuse happened and yet doctors are unable to provide an explanation other than that the survivor experienced pain in that region of her or his body when being sexually abused.

7. Is there any other evidence that confirms or contradicts the survivor's and defendant's stories when they are assessed as a whole? For example, did the defendant have the opportunity to sexually assault the survivor in the place and during the times the survivor claims?

8. Are there any other factors that support and/or undermine the survivor's credibility outside of those factors used to assess the reliability of her or his recovered traumatic memory? For example, have her or his disclosures been consistent? What was her or his demeanour on the stand, and was she or he intoxicated or under the influence of drugs at the time of the alleged events?

9. Does the survivor suffer from any medically recognized mental disorders that might impair her or his ability to perceive reality, such as delusions or hallucinations?

10. Does the survivor suffer from any medically recognized memory disorders that may either explain the loss and subsequent recovery process or, conversely, would impair that survivor's memory? For example, does the survivor suffer from dissociative disorder under the DSM-IV? Was the recovery of memory triggered by a stimulus associated with the abuse? Did the memory return in the form of a flashback?

11. How does the *defendant's* credibility fare after it has been appropriately scrutinized? This last guideline is, I suggest, as important as the above 10 guidelines combined.

 In focusing on the credibility of survivors of sexual assault, the credibility of the defendant is all but forgotten. If the mental condition of victims is judged by the courts to be relevant in certain circumstances, then the mental condition of defendants should also be relevant in appropriate circumstances. Even if there are some uncertainties regarding the reliability of the survivor's recovered traumatic memory, if the defendant's credibility has been effectively attacked, the balance of probabilities may still favour the victim. Similarly, the higher criminal standard of proof beyond a reasonable doubt may be satisfied.

My set of guidelines is not an exhaustive list, and no doubt it will both evolve and be modified, depending upon the specific challenges presented by any particular case, and the progress in the scientific research into recovered traumatic memory. It is a work in progress. Further, the presence or absence of any of these factors is obviously not conclusive on the issue of reliability of any particular recovered traumatic memory, much less on the issue of overall credibility. However, it is hoped that these suggested guidelines will alert advocates to the need for creativity and discipline that must be applied to recovered traumatic memory cases.

Conclusion

The challenge presented by FMS and false memory-related allegations is one that bears a theme repeatedly found in sexual assault defences: the undermining of women's credibility based on myths about how women react to being sexually assaulted. The use of pathology to undermine the credibility of women is also a common theme that perpetuates myths about women's ability to know what they have or have not experienced. The danger presented by this challenge is that it seeks to appeal to a world view that does not want to believe that sexual abuse occurs to the extent or degree that it is claimed.

I hope that by exposing the myths underlying FMS, this article will help advocates to develop parameters for the assessment of recovered traumatic memory which honour the reality and experiences of survivors of sexual abuse, rather than dismiss them.

Endnotes

1. The author gratefully acknowledges the support of Elizabeth K.P. Grace, whose valuable comments on earlier drafts greatly improved the quality of this paper.

2. "False Memory Syndrome" has its roots in the United States. While it is beyond the scope of this chapter to explore the American caselaw, some notable U.S. cases in this area are: *Franklin* v. *Duncan*, 884 F. Supp. 1435 (N.D. Cal. 1995), aff'd 70 F. 3d 75 (9th Cir. 1995); *Hoult* v. *Hoult*, 57 F. 3d 1 (1st Cir. 1995) [discussed by Jennifer Hoult in this book]; *Isley* v. *Capuchin Province*, 877 F. Supp. 1055 (E.D. Mich. 1995); *Slate* v. *Hungerford*, 142 N.H. 110, 697 A. 2d 916 (1997).

3. *F.M.S.F. Newsletter* (June 1992). Note also the logo of the FMSF found on the Foundation's pamphlets, which is "False Memory Syndrome: Destroying Families."

4. The Canadian Psychiatric Association does not currently recognize FMS as a scientifically valid medical condition. The American Psychiatric Association and the Canadian Psychiatric Association have, however, issued statements to the psychiatric profession alerting it to the controversy around recovered memory. See: Board of Directors of the Canadian Psychiatric Association, "Statement on Adult Recovered Memories of Child Sexual Abuse" (March 25, 1996); and Board of Trustees of the American Psychiatric Association, "Statement on Memories on Sexual Abuse" (December 12, 1993).

5. As noted by J.A. Finlayson in *R*. v. *Norman* (1993), 16 O.R. (3d) 295, 68 O.A.C. 22, no testimony based on memory will ever be entirely historically accurate. Memory is, and always has been, a reconstructive process. The fact that memory was lost and then recovered does not alter this reality.

6. *Diagnostic and Statistical Manual of Mental Disorders (4th Edition)* [referred to as DSM-IV] (Washington, D.C.: American Psychiatric Association, 1994).

7. DSM-IV (1994), p. 771.

8. See, for example, Isabelle Côté, "False Memory Syndrome: Assessment of Adults Reporting Childhood Sexual Abuse," *Western State University Law Review* 20, 2 (Spring 1993), p. 428. Dr. Côté suggests that it is highly unlikely that FMS will ever be characterized as a "syndrome."

9. "Legal Aspects of False Memory Syndrome," *F.M.S.F. Newsletter* (June 1992). This publication suggests that its members pursue court cases against their children's therapists alleging FMS as the basis of family breakdown. See also: *F.M.S.F. Newsletter* (July 1992).

10. "Fact Sheet," FMSF (June 1992).

11. John Henry Wigmore, *Evidence in Trials at Common Law (3rd Edition)* (Boston, MA: Little Brown, 1940).

12. L. Laurence & B. Weinhouse, *Outrageous Practices: The Alarming Truth About How Medicine Mistreats Women* (New York: Fawcett Columbine, 1994). See especially Chapter 11 where the authors reveal numerous examples of how the conditions of women continue to be mischaracterized to their detriment by the mental health profession.

13. *F.M.S.F. Newsletter* (June 1992).

14. For purposes of this paper, the phrase "memory loss" will be used as a lay person's term for lacking conscious visual memory of traumatic incidents. Currently, there are many theories concerning the process by which memory of traumatic events is lost, the most common of which are dissociation and amnesia.

15. "Legal Aspects of False Memory Syndrome," FMSF (June 1992).

16. *F.M.S.F. Newsletter* (July 1992).

17. See, for example, the clinical study of: Linda Meyer Williams, "Recall of Childhood Trauma: A Perspective Study of Women's Memories of Childhood Sexual Abuse," paper presented at the Annual Meeting of the American Society of Criminology (October 27, 1993); and John Briere & Jon R. Conte, "Self-Reported Amnesia for Abuse in Adults Molested as Children" *Journal of Traumatic Stress* 3 (1993), p. 21. See also: Elizabeth Loftus, "The Reality of Repressed Memories" *American Psychologist* (May 1993), p. 518, in which this leading proponent of FMS documented some cases of recovered traumatic memory.

18. R.J. McNally & L.M. Shin, "Association of intelligence with severity of post-traumatic stress disorders symptoms in Vietnam combat veterans," *American Journal of Psychiatry* 152, 6 (June 1995), p. 936. For a review of the literature, see: John Briere, *Psychological Assessment of Adult Post-traumatic States* (Washington, DC: American Psychological Association, 1997), pp. 38-41.

19. See, for example: *R. v. Francois* (1993), 64 O.A.C. 140 (C.A.), aff'd [1994] 2 S.C.R. 827, 116 D.L.R. (4th) 69, in which it was suggested unsuccessfully that the inducers of the alleged false memories in question were the police who questioned the complainant about her past in the context of unrelated custody proceedings involving her own children; *M.(K.)* v. *M.(H.)*, [1992] 3 S.C.R. 3, 96 D.L.R. (4th) 289, per LaForest, J.; *R.* v. *G.D.L.* [1993] O.J. No.3356 (Q.L.) (unreported decision of Donnelly, J. of the Ontario Court (General Division); *R.* v. *E.F.H.*, [1994] O.J. No. 452 (unreported decision of Stortini, J. of the Ontario Court (General Division), aff'd

[1996] O.J. No. 553 (C.A.) (Q.L.); *R.* v. *C.(R.A.)* (1990), 57 C.C.C. (3d) 522 (B.C.C.A.); *R.* v. *J.E.T.*, [1994] O.J. No. 3067 (unreported decision of Hill, J. of the Ontario Court (General Division)).

20. A.S. Reber, *Implicit Learning and Tacit Knowledge: An Essay on the Cognitive Unconscious* (New York: Oxford University Press, 1993); and Bessell A. van der Kolk, "The Body Keeps the Score: Memory and the Evolving Psychobiology of Post-Traumatic Stress," *Harvard Review of Psychiatry* 1 (1994), pp. 253-265.

21. Wendy Hovdestad & Connie Kristiansen, "Mind Meets Body: On the Nature of Recovered Memories of Trauma," *Women and Therapy* 19 (1996), pp. 31-45. See, for example: *R.* v. *E.F.H.* (see endnote 18).

22. See Justice LaForest's comments in *M.(K.)* v. *M.(H.)* (see endnote 19).

23. See, for example, *R.* v. *Mohan*, [1994] 2 S.C.R. 9, 89 C.C.C. (3d) 402.

24. Badgley Report of the Committee on Sexual Offenses Against Children and Youths, "Sexual Offenses Against Children" (Ottawa: Department of Supply and Services, 1984).

25. Rix Rogers Report of the Special Advisor to the Minister of Health and Welfare Canada on Child Sexual Abuse in Canada, "Reaching for Solutions" (Ottawa: The Advisor, 1990).

26. See, for example: *R.* v. *P.(C.)* (1992), 74 C.C.C. (3d) 481 (B.C.C.A.); and *R.* v. *J.(F.E.)* (1989), 53 C.C.C. (3d) 64 (Ont. C.A.).

27. See Kenneth S. Pope & Laura S. Brown, *Recovered Memories of Abuse: Assessment, Therapy, Forensics* (Washington, D.C.: American Psychological Association, 1996).

28. See, for example: *R.* v. *S.G.R.*, [1993] O.J. No. 610 (Q.L.); John Briere, "Science Versus Politics in Delayed Memory Debate: A Commentary," *The Counselling Psychologist* 23 (1995), p. 290; D.L. Schacter, "Memory Distortion: History and Current Status," in K.L. Schacter et. al (eds.), *Memory Distortion* (Cambridge, MA: Harvard University Press, forthcoming).

29. See, for example: *R.* v. *Bell* (1997), 115 C.C.C. (3d) 107 (N.W.T. C.A.); and *R.* v. *Stapleton* (19 January 1994), (Ont. Ct. Gen. Div.), Weekes, J., (unreported).

30. *C.(P.)* v. *C.(R.)* (1994), 114 D.L.R. (4th) 151 (Ont. Ct. Gen. Div.). Note that the publication ban initially imposed by Corbett, at the request of the defendant who sought to protect his teenage sons from bad publicity, was dissolved by Corbett at the conclusion of the trial, at the request of the complainant. The editors of the *Dominion Law Reports* refused to cite the case using complete names, despite a request by Ms. Colquhoun, stating that its editorial policy is to always report a sexual assault case by reference to initials only, regardless of the complainant's express wish to break the silence surrounding her own case.

31. Ibid., p. 168.

32. Ibid., p. 169.

33. Ibid., p. 168.

34. "Hypnosis" is defined as "an artificially induced trance-like state resembling somnambulism in which the subject is highly susceptible to suggestion, oblivious to all else and responds readily to commands of the hypnotist," from *Stedman's Medical Dictionary: Fifth Unabridged Lawyers' Edition* (Baltimore, MD: Andersen, 1982).

35. For a discussion of the significance of the condition of hypnotizability and its possible interrelationship with the creation of pseudomemory, see: D. Brown, "Pseudomemories: The Standard of Science and Standard of Care in Trauma Treatment," *American Journal of Clinical Hypnosis* 37 (1995), pp. 1-24; and E.S. Bowman, "Delayed Memories of Child Abuse, Part II: An Overview of Research Findings Relevant to Understanding Their Reliability and Suggestibility," *Dissociation* 9, 23/2 (1996), pp. 235-236, 240.

36. The author is grateful to Dr. Arnold H. Rubenstein, an expert psychologist in the field of forensic hypnosis, who took the time to explain these concepts to me.

37. Ibid.

38. *R.* v. *Clark*, (1984), 13 C.C.C. (3d) 117 (Alta Q.B.).

39. For example, the *Hypnosis Act*, R.S.O. 1990 c.H-22, which provides that only licensed dentists, registered psychologists, psychiatrists and others expressly permitted by the Act can use hypnosis.

40. *M.(K.)* v. *M.(H.)* (see endnote 19).

41. Ibid., p. 311-14.

42. *R.* v. *Francois* (see endnote 19).

43. For example, in *R.* v. *Francois* (see endnote 19), it was suggested unsuccessfully that the inducers of the alleged false memories in question were the police who questioned the complainant about her past in the context of unrelated custody proceedings involving her own children.

44. Ibid., p. 147.

45. The issue of the validity of recovered traumatic memories has also been raised in the family law forum, in the context of custody disputes. See, for example, *V.A.L.*, v. *J.F.L.*, [1994] O.J. No.642 (Q.L.) (unreported judgement of Pardu, J., Ontario Court — General Division, released March 21, 1994), and *Perrier* v. *Perrier*, [1996] O.J. No. 2446 (Q.L.).

MEMORY ON TRIAL

The Use of False Memory Syndrome in Court

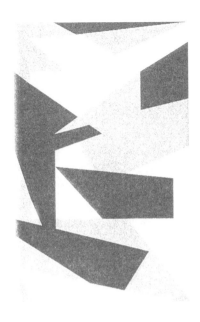

Katharine D. Kelly, Connie M. Kristiansen & Susan J. Haslip

"Memory is on trial in Canada as never before. Experts on witness stands debate the mysteries of human recall, the existence of unconsciousness and the significance of dreams. Judges and juries are asked to decide: Was Freud right? Do we bury memory? Can we retrieve it again, pristine and intact? Or are some individuals simply so weak and susceptible that they are led to 'remember' acts of incest and indecency that, in fact, never occurred?" [1]

— Lynda Shorten

These recent reflections on the legal system's engagement with the debates about memory, recall and suggestibility are matched by an extensive debate in academic literature.[2] On the surface, legal and psychological debates simply question whether memories of traumatic events can be "forgotten" and then revived. More

fundamentally, these debates are also about values, attitudes and beliefs. Thus when "memory is on trial," so too are the socio-political values embedded in the debates.

False memory syndrome (FMS) is described as "a condition in which a person's identity and interpersonal relationships are centred around a memory of traumatic experience which is objectively false, but in which the person strongly believes." [3] It was developed by the False Memory Syndrome Foundation (FMSF) to account for claims of innocence made by people, usually men, whose adult children, usually daughters, have recovered previously forgotten memories of childhood sexual abuse. However, it is not a medically recognized syndrome.

The FMSF explanation for why a woman would falsely charge a previously loved or respected person of abusing her is the influence of bad therapists and bad therapy. Bad therapists are held to use various techniques to suggest to clients that they have been sexually abused and that they have forgotten. They focus on child sexual abuse as the root cause of the problem(s) for which the client seeks help and then convince the client that she was abused.[4] Bad therapists also use "bad" techniques including hypnosis, guided imagery, automatic writing, support groups, direct suggestions and interpersonal pressure through "propaganda" such as self-help books.

The FMSF argument that recovered memories are always false memories has led to extensive scientific research in the area of suggestibility. Research indicates that people are suggestible and that you can create false memories of upsetting events. Ira Hyman and Joel Pentland report that researchers:

> "... have created memories of being lost, of overnight visits to hospitals ... and of spilling punchbowls at wedding receptions. Between 15 and 25 percent of adults have been found to create false memories in the various studies." [5]

However, caution is required in interpreting these findings. None of these events is comparable to the trauma of childhood sexual abuse.[6] Further, the statistics that between 15 and 25 percent of adults are vulnerable to suggestion does not mean that 15 to 25 percent of all recovered memories are false. This is because only 15.8 percent of women recover memories in therapy.[7] This would mean that only 4 percent (25 percent of the 15.8 percent who recover memories in therapy) of memories recovered in therapy could be false.[8]

Some recovered memories may be false. Yet this does not account for the courts' sceptical response to recalled memories. Estimates are that about five percent of all criminal complaints are false,[9] suggesting that all claims might be equally suspect. One factor supporting FMS claims seems to be that researchers disagree over what proportion of recovered memories is likely to be false. Pro-FMS researchers Richard Ofshe, Ethan Watters and Mark Pendergrast argue that nearly 100 percent of them are false.[10] Harold Lief, a psychologist and leading proponent of FMS, estimates that a quarter of all recovered memory claims are false,[11] while feminist researchers Connie Kristiansen, Judith Herman and Mary Harvey argue that about five percent may be false.[12]

Why is there so much discrepancy in the estimates and why does the FMS Foundation's claims that women are vulnerable to suggestions receive such credence? Sandra Harding, a leading feminist scholar in the area of research methods, argues that because science is shaped by the cultural context in which it emerges we need to be cautious when consuming scientific literature. Science, she writes, "is politics by other means, and ... it appears absurd to regard science as the value-free, disinterested, impartial, Archimedean arbiter of conflicting agendas, as conventional mythology holds." [13] Thus, scientific research on FMS is unlikely to provide value-free, disinterested, impartial answers to questions about recovered memories. There is a strong socio-political dimension to the debate.

If research, generally, is vulnerable to bias, then it is important to note that bias in research on childhood sexual abuse has historically been particularly problematic. Erna Olafson, David Corwin and Roland Summit argue that the 19th and 20th centuries have been characterized by periods of awareness and suppression of childhood sexual abuse. They argue that what is currently occurring with respect to debates about child sexual abuse and recovered memories is a cycle of repressive activity. This activity is linked to the fact that the persons being accused are a particular sex: male.[14] Further, is it linked to our stereotypes of rapist as a "misfit," the fact that the accused men do not generally fit this stereotype, and that admitting that many rapists are "normal" men is highly disruptive to our familial and societal values.[15] Olafsen, Corwin and Summit argue that "... the intensity of the current debate is fuelled by the defence of gender and professional privilege and hierarchy. Female or child 'surveillance' of adult male behaviour can be interpreted as a tabooed reversal." [16]

FMS fits into this argument. It was developed by a partisan organization to resist attempts to unmask the presence of sexual abuse in apparently "normal" families by male authority figures. This alone indicates the socio-political nature of FMS. In addition, research shows that disbelief in the validity of recovered memories and whether recovered memories should be allowed in courts is strongly predicted by chauvinist, authoritarian opposition to women's equality.[17]

The use of FMS in the courts introduces a new set of contextual issues. FMS cases are essentially rape cases, and rape has been a hotly contested legal issue internationally. In the past 15 years, rape laws have been reformed in Canada, the United States, Great Britain and Australia.[18] Although the issues varied from place to place, these reforms generally sought to redress the use of rape myths in trying cases. These myths reflect not only social beliefs, but also legal doctrine, education, practice and precedent.[19]

The myths begin with a belief that women and girls are likely to lie about rape.[20] The reasons provided for this vary, but in the courts the belief that rape complainants are likely to lie resulted in a number of "special" requirements for trying these cases. These include the doctrine of recent complaint (a victim must complain at the first available opportunity) and the requirement for corroboration (some other testimony or evidence that supports the claim). Further, the courts have historically accorded legal protection only to "chaste" women — a characterization based on the primary witness' past sexual activities.[21]

Legal reform in Canada has removed the requirement of both recent complaint and corroboration.[22] It has also restricted the use of evidence of past sexual activity to those few cases where it is deemed appropriate.[23] In doing this, legislators and the Supreme Court have argued that they are seeking to end the use of rape myths in court. Sherene Razack's research suggests that despite law reform, however, the courts still maintain a view that rape claims are suspect and continue to use rape myths in establishing whether a claim is "true." [24] Because of the persistence of rape myths within the legal system, false memories have been readily accepted as a defence strategy. False Memory Syndrome fits into already established disbelief in rape claims, and moreover, it does so with the support of so-called "science" behind it. It should be noted that, although our study examines only Canadian case law, similar myths can be assumed to be operating as part of the legal environment in many other countries.

Our Research on the Use of
False Memory Syndrome In Canadian Courts

In this study we examined how the courts have dealt with the issue of child sexual abuse and recovered memories. We argue that when the courts use "science" to justify the legal use of myths about rape, or when the courts ignore the biases inherent in the FMS debate, then the courts are brought into disrepute.[25] Are the courts using FMS to turn their backs on the knowledge of child sexual abuse, or are they engaging critically with the FMS position and the myths and partisan beliefs embedded in it? Engaging with scientific debates in a critical manner may be difficult. The technical background to research and the theoretical basis for specific positions may be difficult to explain in court and difficult for lay people in court to understand. We therefore ask whether the courts evaluate the merit of expert testimony about recovered memories, and of which dimensions they are and are not critical. The harmony between FMS and legal stereotype on rape is likely to result in an uncritical acceptance by the courts of the gender and other biases embedded in FMS claims. If this is true, then we should see both the use and the justification of rape myths in these cases.

For this study we selected a 10 percent random sample of approximately 170 judgements that cited false memories or false memory syndrome and sexual assault. These were listed in QuickLaw, a Canadian legal database. The database contains only a small proportion of all judgements, because the judgements are registered at the discretion of the judge(s). Thus, some caution is necessary in interpreting the results. While the study is reliable (it could be replicated), the data do not necessarily reflect all cases where recovered or false memories are at issue.

The judgements are not complete summaries of trial testimony. Instead they are the judges' summaries of the facts and the issues that they held to be important for deciding the case as they do. Judgements in QuickLaw are categorized as court judgements, *voir dires* (a separate trial held as part of a larger trial — a "trial within a trial"),[26] appeal court judgements or civil judgements. For any single case there may be one or all four types of judgements. Thus, as we sampled the cases we sought any additional judgements relating to the same case. For example, if the sample case was an appeal decision we sought the original judgement, any *voir dires* and any civil court decisions. From our search, we collected a sample of 16 judgements: five civil judgements for damages, one *voir dire* for a

civil case; six criminal trial decisions and four *voir dires* for criminal cases. There are nine cases from Ontario, four from British Columbia, and one each from Prince Edward Island, Alberta and Manitoba. Our search for additional references yielded three further judgements for a total of 19 decisions.

We examined the judgements for whether or not they accepted FMS as a "fact" and how they might be critical of it. We argue that a feminist look at the syndrome would involve accepting that false memories were rare and acknowledging that the FMSF view is partisan.

Then we looked for critical engagement with the scientific literature. This included examining the judgements for conflicting expert testimony, judges' summaries of the debates and critical cross-examination. We were also concerned with the factors that were held to be at issue.

In particular, the judgements were examined for rape myths. This included a concern with recency of complaint or corroboration, the myth that women lie vindictively about rape, the inclusion of past sexual activity evidence and the belief that "ordinary men" (or men who appear to be ordinary) do not commit rape. We also examined whether there were attempts to label primary witnesses as mentally ill (psychotic and delusional) as a method for denying a claim.[27]

Finally, we examined the issue of suggestibility, as it is a key criterion of FMS. We also noted whether the defence and/or the Crown or plaintiff introduced these myths.

Our sample consisted of 19 judgements — 16 cases, three of which had two judgements recorded. The shortest judgement is a single page, the longest more than 200 pages. On average the judgements were 42 pages. The *voir dire* judgements, where the focus is single points at issue, are generally shorter than the criminal and civil judgements. All the complainants were women and all the defendants were men. Most were family members or persons of authority (coach, physician, youth group leader).

Table 1 contains a summary of the case outcomes.[28]

Predilections of the Random Cases

We found considerable discussion about FMS in the 16 cases we reviewed. The judges noted that the study of these memories was in its infancy and that they were controversial within the psychological profession. Each case began with disbelief, typically a presumption that all recovered memories are suspect and the belief that FMS was a reasonable defence

Table 1: Summary of Cases

Case No.	Summary Cases	Outcomes	FMS Accepted
1	D.M.M. v. Pilo [a]	Found for plaintiff. Plaintiff awarded $95,000 for general damages, breach of fiduciary duty and punitive damages.	yes
2	T.K.S. v. E.B.S. [a]	Found for plaintiff. Plaintiff awarded $89,785.59 plus costs for damages, loss of income and counselling.	yes
3	Colquhoun v. Colquhoun [a]	Found for plaintiff. Plaintiff awarded $64,218 for damages, past and future therapy and educational upgrading.	yes
4	D.A.A. v. D.K.B. [a]	Found for plaintiff. Plaintiff awarded $147,574.20 for general, aggravated and punitive damages, costs of therapy and medication and loss of income (past and future).	not clear, alleged
5	S.M. v. D.D.R. [a]	Found for defendant — defendant awarded his costs.	yes
6	M.E.D.K. v. Delisle [b]	Granted — access to complainant's therapy records seeking evidence of previous inconsistent statements and false memories.	yes
7	R. v. J.E.T. [c]	Denied — expert testimony well established in legal precedent. Defence seeks to exclude recovered memories from the case.	yes
8	R. v. Allen [c]	Granted — access to the complainant's medical and therapy records for the purposes of establishing whether these are likely to be false memories.	yes
9	R. v. J.L. [c]	Denied without prejudice — defence seeks access to primary witness' records — alleges FMS though always remembered.	yes
10	R. v. S.C.H. [c]	At issue — what experts can testify to. Cannot testify that they believe the primary witness' recall.	yes
11	R. v. C.J.S. [d] (trial)	Guilty of assaulting all three of his sisters.	yes
11a	R. v. C.J.S. [d] (appeal)	Guilty verdict overturned. Trial judge erred in treating inconsistencies in testimony of adult survivors as he would treat recall of children.	yes
12	R. v. E.F.H. [d] (trial)	Guilty on most counts. Non-guilty on recovered memory from age 18 months.	yes
12a	R. v. E.F.H. [d] (appeal)	Upheld with a caution that convicting on recovered memories alone is likely to result in a miscarriage of justice.	yes
13	R. v. Norman [d] (trial)	Guilty on the single count of sexual assault.	yes
13a	R. v. Norman [d] (appeal)	Overturned on Appeal. Court felt judge allowed experts to decide whether primary witness was telling the truth.	yes
14	R. v. Makarenko [d]	Guilty on remembered assaults, not guilty on recovered memory of sexual intercourse (memory tainted by suggestion).	yes
15	R. v. H.B.F. [d] (appeal)	Overturned.	yes
16	R. v. R.L.B. [e]	Acquittal, primary witness is described as delusional.	yes

EXPLANATORY NOTES:
a = civil case judgement; b = civil *voir dire* judgement; c = criminal *voir dire* judgement;
d = criminal case judgement; e = no defence offered.

against recovered memories. The disbelief in recovered memories and belief in FMS led the attorneys and the judges to: (a) argue that all recall had to be carefully scrutinized; and (b) assert that you could not rely on the plaintiff's demeanor to assess her credibility because of the likelihood that survivors honestly, but incorrectly, believe in their false memories. Instead, assessing credibility required instruction from experts on false memories. What follows are examples from the cases to illustrate these points.

FMS as a Defence

Recovered memories and the rape claims that they represent are viewed as suspect. For example, in case #1, the judge writes about recovered memories: "This section of these reasons is *very controversial* and in it I am merely reciting the memory flashbacks that D.M.M. *says* she experienced [italics added]." He notes that there are many unknowns with respect to recovered memories and that the study of them is in their infancy. Thus, there is and should be suspicion of such claims. In case #6, the judge describes the memories as "recaptured," a description that suggests that such memories are illusive, wild and in need of being tamed. It was said that caution is necessary, perhaps to prevent them from wreaking havoc in the lives of accused men so many years after the alleged events. In case #7, the defence tries to exclude recovered memory evidence because of the controversy over the memories. The judge, however, allows the evidence, noting that the existence of differing expert views on recovered memories does not mean they should not be used. Indeed, he rules that the evidence has considerable probative value. This is the only judgement where there is a move to prevent expert testimony from coming forward.

None of the judgements includes objections to the use of the equally controversial FMS as a defence. FMS is deemed a reasonable defence strategy by both Crown/plaintiffs and defence. In case #8, for example, "… the Crown did not disagree that false memory syndrome was a legitimate consideration for the eventual trier of fact." Even when memories are always remembered, as in case #9, the defence may allege FMS as grounds for disbelieving a claim.

The acceptance of FMS (an honest belief in a false memory) also led the judges to insist that they could not rely on the primary witness' demeanor to assess credibility because, when a person has false memory syndrome, she honestly believes in the allegations. So once again, the

conclusion is that all such cases require careful scrutiny and that we should begin with distrust, if not disbelief, no matter how honest, reliable and credible a primary witness is.

The judges then struggle with whether (by what criteria) the primary witnesses' testimony can be believed. In case #6, Judge Berger states that it is almost impossible to separate the substantive issue of recovered memory/false memory syndrome from questions touching on the credibility of the complainant. In case #2, the judge is unable to accept what he sees as increasingly bizarre events. Rather than suggest the complainant is lying, he says that she completely believes the memories even though he doesn't believe them. In one appeal, case #12a, the judges write that at trial the defence did not challenge the honesty or sincerity of the complainant's belief, but whether the recollection was of real events. At trial (case #12), her honest, but mistaken, belief is the basis of the defence, and the Crown responds by attempting to prove that the primary witness does not have FMS. In case #13, the issue is again the link between belief in the memories and credibility. On appeal, case #13a, recall and forgetting due to trauma are given short shrift. The judges conclude that the recall by both the primary witness and a corroborating witness is the result of collusion. In acquitting the accused in case #16, the judge states that the issue is not the complainant's honesty, but the reliability of her recall.

What resonated throughout the judgements is a belief in false memories and that all recall must be carefully scrutinized. Further, disbelief in all recovered memories may well become the norm in cases following the appeal of case 12a. The appeal court judges write that:

> "This type of case, perhaps more so than any other, carries with it the potential for a serious miscarriage of justice. Our uneasiness in this case has been heightened due to a number of concerns, including the complainant's apparent ability to recall in detail repressed memories of events which allegedly occurred when she was less than two years old; the bizarre nature of certain of the events described ... [italics added]."

This judgement serves as a warning against convicting on any recovered memories. They are all deemed to be suspect and likely to result in a serious miscarriage of justice.

Given the complexity of the literature on recovered memories, we argue that it is possible that the court's acceptance of FMS follows from an uncritical acceptance of expert or scientific claims. Contrary to this, the

judgements indicate considerable critical engagement and with professional partisanship in particular. In case #2, the judge describes the defence expert as a partisan FMS advocate. In contrast, another expert, Dr. Roy O'Shaughnsey, is described as "... a well-known and respected psychiatrist who, according to his own admission is fairly conservative." Similarly, in the judgement of case #1, the plaintiff's lawyer has one expert, Dr. Harold Merskey, admit that he was previously censured by a judge for acting as an advocate rather than as an expert. Merskey's affiliation with the FMS Foundation is also noted and held to be of import.

Expert Testimony

Specific errors in expert testimony are also carefully scrutinized. For example, in case #1, Dr. Merskey alleges on direct examination that AA "gives people ideas." On cross-examination, the plaintiff's counsel elicited that Dr. Merskey:

> "... had never been to an AA meeting and has never read the Big Book which is a volume of programs and recommendations. He might have read some pamphlets. However, he does not know when he last read a pamphlet about AA. Dr. Merskey does not know if they counsel sex abuse victims."

The testimony of the plaintiff's expert in the same judgement provides an interesting contrast to that of Dr. Merskey. The expert, Dr. Harvey Armstrong, terms the FMS Foundation literature propaganda. When he is challenged in cross-examination about what he bases this on he answers that he has read the FMSF material and describes the founding of the organization. In case #14, a defence expert testifies that a test indicating sexual aggression is 95 percent accurate. The judge noted that the cross-examination revealed that there was no scientific literature to support this figure. In case #5, the judge critically assesses the experts' conclusions because of bias and faulty reasoning. The judges appreciate a balanced position. In case #12, the judge notes that in his testimony, Dr. Berry, the expert witness, cites specific studies from a range of pro- and anti-FMS positions. Similarly, in two of the *voir dires* (cases #7 and #10) the judges refer to extensive literature, research and practical experience as shaping expert testimony. Finally, in case #14, the defence expert is criticized as vague and defensive and as having overstated the accuracy of his test results.

There is also evidence in all the judgements that there is a debate about both false and recovered memories. The debate ranges widely, and judges often quote at length from the experts' reports and testimony. The issue is described as very controversial in case #2. The debate is extensively summarized in cases #1, #11 and #12. In case #14, evidence is brought forward that indicates no scientific basis to refer to therapy-revived memory as a "syndrome." Though the idea of FMS is rejected, the judge concludes, nevertheless, that false memories are possible and therefore that recovered memories merit special scrutiny.

However, the engagement with the scientific literature is not without problems. In case #13a, for example, the court accepts scientific testimony that is simply wrong. At trial, on the Crown-led evidence about how the memories of abuse were recovered, expert testimony correctly stated that recall was generally fragmentary.[29] The defence expert disagreed and argued that recall was all at once and had a revelational quality. This incorrect testimony by the defence expert was accepted by the appeal court and was used to question the authenticity of the primary witness' recall.

In general, the review of the judgements reveals considerable critical engagement with the issues surrounding memory retrieval, suggestion, mechanisms for "losing" memories, why children do not report abuse, and how, even as adults, people are often unable to connect their problems to their past abuse. Experts challenge each others' opinions and the research on which they rely. They challenge diagnoses, and they challenge whether the recall is "real" or false. Inconsistencies, exaggerated claims and advocacy versus expert testimony are all brought into issue. What is not considered is the disbelief in sexual assault claims, an issue that under-scores the entire process. False memories are not seen as rare occurrences, but as highly probable events. In not a single case did the judges think it was important, if it was present at all, to include information on the likelihood of false memories.

Rape Myths

As we noted earlier, disbelief in rape charges has it roots in our social, political and legal cultures. Historically rape cases have been biased against women and have been based on myths. FMS is also biased against women and contains myths about our vulnerability to suggestion and the kinds of men who rape. These biases persist in the cases we reviewed,

albeit with some significant changes. The cases provided evidence of six rape myths. Three are standard legal myths: (1) that recency of complaint is necessary, (2) that women lie about being raped and (3) that past sexual activity is an important factor to consider in assessing whether a woman is "rapeable." In addition, we found two new myths: (4) the myth that women claiming to have been raped are potentially psychotic or delusional and hence not believable, which emerged after the restriction of past sexual activity evidence and (5) the myth that women are mentally and emotionally vulnerable to suggestion, leading them to believe false memories of abuse (this reflects the FMS argument).[30] Finally, we found a myth that excludes men from consideration as a rapist: (6) that normal men cannot perpetuate such assaults. This is framed by the response that "only bad men rape." [31] Table 2 summarizes the myths present in the cases by type of judgements.

 Tables 2 and 3 indicate how common both the new and old myths are. Table 3 shows that civil cases seem to exercise more latitude with respect to the use of myths than criminal cases. Finally, the *voir dires* have fewer myths per judgement, but this probably reflects the narrowness of the question(s) under consideration. Below we give some examples of how the myths are used in the judgements.

Table 2: Rape Myths by Type of Judgement

Type of Judge-ment	Recency of Complaint	Lying, Vindictive Women	Delusional, Psychotic Women	Vulnerable to Suggestion	Complainant's Past Sexual Activity	Only "Bad" Men Rape
Civil	3 of 4	all	all	all	3 of 4	all
Voir Dire	1 of 5	3 of 5	1 of 5	1 of 5	none	none
Criminal	2 of 6	all	4 of 6	3 of 6	3 of 6	3 of 6

Table 3: Rape Myths in the Judgements

Case No.	Judgements	Recency of Complaint	Lying, Vindictive Women	Delusional, Psychotic Women	Vulnerable to Suggestion	Complainant's Past Sexual Activity	Only "Bad" Men Rape
1	D.M.M. v. Pilo [a]	yes	yes	yes	yes	yes	yes
2	T.K.S. v. E.B.S. [a]	yes	yes	yes	yes	yes	yes
3	D.A.A. v. D.K.B. [a]	n/a [e]	n/a [e]	n/a [e]	n/a [e]	n/a [e]	n/a [e]
4	Colquhoun v. Colquhoun [a]	no [f]	yes	yes	yes	no	yes
5	S.M. v. D.D.R. [a]	yes	yes	yes	yes	yes	yes [g]
6	M.E.D.K. v. Delisle [b]	no	yes	no	no	no	no [h]
7	R. v. J.E.T. [c]	no	yes	no	yes	no	no [h]
8	R. v. Allen [c]	unclear	no	no	no	no	no [h]
9	R. v. J.L. [c]	yes	no	yes	no	no	no [h]
10	R. v. S.C.H. [c]	no	yes	no	no	no	no [h]
11	R. v. C.J.S. [d] (trial)	yes	no	yes	no	no	yes
11a	R. v. C.J.S. [d] (appeal)	yes	yes	yes	no	no	no [i]
12	R. v. E.F.H. [d] (trial)	yes	yes	yes	yes	yes	yes
12a	R. v. E.F.H. [d] (appeal)	no	no	no	yes	no	no [i]
13	R. v. Norman [d] (trial)	no	yes	no	yes	yes	no [j]
13a	R. v. Norman [d] (appeal)	no	yes	no	no	no	no [i]
14	R. v. Makarenko [d]	no	yes	no [k]	yes	no	yes
15	R. v. H.B.F. [d] (appeal)	no	yes	yes	no	yes	no [i]
16	R. v. R.L.B. [c]	no	no	yes	no	no	no [l]

EXPLANATORY NOTES:
a = civil case judgement; b = civil *voir dire* judgement; c = criminal *voir dire* judgement;
d = criminal case judgement; e = no defence offered; f = recent accusation;
g = found for the defence; h = not a trial; i = overturned;
j = desc. as sexual intercourse; k = no mental health history; l = acquittal.

Recent Complaint

Although this requirement was removed from Canadian law more than 10 years ago, it often reappears in FMS judgements as a "scientific" issue. The judgements introduce the recency of complaint requirement in various ways. In cases #1 and #7, the issue is raised through expert testimony explaining why children do not complain about the abuse and often return to their abusers. In case #7, the expert testimony has the potential of dealing with this issue when the judge writes that the expert for the Crown will testify on, among other things, survivors' coping strategies.

In cases #2, #5, #8, #9, #11 and #12, the references are to the presence or absence of recency of complaint, based on the traditional belief that a victim would naturally complain at the first opportunity. In case #2, the judge writes that there was no recency of complaint to "assist her [the complainant's] case." In case #5, the only unsuccessful civil judgement, the judge questions why at the time, the child did not reveal the abuse to her social worker. In case #8, the judge is concerned with the length of time between the assaults and first disclosure. It is unclear whether this is a recency of complaint issue, but it appears to be because the judge does not raise the issue of faulty memory. In case #9, #11 and #12, the case is supported because the child(ren) attempted to disclose the abuse at the time. In case #9, the judge writes that the complainant "tried at least on one occasion to tell her mother some considerable time ago and in close proximity to the assault, about the incidents of her father's assaults. She was unsuccessful at that time."

Lying, Vindictive Women

Many of the cases (#1, #2, #3, #5, #6, #7, #10, #13, #14 and #15) depict the primary witnesses as "lying" or vindictive women. In case #1, the defence expert alleges that 40 percent of all rape complaints are false and that many women lie vindictively. There are no comments on this and hence it is unclear how the judge views it. There is also a suggestion by the defence that the plaintiff and the seven other clients, who allege being similarly assaulted, are colluding and hence lying. In addition, the plaintiff's expert asserts that false allegations are common in custody cases and

that "... the circumstances and context of the allegations in such cases must be closely reviewed because of [the] person's motives." The judgement in case #5 is filled with descriptions of the plaintiff as a vengeful and angry woman. Justice Hamilton writes:

> "The motive of revenge is also referred to in the March 27, 1975 report of the Port Coquitlam Health Centre as follows:
>
> > 'Mother threatened S. with a beating from D. and S. was very angry and upset and has considered taking revenge, but won't for the youngest daughers [sic] sake. She thinks mother has no sympathy for her.' "

Later he quotes selectively from the plaintiff's therapy notes, focusing on her anger, her desire to charge her stepfather and her view of his abuse of her as the "cause" of her marital problems. Though the judge indicates that the plaintiff saw her therapist on a weekly basis, the selected quotes cover notes written months apart. He writes, "[D]id the circumstances finally bring the plaintiff to blurt the truth, or did she simply make this vindictive remark in retribution for the ill treatment that she felt she had been afforded by the defendant?"

In cases #2, #10, #13 and #15, the myth of the lying, vindictive woman was raised. Instead of being led by the defence, the myth is referred to by the plaintiff and then dismissed as a possibility. In cases #2 and #13, the issue of lying is raised through a consideration of why the primary witness complained. The presumption is that bringing a charge is suspicious in and of itself. In both cases, the plaintiff is said to have complained to protect others. The appellate court in case #13 seems to believe in lying women, suggesting collusion between the primary witness and another Crown witness as the basis for the primary witness' case. In case #10, a *voir dire*, there is a request to introduce the expert opinion that few people, if any, could have sustained a lie so effectively. In case #15, the Crown's expert witness notes that the primary witness does not appear to be angry with her stepfather, "if anger is a motive for lying."

It is interesting to note there were only two criminal judgements (#11 and #12) with no direct references to the primary witness as lying. Instead she is described as mistakenly, but sincerely, believing the accusations. The accusations are described as false memories, the "scientific" technique for establishing that she was not assaulted.

Delusional and Psychotic Women

Sherene Razack's research indicated that women who can be labelled mentally ill are likely to find themselves outside of legal protection in rape cases.[32] An examination of primary witnesses' mental states forms an integral part of many cases (cases #1, #2, #3, #5, #9, #11, #12, #15, #16). The consequences of childhood abuse and the logic of FMS make such a strategy attractive to the defence. It is important to note, however, that the issue is recognized by both the defence/respondent and the prosecution/plaintiff. Thus, portrayals of the primary witness as psychotic and/or delusional are more common in cases where there the primary witness has an extensive mental health history.

One interesting attempt to dismiss the primary witness claims because of mental instability occurs in case #1. The plaintiff has an extensive mental health history. The claim that her memories are delusional is problematic, because there are seven witnesses who offer similar-fact evidence. It should be noted, however, that a defence expert testifies that contagion may have led these other women to report. In case #2, #3 and #15 the plaintiff's counsel thought it prudent to lead expert testimony that the primary witness suffered from no psychiatric disorder. In case #3, the plaintiff's counsel led expert testimony that the plaintiff is not delusional, though she does have a range of mental health problems (injuries) resulting from the assaults. The appeal court notes in case #15 that the Crown's expert testified that the primary witness "... was not psychotic or hallucinating, and there were no signs of any delusions on her part."

The defence/respondent uses records to establish that mental health problems explain why the complainants made false allegations. In case #5, the plaintiff's mental health records are used to provide alternatives to sexual abuse for her problems. One explanation is a "deep-rooted pathology" attributed to her separation from her mother. Access to the primary witness's mental health records is at issue in three *voir dires* (cases #6, #8, #9). In each case, the respondent plans to assess the records for evidence that the primary witness may be mentally unreliable as a witness.

The issue of mental deficiency rendering the accusations incredible is raised in four of the six criminal judgements (#11, #12, #15, #16). The judgement is very short in case #16, a single page. The primary witness has suffered from delusions in the past, and the judge states that it would be dangerous to convict the accused without supporting evidence. Hence her previous mental illness renders her outside the protection of the law. In the

trial decision for case #12, the judge notes that the primary witness' psychiatrist found no evidence of psychosis and that, as the primary witness recovered more memories, she became increasingly distressed but did not "lose touch with reality." The remaining criminal judgements (case #13, #14) do not raise the issue of delusion or psychosis. In case #13, there are references to the primary witness' mental health records, but not references to her mental state. In case #14, the primary witness does not have a mental health history.

Suggestibility

A critical component of the FMS claim is that false recall is implanted in the primary witness(es). Not surprisingly, both suggestions by therapists or others and vulnerability to such suggestions are common themes in these judgements. What is startling is the very low standard of suggestion held to create a "false" memory. What are the sources of "suggested" memories? One is a primary witness seeing what is described as "too many therapists" (case #5). How the number of therapists relates to false memories is unclear. In two cases (case #1, case #2), the memories are held to be too bizarre to be true and are attributed to suggestion.

Another common accusation is that the primary witness was exposed to suggestive techniques in the course of therapy. These include regressive hypnosis in cases #2 and #13. This does concur with the research literature as a potential risk, though the specific risk of each primary witness (i.e., her vulnerability) is not addressed. There are also general assertions that unspecified techniques were suggestive (case #9). In two cases, case #1 and case #12, it is asserted that all memories recovered in therapy are suspect, because the client is likely to have been misled by a person in authority. This allegation is not supported by the scientific literature. In some cases, the standard for suggestability was extraordinarily low. In case #1 and case #12, it was asserted that reading a single line in a book could result in a false memory. An investigating officer saying three times that he thought there was something more the complainant was not telling him was held to be sufficient in case #3. The sharing of abuse accounts by unrelated persons (with different abusers) during group therapy (case #12) is also held as a risk factor. The only claim that is addressed critically is that going to an Alcoholics Anonymous meeting (case #1) "gives people ideas."

On the other hand, in cases #1 and #12, the prosecution or plaintiff's lawyer also provided information that implanting false memories is difficult. In case #12, the Crown expert noted that for false memories you need to be "bombarded" with information before a suggestion would be accepted. In this judgement, there was no evidence of induced recall. In case #1, the plaintiff's testimony is assessed as not suggestible.

Primary Witness' Past Sexual Activity

One of the most disturbing features of these judgements is the use of therapy records to introduce the primary witness' past sexual activity into the case. This is done without the requisite *voir dire* hearing on admission of past sexual activity evidence, because the information is contained in the therapy case notes. Sexual dysfunction, both inhibition and promiscuity, is often a problem for adult survivors of child sexual abuse.[33] However, in some judgements, the case notes appear to have been used not to support claims that the primary witness was likely to have been abused, but to discredit her. The most glaring instance is case #5, where the judge, for reasons that are not indicated, reports that in her early teens the primary witness was in contact with two pimps. He also notes that she was sexually active at an early age, writing that "… she has been on birth control pills since September 1975 [at age 16]." In other judgements, there is a litany of sexual activity and problems paraded before the court (cases #1, #2, #12 #13, #15) in the guise of expert testimony or records. Their use is complex. At times, such as in case #5, they suggest that the plaintiff is a slut. In other cases, the sexual histories are explored to establish that the events were too bizarre to be believed (cases #2, #12), and in others they provide evidence of the on-going harm done. But in every instance they read like pornographic vignettes of women's lives.

Only "Bad" Men Rape

The judgements also struggle with myths about what kinds of men are rapists. As we noted in our introductory review, it is presumed that only "perverse" misfits rape. Again, the perversity or lack of perversity in the accused is used to assert the likelihood of guilt or innocence. Unfortunately, we know all too well that rapists come from a wide spectrum. We

cannot identify them by their dress, drinking habits, educational levels or other such commonly used markers.

The judgements, however, struggle with the belief that we can. For example, in exonerating the primary witness' stepfather in case #5, the judge struggles not to accept this myth. He notes that he found no independent evidence for the complainant's assertions that the defendant "drank more than he worked." The judge goes on to note that "[t]his goes to the credibility of Mrs. H. and not to the issue to be decided. Some notable persons, reputed to be of excellent character, have committed offences such as are alleged here. Sober, hardworking men can be sexual deviants." In case #3, the defendant admitted his guilt in writing to the plaintiff and had pleaded guilty in a criminal trial. In addition, he had sought treatment for what he described as an "addiction" to sex. This information is deemed essential to include, because it provides not simply an admission of guilt, but also an explanation of why the assaults occurred. The accused is "abnormal"; he fits the mythical "rapist."

Similarly, in case #2, the judge describes the defendant as having an inordinate interest in sex generally and in young girls in particular. In case #12, a variety of evidence is used to construct the accused as a "bad" man. He is described as an alcoholic and physically abusive, and the Crown expert argues that sexual abuse is not uncommon in families that are dysfunctional in these ways. While one might agree, the use of this characterization to explain the assaults simultaneously perpetuates the myth that ordinary men do not rape.

A Critique of the Legal System

Sexual assault claims have historically been, and continue to be, regarded with disbelief both in the courts and in society. We have held for too long a belief that rape is rare; false complaints are common; and rape is the venue of the sexual pervert, not ordinary boys and men. These myths have been challenged and have led to many modifications in the law with respect to sexual assault. But FMS still plays an important role in reducing these gains. And, more important, it appears to provide a "scientific," supposedly unbiased, value-free basis for disbelieving sexual assault complaints.

We fault the court's use of FMS in three ways: (1) the failure to examine the socio-politics of the FMS debate, (2) the limited critical

examination of other dimensions of the FMS debate and (3) the continued reliance on myths and the use of expert testimony and records to introduce them. As such, the court brings itself into disrepute by its own lowered standards.

The courts have, in these cases, been all too willing to believe that FMS exists, which, in turn, establishes the incredibility of recovered memory claims. On the other hand, the courts have not been equally critical in their evaluation of FMS arguments. FMS is accepted because it is in harmony with the traditional legal disbelief in sexual assault complaints. This harmony reflects the socio-political dimension of the memory debate. The failure of the legal system to engage critically with the socio-politics of the FMS debate brings the court into disrepute. It allows gender bias to continue to shape legal precedent.

The courts' disrepute is furthered by its critical engagement with particular dimensions of the FMS debate, with therapy records and with the testimony of experts. This engagement indicates that, when it chooses to, the court has the ability to engage critically with scientific debates. Partisan "experts" do not easily confuse the courts, nor are the courts unaware that scientific "truths" often involve competing research claims. The selective nature of the legal engagement with experts and expert testimony makes ignoring the partisan nature of FMS and the rarity of false memories even more disreputable.

In our study, we found that myths for dismissing sexual assault complaints are given the appearance of being grounded in science. In particular, science is used to provide a reason for both disbelieving women when they file sexual assault complaints and allowing the introduction of myths back into the courts. Women need to justify why they have complained. As a result, instead of being justified by a right upheld by the Supreme Court,[34] women who disclose abuse in the court system must establish that they are not lying or vindictive or delusional or vulnerable to suggestion. The courts then use the myths buried within the scientific literature and the long-standing legal reliance on similar myths to justify the special scrutiny of sexual assault complaints. The result is that women continue to be the subject of the male legal gaze. Attempts to turn the gaze onto the perpetrators of abuse are still resisted.

How might the courts deal more successfully with the issue of disbelief in sexual assault cases? While the courts are sensitive to issues regarding legal reasoning and precedent, they are not so obviously aware of sexism in the courts. We ask that, in their judgements, judges make clear

and direct reference to rape myths. Judges should caution themselves and juries how to view such myths and indicate that they should not be used to decide the case. The use of rape myths should be grounds for appeal and for ensuring that the decision reflects "facts," not myths. The legal system has held that such myths are inappropriate. Their presence in the cases cited in our study suggests that this is only words. If not backed by either belief or action, their use, especially in the guise of science through the use of FMS, brings the court into disrepute.

References for Cases Examined

#1. *D.M.M.* v. *Pilo* (1996) Ontario Judgement No. 938. March 25, 1996.

#2. *T.K.S.* v. *E.B.S.* [1992] British Columbia Judgement No. 2452. November 19, 1992.

#3. *Colquhoun* v. *Colquhoun* [1994] Ontario Judgement No. 681. April 11, 1994.

#4. *D.A.A.* v. *D.K.B.* [1995] Ontario Judgement No. 3901. December 15, 1995.

#5. *S.M.* v. *D.D.R.* [1994] British Columbia Judgement No. 2243. Judgement: September 20, 1994, Filed: September 23, 1994.

#6. *M.E.D.K.* v. *Delisle* [1996] Alberta Judgement No. 318. Judgement: April 1, 1996, Filed: April 3, 1996.

#7. *R.* v. *J.E.T.* [1994] Ontario Judgement No. 3067. November 30, 1994.

#8. *R.* v. *Allen* [1995] Ontario Judgement No. 150. January 27, 1995.

#9. *R.* v. *J.L.* [1994] Ontario Judgement No. 3262. December 14, 1994.

#10. *R.* v. *S.C.H.* [1995] British Columbia Judgement No. 237. January 30, 1995.

#11. *R.* v. *C.J.S.* [1994] Prince Edward Island Judgement No. 22. March 3, 1994.

#11a. *R.* v. *C.J.S.* [1996] Prince Edward Island Judgement No. 8. January 10, 1996.

#12. *R.* v. *E.F.H.* [1994] Ontario Judgement No. 452. March 2, 1994.

#12a. *R.* v. *E.F.H.* [1996] Ontario Judgement No. 553. February 19, 1996.

#13. *R.* v. *Norman* [1992] Ontario Judgement No. 1557. June 2, 1992.

#13a. *R.* v. *Norman* [1993] Ontario Judgement No. 2802. November 26, 1993.

#14. *R.* v. *Makarenko* [1994] Ontario Judgement No. 2367. June 16, 1994.

#15. *R.* v. *H.B.F.* [1995] British Columbia Judgement No. 961. May 2, 1995.

#16. *R.* v. *R.L.B.* [1994] Manitoba Judgement No. 416. June 22, 1994.

Endnotes

1. Lynda Shorten, "False Memory Syndrome," *The Canadian Lawyer* 18 (1994), p. 16.

2. Shorten (1994), pp. 16-20; John Briere & Jon Conte, "Self-reported Amnesia for

Abuse in Adults Molested as Children," *Journal of Traumatic Stress* 6 (1993), pp. 21-31; Judith L. Herman, *Trauma and Recovery* (New York: Basic Books, 1992); Judith L. Herman & Mary Harvey, "The False Memory Debate: Social Science or Social Backlash?" *The Harvard Mental Health Letter* 9, 10 (1993), pp. 4-6; Elizabeth F. Loftus, "The Reality of Repressed Memories," *American Psychologist* 48 (1993), pp. 518-537; Elizabeth F. Loftus & Katherine Ketcham, *The Myth of Repressed Memory*, (New York: St Martin's, 1994); Elizabeth F. Loftus, Sara Polonsky & Mindy T. Fullilove, "Memories of Childhood Sexual Abuse: Remembering and Repressing," *Psychology of Women Quarterly* 18 (1994), pp. 67-84; and Richard Ofshe & Ethan Watters, *Making Monsters: False Memories: Psychotherapy and Sexual Hysteria* (New York: Scribner's, 1994).

3. John Kihlstrom, "Exhumed Memory," in Steven J. Lynn & Kevin M. McConkey (eds.), *Truth in Memory* (New York: Guilford, 1996).

4. Martin Gardner, "Notes on a Fringe Watcher: The False Memory Syndrome," *Sceptical Inquirer* 17 (1993), pp. 370-371.

5. Ira E. Hyman & Joel Pentland, "Guided Imagery and the Creation of Childhood Memories," *Journal of Memory and Language* 35 (1996), p. 103.

6. Connie M. Kristiansen, "Recovered Memory Research and the Influence of Social Attitudes," paper presented in response to Dr. Elizabeth Loftus at the Beyond the Controversy: Recovering Memories of Early Life Trauma conference in Peterborough, Ontario (May 23-24, 1996).

7. Debra A. Poole, Stephan D. Lindsay & Ray Bull, "Psychotherapy and the Recovery of Memories of Childhood Sexual Abuse: U.S. and British Practitioners' Opinions, Practices, and Experiences," *Journal of Consulting and Clinical Psychology* 63 (1995), p. 432.

8. Kristiansen (May 23-24, 1996).

9. Morrison Torrey, "When Will We Be Believed? Rape Myths and the Idea of a Fair Trial in Rape Prosecution," *University of California at Davis Law Review* 24 (1991), pp. 1013-1027.

10. Ofshe & Watters (1994); and Mark Pendergrast, *Victims of Memory* (Hinesburg, VT: Upper Access Books, 1995).

11. Harold I. Lief, "True and False Accusations by Adult Survivors of Childhood Sexual Abuse," presented at a symposium at Montreal General Hospital, Montreal, Quebec (November 11, 1993).

12. Kristiansen (May 23-24, 1996); Herman & Harvey (1993).

13. Sandra Harding, *Whose Science? Whose Knowledge?* (Ithaca, NY: Cornell University Press, 1991), p. 10.

14. Erna Olarson, David L. Corwin & Roland C. Summit, "Modern History of Child Sexual Abuse Awareness: Cycles of Discovery and Suppression," *Child Abuse and Neglect* 17 (1993), pp. 7-24.

15. Diana Scully, *Understanding Sexual Violence: A Study of Convicted Rapists* (London: Harper-Collins Academic, 1990).

16. Olarson, Corwin & Summit (1993), p. 17.

17. Connie M. Kristiansen, Kathleen A. Felton & Wendy E. Hovdestad, "Recovered

Memories of Child Abuse: Fact, Fantasy, or Fancy?", *Women and Therapy* 19, 1 (1996), pp. 47-59.

18. Susan Estrich, *Real Rape* (Cambridge, MA: Harvard University Press, 1987); Carol Smart, *Feminism and the Power of Law* (London: Routledge, 1989); Sherene Razack, "From Consent to Responsibility, From Pity to Respect: Subtexts in Cases of Sexual Violence Involving Girls and Women with Developmental Disabilities," *Law and Social Inquiry* 20 (1995), pp. 891-922; Julian Roberts & Robert J. Gebotys, "Reforming Rape Laws: Effects of Legislative Change in Canada," *Law and Human Behaviour* 16, 3 (1992), pp. 555-573; and Margaret Thornton, "Feminism and the Contradictions of Law Reform," *International Journal of Sociology of Law* 19 (1991), pp. 453-474.

19. Martha J. Burt, "Cultural Myths and Supports for Rape," *Journal of Personality and Social Psychology* 38, 2 (1980), pp. 217-230.

20. John Wigmore, *Evidence on Trial at Common Law* (Boston: Little, Brown, 1940); see also the critique of Wigmore by: Leigh Bienen, "A Question of Credibility: John Wigmore's Use of Scientific Authority in Section 924a of the Treatise on Evidence," *California Western Law Review* 19 (1983), pp. 235-268.

21. Constance Backhouse, *Petticoats and Prejudice* (Toronto: Osgoode Law Society, 1991).

22. Maria Lös, "The Struggle to Redefine Rape in the Early 1980s," in Julian V. Roberts & Renate M. Mohr (eds.), *Confronting Sexual Assault: A Decade of Legal and Social Change* (Toronto: University of Toronto Press, 1994), ch. 2.; and Julian V. Roberts, *Sexual Assault Legislation in Canada: An Evaluation — Report No. 4* (Ottawa: Department of Justice, Policy and Research Sector, Research Division, 1999).

23. Ibid.

24. Razack (1995).

25. We focus on these because of their link to FMSF. It is essential to note that both the FMS debate and the court judgements are likely reflective of biases against particular social and cultural groups. For example, the belief that sexual abuse of children is more common in poor families.

26. In sexual assault cases these typically include decisions on whether it is appropriate in "this" case to admit past sexual activity.

27. For more information on this issue, see: Razack (1995).

28. In Table 1 we identify each case with a number — this number is used in the body of the paper to refer to that case.

29. Connie M. Kristiansen, Susan J. Haslip & Katharine D. Kelly, "Scientific and Judicial Illusions of Objectivity in the Recovered Memory Debate," *Feminism and Psychology* 7, 1 (1997), pp. 39-45.

30. Razack (1995).

31. Sherene Razack, *Feminism and the Law: The Women's Legal Education and Action Fund and the Pursuit of Equality in the Eighties* (Toronto: Second Story, 1991).

32. Razack (1995).

33. Lucy Berliner & Diana M. Elliot, "Sexual Abuse of Children," in John Briere,

Lucy Berliner, Josephine A. Bulkley, Carole Jenny & Theresa Reid (eds.), *The APSAC Handbook on Child Maltreatment* (Thousand Oaks, CA: Sage, 1996), pp. 55-71.

34. Re Dawson and the Queen (1983) 7 C.C.C. (3d) 247.

WHY CONVICTIONS ARE DIFFICULT TO OBTAIN IN SEXUAL VIOLENCE PROSECUTIONS

Karen Busby

Introduction

Should women who have been sexually violated go to court? Anyone interested in this question needs to understand how certain legal principles and practices in sexual violence cases make it difficult to secure convictions. In this article, I draw on my experience as a lawyer, a law professor and many years of volunteering with the Women's Legal Education and Action Fund (a Canadian group undertaking women's equality issues in the courts) and other anti-violence organizations as I address questions about the technicalities of criminal law and sexual violence prosecutions that are most frequently asked by complainants (the term used in criminal proceedings to describe those who lay complaints of sexual violence), counsellors and feminist activists who are grappling with the implications of laying a criminal charge.

The foundational rules underlying all criminal proceedings maintain a process that is biased in the defendant's favour and may prevent the

whole story from being told. As well, laws specific to sexual violence offences have reflected and perpetuated women's and children's inequality, and continue to do so. While some of the most blatantly discriminatory laws have been changed in the past two decades, sexual violence laws were founded on stereotypical beliefs or myths about the kinds of women who would make false rape complaints. These beliefs remain deeply insinuated in many judges' thinking about sexual violence. The most blatant myth — the belief that women and children frequently lie about sexual violence out of malice or delusion — has never been expressly repudiated by a Canadian judge.[1] More recently, new beliefs, like the spectre of therapy-induced memories, have been used by the Supreme Court of Canada (also referred to in this article as the "Court"), Canada's highest court, even though there was no evidence before the Court on therapy and memory, as these issues did not arise in the cases where the Court has considered them.[2] In a nutshell, it is the interaction of the foundational rules of criminal procedure, which foster partial and incomplete fact findings in all criminal cases, and rape mythologies, which perpetuate inequalities in sexual violence prosecutions, that makes it difficult to obtain convictions.

This article focuses on criminal presentations in Canada. However, the sexual violence laws in common-law countries, like the United States and the United Kingdom, generally speaking are quite similar. The notable exception is that no jurisdiction has permitted defence access to a complainant's personal records (described later in this article) to anywhere near the extent the practice has emerged in Canada.

My observations on sexual violence prosecutions, bleak as they are, should not be taken to mean that there is little or no point in laying complaints or prosecuting these cases. Women and children have resorted to the criminal justice system for centuries. If, upon consideration of the therapeutic, political and legal difficulties with this decision, a criminal court is still the forum where an individual wants to be heard, her or his decisions should be supported. One objective of this article is to ensure that those considering laying a complaint are aware of the significant legal obstacles to conviction. Similarly, many feminists and feminist organizations are interested in broadly based political work on the issue of ending male violence against women and children.[3] While acknowledging ambivalence about relying on a coercive and unresponsive legal system, demands are being made that it become more responsive. Not only might these demands result in some men being held accountable for their violence but they might also send a powerful message to all men about the

possible consequences of sexual violence. Additionally, some women, and especially children, do not have much control over whether a case involving them goes to trial. The other objective of this article is to identify some of the serious weaknesses in current sexual violence laws that inhibit convictions. Perhaps this will lay the groundwork for making the difficult political choices involved in whether and how to engage with the criminal justice system.

Foundational Rules of Criminal Law

Among the important principles underlying Canadian laws on criminal procedure are the following: criminal convictions are extremely serious and therefore should be obtained only if there is a very high degree of certainty that an offence was committed; and police should be restrained from using coercive tactics during investigations. Three foundational rules that apply to all criminal prosecutions are: the defendant (the accused) is presumed innocent until the charge is proved; the defendant has the right to silence; and, most important, the Crown must prove the offence "beyond a reasonable doubt." All three rules are meant to protect the civil rights of the accused.

Presumption of Innocence

Anyone charged with a criminal offence is presumed to be innocent. The state (or, as described in Canada, "the Crown") has the burden of proving that the defendant did the acts that amount to an offence and also intended to commit the acts. In order to satisfy the intention element in sexual assault cases, the Crown must prove not only that the defendant intended to commit a sexual act, but also that he intended to do it in the absence of consent. Since it is most often men who commit acts of sexual violence, male pronouns are used in this paper to describe defendants.

Crown attorneys represent the state; they do not represent the complainant. With the exception of records applications, complainants do not have the right to independent legal representation in court in criminal cases. From a legal perspective, complainants have no interest in the outcome of criminal proceedings. Moreover, the Crown attorney's role is not to obtain convictions, it is to ensure that the evidence in the case is presented fairly. Police lay charges if they have information suggesting

that there are grounds to believe that an offence has been committed. The standard for taking a case to trial is higher: Crown attorneys can proceed only if there is a reasonable chance of conviction, based on admissible evidence. If they are of the view that this higher standard is not met, they must drop the charges and cannot proceed to trial. The complainant's desire to have the case heard is not a factor the Crown attorney can consider in making this decision. Conversely, in cases involving children, the Crown may decide to continue the prosecution even when the complainant wants proceedings halted.

Right to Silence

It has been said that "perhaps the single most important organizing principle in criminal law is the right of an accused not to be forced into assisting in his or her own prosecution." [4] A defendant cannot be compelled to testify at his own trial, nor can evidence he has given in a previous proceeding be used against him. Moreover, no adverse inference can be drawn from his failure to testify, unless it is an uncommon case where the defendant is in the unique position of offering an explanation about an unusual fact. As discussed later in this article, all witnesses, including the defendant, can be cross-examined about their character. If there is anything unsavory about the defendant's character, particularly prior criminal convictions, the defendant will be strongly advised by his lawyer not to take the stand.

The right to silence extends to the investigative stages of the proceedings. Evidence obtained in violation of the right-to-silence rule during an investigation cannot be used at trial even in very serious cases (like murder), except in rare circumstances. The purpose of this exclusionary rule is to curb police reliance on coercive tactics during investigations, and the rule is strictly enforced by courts. Thus, for example, any statements made by the defendant to the police (or others in authority) will be scrutinized by the judge to ensure that they were made voluntarily and taken only after the defendant was advised of the right to a lawyer. If there is any hint that the police used coercion or deception, the statement will not be admitted into evidence. For example, in *R. v. Moreau* the police took the complainant to the hospital and then arrested the defendant. The police told him that the medical examination would determine conclusively whether a sexual assault had taken place. After receiving a positive answer to the question, "Doctors can tell for sure, can they?" the defendant

confessed to sexual assault. His conviction was overturned on appeal because the appeal court held that the confession was obtained by deception. A medical examination cannot prove with certainty that an assault has taken place.[5]

Proof Beyond a Reasonable Doubt

The Crown is also held to a strict standard in proving the case. The judge or jury must be convinced "beyond a reasonable doubt," when all the evidence is assessed together, that the defendant committed the alleged acts. If there is a doubt, the defendant must be acquitted. The Supreme Court of Canada has recently stated that jury instructions should include a statement such as the following: "Even if you believe the accused is *probably guilty, that is not sufficient.* In those circumstances, you must give the benefit of the doubt to the accused and acquit because the Crown has failed to satisfy you beyond a reasonable doubt" [emphasis added].[6] Convictions in sexual violence cases are difficult to obtain because of this stringent application of the "reasonable doubt" standard.

The "reasonable doubt" standard in sexual violence cases falls far short of a positive response to the question "Is she lying?" Rather the standard is "Are you convinced about her version of the events?" Therefore if the defence lawyer can show that a complainant's credibility is compromised in some way, or that a different interpretation of the events is possible, the defence probably will have raised a "reasonable doubt" in the minds of the judge and jury, and the defendant will be acquitted.

Most commonly, something about the complainant's character or differences in her story as told to different people will compromise her credibility as a witness. In *R. v. Adams,*[7] for example, the evidence was clear that the complainant had agreed to engage in sexual activities with the defendant. The various judges who heard or read the rest of the evidence described it as confusing and contradictory. The defendant testified that he did not want to have sex with her when he discovered she was pregnant, and that she robbed him and, when confronted, became hysterical and attacked him. The complainant testified that she was attacked with a sword, was forced to perform sexual acts, and fled in her underwear. His assertion that she was a prostitute was repeated by each of the 10 trial and appeal judges who heard the case. However not one judge commented on her denial of this assertion or her evidence that the defendant inflicted a wound on her that required stitches.[8] A defendant

who takes the stand and denies the events will be acquitted, if he is a credible witness. However, in *Adams*, the trial judge found that neither the complainant nor the defendant was "completely reliable," although he did not articulate reasons for these conclusions. The judge then found that, as there was no independent verification of the events, the benefit of the doubt had to go to the defendant, and he was acquitted. One wonders about the independent evidence of the wound. Reliance on the myth of the "extortionate prostitute" seems to have compromised the complainant's credibility, thereby aiding the defendant in securing an acquittal.

The defence strategy in historic abuse cases (cases where the events giving rise to the charge occurred years before the charges were laid) is to argue that, because of the passage of time, the evidence is too weak to satisfy the reasonable doubt standard. It is not uncommon in these cases for the judge to state that he or she believes the complainant's evidence, but nonetheless has some doubt arising from the defendant's sworn denial and the absence of corroborative evidence. For example, in *R*. v. *A.J.G.* the judge found that the complainant was reliable and had no ulterior motive in laying a complaint against his father. The judge even stated, "I am satisfied that the accused may well have compelled the complainant to ... perform fellatio and sodomized him ..." Nonetheless the defendant was acquitted by the judge who stated that:

> "I do not have the degree of certainty required to support a criminal conviction because of the inherent difficulty for any witness to recall and relate accurately events said to have occurred more than 30 years previously and the difficulty for an adult to relate events which are said to have begun at the age of three. To rest the entire burden of the Crown's case upon such evidence is not safe." [9]

Reasonable Doubt and Recovered Memory: An Example

Cases involving recovered memories are not likely to meet the "reasonable doubt" standard and, for this reason, are rarely prosecuted in a criminal court. The Ontario Court of Appeal held in *R*. v. *E.F.H.* that "we are mindful of the fact that this type of case, perhaps more so than any other, carries with it the potential for a serious miscarriage of justice." [10] Convictions will be obtained in recovered memory cases only if the following conditions exist: First, the Crown must establish that the memories were not falsely induced. Secondly, the trial judge must determine that the defendant (if he testifies) is lying. Thirdly, there must be independent

evidence that supports the complainant's story but which is not so bizarre that it detracts from the believability of the story.

A closer examination of the *E.F.H.* court cases at trial and on appeal illustrates why such cases are so difficult to prosecute. The complainant had repressed memories of sexual abuse until shortly after the birth of her first child. She had been sexually and physically abused by her alcoholic father from a very young age, until just after she reached puberty. The trial judge determined that, first, he had to be satisfied that the memories were not falsely induced by external sources (like therapists or the book *Courage to Heal*) or the internally driven result of an emotional disturbed person's imagination. As the father/defendant had testified at trial that none of the acts had occurred, the judge had to determine the credibility of his evidence. The judge found that he was not credible, since he lied under oath about certain provable facts, such as his alcoholism and whether he was physically abusive of his wife and other children. But the court held that even these two findings (memories were not falsely induced and the defendant was lying) were *not* sufficient to sustain a conviction.

On an appeal affirming the trial decision, the appeal court described recovered memories as inherently frail in the context of a criminal prosecution. In other words, the complainant's testimony alone on the specific details of the offence was insufficient to support a conviction. The court held that recovered memories on their own, without more substantiation, are not reliable enough to satisfy the "reasonable doubt" standard. Corroborative or confirmatory evidence is required in recovered memory cases.

"Corroborative" evidence (evidence independent of the complainant that directly supports the complainant's story, such as an eyewitness or a DNA match) usually cannot be found in sexual violence cases, because the acts occur in private and are not investigated immediately after they occur. In *E.F.H.*, the appeal court noted that the complainant's abortion (at age 12) was not traceable either through records (because it was illegal), or by a physical examination (because the complainant had given birth). However, the trial judge's findings respecting "confirmatory" evidence (independent evidence that indirectly supports the complainant's story) were upheld by the appeal court. This evidence included information such as the complainant's mother finding blood stains on the complainant's underwear prior to puberty; a hemorrhage after a tonsillectomy (which had no medical explanation, but was consistent with fellatio); recovered memories of the father's killing or injuring family pets (events the father denied,

but other family members confirmed); and remembered details (such as closet dimensions, which could be independently verified).

Without confirmatory evidence, a conviction would not have been sustained in the *E.F.H.* case. While it was the duration and the viciousness of the assaults in the case that provided the trail of confirmatory evidence necessary for a conviction, the appeal court also stated that the bizarre nature of the alleged acts gave cause for heightened concern about a wrongful conviction. This observation creates a Catch 22 — the confirmatory evidence must be consistent with the assaults, but not so bizarre that it strains credulity.

The Specific Elements of Sexual Offences

The most common defence to a sexual offence charge involving a teenager or adult is either that "nothing happened" or that "she consented" to the sexual acts. "Nothing happened" or inaccurate memory is the usual defence in cases involving children. Unusual or uncommon defences include diminished responsibility arising from, for example, insanity or, in cases where the defendant is a stranger to the complainant, the defence will be identity ("you have the wrong person"). Whether the alleged acts constitute an offence is sometimes in issue, particularly in historic cases. As already discussed, recovered memory cases are rarely prosecuted, but when they are, the issues will be: Is there a possibility the memory is false? If he testified, is the defendant credible? Are the recovered memories confirmed by other evidence?

The precise acts necessary to a criminal charge have been subject to revisions by the Canadian Parliament in 1983, 1985 and 1992. Since the applicable law is what was in effect at the time of the acts giving rise to the charges, the former laws continue to be applied to some historic abuse cases regardless of when the charges are laid. Thus, for example, for events before 1983, proof of vaginal-penile penetration is a requirement in rape cases. Husbands cannot be charged with raping their wives. Some judges are of the view that no offence was committed unless it can be proven that the defendant used physical force and the complainant attempted to resist this force. In contrast, after 1983, the law is more straightforward. A "sexual assault" is committed when the acts in question are of a sexual nature and the sexual integrity of the complainant is violated. Most common law jurisdictions, including American states, amended their

criminal laws along similar lines in the 1970s and 1980s. Older cases can be more difficult to prosecute, because old legal norms, such as proof of resistance, may still apply.

Prior to the 1985 Canadian *Criminal Code* amendments, sexual offences against children focused on whether the complainant was "of previously chaste character" and applied, in most cases, only to females. The post-1985 provisions are gender-neutral and are based on a combination of age, power dynamics and specific activities. For example, consent is not a defence to any sexual offence charge if the complainant is younger than 12. If the complainant is 12 or 13, consent is not a defence unless the defendant is less than two years older than the complainant. An offence is committed when a person who is in a position of trust or authority, or with whom the complainant is in a relationship of dependency, engages in sexual activity with someone between 14 and 17. "Procuring" and other prostitution-related offences attract harsher sentences, if minors are involved. However, in age-based cases, judges still sometimes discount the harm to the complainant caused by the defendant. For example, in *R. v. Bauder*, the Manitoba Court of Appeal commented in a sentencing appeal that "the [12-13 year old] girl, of course, could not consent in the legal sense, but nonetheless was a willing participant. She was apparently more sophisticated than many her age and was performing many household tasks including babysitting the accused's children. The accused and his wife were somewhat estranged." [11]

When the defence is consent or memory, the defence lawyer's likely strategy will be to raise some doubt about whether the complainant is telling the truth. A complainant's credibility can be undermined, for example, by showing bias, prejudice, bad character, inconsistent previous statements, impaired capacity to recall, or possibly false memories. While feminists have attempted to limit ways in which credibility attacks can be mounted against complainants, another strategy has been to redefine the legal meaning of "consent." This entails imposing positive obligations on parties to obtain voluntary agreements and, as already discussed, by imposing age restrictions on some activities.

The 1992 amendments to the *Criminal Code* (often referred to as Bill C-49) redefined the "consent" element in sexual assault law to be the voluntary agreement of the complainant to engage in the sexual activity in question. This is in contrast to permitting an inference of consent from questions such as whether she offered a sufficient degree of resistance or whether she consented on a previous occasion. This amendment is

intended to shift the factual and legal issue at trial away from what the defendant might have "thought," to what the complainant actually said at the time of the incidents. The intent here is to prevent an initiator of sexual activity from relying in his defence on an assumption of consent based on his stereotypes or fantasies about women, in general, or his knowledge of the complainant's sexual life. It is now the initiator who has the obligation to determine whether the woman is agreeing on this occasion to sexual activity with him. Though this change in the law represents a significant theoretical shift in the elements of sexual assault, it is difficult to determine to what extent this shift has become part of judges' thinking about sexual violence.

General Evidence Rules

In sexual violence cases, some of the facts that must be proven include the elements of the offence, such as the complainant's age and whether the accused obtained voluntary agreement. As well, a witness' credibility is also a fact that can be proven or disproven by the evidence admitted at trial. Information is admissible in court if it is *relevant*, that is, if it tends to prove or disprove a fact in issue, and if the information is *reliable*.

While there is usually a high degree of consensus on which information is *relevant*, it must be recognized that this determination, especially on credibility issues, will be affected by a judge's experience, common sense and logic. As one Supreme Court of Canada judge said, "It is a decision particularly vulnerable to the application of private beliefs ... there are certain areas of inquiry where experience, common sense and logic are informed by stereotype and myth." [12]

The *Brown* case provides a good example of how judges' "experience and common sense" inform credibility findings.[13] The defendant lawyer argued that the complainant, who was 13 at the time of the incidents giving rise to the charges, should not be believed because, if she had been abused as alleged, she would not have maintained contact with the defendant (her best friend's father). Also if she had been bruised and bleeding as alleged, she would have gone to a doctor. The trial judge's rejection of these arguments, presumably based on her common sense and experience, was criticized by the appeal court. This court stated that a trial judge cannot reject arguments, such as those presented by the defence lawyer, unless there is *expert* evidence that would explain the complainant's conduct.

Implicitly, the appeal court judges' view of "common sense" was that a 13-year-old would have taken the initiative to end all contact with the defendant (and therefore her friend) and would have figured out how to get to the doctor.

Various evidence rules have developed to try to ensure the *reliability* of evidence. For example, the testimony of children under the age of 14 cannot be received under oath, unless it is first established that the child understands a moral obligation to tell the truth and has the capacity to perceive, remember and communicate events. In the rare cases where a witness suffers from a mental disability that affects his or her reliability, expert witnesses may be called upon to give evidence about the impact of the disability on the witness' memory or perception.

General evidence rules exclude information that may be relevant and reliable, if the probative value (the relevance of the evidence to the case) is outweighed by a competing concern about its use in criminal proceedings. Thus, for example, the Crown cannot enter evidence of defendants' prior convictions or character in sexual violence proceedings, unless the defendant testifies or otherwise raises these issues. Why? The fact that the defendant has committed crimes in the past is of little relevance at the trial since it does not tell the judge or jury whether he committed the specific acts in question. Moreover, it is unfair to require the defendant to account for previous wrongdoings. Finally, such an inquiry would lengthen trial proceedings considerably. Even if the defendant does testify, the trial judge can restrict questioning on character and, generally, questions on criminal record are restricted to offences related to honesty, such as perjury or fraud. These same rules do not apply with the same force to other witnesses, including complainants, since they are not being tried and do not risk the serious consequences of a criminal conviction. Character evidence, including cross-examination on criminal records and other discreditable acts, is often used to undermine complainants' credibility.

Another exclusionary rule concerns "similar fact evidence." Similar fact evidence is information that the defendant has committed acts which are similar to those which are the subject matter of the charge before the court. Like evidence on the defendant's character, similar fact evidence is not admissible, because such evidence has the severely prejudicial effect of inducing the jury to think of the defendant as a "bad person," who has a propensity to commit such acts. The argument here is that the evidence possesses little relevance to the precise issue of whether the defendant committed the particular act for which he stands charged. In other words,

the fact that someone has committed other acts of sexual violence does not tell us much about whether he committed the assault that is the subject of the charge. (If a conviction is obtained, prior convictions are relevant to the issue of sentence and therefore such evidence can be received at a sentencing hearing.) However, the evidence can be received if the similar acts "are so unusual and strikingly similar that their similarities cannot be attributed to coincidence." [14]

Similar fact evidence is unlikely to be admissible in many child sexual abuse cases, including historic and recovered memory cases. First, the evidence is unlikely to be received to show that the *modus operandi* of the defendant is the same, because it is unlikely that the *modus* will be significantly different from that used by many abusers. For example, evidence that he told the complainant and others "never to tell anyone," would not meet the "so unusual" test as this instruction is common. Therefore the evidence is not probative. If the "so unusual" test is met, the Catch 22 described in *E.D.H.* could come into play: the bizarreness of the evidence may be cause for heightened concern about its credibility. Finally, the Supreme Court of Canada has said that similar fact evidence should be regarded with suspicion, if there was any opportunity for collusion or collaboration to concoct the evidence between the complainants or a complainant and another witness giving similar-fact evidence.[15] Such contact opportunities would be the norm, rather than the exception, in cases involving numbers of children. They would include, for example, cases where the complainants are relatives, are participating in civil actions, or were involved in the same organizations or institutions (such as schools or sports teams), or come from the same geographical area.

Specific Evidence Rules in Sexual Violence Cases

For centuries, special evidence rules have applied to sexual violence cases. In particular, the rules, as formal principles or by judicial application, have permitted far greater range for attacking the complainant's credibility than is permitted in other criminal cases. The underlying myth that progressive advocates are trying to dispel is that women and children frequently lie about sexual violence out of delusion or malice. In spite of the legal reforms of the past 20 years, this myth remains deeply ingrained in sexual violence law. Until 1983 in Canada, for example, a complainant's

testimony had to be independently corroborated (not merely confirmed) before a conviction for some sexual offences. For other sexual offences, a judge had to warn a jury that it was dangerous to convict in the absence of corroboration. Similarly, if a complainant failed to tell someone about the assault at the first reasonable opportunity after it occurred, the "recent complaint" doctrine required judges to tell juries that this failure supported a strong presumption that the complainant's evidence was not reliable. The belief underlying this rule — and freely described as such by judges — was that women would fabricate complaints, if given time to think them up, to protect their reputations. While the recent complaint doctrine was also repealed by Parliament in 1983, it re-emerges in cases where judges draw negative inferences from a complainant's failure to obtain a forensic medical examination immediately after an assault.[16]

The most egregious special evidence rules and practices, which sustain continued reliance on the myth of delusional or spiteful complainants, are those permitting defence questioning of a complainant about her sexual history and the new practice of defence access to complainants' personal records. The defendant's ability to use both of these tactics, when coupled with the foundational rules described earlier, significantly increase the likelihood of an acquittal.

Sexual History Evidence

At common law (law made and developed by judges, in the absence of, or prior to, legislative intervention), a complainant in a sexual violence case could be questioned about her sexual history, because judges believed that this information was relevant to her general credibility ("unchaste women" are less worthy of belief) and to whether she consented ("unchaste women" are more likely to consent to the acts giving rise to the charge). These two uses of sexual history (often referred to as the "twin myths") and the discriminatory logic underlying them were so firmly embedded in Canadian law that it took a specific legislative amendment to remove them from the law. This amendment was subjected to a constitutional challenge in the *Seaboyer* case on the ground that it interfered with the defendant's fair trial rights. The Supreme Court of Canada also overturned the laws on the "twin myths" of sexual history evidence in rejecting this constitutional challenge in *Seaboyer*.[17]

However, the Court also struck down the 1983 *Criminal Code* amendment that restricted the admissibility of evidence on the complainant's

sexual history to very specific circumstances. The Court stated that there were a number of other situations where the complainant's sexual history might be relevant and admissible. By way of illustration only, the Court gave the following examples: to explain the complainant's physical condition, to prove bias or motive to fabricate and to establish similar fact conduct on the part of the complainant. The Court predicted that it would be an exceptional case where the evidence would be admitted and expressed confidence that judges were now free of sexist biases. However, the guidelines were so open-ended that they served only to encourage defence attempts to admit sexual history evidence and to ensure the success of these attempts.

The *Seaboyer* decision outraged people across Canada, and that outrage mobilized demands, particularly from feminist organizations, for Parliament to act. Parliament's response, commonly called Bill C-49, states in its preamble that a complainant's sexual history is rarely relevant and that before admitting it, judges should bear in mind the inherently prejudicial character of such evidence. The bill clarifies that sexual history evidence cannot be used to support the inferences arising from the twin myths. It also states that the evidence must be of specific instances of sexual behaviour, relevant to an issue at trial, and of significant probative value not outweighed by the danger of its prejudice. Bill C-49 has been attacked by defence lawyers as an unconstitutional infringement of a defendant's fair trial rights. A decision on the Bill's constitutionality, in a case known as *Darrach*, is expected in early 2000 from the Supreme Court of Canada.

Sexual history evidence should be admitted into evidence in court, only if the defence lawyer first makes an application to have it admitted. Usually the judge will call for a *voir dire* (a trial within a trial), during which the complainant will be required to answer questions about her sexual history. (The jury is excluded from this proceeding.) If the judge determines that the evidence is admissible, full court will be reconvened, and the complainant will be required to give the evidence a second time. As one judge has recently noted, in spite of the application requirement, defence lawyers sometimes simply begin questioning a complainant about her sexual history without having made an application.[18] Most often the Crown does not to object to the line of questioning. (Note that the Crown tends to be very passive in sexual violence cases. One study on sexual violence trials noted that the Crown made no objections to any questions in 55 percent of the cases.[19]) As lawyers, not judges, are responsible in

presenting the case, most judges believe it is not appropriate to stop defence questions in the absence of a Crown objection.

A recent study prepared for the federal Department of Justice on the first three years of Bill C-49's operation presents a bleak picture of its effectiveness.[20] Applications to have sexual history admitted are made in 10 to 20 percent of cases and, it appears, they are often successful. A review of the case law indicates that judges, particularly appeal court judges, find that sexual history evidence is relevant, if it "might, under any circumstances, have some potential connection" to issues of credibility, bias or motive, or mistaken belief. Moreover, the report finds that judges have "little or no understanding of the impact of the 'twin myths' and the likelihood that a jury will be unable to 'disabuse' its mind of those myths when presented with such evidence."

Evidence of prior sexual abuse (which is considered by some judges to be sexual history) has been sought to show that, because the complainant has been abused, she has a disordered sexual perception that could lead to misinterpretations and false criminal accusations. Alternatively, such evidence is sought to show that the complainant has made prior allegations of abuse that did not result in a criminal conviction. Defence lawyers state that such allegations indicate that she has a tendency to lie. If the acts giving rise to the charge occurred before 1985 and involved a minor, it may be necessary to prove that she "was of previously chaste character."

Defence lawyers also rely on a number of stereotypes about the sexuality of certain kinds of women — for example, prostitutes, disabled women, teenaged mothers — to discredit them as witnesses without directly questioning them about their sexual past. The judges in *Adams* seem to have been influenced by the defendant's testimony that the complainant was a prostitute. Sherene Razack describes how the defence lawyer in another case appeared to rely on the stereotype of women with mental disabilities who will "stop at nothing to get the male attention usually denied to her." [21] Questions about the complainant's manner of dress at the time of the assault are still routine, as are such questions as the age at which the complainant first gave birth and whether she is living with her boyfriend. A complainant's answers to questions about involvement in acceptable social behaviour, such as going to a nightclub for an evening of dancing and drinking or inviting a male acquaintance to a private residence, are distorted by defence lawyers. They rely on the stereotype of the loose woman who does not deserve law's protection.

The Supreme Court of Canada predicted, Parliament clearly intended, and the general public believes that sexual history evidence cannot be used in court in sexual violence proceedings, except rarely. These predictions, hopes and beliefs are wrong. The fact is that women are often required to give sexual history evidence, directly or indirectly, both at the *voir dire* and again in full court. In light of the heavy burden placed on the Crown (especially the requirement of proof beyond a reasonable doubt), defence use of information concerning the complainant's sexuality is still a powerful tool in undermining the complainant's credibility.

Access to Personal Records

Notwithstanding the limited effectiveness of Bill C-49, most defence lawyers were of the view that Bill C-49's restrictions on sexual history evidence went too far in limiting their ability to represent clients in sexual assault trials. And they lost little time in developing a tactic to counter Bill C-49 — seeking access to any personal records about a complainant that might contain any other embarrassing information. Counselling records, medical records and child welfare records are most commonly sought by defendants. In fact every imaginable personal record has been the object of a defence application, including diaries and records from abortion and birth control clinics, child welfare agencies, adoption agencies, residential and public schools, drug and alcohol abuse recovery centres, other doctors, employers, reporters, the military, psychiatric hospitals, victim/witness assistance programs, criminal injuries compensation boards, prisons and youth detention centres, social welfare agencies, immigration offices, and the Crown on unrelated charges against the complainant. More than one set of records is sought in more than 60 percent of the cases.[22]

Personal records were rarely sought by defence lawyers before 1992, but by 1995 the Supreme Court of Canada issued the infamous *O'Connor* decision. Because of this decision, access to complainants' personal records became part of the defendant's constitutional right to a fair trial. One defence lawyer stated shortly after the *O'Connor* decision was released that it would be negligent not to seek every possible record on a complainant in all sexual violence cases. The counselling and political implications of such a practice are profound.

O'Connor was charged with having committed various sexual offences in the early 1960s against four Aboriginal women who, at the time of the offences, were students or former students employed at the residential

school where O'Connor was priest, teacher and principal. O'Connor's defence was that two of the women had consented to have sex with him and that nothing had happened between him and the other two women. A judge ordered the women to authorize the release to O'Connor of their entire residential school records (academic, medical and employment) and all therapy and medical records since the time they had left the school. None of these records were in the Crown Attorney's possession, and as the ordered records covered a 20- to 30-year period for four women, the records were difficult to obtain, and compliance with the order was difficult. O'Connor made numerous applications to have the proceedings stayed (in effect, dismissed) for failure to produce and, ultimately, the trial judge made such an order. The stay was appealed to the Supreme Court of Canada. While the Court overturned the stay, finding that the Crown's actions were not an abuse of process, it gave exceptionally large scope to defence access to complainants' personal records.

The majority decision in *O'Connor* paid lipservice to notions of protecting a complainant's privacy "interests." [23] However it failed to comprehend that personal records production was the latest manifestation of laws that reflect and perpetuate women and children's inequality. For example, they accepted, without comment on this double standard, that records are sought in sexual violence cases, but not others. They failed to note that the Court has been quick to protect against access to a witness' records in other criminal cases, but, in sexual violence cases, flimsy and highly prejudicial rationales for records access have sufficed. The Court also failed to notice that the practice — which they now elevated to a constitutional right — was then barely three years old and was an obvious backlash to Bill C-49. They disregarded the fact, as frankly admitted by defence lawyers in other settings, that personal record production orders were sought not for relevant information, but with the intent to intimidate complainants. [24]

The Court simply ignored the fact that residential school records were sought by O'Connor. Thus they avoided having to consider whether records created in a system designed to destroy Aboriginal cultures have any place being used to now discredit those subject to such a system. They refused to consider how records applications would disproportionally impact women who have been subject to extensive record keeping in contexts of multiple inequalities, like residential schools, psychiatric treatment or the child welfare system. They also avoided having to consider whether records written by the defendant (as the residential

school records almost certainly were in *O'Connor*) are inherently unreliable. They paid scant heed to the effects records release has on counselling relationships or the willingness to report sexual violence crimes to the police.

All of these issues, each of which gives rise to constitutional equality rights claims, were squarely before the Court in *O'Connor* and fully argued by various interveners, including a feminist coalition involving the Canadian Association of Sexual Assault Centres, DisAbled Women's Network, Aboriginal Women's Network of British Columbia and the Women's Legal Education and Action Fund.[25] *Yet the Court failed to deal with them.*

In contrast, the Court credited the newest rape mythologies — the beliefs that women falsely conjure up sexual abuse histories and lay charges against innocent men, and that counsellors use therapy to improperly influence complainants' memories — even though there was no evidence before the Court of such influences. None of the prosecutions in *O'Connor* involved recovered memories. After *O'Connor*, defence lawyers' assertions that complainants suffered from some sort of perceptual problems became commonplace, as did allegations of improper therapy influences.[26]

Well in advance of the Court's 1995 ruling in *O'Connor*, feminist organizations had been attempting to deal with the crisis engendered by burgeoning disclosure practices. One strategy adopted by some record keepers, particularly sexual assault counsellors, was to alter note-taking and record retention practices. Another strategy was to pressure the federal government to pass legislation to prohibit the practice altogether. As happened after the *Seaboyer* decision, the *O'Connor* case provoked a countrywide outcry, and after extensive consultations with representatives from sexual assault centres and other feminist organizations, defence lawyers and feminist lawyers, the government introduced Bill C-46. This bill passed into law in 1997.

With Bill C-46, Parliament requires judges to take into account something the Supreme Court of Canada turned a deaf ear to in *O'Connor*: a reconciliation and accommodation of women's constitutional equality rights with the defendant's right to a fair trial. Records cannot even be considered for release if the defence cannot establish that they are "likely relevant." Parliament has set out examples of rationales that would not meet this test, including the fact of having seen a counsellor or the possibility that the record may contain information about the acts giving

rise to the charge. Records that cross the likely relevance threshold cannot be released to the judge or to the defendant, unless that judge has weighed a number of factors including effects on counselling relationships or the potential for biases to operate. Complainants and record holders have the right to be represented by lawyers at the hearing of these applications. The usual subpoena forms have been changed for these applications, so that record holders are *not* required to bring the records to court with them.

Bill C-46 will not prohibit all records production applications and therefore falls short of the position feminist organizations advocated before the Supreme Court of Canada and Parliament. However, it is designed to restrict significantly the situations where personal records can be released to a judge and make it even less likely they will be ordered released to defendants. On this basis, feminist organizations have accepted it as the minimal protection required to protect women's constitutional equality rights. Whether it will have this effect remains to be seen. This law already has been subject to constitutional challenge by defence lawyers, and it is not being applied by judges in some jurisdictions. The Supreme Court of Canada's decision on this issue in the *Mills* case is expected in late 1999.

Preparing for Backlash

Women contemplating laying charges must recognize that if a conviction is not achieved, she risks the perception that no wrongdoing occurred. A favorite expression of many judges and defence lawyers is that "she is not a victim until a conviction is entered." If the defendant is found "not guilty," a complainant often runs the additional risk of being turned into the wrongdoer. For example, in the *Adams* case (the "extortionate" prostitute case discussed earlier), the trial judge lifted the order banning publication of the complainant's name after finding the defendant not guilty. In turning the complainant into the wrongdoer, the trial judge lost sight of the fact that the complainant was not on trial for soliciting, assault or robbery. While the Supreme Court of Canada reinstated the publication ban, it was silent on the impropriety of the trial judge's lifting the ban in the first place. If a judge can forget about the limits of criminal fact-finding, it is hardly surprising that others will too.

The legal principles applicable to all criminal cases, and the specific rules applicable only to sexual violence cases, make it very difficult to

obtain a conviction. The likelihood of a conviction worsens in historic cases. In recovered memory cases, it is all but nonexistent, unless it can be established that the memory is not false, the defendant (if he testifies) is not credible, and there is strong confirmatory evidence. Complainants must be prepared for an invasive and insulting cross-examination about their character and the very real possibility that personal records will be released not only to the judge, but also to the defence counsel and the defendant. The content of these records may also be revealed in open court. It is hardly surprising that that few sexually violated women turn to the criminal justice system.

Endnotes

1. Jennifer Scott & Sheila McIntyre, "Women's Legal Education and Fund (LEAF) Submissions to the Standing Committee on Justice and Legal Affairs Review of Bill C-46" (unpublished, March 1997).

2. *R.* v. *O'Connor*, [1995] 4 Supreme Court Reports 411 and *R.* v. *Carosella* [1997] 1 Supreme Court Reports 80.

3. See: Sheila McIntyre, "Redefining Reformism: The Consultations that Shaped Bill C-49," in Julian Roberts & Renate Mohr (eds.), *Confronting Sexual Assault: A Decade of Legal and Social Change* (Toronto: University of Toronto Press, 1994).

4. *R.* v. *P.(M.B.)* (1994), 89 Canadian Criminal Cases (3d) 289 at 304 (Supreme Court of Canada).

5. *R.* v. *Moreau* (1986), 26 Canadian Criminal Cases (3d) 359 (Ontario Court of Appeal).

6. *R.* v. *Litchus*, [1997] Supreme Court Judgements No. 77 (Q/L).

7. *R.* v. *Adams* [1995] 4 Supreme Court Reports 707.

8. Stephen Bindman, "Doesn't Deserve Protection: Judge Strips 'Prostitute' of Publication Ban," *Law Times* (March 5, 1995).

9. *R.* v. *A.J.G.* [1998] Ontario Judgements No. 1742 (Q/L) (Court of Justice).

10. *R.* v. *E.F.H.* [1994] Ontario Judgements No. 452 (Q/L) (General Division), affirmed [1996] Ontario Judgements No. 553 (Q/L) (Court of Appeal).

11. *R.* v. *Bauder* [1997] Manitoba Judgements No. 270 (Q/L) (Court of Appeal).

12. *R.* v. *Seaboyer*, [1991] 2 Supreme Court Reports 577.

13. *R.* v. *Brown* [1994] Nova Scotia Judgements No. 269 (Q/L) (Court of Appeal).

14. *R.* v. *C.(M.H.)*, [1991] 1 Supreme Court Reports 763.

15. *R.* v. *Burke*, [1996] 1 Supreme Court Reports 474.

16. Georgina Feldberg, "Defining the Facts of Rape: The Uses of Medical Evidence in Sexual Assault Trials," *Canadian Journal of Women and the Law/Revue "Femmes et Droit"* 9 (1997), p. 89.

17. See endnote 12.

18. The Honourable Judge Donna Hackett, "Finding and Following 'The Road Less Travelled': Judicial Neutrality and the Protection and Enforcement of Equality Rights in Criminal Trial Courts," *Canadian Journal of Women and the Law/Review "Femmes et Droit"* 10 (1998), p. 129.

19. Christine Alknsis, Edward Renner & Laura Park, "The Study of Social Justice as a Research Process," *Canadian Psychology* 39 (1997), p. 91.

20. Colin Meredith, Renate Mohr & Rosemary Cairns Way, "Implementation Review of Bill C-49," TR1997-le (Ottawa: Department of Justice, February, 1997).

21. Sherene Razack, *Looking White People in the Eye: Gender, Race and Culture in the Courtrooms and Classrooms* (Toronto: University of Toronto Press, 1998), p. 142.

22. Karen Busby, "Third Party Records Cases Since *R.* v. *O'Connor*," *Manitoba Law Journal* (forthcoming, 1999).

23. See: Karen Busby, "Discriminatory Uses of Personal Records in Sexual Violence Cases," *Canadian Journal of Women and the Law/Revue "Femmes et Droit"* 9 (1997), p. 148.

24. See: Katherine Kelly, "You Must Be Crazy If You Think You Were Raped: Reflections on the Use of Complainants' Personal and Therapy Records in Sexual Assault Trials," *Canadian Journal of Women and the Law/Revue "Femme et Droit"* (1997), p. 178; and Bruce Feldthusen, "The Best Defense is a Good Offence: Access to Private Therapeutic Records Under O'Connor Guidelines and Bill C-46," *Canadian Bar Review* 37 (1996), p. 537.

25. Women's Legal Education Education and Action Fund, *Equality and the Charter: Ten Years of Feminist Advocacy Before the Supreme Court of Canada* (Toronto: Emond Montgomery, 1996).

26. Karen Busby (1999).

CONFESSIONS OF A WHISTLE-BLOWER

Lessons Learned

Anna C. Salter

In 1988 the first of a series of events occurred that ultimately changed my beliefs and expectations regarding the nature of the backlash against child sexual abuse. In that year I obtained a small grant from the New England Association of Child Welfare Commissioners and Directors [in the United States]. The purpose of the grant was to study emerging claims that standard interviewing techniques of children were leading and suggestive and were resulting in false accusations of child sexual abuse.

This was 1988, and the backlash against child sexual abuse was relatively new. No one really knew how seriously to take these claims, and I thought they should not be rejected out of hand or accepted out of hand but deserved careful scrutiny.

I agreed that at the conclusion of my study I would make some recommendations to the New England Child Welfare agencies regarding changes in interviewing techniques in those areas in which I thought changes were needed. I also agreed to prepare materials that could be used

to rebut attacks on the credibility of children in court in those areas in which it was clear the concerns about suggestibility were not warranted.

There was an emerging but not terribly voluminous literature on suggestibility and child sexual abuse at the time, and many of the claims were being made by a very few writers. I eventually focused on the work of two authors: Ralph Underwager and Hollida Wakefield. They co-wrote a book called *Accusations of Child Sexual Abuse*.[1] At that time Underwager and Wakefield were considered to be leading spokespeople for the claims regarding leading and suggestive questioning, and their book was being cited as the academic scaffolding for the growing backlash.

This was before Underwager and Wakefield's famous interview with the Dutch paedophilic magazine *Paidika, The Journal of Paedophilia*, in which Underwager stated that the choice of being a pedophile was "responsible" and urged pedophiles to "boldly and courageously affirm what they choose." Underwager went on to recommend that pedophiles not be so defensive about their behaviour; he felt they should assert that pedophilia was about "intimacy and love" and was, in fact, "God's will." [2]

That interview resulted in Underwager's resignation from the False Memory Syndrome Foundation Scientific and Professional Advisory Board and radically diminished his and Wakefield's credibility in general. In 1988, however, Underwager and Wakefield's views on suggestibility were widely cited and given great credence.

I reviewed their book on false accusations as an academic tract and went back to the original sources because the work extensively relied on the research of others. I was quite surprised at what I found. I found systematic misrepresentations of that research.

There were instances too numerous to cite. For example, a 1980 study by Graesser, Woll, Kowalski and Smith was described by Wakefield and Underwager as follows: "This research suggests that older children, when trying to revive a particular memory enmeshed in a general script, may produce more inferences, both correct and incorrect, than younger children." [3] The study, in fact, was a study of college students, and there were no children in the study. In addition, the study was not on adding information to stories but on memory for typical and atypical actions.

When Underwager and Wakefield rebutted my critique in writing (in the context of a court case they later brought against me), I was, at least, equally surprised to discover that none of the problems with their book had an adequate explanation. For example, their defence with regards to the Graesser et al. study was not that they had accidentally cited the wrong

study, as I thought might have happened (although I could not find a study that matched their description) but instead that their description of the study was accurate.[4]

Wakefield and Underwager asserted their description was correct because college students were, in their opinion, children, and there were numerous studies of college students in the research literature. Specifically, they stated: "When we use the phrase older children to describe the study sample we are following the conventional usage within the science of psychology."[5]

They also pointed out that Achenbach's Child Behaviour Checklist included 19-year-olds and that the adolescent Minnesota Multiphasic Personality Inventory norms were used for college students. Wakefield and Underwager went on to note that they had checked the entire 1980 volume of the *Journal of Experimental Psychology: Human Learning and Memory* (in which the Graesser et al. study appeared) and found only one study that did not use college students.

That may well be true, but each of those studies accurately identified their sample as college students, not as younger and older children. The facts that they had described the Graesser et al. study as of younger and older children and also described it as being on a different topic from the one it was on were not addressed. More important, the fact that they used the article as part of an attack on the credibility of children's testimony in comparison to adults — when in reality they were using a study of adults — was not addressed.

Had this been all, I would not be writing this article. I expected a back-and-forth academic exchange, vigorous no doubt, and even biting (although I did not expect a response as silly as the one cited previously), but played out on a field I understood, with research as the context and logic as the tool. Instead, a very different process emerged.

It began with phony phone calls. On two occasions individuals called, misrepresented who they were, and asked for my help in combating testimony by Underwager. At the time I thought the calls were genuine, but events shortly revealed they were phony and the conversations were taped. For example, after the first one, I received a transcript of my comments in the mail from Underwager with a demand that I retract and hints of legal action if I did not.

Phony phone calls were subsequently made to the offices of the Association of New England Commissioners and to Sage Publications, in which a private detective that Underwager later admitted under oath that

he hired, misrepresented himself and tried to elicit information about me.[6]

Wakefield and Underwager attempted to introduce the first phony phone call in an ethics charge that Wakefield made against me with the American Psychological Association in the spring of 1989. The irony of attempting to use a phone call made by a woman who lied about her name, gave a phony story and clandestinely taped the conversation in an ethics charge was evidently not appreciated.

The essence of the complaint was that I thought Dr. Underwager guilty of an ethical violation (presumably in regard to misrepresenting the research) but had failed to notify him of such. Along with a tape of the phony phone call, Wakefield offered as evidence comments that I made in rebuttal of Wakefield and Underwager at a meeting of the Tennessee Association of Criminal Defense Lawyers on December 10, 1988.

Among the oddities of the ethics charge was the fact that at the previously cited meeting, Dr. Underwager and Ms. Wakefield were sitting in the audience when I made my comments. It appeared to me, therefore, that they were informed at that time of my concern (which was the first time I had spoken publicly about my work in this area), but apparently they disagreed.

Even stranger, the ethics charge misrepresented my comments extensively. In an affidavit signed by Ralph Underwager on March 14, 1989, and forwarded to the APA Ethics Committee, he stated that that at the conference:

> "The woman, now identified as Anna Salter, Ph.D ... said that a group of people in New England were so agitated by my reprehensible behaviour and bad science that she had gotten a grant from the New England Commissioners of Child Welfare to examine my work and prove that I was doing bad work. She repeatedly made negative *ad hominem* remarks about me in the course of her purported rebuttal." [7]

Solely by chance, I had taped my comments, as part of taping the entire meeting (with permission). A transcript of the tape supported my contention that I had made no *ad hominem* comments at all. In actuality, I began my five-minute comments by stating that although I disagreed with Dr. Underwager on many points:

> "I do want to make it clear that those disagreements are not based on the point of view that he (represents) [This word is inaudible in the

tape but in context should be either *represents* or *endorses*.] because I do believe you can raise some very valuable questions about some of the interview techniques that are used today, particularly leading questions, also multiple interviews and, in fact, some folks really are using some very coercive interview techniques that are likely to lead to error. I also agree with him about behavioural indicators of sexual abuse. I have a chapter in my book on that. They're just not specific enough. But, as an academic, I really get agitated with what I believe are just sort of misstatements of fact about the professional literature and since I only have five minutes to talk with you, I'll only give you a few examples." [8]

I then went on to comment on the literature on prevalence and on the plethysmograph. I then summed up as follows:

"Let me just say in summary that there has been so much concern among professionals about the statements that Dr. Underwager makes and their accuracy in the literature that I have been given a grant to develop rebuttal materials — to go through his literature and sort out what is accurate and what is inaccurate and make that available to everybody." [9]

In support of my contention that I had made no *ad hominem* comments of any sort throughout the conference, I forwarded to the Ethics Committee a transcript of the few brief questions and comments I had made from the audience through the course of the two-day conference. Again, there were no *ad hominem* comments.

In addition to the ethics suit and the phony phone calls, Dr. Underwager accused me in various forums of a variety of unsavoury acts — most notably, laundering federal grant money. The following exchange occurred in a deposition Underwager gave in a Hardin County, Texas, case in 1992:

Q. "Who funded Anna Salter's research?"

A. "Who funded it?"

Q. "Yes."

A. "The National Centre for Prosecution of Child Abuse. They gave money through — they tried to launder it and she has claimed that it was the New England Commissioners for Child Welfare that gave her the grant, but the New England Commissioners of Child Welfare say 'We don't give any grants' and nobody at the office of the New

England Commissioners of Child Welfare knew what Anna Salter was doing other than they said, 'We think she's supposed to be putting up little libraries around New England on child abuse,' child sexual abuse, but the money went from the National Centre for Child Abuse Neglect to the National — no, the Offices of Juvenile Justice and Delinquency to the National Centre of Prosecution to the State of Alabama to, oh, Kramer's place in Huntsville, Alabama, and I don't remember the name, and then to Salter."

Q. "And why are all these people in a conspiracy against you, sir?" [10]

Underwager eventually sued me several times as well. In his deposition of April 15, 1993, in the Wisconsin case he brought against me, he finally admitted under oath that he had absolutely no evidence to support his contention regarding laundering federal money. He claimed that a private investigator he hired to investigate me told him I had laundered the money but had provided no evidence. Underwager stated that the investigator had not even submitted a report to him.[11]

Between the phony phone calls, the lawsuits, the ethic suits and the slanderous (although silly) comments about laundering federal grant money, I think it is fair to state that a campaign of intimidation and harassment began against me in 1988 that lasted for several years. All of these attempts at intimidation and harassment eventually failed. In a letter dated July 5, 1989, the APA Ethics Committee informed me that "the Committee voted unanimously not to find you in violation of the Ethical Principles and to dismiss the complaint as entirely without merit." [12]

Subsequently, lawsuits in Wisconsin and California were dismissed at the summary judgement level, and in a decision by the U.S. District Court, Southern District of California, issued on December 9, 1993, Underwager was "permanently enjoined from prosecuting and/or commencing any causes of action or claims against Dr. Salter in any and all other federal courts or in the courts of any state, including but not limited to Maryland, Virginia, Indiana, and Texas" for any of my comments in my monograph or on "60 Minutes Australia." [13]

Underwager appealed the dismissal of his lawsuit against me in Wisconsin, and the U.S. Court of Appeals for the 7th Circuit ruled on his appeal on April 25, 1994. His appeal was rejected as the court found no evidence on my part of malice. The court noted that:

"Both Salter and Toth [my co-defendant] came to believe that Underwager is a hired gun who makes his living by deceiving judges

about the state of medical knowledge and thus assisting child molesters to evade punishment. Persons who hold such opinions cannot be expected to look kindly on their subjects, and the law certainly does not insist that they shut up as soon as they are challenged ... Underwager and Wakefield cannot, simply by filing suit and crying 'character assassination!', silence those who hold divergent views, no matter how adverse those views may be to plaintiffs' interests. Scientific controversies must be settled by the methods of science rather than by the methods of litigation." [14]

As regards my opinion of Underwager's work, the court noted that all of the reviews of *Accusations of Child Sexual Abuse*[15] appeared to agree with me, as had several courts.

My study was eventually completed. It was titled "Accuracy of Expert Testimony in Child Sexual Abuse Cases: A Case Study of Ralph Under-wager and Hollida Wakefield," and it was made available to interested parties by myself and by the Centre for the Prosecution of Child Abuse.[16]

What is interesting, however, about the situation described here is not simply the harassment that occurred or the fact that I was vindicated. What is interesting is the meaning of the events that transpired and what can be learned from them.

As an undergraduate at the University of North Carolina, I majored in philosophy and was used to vigorous, even vicious academic debate. Philosophy, like chess, is an arena in which combatants constantly go for the academic jugular. I expected a vigorous counterattack from Under-wager and Wakefield, but I never expected taped phone calls, private detectives, systematic lying, frivolous ethic charges, bogus lawsuits, groundless charges of laundering grant monies and so forth.

To this day, I read claims by Underwager and Wakefield that the courts found I had defamed them, despite the fact that the test of summary judgement is whether the plaintiff would have a case if the plaintiff were correct about matters of fact. To apply that test, the court must temporarily assume that the plaintiff's claims are true and asks the question of whether in that instance the plaintiff would have a claim. This assumption for the sake of deciding summary judgement is not the same thing as a factual finding that the plaintiffs were defamed. It is not a finding of fact at all.

In musing on all that occurred in the course of the several years of harassment, the error I decided I made, and others frequently make, is to assume that we are all academics trying to sort out intellectual issues. The False Memory Syndrome Foundation is a political organization composed

primarily of individuals who have been accused of child sexual abuse and those who support and defend them, sometimes for considerable sums.

Such people are not going to be swayed by the research. They start with a fixed point of view — the need to deflect threat. That threat comes in the form of public exposure, loss of income, monetary penalties, or even in some cases incarceration. I heard a colleague say recently, in referring to the 30 or so studies that document the existence of recovered memory, "You get to the point where you wonder when is it going to be enough." It is never going to be enough if the point is not searching for the truth but protecting a particular point of view.

There is another dynamic that I feel we, in this field, have been slow to recognize at our peril. People, in general, tend to project onto others their own state of mind. Well-meaning people inevitably assume other people are well meaning. People who cheat assume everyone cheats. People who deceive assume everybody deceives. "The liar's punishment," George Bernard Shaw wrote, "is not in the least that he is not believed, but that he cannot believe anyone else." [17]

Therefore, the person who scores high on measures of psychopathy says to the therapist: "What's in this for you? You're looking out for number one just like everybody else. So what's your game?" The therapist — stung to the quick by such accusations — all too often defends her- or himself, trying hard to persuade the client that he or she is just trying to help. A more appropriate response might be not to argue the point at all but to take the material as diagnostic. Unfortunately, the exchange is diagnostic on both sides.

In projecting onto others their own moral sense, therapists sometimes make terrible errors. Child physical abusers are automatically labelled "impulsive," despite extensive evidence that they are not necessarily impulsive but more often make thinking errors that justify the assaults. Sexual and physical offenders who profess to be remorseful after they are caught are automatically assumed to be sincere. After all, the therapist would feel terrible if he or she did such a thing. It makes perfect sense that the offender would regret abusing a child. People routinely listen to their own moral sense and assume that others share it.

Thus, those who are malevolent attack others as being malevolent, as engaging in dirty tricks, as being "in it for the money," and those who are well meaning assume others are, too, and keep arguing logically, keep producing more studies, keep expecting an academic debate, all the time assuming that the issue at hand is the truth of the matter.

However, the argument between the field of child sexual abuse and the backlash against survivors is not an academic debate between two well-meaning groups equally invested in ascertaining truth. It is not an academic debate at all; it is a political fight.

It is a political fight between a group of well-financed, well-organized people whose freedom, livelihood, finances, reputation or liberty is being threatened by disclosures of child sexual abuse and — on the other hand — a group of well-meaning, ill-organized, underfinanced, and often terribly naïve academics who expect fair play. Why do we expect fair play? Because we project onto others our own moral sense, and we do not want to face the existence of malevolence any more than the American public does.

For every group, malevolence is always somewhere else. Maybe we understand at this point in history that it can occur at night in darkened rooms where small children sleep. However, surely not in academia. Surely lying and deception do not occur among people who go to conferences, who write books, who testify in court, and who have Ph.Ds.

At one point I complained to a Florida judge that I was astonished to see an expert witness lying on the stand. I thought one had to tell the truth in court. I thought if someone didn't, she didn't get her milk and cookies. I thought God came down and plucked someone right out of the witness stand if he lied in court. I thought a lying witness would step out of court and get hit by a bus. A wiser woman than I, the judge's answer was, "Silly you."

I was not alone in my naïveté. Many of us assumed that we are all looking for the truth and that truth will prevail. However, truth prevails only in true academic debates and then only sometimes. It does not win political fights. What wins political fights is organization and stamina and a refusal to intimidated.

Where does that leave all of us how have been targeted for harassment by the backlash and those who will be? We must understand more than the research on suggestibility and recovered memory to comprehend what is happening today. We must know something about malevolence, about how to recognize it, and about how not to make excuses for it. We must know that we cannot expect fair play.

That is, perhaps, most crucial of all. Those of us who practise in this field must face the implications of the fact that we are dealing with sexual abuse. Child sex offenders — people who exploit children's bodies and betray their trust — are not going to hesitate to lie outright. This is obvious but nonetheless frequently seems to catch people by surprise.

The people who support and defend those accused of child sexual abuse indiscriminately, those who join organizations dedicated to defending people who are accused of child sexual abuse with no screening whatsoever to keep out those who are guilty as charged, are likewise not necessarily people engaged in an objective search for the truth. Some of them can and do use deceit, trickery, misstated research, harassment, intimidation and charges of laundering federal money to silence their opponents.

Those of us who are the recipients of bogus lawsuits and frivolous ethics charges and phony phone calls and pickets outside our offices must know more than the research to survive such tactics. We must know something abut endurance and about the importance of refusing to be intimidated.

It is important to refuse to be intimidated. That refusal must not be based simply on a calculation of the odds of succeeding. At times, in my case, multiple lawsuits and an ethics charge seemed overwhelming, and the fact that I knew my work to be accurate and responsible was only partial solace. I was well aware that court, like the National Football League, is an arena in which, on any give Sunday, anybody can win.

The refusal to be intimidated must come, in the end, not from a sureness of succeeding but from a knowledge of the cost of scurrying for shelter through fake retractions and disowned truths. It is a question, in the end, of self-respect. Joan Didion described it well:

> "There is a common superstition that 'self-respect' is a kind of charm against snakes, something that keeps those who have it locked in some unblighted Eden, out of strange beds, ambivalent conversations, and trouble in general. It does not at all. It has nothing to do with the face of things, but concerns instead a separate peace, a private reconciliation." [18]

Who among us could, in good faith, ever face a survivor of childhood abuse again were we to run for cover when pressed ourselves? Children are not permitted that choice, and the adults who choose to work with them and with the survivors they become cannot afford to make it. It would be a choice to become, through betrayal and deceit, that to which we object.

Our alternative, then, is not to hide, not to refuse to treat adult survivors, not to refuse to go to court in their defence, not to apologize and retract statements we know are true, but to cultivate endurance and tenacity as carefully as we read the research.

As for me, I take to heart a poem by Margaret Atwood called "Solicit."
She is writing about her daughter, but we should listen too when she says,

> *How can I teach her*
> *some way of being human*
> *that won't destroy her*
> *I would like to tell her, Love*
> *is enough, I would like to say,*
> *Find shelter in another skin.*
>
> *I would like to say, Dance*
> *and be happy. Instead I will say*
> *in my crone's voice, Be*
> *ruthless when you have to, tell*
> *the truth when you can.*[19]

Endnotes

1. Hollida Wakefield & Ralph Underwager, *Accusations of Child Sexual Abuse* (Springfield, IL: Charles C. Thomas, 1988).

2. Holliday Wakefield & Ralph Underwager, "Interview," *Paidika, The Journal of Paedophilia* 3, 1 , 9 (1993), pp. 3-4.

3. A.C. Graesser, S.B. Woll, D.J. Kowalkski & D.A. Smith, "Memory for Typical and Atypical Actions in Scripted Activities," in Wakefield & Underwager (1988), p. 72.

4. *Ralph Underwager and Hollida Wakefield v. Anna Salter and Patricia Toth*, Response to First Request for Production of Documents to Plaintiffs (No. 92-C-229-S. 7th Cir. W. D. Wisc. 1993).

5. Ibid., p. 48.

6. *Underwager and Wakefield v. Salter and Toth*, Deposition of Ralph Charles Underwager (April 15, 1993), p. 93.

7. Anna C. Salter, *Accuracy of Expert Testimony in Child Sexual Abuse Cases: A Case Study of Ralph Underwager and Hollida Wakefield* (unpublished manuscript, 1992), p. 64.

8. Ibid., p. 65.

9. Ibid., p. 67.

10. *J.G.* v. *T.B. and M.B.*, Deposition of Ralph Charles Underwager (No. 30, 692-A, D. C. of Hardin County, Texas, 88th Judicial District, February 24, 1992), pp. 128-129.

11. *Underwager and Wakefield v. Salter and Toth*, Deposition of Ralph Charles Underwager (April 15, 1993), pp. 93-98.

12. Salter (1992), p. 68.

13. *Ralph Underwager v. M. Munro, C. Vaughn, J. Peters, A. Salter, K. Oates and A.*

Schlebaurm (No. 92-7221 (CM), S. D. CA, December 9, 1993).

14. *Underwager and Wakefield* v. *Salter et al.* (22F. 3d 730 1994), p. 11.

15. Wakefield & Underwager (1988).

16. Salter (1992).

17. George Bernard Shaw, in R. Andrews (ed.), *The Concise Columbia Dictionary of Quotations* (New York: Columbia, 1990), p. 183.

18. Joan Didion, *Slouching Towards Bethlehem* (New York: Pocket Books, 1968), p. 147.

19. Margaret Atwood, *Selected Poems II: Poems Selected and New, 1976-1986* (Boston: Houghton Mifflin, 1986), p. 43.

PART THREE

Memory

in

Culture

INTRODUCTION TO PART THREE

Memory in Culture

Margo Rivera

At the heart of the current debate about recovered memories of childhood sexual abuse is the sexism that is endemic in our culture. Sandy McFarlane and Bessel van der Kolk, in their recent book, *Traumatic Stress: The Effects of Overwhelming Experience on Mind, Body and Society*, point out that:

> "Interestingly, the issue of delayed recall was not controversial when Meyers (1940) and Kardiner (1941) gave detailed descriptions of it in their books on combat neuroses; when Sargant and Slater (1941) reported that 144 of 1,000 consecutive admissions to a field hospital had amnesia for their trauma; or when van der Kolk noted it in combat veterans (1989) or in a survivor of the Cocoanut Grove nightclub fire (1987). It appears that as long as men were found to suffer from delayed recall of atrocities committed either by a clearly identifiable enemy or by themselves, the issue was not controversial. However, when similar memory problems started to be documented in girls and women in the context of domestic abuse, the news was

unbearable; when female victims started to seek justice against alleged perpetrators, the issue moved from science into politics." [1]

The issue of child sexual abuse is indeed inherently political. One of the strongest tenets of our society's ideology is that of "family values." We say again and again, privately but especially publicly, that we value our children as our future and we do everything we can to keep them from harm. We speak, individually and collectively, about our abhorrence of the sexual abuse of children. When I worked in a child protection agency, I heard the shocked disbelief of mothers of children disclosing intrafamilial sexual abuse, who wanted to believe that their children were safe in their own homes. This disbelief is echoed throughout our society. Despite the well-known prevalence of rape and wife battering, the proliferation of violent misogynist pornography, the continuing and growing wage gap between women and men in the workplace, and the many other ways it is clear that systemic oppression of women is widespread, we want to believe at least that children, if not women, are sheltered from our social sins.

But the widespread sexual abuse of children, especially when it is perpetrated by their fathers, stepfathers, and other male caretakers whom they love and trust, is not an unfortunate effect of a few deviant men going after some vulnerable and neglected children. It is the inevitable outcome of the power inequities that are built into our social structures. A man's home is his castle. This is not only a cliché: it is a central value in a patriarchal culture. Children who are sexually abused in their homes by close relatives, or by adults in school, the hockey arena, the church basement, summer camp, in any of the many settings in which children are entrusted by their parents to the care of other adults — and the large majority of victims know their victimizers well — are subjected to the extremes of patriarchal socialization. They are taught in intimate and concrete ways that their abuser — usually an adult male, sometimes an adult woman, teenager, or even another child who has power over their day-to-day life — is in charge of their body and their responses. They are taught that survival demands compliance and silence.

In many cases, these children discover that the best way to ensure survival and secrecy is to forget about what is happening to them. Sometimes they manage to forget for minutes or hours, sometimes for years on end. They activate these mechanisms of distancing, compartmentalizing and sometimes blocking out knowledge for long periods of time, habitually — usually without even considering the process consciously. These

strategies of dissociating frightening experiences and the emotions connected to them from their general awareness enable children to maintain their relationship with the abuser when they need him and/or fear him. These stratagies allow the victim to comply with the perpetrator's demands for secrecy, which are frequently coupled with dire threats children take literally; what you succeed in not thinking about, you are not likely to reveal in an unguarded moment. They create enough mental and emotional space in the child's life so that she can play, learn, eat and sleep — maybe not as easily as she might if she were not fending off her thoughts about the abuse, but better than if she had no defence against them at all. The psychological mechanisms that ensure survival in her desperately insecure childhood provide the basis for the very rationalizations the offender uses, many years later, to claim that her testimony is invalid. "No one would forget such horrible things. They never happened."

In this defence, the perpetrator is well supported by others, who say that their children are also accusing them of the same preposterous acts. Professionals from a range of disciplines join the chorus, accusing the therapist — who helped the client open up her own awareness — of being the real perpetrator for destroying the family by implanting these noxious ideas in the vulnerable. Voices in the media project the reassuring message that the epidemic of sexual abuse previously reported was greatly exaggerated. Many people breathe a sigh of relief, reflecting our individual and our collective disinclination to know how much of our culture rests on the foundations of oppression, the exploitation of the more vulnerable by the more powerful, including the sexual abuse of our youngest citizens.

The articles in "Memory In Culture" look at some of the ways in which the debate about child sexual abuse and memory intersect with the social structures in which we live, work and learn how to understand and speak about our experiences with each other.

"I gradually awoke to a world that was much bleaker than I had previously imagined — and much more heroic." In "Dreams and the Recovered Memory Debate: One Clinical Researcher's Journey," Kathryn Belicki describes her experience as a research psychologist who chanced upon the issue of child sexual abuse in the course of her studies about dreams. Nothing in her previously peaceful academic life, when her greatest challenge was to break through colleagues' obvious boredom when she presented her data, had prepared her for the turbulent experience of becoming a researcher about the issue of child sexual abuse and memory.

Susan Campbell looks at the recovered memory debates from the
point of view of a philosopher who is interested in how the False Memory
Syndrome Foundation has persuaded the public that women who come
forward to speak about their childhood history of sexual abuse are not
trustworthy witnesses to their own life experience. In her article "Framing
Women's Testimony," she notes that attempts to make those who speak of
past abuse immediately subject to the evidential standards of legal pro-
ceedings encourage the public to take a stance as aggressive cross-exam-
iners, ensuring that women whose memories are fragmentary or even
simply distressing will be silent about their experience, rather than subject-
ing themselves to this combative stance.

Cindy Veldhuis and Jennifer Freyd explore the relationship between
language and memory for child sexual abuse in their article, "Groomed for
Silence, Groomed for Betrayal." Sexual abuse happens to a child in
relationship — relationship with the offender and the relationship both of
them maintain in their family and community. Veldhuis and Freyd theo-
rize that certain victim/perpetrator patterns of communication, and related
patterns of communication within their social network, can have a predict-
able effect on the victim's ability to disclose and even to process and
remember the abuse. They emphasize that the search for the mechanisms
and motivations that underlie the unawareness that is so often a part of an
individual's relationship to her abuse history must be a multi-faceted one,
taking into account both individual cognitive and social-relational aspects
of the phenomenon of functional memory impairment for experiences of
traumatic child sexual abuse.

In "Re-viewing the Memory Wars: Some Feminist Philosophical
Reflections," Shelley Park sees the extreme false memory syndrome
position as a conservative backlash against contemporary feminism's
successful challenge to some of the most sacrosanct symbols of patriarchy,
including the benevolent patriarch and the traditional family. She argues
that, though it is tempting to respond to the attack with global denials,
feminist theorists must not be seduced into adopting the simple terms
furnished by the extremes of the debate. Park insists that it is crucial that
feminist theorists continue to examine the issue of memory and pervasive
sexual abuse with the widest possible lens and to attempt to explore and
understand every nuance of this phenomenon she calls "the collective
cultural spitting up of patriarchy."

Elizabeth Wilson sees an increasingly polarized debate about recov-
ered memories. Either sexual abuse happened exactly as reported or

nothing happened. In her article, "'Something Happened': The Repressed Memory Controversy and the Social Recognition of Victims," she argues that the debate needs to be understood in the context of broader social assumptions about who each victim is and what victimization is. Wilson claims that we have created a climate in which physical sexual abuse is privileged as the only form of genuine victimization. What is being lost is the fact that there are other forms of maltreatment that have devastating consequences for the children who endure them.

The issue of the intersection of child sexual abuse and memory is clearly a cultural artifact. Twenty-five years ago, reading about the topic or talking about it professionally or socially would have been as likely to occur as a discussion about the internet. And as is also obviously true about the internet, the issue cannot be examined productively if it is examined narrowly. Talk to 100 internet users and you will unearth more than 100 ways it has made a difference in their lives, and well more than 100 concerns about its effect on them, on others and on our culture. Even those, maybe sometimes especially those who will not give house room to a computer, often have strong opinions about it.

Fragment By Fragment gathers together the opinions of 18 feminists coming to the topic of memory and child sexual abuse from a wide range of perspectives. One point on which we all agree is that bringing the issue of child sexual abuse out into the open in the past 25 years has been a blessing for our society and its people. It has changed the way in which we look at many important aspects of our lives and our culture. Even those who claim that the concern about the sexual exploitation of children is a hysterical witchhunt, targeting men this time around, cannot claim to see the world the same way they did before our society acknowledged publicly that a large number of our children are sexually abused each year, each day, each hour. This change has indeed been a blessing, but a blessing with many associated costs and responsibilities. The articles in "Memory In Culture" — along with all the articles in this book — point to some of those costs and many of the responsibilities.

Endnotes

1. Alexander McFarlane & Bessel van der Kolk, "Conclusions and Future Directions," in Alexander McFarlane, Bessel van der Kolk & L. Weisabeth (eds.), *Traumatic Stress: The Effects of Overwhelming Experience on Mind, Body and Society* (New York: Guilford Press, 1996), p. 566.

DREAMS AND THE RECOVERED MEMORY DEBATE

One Clinical Researcher's Journey

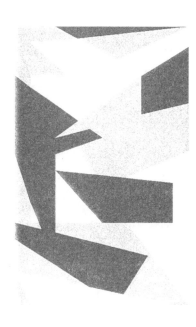

Kathryn Belicki

Until 1984, I thought sexual abuse was an extraordinarily rare event. In this I was not alone: prior surveys of therapists had shown that the majority of mental health professionals similarly tended to underestimate both the prevalence of sexual abuse and the extent of the resulting psychological harm.[1] These beliefs reflected in my undergraduate and graduate training as a research and clinical psychologist. Despite the fact that both programs were of a high quality, I cannot recall being assigned a single paper on the topic.

My discovery of sexual abuse, and subsequently other forms of domestic violence, was quite serendipitous and occurred not because of my clinical training, nor because of my personal insight, but because of my role as researcher and research supervisor. It began with two students, Marion Cuddy and Alicia Dunlop, walking into my life and refusing to walk away at the natural junctures when such partings usually occur, at the end of their project or at subsequent graduation. As they and others prodded my research program in directions where I at first was not

particularly enthusiastic about going, I gradually awoke to a world that was much bleaker than I had previously imagined — and much more heroic.

Along the way, I also experienced a revolution in my understanding of the relationship between research and politics and the personal aspects of conducting research. The study of recovered memories has been fraught with political (and personal) agendas.[2] This has been dismaying, but it certainly educated me to the reality that research does affect lives and that researchers, to be truly effective, need to responsibly accept that fact. It has also taught me a new way of being a critical consumer of research. I am now much quicker to ask of any manuscript, "Who benefits from the ideas described therein?" By this I mean both what "humanitarian" benefit might exist and what agendas might be supported by this research, in ways perhaps quite unintended by the researcher. Similarly, who might be hurt by these ideas? Increasingly the capacities for political sensitivity and activism are qualities I now value in researchers.

In this article, I have two goals. The first is to describe my journey and some of the issues it has forced me to reflect on. The second is to describe one resource that has been under-utilized in the study of trauma: individuals' night dreams.

My story begins with an interest in the study of dreams which took root in my undergraduate training and has persisted ever since. Dreams share one intriguing commonalty with the phenomena of sexual and familial abuse: they represent a significant portion of human experience and yet are widely neglected by the very professionals who arguably should take note of them. For example, if their sheer prevalence were to dictate their place in introductory psychology texts, both topics would occupy one or more chapters, and yet both typically command at most a few paragraphs. Both are also noticeably absent from psychology curricula. Therefore, conducting research on dreams taught me that "big" phenomena of considerable relevance to "ordinary" people could be ignored by the professional mainstream.

When I began to pursue the study of nightmares, I learned more about how marginalized phenomena can be denied and actively resisted, and how grossly distorted perceptions can be assimilated into general perception as fact. In the late '70s, there was little active research on nightmares. Despite some well-forgotten data to the contrary, such as an excellent study by Cason,[3] it was commonly believed that nightmares were rare in adults, were characterized by anxiety (in contrast to other negative emotions), and were secondary to either trauma or psychopathology. Furthermore, it was

thought that post-traumatic nightmares simply replayed the precipitating trauma in a videotape-like fashion.

My finding that nightmares were a widespread phenomenon was accidental. One year, as a graduate student, I was part of a research team that was screening large numbers of students for hypnotic ability. I tucked into the inventory a question about nightmare frequency, because I had reason to think it would be associated with hypnotizability.

A small relationship with hypnotic ability did obtain, but the much more surprising finding was that a large majority of students (80 percent) reported having at least one nightmare in the prior year, with more than 10 percent indicating that they experienced one or more nightmares a month — a frequency I found surprising. My first reaction was not to believe the data and to assume that the question I had designed was not clear enough. In subsequent studies, I tightened the wording and still found that similar frequencies persisted.[4] Now, personally convinced that nightmares were prevalent, I turned to the more daunting task of convincing others.

Initially, I encountered considerable professional resistance, particularly from those studying sleep and dreams. A frequent refrain was that if nightmares were so common, surely they would have heard about them. I could only recount my experience, that I too had not heard about them until I asked. In recent years I have had the *déjà vu* experience of repeating this conversation — but now on the topic of sexual abuse. It is not clear to me when and how the shift in researchers' perception came, but there is now general acceptance, at least among dream researchers, that nightmares are a common phenomenon in general populations of adults.

I wonder if the day will come when childhood abuse, recovered memories, distorted memories (and phenomena I have yet to learn to see) will similarly emerge from invisibility; when people will have difficulty even believing there was a time when the existence of these had to be argued.

Sexual Abuse as a Commonplace Event

In the early 1980s, in my first academic position at York University, I developed a research program directed toward the causes of nightmares. While I considered several factors, it never occurred to me to put childhood abuse or trauma on that list. In part, I was influenced by the prevailing belief that post-traumatic nightmares simply replayed trauma. Given that

most nightmares do not involve explicit scenes of childhood abuse, it therefore followed that the causes of such dreams existed elsewhere. I know I was also influenced by another prevailing theory that shaded my eyes, namely the prevalent meta-belief that dreams reflect internal realities, not external events.

In the midst of this, in 1984, Alicia Dunlop landed on my office doorstep wanting to do an honours thesis on sexual abuse. She was the first to draw to my attention the statistics concerning this issue. When she summarized for me from the literature that existed at the time that it appeared that one in four women had been sexually abused as children and one in 10 men, I told her flatly that the research must be mistaken and the statistics inflated. After all, no one had mentioned this issue in my training; moreover (and probably more important) I believed myself to be a fine clinician and only on one occasion had someone mentioned sexual abuse to me. If it was "out there," I would have heard about it.

Therefore, for her thesis, we developed a measure using conservative, unambiguous language asking about childhood experiences involving abusive, unwanted sexual touch. Twenty fourth-year honours students completed the measure, and to my utter consternation, exactly 25 percent of the sample indicated they had been sexually abused in childhood. This was a dizzying experience for me. It led to some profound reflection on my prior clinical practice, in which I wondered just how many people I had missed and why almost no one felt they could disclose this to me.

As a result of this experience, when a doctoral student, Marion Cuddy, subsequently wanted to do her dissertation on the problem of therapists being unaware of sexual abuse in their clients, I was very interested. The strategy we took consisted of attempting to identify unique signs and symptoms of abuse that would alert clinicians that a client might have been sexually abused.[5] We anticipated that sleep and dream experience might provide a rich source of clues to prior abuse.

In our first study, we surveyed 539 university women, asking about abusive experience (sexual and physical) and about the qualities of participants' sleep and dreams. Participants also completed a measure of depression. Those reporting any form of childhood abuse were more depressed than those not reporting abuse and they indicated more sleep disruption, greater nightmare and sleep terror frequency. (Nightmares are extremely upsetting dreams; sleep terrors are events in which the individual awakens out of slow-wave sleep in a state of extreme terror, often without any recall of a dream.) The findings of more disturbing sleep and dreams in those

reporting abuse remained even when we removed the effects of depression.[6]

In the second study, we compared four groups on a variety of measures (post-traumatic symptomatology, somatization, dissociation and nightmare content) that might have discriminative utility. The four groups were those reporting (1) no abuse, (2) sexual abuse, (3) physical abuse and (4) both sexual and physical abuse. Although our focus was on sexual abuse, we included physical abuse comparison groups because of a remarkable conversation I had with a feminist colleague. She casually remarked to me that surely sexual abuse was not harmful by itself, but only when combined with physical abuse.

We found that the abuse groups differed from the no-abuse group on all the measures. We also found that a detailed content analysis of people's descriptions of their "worst" nightmare revealed distinctive patterns of nightmare content associated with sexual versus physical abuse. Both groups were markedly different from the no-abuse group, but very tellingly, they were also very different from each other.[7] Furthermore, in the first study, those reporting "only" sexual abuse had as many nightmares and sleep terrors as those reporting physical abuse. Clearly sexual abuse was hurtful quite independently of physical harm.

The patterns of nightmare content were not what one might naïvely assume: the dreams did not in a simple way replay the historical events. Instead these dreams reflected the emotional reality of life after abuse. Interestingly, given this lack of explicit, abusive content, many of the participants themselves, when asked, did not see a connection between their nightmares and their prior abuse history. Yet on the basis of those nightmares, and no other information about the dreamer, we were able to statistically identify individuals reporting sexual versus physical (versus no) abuse with a high degree of accuracy. In fact, using discriminant function analysis, we were able to sort those reporting "just" sexual abuse from those reporting "just" physical abuse with 100 percent accuracy.

It is one thing for a computer to be able to sort reports statistically on the basis of detailed content analyses. It is a different matter for an individual to make a judgement about a dream after just hearing it or reading it. Therefore, the next step was to study people's abilities to read a dream report and decide whether the dreamer had been sexually abused. Angela DeDonato, Marion Cuddy and I ran two studies in which we handed university students in the first, and a group of dream researchers and therapists in the second, a number of nightmare reports. Half were derived

from those reporting sexual abuse and half from those reporting no abuse in Marion Cuddy's prior dissertation.[8] In both cases, participants were asked to simply sort the nightmares. Some were given instruction about what our research had found to be the characteristics of each type of dream; others were told nothing. It turned out that the instructions conveyed no benefit.

In general, people could sort dreams at a level greater than chance (70 percent where chance would be 50 percent). Of course, this level is utterly inadequate as a clinical test, but is nonetheless impressive given that the judges had only one dream and no other information about the dreamer. In addition, participants varied in their accuracy from 46 percent (essentially chance) to 89 percent. The most important predictor of accuracy was willingness to "see" abuse. Specifically, although told that "about half" of the reports came from those reporting abuse, the majority of participants underestimated the number of reports, sorting less than half into the "abuse" pile. Both therapists and undergraduate students were equally prone to underestimating abuse.

Among other things, these studies underscored what I had become convinced of from my personal and clinical experience. There is no need to search for a special technique to "detect" that an individual has been abused. If a university student, without professional training, who has not even been taught what to look for in a nightmare report, can read a single dream and on the basis of that, and that alone, recognize that a dreamer has been sexually abused, then we do not need to search for the "hidden" signs of sexual abuse. However, if one is not willing to "see" abuse, it will not be seen. Clearly, what we need to do is to remove impediments to sight.

A related insight that I had was that the most potent "technique" for uncovering abuse histories is simply to ask. After the first study with Alicia Dunlop, in my clinical assessments I started routinely asking people about aversive sexual experiences; at the same time I would do my other routine questioning about symptoms and experiences. I did not always hear right away, but sometimes did. At other times clients would disclose to me after we had established a firmer relationship. In a short time, I went from almost never hearing about sexual abuse to hearing about it routinely.

Before moving on, I should note that through much of this period, the study of childhood abuse continued to be a secondary interest for me, eclipsed by my primary interest in dreams. In fact, were it not for a steady stream of students interested in studying sexual abuse, I would not have conducted any further research in this area.

That situation was to change abruptly in 1992.

Into the Maelstrom of False Memory Syndrome

A pivotal, transformative event on my research journey was an address I gave to the Association for the Study of Dreams in which I described how nightmare content illustrates the emotional reality of abuse.[9] There was a strong response from the audience, both in the question period and in subsequent conversations. About half the group of approximately 200 lined up after the talk to tell me how it had connected with their experience or with that of others close to them who had been abused. It is one thing to read about the incidence statistics; it is quite another to witness the statistics in such a concrete way. It was a profoundly visceral experience that moved me to my core.

In contrast, two psychiatrists were stridently critical of the address, one arguing that I was naïve to believe my participants' reports of abuse, the other insisting that such reports merely reflect individuals' fantasies arising from their "natural" desire to have sex with their parents. Frankly, I was flabbergasted. In terms of the participants' reports of abuse, while I had always assumed that some of my research participants might be classified in the wrong group (with it equally being the case that some of the "no-abuse" reporters belonged in the abuse group), there were no *a priori* grounds to assume widespread deception from the participants. These people had all taken part in large sample studies where all partici-pants were anonymous: they gained no objective benefit in ticking off the box that said they had been abused.

In terms of the reports reflecting individuals' fantasies, while I had read Freud and even appreciated some of his insights, I had never before met someone who actually believed that 20+ percent of people have the experience of remembering abuse because as children they wanted to have sex with their parents.

Quite apart from my reaction to these viewpoints, I was particularly disturbed by the realization that the two voices of the psychiatrists speak-ing from their theories would be heard more clearly and respectfully by society than the voices of the hundred who spoke "merely" from their experience. This would be even more probable given that one of the psychiatrists was renowned. That day I lost my taste for the kinds of dream research questions that had so engaged me previously. I decided to study the authenticity of abuse reports.

Shortly thereafter, the False Memory Syndrome Foundation captured the attention of the populace. It was particularly disturbing, after spending

years studying how to remedy the problem of therapists underestimating the prevalence and impact of abuse, to be told that there was an epidemic of therapists who were creating false memories of abuse. It was doubly unnerving because it conflicted with everything I knew about the process of therapy, either from my experience as a therapist or my study as a researcher. Specifically, after H. J. Eysenck published in 1952 his data suggesting that psychotherapy had no effectiveness,[10] it took decades of research before we could assert with confidence that psychotherapy had some utility. It is difficult to conceive that therapists who have such difficulty improving someone's thoughts could so easily create an entire, false revision of a client's history.

And what about "resistance" in clients? While not everyone likes the label "resistance" (myself included), and for very good reason, the phenomenon is real. People seeking the assistance of psychotherapists may be emotionally distraught, but as a group they are not pushovers. The neophyte therapist learns quickly that giving advice leads predictably to a "Yes, but." Similarly, if one makes an interpretation with which a client disagrees, not only will the interpretation be rejected, but the client may not return to therapy. Therapists are just not as powerful, nor clients as malleable, as the FMS Foundation's view of the world would suggest. In extraordinary circumstances, with some individuals, I do (now) believe that profoundly disturbing memories can be created, but I have not seen evidence that this is a frequent or usual side effect of therapy.

What particularly amazed me was to see who supported the false memory hypothesis. I could understand social psychologists and experimental memory researchers embracing this thinking. Their research sensitizes them to the many ways that cognition can be influenced, while, on the other hand, they are unfamiliar with the realties of the therapeutic process that confronts us with our limitations in influencing others. However, I could not understand why they brought such emotional energy to discussions of abuse and memory, particularly when it was not their area of research. Despite the myth of the dispassionate scientist, all talented researchers that I have met are passionate about their theories and their data, and defend them with an energy mother bears might envy. But why the energy and emotion around *this* issue which was so unrelated to their own interests? I also could not understand the number of clinical psychologists and hypnosis researchers/practitioners of my acquaintance who rushed to embrace the false memory hypothesis.

Some of the hypotheses of the FMS Foundation became the focus of my studies conducted in collaboration with a number of students. We adopted a variety of approaches. For example, we looked at the characteristics of individuals reporting recovered memories for abuse and compared them to three other groups — those reporting continuous memory for abuse, those reporting no abuse, and those reporting no abuse whom we asked to complete the measures as if they had been sexually abused (abuse simulators). In general, we found that those with recovered memories were as likely to report corroboration as those with continous memory, and they were no more likely to have seen a therapist.[11]

The two groups did differ on some variables: for example, those with recovered memories reported greater severity of abuse and scored more highly on inventories of dissociation. Nonetheless, the two groups tended to be quite similar and could be differentiated from those simulating abuse.

In another study conducted by Mary Barzyk, Diane Bell, Alicia Dunlop and myself, we examined abuse survivors' experience of therapists.[12] Of greatest relevance to the issue of recovered memories was the finding that participants' most frequent complaint was that their therapist ignored, dismissed or failed to appreciate the significance of the survivors' account of abuse. This, of course, was entirely consistent with our findings that most people underestimated abuse frequency when sorting dream reports. At least in our corner of North America, in the early 1990s, we could not find evidence of an epidemic of therapist zealots imagining abuse in every client. Quite to the contrary, given that many of our participants had not shared their abuse with any professionals, a finding Diane Bell and I later replicated in a community sample,[13] it was reasonable to conclude that false negatives (the failure to detect what is there) were the predominating error.

Nightmares, Dreams and Implicit Memories

Nightmare content became again a particularly useful variable for further research into childhood sexual abuse trauma. Because nightmares typically do not re-enact childhood abuse (although they sometimes do), and given that dreamers usually do not recognize the connection between their nightmares and their prior experiences of abuse, nightmares are an excellent means of measuring implicit memory for abuse.

Implicit memory is memory through indirect emotional responses, rather than memory for the actual events that have caused trauma. When people appear to forget trauma, what is "lost" is explicit memory, not implicit memory.[14] In contrast, there is evidence to suggest that implicit memory remains intact through such manifestations, for example, as emotional difficulties, sleep disruption, nightmares.

The person who hypothetically has an entirely false memory for abuse would be one who has an explicit memory but no implicit memory for abuse. Such individuals might have symptoms like depression, because that would be an understandable result of coming to believe they were abused, but they would not show the subtler signs of implicit memory. Given this reasoning, it is significant that in one study we did, the nightmares of those with recovered memories were indistinguishable from those with continuous memories. In contrast, those simulating abuse were much more likely to report (fabricate) nightmares involving explicit sexual abuse.[15]

Let me clarify that nightmares are not sufficiently sensitive to be generally useful as a *legal* test of whether or not someone has been abused. There has been an unfortunate tendency in the disputes over recovered memory to muddle the needs of legal contexts with the needs of therapy or research. While nightmares may not be the stuff of legal evidence, as a clinical or research tool they can have considerable utility. Even in those with continuous, explicit memory for abuse, it is implicit memory that looms large in their experience, rippling into their mood, self-concept, relationships with others, world view and their dreams in the dark of night.

A recent strategy of our research team has been to examine some of the misconceptions that fuel the recovered memory debate. One misconception is the conclusion that therapy must be harmful because an individual appeared to be functioning very well until she or he went into therapy — and then everything went wrong. Of course the first clue that perhaps all was not well, when it seemed to be, was that the person went into therapy in the first place.

Nonetheless, misunderstanding rather naturally abounds when people who look as if they feel well claim to have been abused and hurt. There is an understandable tendency to either disbelieve them or assume that the abuse could not have been "that bad." (As an aside, this is a no-win scenario for survivors: those who clearly look wounded because of their experience tend to be disbelieved because as marginalized people, for example in the psychiatric or criminal system, they are not credible.)

In a recent study I undertook with Elisha Chambers, we used quality of sleep and dreams as a means for examining apparently resilient survivors of abuse.[16] By way of background to this study, because I work in a university, many of the trauma/abuse survivors I know are resilient almost by definition — they are, after all, able to function in a university setting. It has been my experience that such resilience, while valid and applaudable in its own right, can mask profound pain. When this pain erupts, as it is wont to do periodically, the social environment tends to be perplexed and non-supportive, because there is no apparent reason for the sudden dysfunction.

At my university, students who are in car accidents (who, incidentally, are more likely, statistically, to be male) will be given sympathy, extensions on papers and exams, and access to the services of the Special Needs Office. Students who were sexually abused as children (statistically more likely to be female), and who periodically become non-functional when their past history surfaces to haunt them, are pretty much on their own to negotiate extensions, etc. Over time they will be flagged as problematic and unreliable, which can jeopardize, for example, their ability to get good letters of reference for graduate school. Essentially, because they usually function so well, no one asks, "What has happened to this person?" in the way it would be asked if they came in on crutches. Moreover, if the emergence of pain constitutes primarily implicit memory for them, disconnected from explicit memory of abuse, they cannot even effectively lobby for themselves. A person who knows she has been raped can at least come to a professor and say she was raped (although that is remarkably more difficult to disclose than to state they were in a car accident). The individual who does not realize the source of her pain cannot similarly "explain" herself, which in itself takes further toll on her self-esteem.

To address this hypothesis — that resilience can mask emotional pain — we had survivors of a wide variety of traumas complete measures of resilient characteristics and of sleep and dream experience. We reasoned that if resilient individuals *feel* well, then resilience will be correlated with better sleep quality. If on the other hand resilience reflects "only" social-behavioural functioning, then resilient individuals will be as likely to have nightmares and other sleep disorders, but these will have less impact on their waking functioning. This is exactly what we found. There was no relationship between resilience and sleep or dream disorders. Resilient people had as many sleep problems as more obviously troubled people. However, resilience was associated with the ability to cope with nightmares and sleep disruption.

Doing Research in the Field of
Trauma and Memory

Let me turn now to the experience of doing research in the area of trauma and memory. The study of recovered memories for abuse is an ideal case-example of what research actually entails, compared with the myths that are sometimes taught about it. The recovered memory debate is the perfect case history for any research methods course. By myths, I mean the story that researchers must adopt an objective, unemotional stance distanced from the objects of their inquiry; that knowledge advances by first objectively observing a phenomenon, being sure to eliminate all opportunity for biases to intrude; that from such observation emerges hypotheses which then are systematically tested against alternative hypotheses, ultimately leading to "Truth." Of course we never say the bit about Truth, because we all faithfully teach that there is no truth, at least accessible to science (except for the truth that there is no truth accessible to science) — but students consistently infer from what we teach that there *is* truth and that this process will carry them to it. (From which I infer that we are either teaching very poorly that part about no Truth or students are rather wisely discerning what we in fact think).

Nothing had fully prepared me for the experience of doing research in trauma. When dreams were my primary focus, the principal challenge was the massive lack of interest of my profession, which created problems in finding publication outlets. I also had to learn how to stay motivated in the face of my colleagues' transparent boredom concerning dreams. In contrast, when I turned to the study of trauma, abuse and memory, I entered a war zone.

I still have trouble finding publication outlets, but for very different reasons. Before, reviews of my manuscripts were short and barely concealed the yawns of reviewers. Now papers came back with reviews that rival the manuscript in length and that at times contain outrageous criticism.

High emotion became the norm in any conversation, when those conversations occurred. Too often, and more chilling to my mind, was the fact that conversations did not occur when they should. Professional acquaintances with whom I used to talk comfortably stopped talking to me. On more than one occasion, colleagues pulled aside my students and grilled them about the research they were doing with me — but did not approach me. Occasionally, I was contacted by e-mail by individuals

professing to be interested in my work. We would begin a dialogue, only for me to find that they were not interested in an exchange of ideas (and on at least one occasion had lied about their reason for initiating the discussion), but were searching for errors in my work or thinking that could suddenly be thrown at me or used in other ways. I am not adverse to critical review; it was the deception that was so distressing. Now I find that people contacting me about my work almost routinely offer details, without my asking, about how they plan to use the information and an explanation of where they stand on the issue. I routinely do the same. This is not open discourse.

Watching the debate unfold in public *fora*, I was dismayed by the abusive use of language in the name of science. For example, in a blatant attempt to discredit an entire viewpoint, individuals who supported the reality of recovered memories were dubbed "true believers," while false memory proponents were granted the title of "sceptics." In fact, extreme "sceptics" could as appropriately be titled "true believers" of false memory. The reality was that scepticism and gullibility abounded on both sides of the debate.[17]

However, none of my experiences approached the horror of what some of my colleagues experienced. They were harassed, became the targets of frivolous ethics complaints or of vicious attack on e-mail lists, and had their homes and practices picketed. While I used to think that to do research one needed critical thinking skills, creativity, knowledge of research design and statistics, suddenly I desperately needed other skills — knowledge of power structures, networking skills, political savvy, and most important, courage.

Knowledge and the Personal Side of Research

In all of this, I began to reflect on how knowledge advances. It occurred to me that some of the repellant characteristics of this debate, those things we might wish to eliminate, were exactly what was necessary for progress to be made, for the progress that has happened.

Let us start with emotion. Many people dislike the emotion associated with discussions of abuse and memory. Moreover, traditionally, emotion is seen as having no place in science (even though it routinely emerges in scientific debates). It is true that emotion must be restrained and managed, but emotion conveys meaning in a way that sheer "facts" cannot. We can

cite statistics about childhood abuse, but it is emotion that conveys the sense of atrocity attendant on children's bodies being invaded and used by people who should protect and treasure them. We can dryly discuss the possibility of a person being falsely accused of a sexual offence. Yet it is emotion that informs us of the horror that enters a person's life when this kind of allegation is made, especially given that it is so hard to disprove.

Emotion is also a form of information processing and a means for communicating information. When that feminist colleague so many years ago blandly stated that surely sexual abuse without physical abuse did no harm, I reacted with mute shock. I suspect that my reaction communicated more to her than any data I subsequently collected. Similarly, my coming to accept that people can develop memories so distorted as to be ostensibly false has been due in large part to the emotion of those I have talked to — from the intense emotion of a colleague who believes that she developed a false memory to the more gentle surprise of a researcher describing his participants' reactions in a study.

What about bias? Surely that is an evil in good research. Many have decried the biases so blatantly evident in those involved in the debate. Recently, it has become very trendy to be perceived as "balanced" or unbiased on this issue, with researchers and clinicians alike jostling for that distinction. Countless times, I have been told by people that *they* are not biased. I am beginning to think I must be one of the few biased people left on this topic. Let me therefore say a few words in favour of bias, or, more specifically, in favour of admitting to bias.

Traditionally, scientists value being unbiased. Feminist methodologists, among others, have challenged the assumption that this is even possible. Who is unbiased? The person who knows nothing. If someone insists she or he is unbiased, and if I were to hypothetically come to believe that person, then I would also likely conclude she or he has nothing to teach me. To be unbiased, if that is possible, is not an asset. To *say* you are unbiased when you are not is an insidious lie in which you deceive yourself and/or your listeners. This does not serve the development of knowledge.

Finally, knowledge comes packaged through people. Take for example, the use of the first-person pronoun. I was taught never to use it in research writing for a variety of reasons. One that I still like is that no matter who discovers something, knowledge is not owned by the person who "finds" it; therefore, the person writing should recede from the reader's view. However, researchers, being human, can be an ambitious lot and, therefore, can be adept at ensuring we all remember them even

when the "I" word never appears in their writing. The other major reason cited for avoiding first-person pronouns is that we are supposed to be detached observers; we are supposed to be writing about others or the world, not ourselves. As I have suggested above, this is simple foolishness, and dangerous foolishness at that.

Behind every researcher I have talked to at length on this topic, I have found a story, and the story makes sense of her or his position. And the story helped me to shift *my* position. Typically a conversation with someone I disagreed with would start with an exchange of "arguments." Now sometimes this is all that is needed for knowledge to advance — ideas, theories, and support for those ideas are exchanged, critically weighed and from that emerges a consensus. I continue to be a fan of good thinking and discourse.

On this topic, however, the discussion usually would reach a point where we had gone as far as we could go, and we would find ourselves staring at each other over a gulf of disagreement. Occasionally, then, in the best moments we then shared the concrete experiences that entrenched us into our viewpoints. Someone can make the cleverest of arguments to suggest that there are no chairs in the world, but I will be unmoved because right now I have the concrete, sensory experience of sitting in a chair as I type. Once I share that experience with the one who believes there are no chairs, that person still has to seriously consider whether I can be trusted, whether my senses are functioning accurately, whether some other factor might account for my experience. The critical thinking process is not suspended, but becomes redirected, refocused in an effective way leading to new insights and conclusions.

Some knowledge is suited to abstract discussion. However, when we are talking about people's lives, we usually need to speak in the first pronoun and exchange stories, at least some of the time. It is from that perspective that I offer this story, my story, of one clinical researcher's journey.

Endnotes

1. R. Attias & J. Goodwin, "Knowledge and Management Strategies in Incest Cases: A Survey of Physicians, Psychologists, and Family Counselors," *Child Abuse and Neglect* 9 (1985), pp. 527-533; N. Eisenberg, R. Owens & M. Dewey, "Attitudes of Health Professionals to Child Abuse and Incest," *Child Abuse and Neglect* 11 (1987), pp. 109-116; and J. LaBarbera, J. Martin & J. Dozier, "Child Psychiatrists' View of

Father-Daughter Incest," *Child Abuse and Neglect* 4 (1980), pp. 147-151.

2. John Briere, "Science Versus Politics in the Delayed Memory Debate," *The Counseling Psychologist* 23 (1995), pp. 290-293.

3. H. Cason, "The Nightmare Dream," *Psychological Monographs* 46, 209 (1935).

4. Kathryn Belicki & Marion Cuddy, "Nightmares: Facts, Fictions and Future Directions," in Jayne Gackenbach & Annes A. Sheikh (eds.), *Dream Images: A Call to Mental Arms* (Farmingdale, NY: Baywood, 1991), pp. 99-113.

5. G. Ellensen, "Detecting a History of Incest: A Predictive Syndrome," *Social Casework* 66 (1985), pp. 525-532; John Briere & M. Runtz, "Post-sexual Abuse Trauma: Data and Implications for Clinical Practice," *Journal of Interpersonal Violence* 2 (1987), pp. 367-379; and John Briere & M. Runtz, "Symptomatology Associated with Childhood Sexual Victimization in a Nonclinical Adult Sample," *Child Abuse and Neglect* 12 (1988), pp. 51-59.

6. Marion Cuddy & Kathryn Belicki, "Nightmare Frequency, Night Terrors, and Related Sleep Disturbance as Indicators of a History of Sexual Abuse," *Dreaming* 2 (1992), pp. 15-22.

7. Marion Cuddy, "Predicting Sexual Abuse from Dissociation, Somatization, and Nightmares," Doctoral dissertation, York University, Ontario (1990); and Kathryn Belicki & Marion Cuddy, "Identifying a History of Sexual Trauma from Patterns of Dream and Sleep Experience," in D. Barrett (ed.), *Trauma and Dreams* (Cambridge, MA: Harvard University Press, 1996), pp. 46-54.

8. Angela DeDonato, Kathryn Belicki & Marion Cuddy, "Rater's Abilities to Identify from Nightmare Content Individuals Reporting Sexual Abuse," *Dreaming* 6 (1996), pp. 33-41.

9. Kathryn Belicki, "Survivors of Sexual Abuse and Their Dreams," paper presented to the Association for the Study of Dreams, Santa Cruz, California (June 1992).

10. H. J. Eysenck, "The Effects of Psychotherapy: An Evaluation," *Journal of Consulting Psychology* 16 (1952), pp. 319-324.

11. Kathryn Belicki, B. Correy, Marion Cuddy, Alicia Dunlop & A. Boucock, "Examining the Authenticity of Reports of Sexual Abuse," paper presented to the Canadian Psychological Association, Montreal, Quebec (June 1993).

12. Mary Barzyk, Kathryn Belicki, Diane Bell & Alicia Dunlop, "Individuals Who Have Been Sexually Abused and Their Experience with Therapy," paper presented to the Canadian Psychological Association, Montreal, Quebec (June 1993).

13. Diane Bell & Kathryn Belicki, "A Community-based Study of Well-being in Adults Reporting Childhood Abuse," *Child Abuse and Neglect* 22 (1998), pp. 681-685.

14. J. D. Bremner, J. Krystal, S. Southwick & D. Charney, "Functional Neuroanatomical Correlates of the Effects of Stress on Memory," *Journal of Traumatic Stress* 8 (1995), pp. 527-553; Wendy L. Hovdestad & Connie M. Krisiansen, "Mind Meets Body: On the Nature of Recovered Memories of Trauma," *Women and Therapy* 19 (1996), pp. 31-45; and Bessell van der Kolk & R. Fisler, "Dissociation and the Fragmentary Nature of Traumatic Memories: Overview and Exploratory Study," *Journal of Traumatic Stress* 8 (1995), pp. 505-525.

15. Kathryn Belicki, S. Kelly, B. Correy, Marion Cuddy & Alicia Dunlop, "Individu-

als Reporting Disrupted Versus Continuous Memory for Abuse," paper presented to the Canadian Psychological Association, Penticton, British Columbia (June 1994).

16. Elisha Chambers & Kathryn Belicki, "Using Sleep Dysfunction to Explore the Nature of Resilience in Adult Survivors of Childhood Abuse or Trauma," *Child Abuse and Neglect* 22 (1998), pp. 753-758.

17. For a scholarly discussion of the "sceptic versus true believer" rhetoric, see: Kenneth S. Pope, "Scientific Research, Recovered Memory, and Context: Seven Surprising Findings," *Women & Therapy* 19 (1996), pp. 123-140.

FRAMING WOMEN'S TESTIMONY

Sue Campbell

Since its inception in 1992, the False Memory Syndrome Foundation (FMSF) has had considerable success at persuading the public that a set of contemporary influences — such as feminist theory, feminist-oriented therapy, self-help books and Oprah-style talk shows — has so affected women that we are not trustworthy as rememberers when we speak of past abuse. They have also undermined women as rememberers by attempting to control the positions from which women can narrate abuse. The success of the FMSF makes it overall less likely that a woman can now come forward and testify to abuse in her past, thus creating a social climate more friendly to abusers.

When a woman acts as a rememberer, when she makes claims to others justified by her memory, she is often in the vulnerable position of narrating a view about the significance of the past to the present that is not shared by the dominant members of her culture. The success of her narrative will depend on whether others grant authority to her as one who can speak about the past. In this article, I will attempt to show how the

FMSF is seeking to challenge women as rememberers partly by undermining the credibility of their positions as memory authorities.

In section 2, I outline a view of memory as a complex set of cognitive abilities and social activities. In section 3, I point to the general vulnerability of women as rememberers. I also describe an FMSF strategy that makes women even more susceptible to having their memories distrusted by restricting the position from which a survivor can speak about her past. The FMSF encourages us to regard women's memories as if women are always giving legal testimony. That is, the FMSF attempts to make those who speak of past abuse immediately subject to the standards of truth, falsity and scepticism found in legal proceedings. In section 4, I describe an alternative narrative position called "testimonio" where both the point of the narrative and the expectations placed on the listener are quite different from those found in a legal context. Testimonio is, I believe, a more productive way to approach narrations of abuse. Finally, in section 5, I argue that FMSF writings specifically deny this alternative position to women.

The Complexity of Memory

"Memory" is the name we give to a system of cognitive capacities and abilities that make it possible for us to learn by experience. Memory is more than the rememberer's access to her past experience as information processed, integrated, and useful to the present. I define memory very broadly as the significance of a person's past experience to her present situation.

One reason for a broader conception of memory is that we require a flexible understanding of what forms memory information can take. Memories are not always unproblematically processed and transparently available to the rememberer. Even memories of mundane events are often indistinct or only half remembered. Writers on trauma stress that trauma memory is often fragmentary, intrusive and highly sensory and embodied:

> "... Bits of memory, flashing like clipped pieces of film held to the light, appear unbidden and in surprising ways, as if possesses of a life independent of will or consciousness." [1]

For a survivor of an adult trauma, memory may take the form of vivid flashbacks of the traumatic event, a reliving of the trauma. Because

children have often not yet developed the capacities to sort experience into adult categories, memories of childhood trauma may be a complex and confusing blend of sensory, representational and symbolic features. While narrow conceptions of memory treat forgetting as a memory lapse or failure, the real value of our memory depends not only on forgetting much useless detail, but on strategies of motivated forgetting of things whose memory would cause us unendurable pain and loss.[2] In this sense, what we do not or cannot remember is often as significant to our present as what we do remember.

A second advantage of a broader understanding of memory is that such an understanding helps direct attention to how much of our memory experience is social and public. I do not only recognize, remember, forget, recall, memorize and relive *for myself*, but also recount, commemorate, reminisce, remind and testify *to others*. How successful I am at these activities does not just depend on how well my memories resemble past events, but also on whether others grant my memories some authority. Whether I am seen as credible depends on my being granted that status by others. It is, then, a mistake to try to understand the importance and structure of memory by examining only the cognitive mechanisms or the content of memory experiences. We must also pay attention to the occasions when memories are formed and when memories are spoken.

There are many different types of memory narratives ("stories" of the past) and they serve different purposes. To express the significance of the past to the present is not always to make claims to truth or historical accuracy. Significance may, for example, be expressed through culturally shared stories where factual detail is of less concern than characters, themes and values. At other times, the social context is one in which the values of truth and believability are dominant. When truth is one of the primary values of a memory narrative — however questionable, difficult to arrive at, or social this truth may be — the narrator occupies a position that is testimonial. Philosopher C.A.J. Coady characterizes the occasion of natural testimony as any occasion on which "we are invited to accept something or other as true because someone says it is, where the someone in question is supposed to be in a position to speak authoritatively on the matter." [3]

We are tremendously reliant not only on our own memory, but on the testimony of others, and they are reliant on our testimony. We recognize the importance of memory testimony as our access to the past by according explicit memory claims a certain authority. When someone says "I remember," they are held to be making a knowledge claim, and are regarded as

having the responsibilities of one who makes a claim from a position of knower. A knower is responsible for making sure her claim is justified or made with good evidence. However, the testifier's sense of responsibility is not all that is necessary to the success of testimony. Thomas Aquinas, a 13th-century philosopher, argued that because we are all so reliant on each other's testimony, responsibility must in general be shared between the testifier and those who listen to the testimony. Those who listen to testimony have the general responsibility to have faith in the testifier, that is, the responsibility to give the rememberer the social authority to make claims about the past:

> "And since among men dwelling together one man should deal with another as with himself in what he is not self-sufficient, therefore it is needful that he be able to stand with as much certainty on what another knows but of which he himself is ignorant, as upon the truths which he himself knows. Hence it is that in human society faith is necessary in order that one man give credence to the words of another, and this is the foundation of justice ..." [4]

Aquinas points out that much of our social interaction depends upon our taking on faith that which another says is true. If you tell me stories about growing up, I trust that what you say is true, unless I have some other reason to suspect that you may be lying. In the absence of some special reason to suspect that what you say is not true, Aquinas thinks my first response must be to believe what you tell me. This is a necessary starting point, if we are going to have any social life at all.

My characterization of memory as the significance of the past to the present is meant to capture two further facts about memory. Both facts are political and troubling to the ideas of faith, mutual reliance and justice that inspired Aquinas. First, political struggles over memory are extraordinarily intense. We do not all share a communal view of events in the past and what they might mean to the present. Many of us have been excluded from contributing to the dominant culture's social memory, but struggle at the site of memory precisely because what has been forgotten forms, for us, the significance of the past to the present. Caribbean-Canadian poet M. Nourbese Philip consciously remembers the history of the slave trade to "defy a culture that wishes to forget; to rewrite a history that at best forgot and omitted, at worst lied." [5]

Secondly, we treat ourselves and others as rememberers on some occasions and not on others. In reminding Canadians of the slave trade,

Philip claims a certain complex narrative position of memory authority — a storyteller, testifier and historian. She designates herself a "long-memoried woman," evoking a figure of the wise-woman storyteller, a woman who can remember so far back that she witnessed and can tell "of what did not happen to me personally, but which accounts for my being here today," [6] a story of origins. When she prefaces many of her subsequent statements with "I remember," she claims both the position and responsibility of a knower about the past. What I wish to point out here is that her position as a rememberer is explicitly claimed. While nearly all of what we do or say is memory reliant, we do not always take ourselves to be speaking with memory authority, nor are we always regarded as doing so by others.

In a testimonial context, I am increasingly likely to make a claim that explicitly depends on memory, when there are no public records to verify what I say, when public records conflict with what I say, or when I want to emphasize the significance of my past. The circumstances in which individuals are likely to rely on memory as a justification for their claims are circumstances in which there may be no independent support for what they say.

Individuals who make memory claims are thus often in an inherently vulnerable social position. The rememberer, while claiming memory authority with its attendant responsibilities is, on those very occasions, in a position of vulnerability where the response of the interpreters to the narrative — whether they operate with Aquinas' trust or with scepticism — becomes important to the success of the narrative. Finally, we may sometimes be put in a position where we have testimonial responsibilities, and so must speak the truth, but where we have little or no recourse to independent support to verify our claims, and where we are made especially vulnerable by the responses of others.

Who Frames the Viewpoint?

Coady identifies the ordinary testifier as one "who is supposed to be in a position to speak authoritatively." Aquinas' addendum — that "faith is necessary ... and this is the foundation of justice" is a warning that real authority about claims about the past does not come simply with the occupation of a testimonial position, whether this position is assumed or determined by circumstance, but depends on the attitude of those, who in

that particular context, witness the testimony. One political strategy, then, for undermining women's memory narratives is to attempt to control testimonial positions such that women testify to abuse in positions that are associated with the responsibilities of making knowledge claims, but in a context which requires interpreters to be highly sceptical. I believe this attempted control of testimonial positions is an important part of FMSF strategy.

To set the context for examining FMSF strategy, it is first worth noting that women have special and longstanding social vulnerabilities and responsibilities as rememberers that undermine possibilities of their testifying to abuse. At a very general level of concern, women in most cultures seem to have less memory authority than men. According to James Fentress and Chris Wickham, the authors of a historical cross-cultural study of social memory, women have been responsible for commemoration of the home, and for socializing children into family values through emphasizing and passing on good family memories. They also state that the authority of a woman's view of the past varies with her culture's tolerance towards female points of view, but, in general, has been prevented both by dominant ideology and, significantly, by dominance over narration:

> "Most men interrupt, devalue their wives' memories, take over the interview, tell their own stories instead, or even, most bizarrely, themselves recount their wives' life stories." [7]

In addition to this general narrative disadvantage, women's abuse narratives in the West conflict with dominant social memory, with the culture's authoritative story of its past and its identity as formed by this past. Elizabeth Loftus, an academic advisor to the FMSF, speaks for dominant social memory of the family when she introduces scepticism about women's narratives of abuse with these words:

> "No parent-child relationship is perfect. When we reflect back on the past, we often find ourselves wishing that our parents had given us more attention, more respect, more love. These are universal yearnings, and even people who grew up in the happiest of homes experience regret and disappointment ..." [8]

It is the memory of the family as a fundamentally happy and secure place for children that women who allege abuse are directly calling into question. Things become even more difficult for women who attempt to make an abusive past a part of social memory when we notice that women

are responsible for commemorating the very sphere abuse victims are now held to be attacking.

Studies of social memory indicate the highly constrained narrative positions allowed to women as rememberers and suggest the special difficulties they might have in testifying to abuse. I now turn to a specific strategy of the FMSF oriented towards maximizing interpreter distrust of women's narratives.

The FMSF presents abuse narratives as if all issue from claimed testimonial positions of women and most lead to criminal action against the purported abuser. The quasi-legal framing of abuse narratives has been readily accepted by the public and justified by the legal penalties for abuse. But, in fact, women rarely take their abusers to court, and when they do, it is most often a civil, and not a criminal, proceeding. The foundation's framing of abuse serves the ulterior strategic purpose of forcing upon the incest survivor a narrative position that resembles a legal proceeding. Thus, she is immediately put in an adversarial setting of interpreter distrust and challenge.

The FMSF insistence on the legal context as a cultural frame for regarding incest is, first, a way of compelling all women who speak of their abuse to take on the responsibilities and vulnerabilities of legal testifiers who have a stake, perhaps vengeful, in the jailing of their own parents. The appropriate interpreter response is evidently meant to be one of a watchful and alarmed scepticism, as if they are a member of the jury. Secondly, the FMSF insistence on a quasi-legal interpretation of abuse narratives safely places the perpetrators of abuse in a cultural position of not having to act as testifiers; they are instead deniers of the "charges." They may deny or simply stand silent and thus do not speak with the same kind of vulnerability that characterizes memory discourse.

Thirdly, narrative position can also significantly determine what counts as forgetting and whether forgetting is regarded as serious memory failure. Obviously, not everything that I once experienced but do not, at present, recall is a case of forgetting. It will count as forgetting only if I cannot remember it in a context that demands it as memory. Because memory narratives involve the significance of the past to the present, this context may have to do with what is of importance to the interpreter rather than the narrator of a memory experience.

It is striking how much detail we can, as interpreters, require of someone's memory. If I say that I remember our dinner, but cannot remember, on your challenge, whether it took place on a Tuesday or Wednesday or what you ate, I may have to withdraw my memory claim.

We often see in legal settings the attempt to undermine memory authority by shifting significance to what has been forgotten, even though no one remembers all the details of an incident in the past. In certain contexts, I can maintain a memory claim only if there is a certain amount I have not forgotten in the surroundings of the past event, and what I am responsible for is often determined by challenge. The framing of women's abuse narratives as quasi-legal testimony encourages the public, as interpreters, to take the stance of cross-examiners who categorize forgetting as memory failure and insist on completeness and consistency of memory detail through all repeated tellings.

Finally, the intent and effect of this insistence — that all abuse narratives are made from within a particular aggressively assumed testimonial position — is not only to decrease the possibility of a sympathetic hearing for women who do seek legal redress, but also to compel women whose memories are traumatic — embodied, fragmentary and confusing and difficult to interpret — to be silent about their experience. This silence is enforced by denying them alternative testimonial positions, particularly the position of performing or enacting testimonio.

"Testimonio": An Alternative Model

Testimonio is a form of self-narrative concerned with harms done to those who are excluded from power in our society, harms including oppression, poverty, abuse and discrimination. The use of the term "testimonio" to describe this type of narrative is fairly recent and comes from Latin-American Spanish. In Latin America, testimonio is recognized as a form of resistance literature involving the first-person narration of political harms the narrator has witnessed or endured. Testimonio is concerned not only with problematic social situations, but also with the difficulties of making these situations understood and urgent for others who are meant to witness or sometimes intervene. Finally, the people engaged in testimonio speak not only for themselves, but "in the name of a community or group." [9]

The testimonio voice is doubly dependent for its existence: first, on the collective it represents, and secondly, on those who facilitate testimonial speech through witnessing, interpreting, translating, recording, reporting and disseminating testimonial narrative. The legal connotations invoked by testimonial narrative imply a pledge of honesty on the part of the narrator. Those who hear testimonio, however, acknowledge the

testifier as vulnerable. Because memory as evidence for claims often comes without corroboration, Aquinas recognized the vulnerability of the everyday testifier by promoting faith as the appropriate interpretative response. Those who engage in testimonio face the additional vulnerability of narrating claims that conflict with dominant social memory. Testimonio is a narrative of self and memory made possible by the interpreter's trust in the credibility of the narrator, and it therefore differs from formal, legal testimony as a narrative position. With the recognized inadequacies of formal judicial settings as forums in which people can obtain a hearing for claims of abuse, testimonio is expressed in resistance literature and personal memoir, in documentary film and video, in anonymous graffiti, and, for many incest survivors, in therapeutic contexts.

The existence of a testimonial pledge does not, of course, guarantee the truth of the testimonial claims. Rather, our assuming the presence of this pledge indicates the respect that we accord others as rememberers in certain circumstances. In our granting to others the position of testimonio, we are respecting, as rememberers, those who narrate accounts of their own harm and oppression. We are acknowledging, at the very least, that the testifier is a person of integrity, that she can represent others who have been silenced by harm, that these harms take place and are serious, and that we may be called upon to act.

According to trauma survivors and those who work with trauma survivors, the narration of traumatic harm is a necessary part of recovery. Speaking of the harm can help the trauma victim to restore a sense of continuity with her past, to gain control over intrusive memories, and to regain a sense of subjectivity and self-integrity. Moreover, Roberta Culbertson points out that traumatic violation destroys the victim's secure connection to the social world and that this connection can be rebuilt through narrative:

> "To establish a relation again with the world, the survivor must tell what happened ... In doing so it becomes possible to return the self to its legitimate social status as something separate, something that tells, that recounts its own biography, undoing the grasp of the perpetrator and reestablishing the social dimension of the self lost in the midst of violation." [10]

Giving incest survivors the opportunity for testimonio facilitates recovery from the harms of incest at an individual level, and, on a social level, acknowledges that women are subject to incest in our society and

that it is a serious harm to them. Only recently have women begun to testify about incest, for it is only recently that this has been a possible testimonial position for women. Since 1978, with the publication of Louise Armstrong's *Kiss Daddy Goodnight*,[11] there have been many incest testimonios, and books written about incest frequently contain a significant amount of testimonial narrative.

The Denial of Testimonio

The notion of abuse victims as engaged in politically powerful testimonio is one that the FMSF would like to discredit, and, in fact, it would like to deprive women entirely of this narrative position. The foundation's success at undermining the idea of incest testimonio has been dependent on the vulnerable position of such narrative in the first place. Testimonio is a fragile type of self-narrative. People who engage in testimonio speak from a position of marginalized victim. Testimonio is a particularly difficult narrative stance for Anglo-European women for whom the status of victim is seen as self-indulgent by those who may have little sense of what constitutes real suffering. This group of women has frequently been criticized by other groups of women and by men for too easily adopting the language of victimization. People considered by some to be most likely to have false memories are, as well, white, middle-class, initially heterosexual, able-bodied and fairly young — and therefore privileged with respect to race, economic class, sexual orientation, ability and age. It is no surprise that this group has been the focus of the FMSF's attention, as the foundation's political success has depended on attracting the economic and political power of a fairly affluent membership. And finally, the kinds of abuse to which women are prone are often harmful acts done to them on an individual basis, and in private, making the collective voice that gives power to testimonio much more difficult to achieve.

In the presentations of the FMSF, there is no narrative category of incest survivor testimony. The word "testimony" is explicitly avoided, even when the women have not at any time forgotten abuse. Many women have told of trauma-associated problems with recall of the abuse. Such tellings are persistently and dismissively referred to, in writings recommended by the FMSF as "anecdotal." Elizabeth Loftus, in denying that there is evidence for repression, speaks of "clinical anecdotes and loose theory." [12] Richard Ofshe and Ethan Watters say "the only support repression has ever

had is anecdotal." [13] Mark Pendergrast speaks of cases that are cited as "anecdotal evidence of ... repression." [14] Eleanor Goldstein and Kevin Farmer dismiss all testimonial writing on incest as the "hundreds of books [that] have been written validating anecdotal stories." [15]

The notion of "anecdote" to cover all survivor accounts immediately puts incest survivors at a disadvantage and far from the possibility of testimonio. By definition, an anecdote is a brief, interesting, sometimes amusing story, passed along orally, that is, unrecorded. It is typically about someone else rather than about oneself. Relating an anecdote requires no pledge of honesty on the part of the narrator, and listening to one requires no trust or action on the part of the interpreter. Anecdote is far removed from the self-narration of serious harm where the presentation of self is that of the individual in a collective mode, and where the recording or dissemination of the testimony needs to be facilitated by others.

The denial of testimonio to incest survivors is also performed and displayed in many FMSF writings. Interestingly Loftus, Pendergrast, Goldstein and Farmer have used a testimonial style of presentation in their own books. Their work includes many first- person accounts and many excerpts of such accounts. But these tellings are those of accused parents, disbelieving siblings, recanters, or women the authors discredit. Survivor testimonio has no existence for these authors because, despite their endorsement of the claim that incest is both frequent and serious, there is little concession in their presentations that parents who deny having sexually abused a child might, in fact, be guilty of the abuse.

Finally, one of the key opportunities for survivor testimonio, the context of therapy, is now dangerously threatened by a movement on the part of groups influenced by the FMSF to introduce legislation limiting access to therapy and limiting the kind of therapy that can be practised, and by judicial decisions violating the confidentiality of therapeutic contexts. As an example of the first, a 1994 fund-raising proposal for developing model legislation in New Hampshire, entitled *Mental Health Consumer Protection Act*, includes recommendations for eliminating "politicized 'psychology' theories ... backing up such rules with expulsion from the relevant profession." [16] As an example of the second, in 1994, the Canadian Supreme Court ruled that third-party records could be required to be made available in court cases when "they may reveal the use of a therapy which influenced the complainant's memory of alleged events." [17] This decision was the result of *R. v. O'Connor*, a case concerning alleged sexual offences by a bishop against Aboriginal students at a residential school. It

is further disturbing evidence of how the sceptical, adversarial viewpoint of the courtroom is infecting the social contexts in which women can speak of their past. Psychiatrist Judith Herman has argued that cultural acknowledgement of the trauma of incest is impossible without politically committed listeners.[18] The current attack on feminist therapists and on therapuetic contexts is an attempt to disallow the presence of perhaps the most valued and significant group of listeners to incest survivors.

Conclusions

An important ideal of testimonio is that one testifies to others on behalf of those silenced. When incest survivors are denied this narrative position, and placed instead in the isolation of adversarial legal settings, they are denied a community of experience with other women and the recognition of group harm. The incest victim in FMSF presentation represents no group, speaks for no harm but her own, must bear the vulnerabilities of memory narrative alone, in an atmosphere of social distrust and public cross-examination, and without the possibility of a reciprocal challenge, since those she accuses are not seen as rememberers. The burden of proof is squarely upon her and not with the person accused of abuse.

The difficulties for women who engage in sexual harm narratives have recently been eloquently articulated by Martha McClusky, who spoke and wrote about her sexual victimization by fraternity students at Colby College in Maine. She concludes that:

> "It is not the subject matter of one's story — victimization — but rather one's position as authoritative subject that determines whether or not narratives of harm bolster or undermine one's power and authority ..." [19]

The FMSF undermines the authority of women who have survived harm by designating them as rememberers, while at the same time working to deny them testimonial positions where social faith could give their/our projects success.

Endnotes

1. Roberta Culbertson, "Embodied Memory, Transcendence and Telling: Recounting Trauma, Re-establishing the Self," *New Literary History* 26 (1995), p. 169.

2. See: Jennifer Freyd, *Betrayal Trauma: The Logic of Forgetting Childhood Abuse* (Cambridge, MA: Harvard University Press, 1996).

3. C.A.J. Coady, *Testimony: A Philosophical Study* (Oxford: Oxford University Press, 1992), p. 27.

4. Thomas Aquinas, "Commentary on Boethius's *De Trinitate*," quoted in Coady, p. 17.

5. M. Nourbese Philip, "A Long-Memoried Woman," in her book, *Frontiers: Essays and Writing on Racism and Culture* (Stratford, ON: Mercury Press, 1992), p. 56.

6. Ibid.

7. James Fentress & Chris Wickham, *Social Memory* (Cambridge, MA: Basil Blackwell, 1992), p. 12.

8. Elizabeth Loftus & Katherine Ketchum, *The Myth of Repressed Memory: False Memories and Allegations of Sexual Abuse* (New York: St. Martin's, 1994), p. 102.

9. John Beverly, "The Margin at the Centre: On Testimonio (Testimonial Narrative)," in Sidonie Smith & Julia Watson (eds.), *De/Colonizing the Subject: The Politics of Gender in Women's Autobiography* (Minneapolis: University of Minnesota Press, 1992), p. 91.

10. Culbertson (1995), p.179. See also: Judith Herman, *Trauma and Recovery* (New York: Basic Books, 1992), ch. 9.

11. Louise Armstrong, *Kiss Daddy Goodnight* (New York: Pocket Books, 1978). See also: Katherine Brady, *Father's Day: A True Story of Incest* (New York: Dell, 1979); Sylvia Fraser, *My Father's House: A Memoir of Incest and Healing* (Toronto: Collins, 1988); Elly Danica, *Don't: A Woman's Word* (Charlottetown, PE: gynergy books, 1988); and Ellen Bass & Louise Thorton (eds.), *I Never Told Anyone: Writings by Women Survivors of Child Sexual Abuse* (New York: Harper & Row, 1983).

12. Elizabeth Loftus, "The Reality of Repressed Memories," *American Psychologist* 48, 5 (1993), p. 519.

13. Richard Ofshe & Ethan Watters, "Making Monsters," *Society* (March/April, 1993), p. 5.

14. Mark Pendergrast, *Victims of Memory: Incest Accusations and Shattered Lives* (Hinesburg, VT: Upper Access, 1995), p. 101.

15. Eleanor Goldstein & Kevin Farmer, *True Stories of False Memories* (Boca Raton, FL: Social Issues Resources Series, 1993), p. 8.

16. "A Proposal to Finance Preparation of Model Legislation Titled *Mental Health Consumer Protection Act*," jointly sponsored by Illinois FMS Society, Ohio Parents Falsely Accused, Texas Friends of FMS, Minnesota Action Committee and Florida Friends of FMS; project managed by National Association for Consumer Protection in Mental Health Practices, 3 Golf Center Plaza, Suite 249, Hoffman Estates, IL 60195 (August 1994).

17. Quoted in: Connie M. Kristiansen, Susan J. Haslip & Katharine D. Kelly, "Scientific and Juridical Illusions of Objectivity in the Recovered Memory Debate," *Feminism and Psychology* 7, 1 (1997), p. 42.

18. Herman (1992), p. 7.

19. Marsha T. McCluskey, "Transforming Victimization," *Tikkun* 9, 2 (1994), p. 56.

GROOMED FOR SILENCE, GROOMED FOR BETRAYAL

Cindy B. Veldhuis & Jennifer J. Freyd

We cannot afford to become captives of our own pain. Victimization has to be shared — and transcended — together.

— Hanan Ashrawi[1]

What does it mean to speak about abuse? What does it mean to hear about abuse? Does speaking about abuse foster healing? Must it be spoken in a certain way or can it just be blurted out as one discusses the weather and what to eat for dinner? For the hearer, is it enough just to listen or must there be a certain listening stance? Does the listener's response have an impact on the trauma survivor, on her or his processing and/or memory for the event?

And what effects do the words of the abuser have on the traumatized? Can the perpetrator's words (and silences) have an influence on the victim's memory for the event? Can perpetrators and others involved in her or his life have an impact on how the survivor processes the event? Can

a perpetrator influence how deeply the abuse subsequently impacts the survivor and whether or not the survivor tells anyone else?

In this article, we seek to explore the relationships between language and memory in the context of childhood abuse. We will consider this language-memory relationship from various perspectives, including the role of childhood development, the role of adult disclosures, the role of societal responses to disclosures and, especially, the role of perpetrator communication on the victim's subsequent memory and processing of the event. We theorize that, in addition to victim motivations related to coping with betrayal trauma (that is, betrayal by someone close to them), certain patterns of communication within the perpetrator-victim relationship and related patterns of communication within the larger social networks surrounding the perpetrator-victim relationship will have predictable effects on victim awareness and memory of the abuse — and perhaps that the perpetrator can exploit these very dynamics to suppress the child's knowledge of the abuse.

We will focus on the most frequent pattern of childhood sexual abuse: male perpetrator, female victim, female non-offending parent. Some of what we discuss may or may not generalize to other abuse patterns (male victim, female offender, male non-offending parent). For now, we have chosen to explore the more frequent scenario, because it accounts for so many cases of abuse and because we believe it both emerges from and contributes to societal patterns of patriarchal oppression of girls and women. Given this focus in this chapter, we will often use the female pronoun for victims and non-offending parents and the male pronoun for perpetrator.

We also focus on specific "grooming" techniques perpetrators use in gaining and maintaining access to children, including a discussion of things perpetrators look for in choosing children. In doing so, we wish to also state that, while some perpetrators look for certain vulnerability clues in the children and their families, even children who come from very strong and supportive families may be abused.[2]

Abuse, Memory and Betrayal Blindness: Our Starting Point

Truth changes colours depending on the light.

— Eve's Bayou[3]

We take as a starting point the empirically demonstrable facts that many people are abused and traumatized in childhood and that, furthermore, many of those abused and traumatized children grow into adults who experience some significant lapse in memory of the event. While these claims have a long history of controversy and disbelief, we consider the evidence for both propositions (that many are abused and that many of those abused fail to remember the abuse) to be quite strong. In her 1996 book, *Betrayal Trauma: The Logic of Forgetting Childhood Abuse*, Jennifer Freyd has summarized evidence for the reality of childhood abuse and the reality of memory failures for childhood abuse.[4]

While the evidence is strong that some people forget real abuse, the evidence is also strong that memories are subject to error and distortion and indeed, that some memories are highly inaccurate. Memories vary from essentially accurate to essentially inaccurate for both recovered memories and never-forgotten memories. These issues are explored more fully in Freyd's article "Science in the memory debate"[5] along with a discussion of some of the ways science has been used and misused in the memory debate.

Our focus in this article is on understanding the role of communication on awareness of real abuse. We will be building upon Freyd's Betrayal Trauma Theory.[6] Freyd proposed a theory of betrayal trauma and betrayal blindness that attempts to account for how and why people forget childhood abuse and other intimate betrayals. Betrayal trauma refers to events that have a high level of social betrayal, such as being sexually abused by a parent, beaten by a partner or raped by a close friend. Betrayal blindness refers to the victim's tendency to remain unaware of betrayal, whether that betrayal be partner infidelity or childhood sexual abuse. Betrayal Trauma Theory offers an explanation for how and why victims may respond with betrayal blindness to betrayal traumas.

A crucial aspect of Betrayal Trauma Theory is to separate two broad dimensions of traumatic experience: life-threatening or fear-inducing aspects of the event versus social-betrayal aspects of the event. Each of these dimensions of the event is hypothesized to relate to different forms of later distress. When these different forms of distress all occur in the same person, that person may be diagnosed with post-traumatic stress disorder (PTSD). However, some people may have only some symptoms or forms of distress after a trauma, and we believe this is because of the underlying nature of traumatic events themselves.[7]

According to Betrayal Trauma Theory, traumatic events can be harmful to people in two fundamental ways. One dimension of harm is the

fear-inducing, life-threatening and terrorizing dimension of trauma. This dimension of trauma is hypothesized to be related to subsequent symptoms of anxiety, intrusive recollections and hyperarousal (for example, an exaggerated startle response). The other way trauma can harm is due to social betrayal. Betrayal Trauma Theory suggests that amnesia and un-awareness are primarily related to the social betrayal aspects of a traumatic situation. Some traumas, like a violent rape by a partner, have high levels of both life threat/fear-inducing and social betrayal. Other traumas may be highly fear-inducing, but without high levels of social betrayal. An example would be a natural disaster followed by community cooperation.

Most important for this article, some traumas may have very high levels of social betrayal without a great deal of immediate fear-inducing life threat. An example of such an event would be slowly escalating incest between a physically affectionate father and his young daughter. Our focus in this article is on the social-betrayal dimension of negative life events, particularly childhood sexual abuse and the related forgetting and un-awareness for these betrayal events. Betrayal Trauma Theory proposes that it is adaptive to forget certain kinds of betrayal — as in childhood sexual abuse by a trusted caregiver — because forgetting allows the relationship to survive. By not knowing about the abuse, the victim can continue to behave in ways that inspire mutual attachment, instead of pulling away and withdrawing and thereby risking abandonment or even worse treatment. In other words, abuse may be forgotten, not for the reduction of suffering, as has so often been assumed, but because remaining unaware of abuse by a caregiver is often necessary for survival. In addition to theorizing about why abuse is forgotten, in previous works on Betrayal Trauma Theory Freyd has proposed various cognitive mechanisms that could be involved in forgetting.[8]

The perspective offered by Betrayal Trauma Theory is, on the one hand, a perspective that emphasizes the individual victim's motivations and mechanisms and, on the other hand, a perspective that implicitly recognizes the social context surrounding the victim that creates the need for unawareness and forgetting. In addition, Freyd has argued that commu-nication plays a crucial role in awareness, that knowledge gets transformed through communication in ways that profoundly influence awareness. The process of putting something into a narrative — into language — changes the way we think about and remember an event.[9]

Freyd also speculated about perpetrator dynamics, suggesting a pattern she called DARVO for Deny, Attack and Reverse Victim and

Offender. This DARVO pattern is hypothesized to be one that the perpetrator uses in response to attempts at victim disclosure.[10] In this article, we argue that DARVO and other perpetrator strategies not only help the perpetrator avoid accountability, but also impact victim awareness of the abusive events.

We will go beyond the earlier work on Betrayal Trauma Theory by integrating the social dynamics involved in the perpetration and perpetuation of abuse with not only mechanisms of forgetting, but also motivations for forgetting. We argue here that the very mechanisms that perpetrators use to gain access to their victims relate in important ways to the forces that underlie unawareness, silence and forgetting. In this article, we also consider other perpetrator methodologies for initiating and maintaining abuse and how these methodologies may impact victim awareness just as they support the abuse.

We believe that the search for the mechanisms underlying unawareness of abuse eventually needs to be multi-faceted one. There is no one mechanism or any one absolute way in which the memory is lost or kept. Ultimately we must examine the issues from political, societal, familial, community and individual levels (and the interactions of these various levels). We must take into account individual cognitive mechanisms and also social-relational mechanisms of how information can be kept from awareness. In this article, we seek to use such a multi-faceted and ecological approach to the questions of amnesia and unawareness of abuse.

Developmental Issues of Knowing and Talking about Trauma

For young children, it is in dialogue with the parent that memory, and especially autobiographical memory, is formed. Parents create a framework with which they enable the child to develop a self and a memory framework of her or his own. How then would this impact memory for trauma? If a child discusses a traumatic event with a parent, is she or he more likely to recall that event later on? Gail Goodman of University of California at Davis and her colleagues investigated whether mothers' support, or lack thereof, would have a strong effect on children's subsequent recollection of a trauma.[11]

In their study of 46 children (ranging in age from three to 10 years) who were to undergo a Voiding Cystourethrogram Fluoroscopy (VCUG),

a very invasive and often humiliating procedure used when children have bladder or kidney problems, Goodman and her colleagues found that higher suggestibility (errors made because of misleading questioning) and poorer recall correlated with a mother who had no time to help her child through it. It appeared that the mothers who did not offer physical comfort to the child after the procedure, who did not explain the procedure to the child in advance or who did not verbally comfort the child afterwards had a negative impact on the child's memory for the event. Their children were more likely to make errors in recalling the events. Intriguingly, how distressed the child was during the exam was not related to her or his ability or inability to recall what happened.

When a traumatic event occurs, the child is likely to want to talk about the event with someone: to gain support, to validate the reality, to voice the pain and to connect with another. Some traumas are highly shareable (such as being bitten by a dog or experiencing an earthquake) and probably are discussed within the family. After speaking about a shareable event, a child is likely to be comforted, to be allowed to cry, to express anger or hurt and to talk about it until the emotional valence of the event dissipates and until the child can make sense of what occurred.

Some traumas however, are not so shareable, especially sexual abuse. Sexual abuse has great components of shame, humiliation and isolation and is often inexpressible in language. Additionally, children do not fully understand what has happened to them. Yet their silence has been demanded by the perpetrator. Together, all of these factors render sexual abuse unutterable. The child or family is likely to suppress discussion of the events. This suppression makes sense from a variety of perspectives: the child might not be believed, might be punished or rejected; the family might be shattered; the non-offending parent might feel responsible. It may be easier to resist reality than to risk losing one's family.

It is in discussing the full experience of the event that the event gets fully and stably understood and encoded. Language shapes what is recalled and highlights what is noteworthy. What about trauma that is not discussed — not made prominent, not made memorable? What would happen if a parent refuses to talk to the child about the trauma or tells the child that it is her fault that the abuse occurred? What happens to the child's memory for that event? Is it retained, if it is not shared? Further, what happens to the memory of an event if the child is told that what she remembers "never happened"?

Disclosing Trauma

Kathy Pezdek and Chantal Roe of the Claremont Graduate School did a study on the suggestibility of memory for touch,[12] which has important implications for the study of traumatic memory — implications that are not usually considered. Frequently, the literature about suggestibility is applied to suggestibility toward false memories of events and especially toward false memories of sexual abuse. The conclusion is drawn that children and adults are vulnerable to the creation of false memories of sexual abuse when it did not actually occur. However, it is useful to consider the findings a bit more closely.

Pezdek and Roe found that it is easier to change a memory than to implant or erase that memory and, in their study with four- and 10-year-olds, implanting and erasing occurred at very similar rates. Perhaps then, this should be considered to indicate that children's memories are more changeable than implantable. These changes in the memory could be brought about by suggestions of the appropriateness, causes or severity of the events. Another suggestibility paradigm offering insight into this is the research on eyewitness testimony. In these studies, participants' memories for events (such as films of an auto accident) can be changed through suggestion. Elizabeth Loftus was able to change participants' memory for events they witnessed by suggesting details that did not actually occur.[13] When a child discloses, this research suggests that, more likely than being vulnerable to implantation of false memories, children are vulnerable to others changing what is remembered. This may then indicate that children's memories for events may be altered through talking, and when they speak of their abuse and an alternative reality is suggested, this may be what is encoded and remembered.

Children who disclose violence are sometimes met with reactions of denial ("It didn't happen," "You are lying") or accusations of wanting or instigating the abuse ("You led him on," "You wanted it, you are a whore"). Sometimes, they are believed but told to forget, or receive no reaction whatsoever. Nearly 14 percent of the mothers in a study by Jessica Heriot did not believe that their children had been abused and almost 12 percent of the mothers were unsure or inconsistent. Furthermore, the more attached the mother was to the perpetrator, the less likely she was to protect, support or believe her child. And the more severe the abuse, the less likely she was to take action or believe her child.[14]

It is possible that the findings of Goodman et al. on children who underwent invasive medical procedures could be extended to experiences of abuse. When mothers did not comfort or talk sympathetically to their children after the medical procedure, the children were more likely to make errors of omission and commission in later interviews. If a child has an incomprehensible sexual encounter with an adult and is then unable to discuss it with the mother, or if the mother is unsupportive, then perhaps that memory is more vulnerable to suggestion, or possibly the processing of the memory is stunted.

This leads to some questions that deserve further study. If the mother says, "That never happened, you are lying" and/or acts as though all is normal, what does this do to the encoding of the memory? What effect does this social-relational mechanism have on the awareness of the abuse? Can this in effect erase the memory for the trauma, as suggested by the Pezdek and Roe study? Can a suggestion that an abusive event never occurred actually cause the child to lose awareness of the event?

Returning to Pezdek and Roe's findings, children's memories are often alterable, if the right conditions exist (especially if the false event itself seems plausible within the child's autobiographical memory).[15] However, we propose that just as likely, if not more so, children are induced to forget that sexual abuse occurs. Freyd calls this "alternative reality defining statements" (such as "That never happened," "You are lying," "Forget about it") and posits that these statements may well have an effect on the subsequent amnesia for sexual abuse.[16] We theorize that children's memories for traumatic events can be erased or changed, or new versions of events can be implanted in dialogue with the non-offending parent. We also propose that the perpetrator's negations, suggestions and alterations can change memory for the events or perhaps even suppress memory. If the child is told that it is her fault, that she is to blame for the abuse or has led on the abuser, this may well alter her narrative and subsequent processing of the trauma. She may then incorporate this into her memory of the events and perhaps still retain a trace of the original events. Alternatively, the new narrative may replace the child's memory for the event, and take precedence. Just as a child can be convinced falsely that something happened,[17] a parent can also impose an alternative inter-pretation onto the events. If a child discloses to an adult that she has been abused, the parent may agree that the events occurred, but may say, "Yes, that happened, but you led him on; you wanted it." The parent may then be implanting false information and thus changing the child's perceptions of

the event. As a consequence, the event becomes labeled in the child's mind as, "I seduced my father into having sex with me," especially since this explanation has been made to seem completely plausible to the child through the perpetrator's grooming process. As mentioned earlier, the more plausible the implantation,[18] the more likely the child is to believe it to be true. As we will demonstrate, the perpetrator works very hard to convince the victim that she is as responsible for the abuse. If this is later reinforced by her mother or other significant adult, she is likely to replace conflicting narratives with the one that states that the abuse was her fault.

Role of Blame, Self-blame, Shame and Humiliation

Blaming the child for the abuse allows the non-offending parent to remain in relationship with the abuser. This may be especially advantageous if the abuser is the partner, boyfriend or husband of the non-offending parent. It could perhaps be a way of resolving the cognitive dissonance that arises when she tries to reconcile the two thoughts of: "This man abused my daughter" and "This man is my husband and I am dependent upon his support." A similar function is attributed to the role of self-blame in the victim.[19] In order to preserve her relationship with the abuser, the child may sacrifice her self-view and transfer the blame to herself and her own actions. However, while this self-blame may allow the child to continue being in relationship with the abuser, it has long-term detrimental effects.

In a study by Curtis McMillen and Susan Zuravin, they compared the blame attributions and subsequent functioning of 154 low-income women. Women in the study who either blamed the perpetrator or blamed no one for the abuse seemed to fare better in a variety of spheres than women who blamed themselves or their family. Those who blamed themselves suffered lower self-esteem, decreased ability to feel comfortable with intimacy and higher relationship anxiety.[20]

There is as well a relationship between the level of sexual activity and resulting shame and self-blame. In their study of 666 women (192 of whom had been sexually abused), Patricia Coffey et al. found that increased levels of sexual activity in the abuse (that is, abuse involving penetration of some kind) were correlated with higher levels of self-blame and stigma (defined as feeling bad, ashamed, tainted).[21] This is material for further investigation: Does shame and/or humiliation have an effect on memory of abusive events?

Abusers' Effects on Disclosure Process

It's important to digress for a moment and add to the issue of children's disclosures to non-offending parents and relatives. Typically, children disclose to their mothers first, and as mentioned earlier, the outcome of this early disclosure has significant impact on the sequence of events that occur in reaction to the abuse and in the child's subsequent processing, memory and experience of the event. While this is important, it is perhaps not sufficient to place the blame on the non-offending parent for efforts, or lack of effort, to protect the child. One piece of the puzzle that can offer insight on mothers' reactions to disclosure can be found in a feminist examination of the complex relationships that affect the mother.

Offenders are quite skillful at appearing trustworthy, at slithering their way into families and into the confidence of whomever they wish. An important component of the grooming process is setting up family members so that they side with him and discount the child. As mentioned earlier, the closer the mother is to the perpetrator, the more likely it is that she will remain loyal to the perpetrator and disbelieve and fail to protect the child.[22] Perpetrators can (and sometimes do) use this to their benefit. Further, the family dynamics when the abuser is a primary caretaker are important to note.

In Mary de Young's 1994 study on maternal reactions to abuse disclosures, many of the mothers were themselves sexually, physically or emotionally abused by the offender and felt they had no resources for survival should they choose to leave him.[23] Just as children may become blind to the betrayal of the perpetrator to save their relationship with him, the mother may do the same. Just as perpetrators seek out children who will be silent or not believed, perhaps they seek out similar qualities in the mother.

Perpetrator Induced Amnesia

Freyd proposes that it is the element of betrayal that influences a child's memory or amnesia for the abuse.[24] According to Freyd, children must depend on caregivers for survival, but this is compromised in cases of abuse by caregivers. She suggests that people are natural detectors of betrayal,[25] and when betrayal is detected we remove ourselves from contact with the betrayer. In cases where the child is abused by a caregiver, the child must maintain attachment with the caregiver for survival, and in order to do, so must remain unaware of the betrayal. To remain aware of

the betrayal is to cause the child to detach from the caregiver, and thus threaten survival.

Freyd also examined several studies to parcel out the relationship of the victim to the perpetrator, and their recall of the abuse. In a re-analysis of data collected by several investigators, Freyd found that forgetting was significantly associated with incestuous abuse. Yet, in some cases, children become amnesic of abuse by a non-caretaker.[26] Elliott, Browne, and Kicoyne studied incarcerated sex offenders and found 32 percent were the parent of the victim, leaving a full 68 percent who were not in a primary caretaking role.[27] If the offender is not in a caretaking role with the child, and thus the child need not remain unaware of the abuse for survival, what then causes this amnesia?

In Dialogue with the Abuser

As the studies mentioned earlier, children's memories for events are greatly influenced by dialogue as the event is occurring. What, then, would the abuser's words during the abuse do to a child's memory of the abuse? Can the abuser cause the child not to remember or increase the detrimental effects of the trauma? Can what the abuser says determine whether the child talks about what happened?

Just as mothers' dialogues with their children during events affect the child's encoding of memories, we propose that perpetrators create conditions conducive to unawareness by talking during the abuse. In looking at the means by which offenders gain access to children and maintain access to them, it seems that their very methods decrease the child's ability to talk about the abuse and increase the child's proclivity to forget the abuse. Specifically, we will examine the ways in which the perpetrator can groom the child for silence, betrayal, disbelief by others, unawareness and self-blame, and ultimately "groom" them for amnesia.

Groomed for Silence

> *You can spot the child who is unsure of [herself] and target [her] with compliments and positive attention.*
>
> — Michele Elliott, Kevin Browne & Jennifer Kilcoyne[28]

Offenders choose children who appeal to them and who will not speak or will not be believed when they do speak.[29] In the Michele Elliott et al.

study, the child's appearance was important in choosing a victim, but not nearly as important as her behavioural characteristics. Offenders stated that they looked for children who were young or small, lacked confidence (49 percent cited this as the main way they decided whom to abuse) or had family problems and/or were alone.[30]

Anna C. Salter describes a teacher who gave his students self-esteem scales and then used the scores to determine whom to molest.[31] Another offender said, "Kids who felt unloved or not appreciated were easiest to victimize, they needed the love I gave them." [32]

Silence protects the offender from discovery and allows him to continue the abuse. Offenders choose children who are already isolated or will work to isolate the child. Methods of isolation include: making the child feel special (which causes her to depend on the abuser and may also make others jealous of the "special" relationship); turning family members away from the child; keeping her from having friends; and forcing her to focus solely on the abuser's needs.[33] The child may enjoy the special attention and may thus remain silent to preserve the good parts of the relationship. "There were moments I remember enjoying. I mean, I was the ugly one and this was the closest thing I had ever experienced to love because I really did feel unloved. The only physical affection that I remember were the incidents with my father." [34]

It is useful to note also that in studies of barriers to disclosure, adult survivors will echo the offenders' methodologies for ensuring silence. Thomas Roesler and Tiffany Wind surveyed 228 women survivors and found that their top reasons for non-disclosure included shame/guilt, fear for safety, loyalty to the perpetrator, fear of blame or punishment and fear for safety of family.[35]

Groomed for Betrayal

Unless the child and I like each other and find each other attractive, it doesn't work. I have to feel as if I am important and special to the child and giving the child the love she needs and isn't getting.

— From: Michele Elliott, Kevin Browne & Jennifer Kilcoyne[36]

Offenders create a strong bond between the child and themselves — a bond that is ripe for betrayal. Even if the offender is not the primary caretaker, he can maneuver himself into a role in the child's life such that the child is highly dependent upon him for survival. Offenders may hang

out at playgrounds, meet children through friends or family, become child-care providers or baby-sitters or may even date single women with children so that they can abuse her children. Also, as some offenders choose children with already troubled backgrounds, who are insecure, who lack strong adult role models, who are vulnerable and/or lonely, they can easily wend their way into the child's life.

> "... then I begin my game. I start out by saying something to him in a way to make him feel good about himself (e.g. 'Hey buddy, how's it going? It sure is good to see you, I've been thinking about you a lot lately. I think you're one of the neatest guys I know. You're more mature than most kids your age.') ... I showered potential victims with small gifts ... Kids really enjoyed the unexpected extras I showered them with. My purpose in the small gifts was to win the child's trust." [37]

This offender had an 80 percent "success" rate with the children he approached and molested up to 100 children both within and outside his family. It is important to digress for a moment and state that in the Elliott et al. study of 91 convicted offenders, 70 percent of the men had offended against one to nine children, 23 percent had abused 10 to 40 children and 7 percent abused 41 to 450 children.[38] These statistics are significant for a variety of reasons, but, for the purposes of this section, it is most useful to state that they indicate that these offenders are highly skilled at gaining access to children and at maintaining silence. Were they unable to keep the children from disclosing the violence, there is no way they could offend at the alarming rates they do.

Betrayal Trauma Theory proposes that children often forget abuse by caregivers, because remaining aware of the abuse threatens survival.[39] It seems as though perpetrators groom children for such a betrayal. By finagling their way into the family, by gaining the trust and love of the victim, the abuser is in effect making the child dependent upon him. If the child speaks of the abuse or remains aware of the abuse, she threatens the relationship and her own survival. Lucy Berliner and Jon Conte researched children's feelings about their perpetrators and the abuse. More than half of the children stated that they loved, liked, needed or depended upon their abuser. One child said, "At that time, I really needed love and he did love me and told me this. He made me feel like I was really important." [40]

Abusers want the children to be so dependent upon them, so trusting and so devoted to them that despite the abuse, the children remain silent;

and the children's feelings can then be exploited. One offender stated that he "counted on them loving me enough not to tell." [41] Abusers count on the children's desire to please, the children's dependence upon them and the family's trust in them to maintain the silence.

Groomed for Disbelief

These perpetrators are not men most would consider dangerous to children; they are the ones people trust with their children. In order to maintain the relationship with the child and to ensure further access to the child, 20 percent of offenders also gain the trust of the family. One offender in the Elliott et al. study stated that because he was so beyond suspicion, he could abuse the child while the family was in the room. [42]

One offender describes his methods of stalking children and their families for months before even approaching them. He assessed their "interests, needs and weaknesses," [43] so that he could approach them in a manner that would guarantee that they would be receptive to him. Offenders often place themselves in a role with the family that elicits a great deal of trust such as the role of coach, teacher or daycare provider. Salter quotes an offender who discusses his relationship to his victims' families, "In the meantime, you're grooming the family. You portray yourself as a church leader or music teacher or whatever it takes to make the family think you're okay ... And you just trick the family into believing that you are the most trustworthy person in the world. Every one of my victims, their families just totally offered, they thought that there was nobody for their kids than me." [44]

In the case of this offender, the family continued to deny that he hurt their children even after the offender confessed to the abuse, and they maintained a relationship with the perpetrator while he was in prison. By creating an environment where the family becomes more aligned with the offender than with the victim, the offender ensures that he will be believed over the child. Not only will he not be punished, but he will actually receive the family's blessing to continue having access to the child. Thus, when children do speak of the abuse, they are often disbelieved, discounted and blamed.

The following is a statement made by Patrick, a youth minister who admits to molesting "53 hands-on definite victims and 42 others that can be questioned [because of their age]":

> "I knew if he told, there would be little or small amounts of belief in
> him. No one would believe him basically if he told. And in fact they
> didn't. When it became a bigger issue, when I was investigated, the

head of the department of my county said, 'You have nothing to worry about, we can tell from the very beginning that this is all a big scheme.' And it was dropped almost as quickly as it came about ... I had many people: counsellors, church leaders, leaders of the community to come up and stand in my defence ... I had a minister come to me and tell me, he said ... 'Roll with the punches and stick with it, you're doing a good job,' he said, 'and in the end, you'll be blessed for it.' " [45]

This offender later states that, "The more I got into my deviancy, the more I would try to do what was good in the eyes of everyone else." He further admits that his work as a minister, his work with disadvantaged children, his accomplishments in school, were all to cover up his offences. This is not uncommon among perpetrators, and it contributes to their double life, a life where their public selves are highly regarded and trusted by many, while molesting children in private.[46] Sex offenders create a persona for themselves that is highly trustworthy and credible, even in the face of disclosures of abuse. The youth minister quoted above said that people would respond to disclosures by saying, "We know him, and this is not something he would do." To which he responds, "And that is true, because I was very careful that they did not see that behaviour." Not only are offenders careful that the behaviour itself is not seen, but also that the behaviour can in no way be matched onto them. Consequently, others may not even be able to fathom the abuser doing anything harmful because they have come to trust and believe the perpetrator so. When a young girl disclosed that she had been raped and impregnated by her mother's boyfriend, the mother stated, "I would have a hard time believing that somebody in my home, who I loved and trusted, would hurt any of my children." [47]

When the abuser succeeds in getting others to believe him, he can then get them to blame the child. Offenders work to keep their victims in silence and to keep them discredited should they speak. As the youth minister quoted above stated, despite the fact that he had been caught twice before being incarcerated and despite the fact that he had at least 53 victims, he was able to convince those around him that the child was lying.[48] He skillfully convinced others that he was the true victim of false reports and that the actual victim is to blame for the course of events. Not only does this play on family members' or society's desire to trust the abuser, it plays into the child's own self-blame.

Groomed for Unawareness

*Confusion and doubt are not only the experiential scar tissue of
trauma, they are the cunning goals and purpose of the traumatizer.
In a state of doubt the victim cannot recognize her or his own voice.*

— Gilead Nachmani[49]

Offenders may often create an environment in which the child really has
no idea what is happening. By playing on the child's lack of sexual
knowledge and the child's desire for connection, the offender can progres-
sively increase the sexual aspects of their relations. Twenty-eight percent
of the offenders in the Elliott et al. study slowly desensitized their victims,
so that the sexualization of activities became normalized. Thirty-two
percent framed the sexual activities as helpful to the offender.[50]

Desensitization and normalization activities are used to create a rela-
tionship in which sexual activity is a "natural" part of the relationship. Some
offenders began by talking about sex, offering to teach the child about sex,
asking the child about her own sexual attractions, leaving sexual materials
lying around to pique the child's interest (or to use as an excuse for
discussing sex) and slowly work up to touching. Forty-seven percent of the
offenders used accidental touching as a way to gauge the child's reactions
and to normalize physical contact.[51] Slowly and progressively, the child is
seduced into a sexual relationship with the offender.

Perpetrators create an alternative reality, one in which the victim's sense
of reality is denied. The person who gives her the most attention, the most
affection, is the one hurting her. The offender seduces her into a relationship
with him; he tells her he loves her, gives her presents, makes her feel special,
all while preparing her for silence and abuse. Children who have little to no
knowledge of sexual activities, who are vulnerable due to their age, lack of
social support and level of insecurity and who gradually become dependent
upon the abuser for affection and attention, are increasingly led into adult
sexual activities for which they have insufficient knowledge or language. It is
not a part of their reality and thus they have no way of processing normally
what is occurring. Adding to that are the things offenders say to place their
actions into an increasingly confusing, yet progressively "normalized" sphere
of abuse. In the Elliott et al. study, 33 percent told their victims not to talk about
the abuse ("because other children would be jealous" or "your mother
wouldn't like it"); 42 percent told the children that it was just a game or
necessary for their education; 24 percent threatened the child with physical

force or used anger to silence; and 20 percent told the child that they would lose the offender's love if they spoke.[52]

Some offenders place their activities so firmly in what is considered normal that secrecy does not even become an issue. They assure the child that the sexual abuse is a part of normal adult/child activities, that it is "what other little girls/boys do with their daddies," and may even tell the child that there is something wrong with her if she does not want to engage in the sexual activities ("You are being mean to daddy" or "You are frigid").

Groomed for Self-blame

One offender said, "Secrecy and blame were my best weapons. Most kids worry that they are to blame for the abuse and that they should keep it a secret." [53] Offenders also place the blame on the child. To say, "It would hurt your mother if you told" places the culpability for the abuse squarely on the lap of the child. The offender's contention that the child wants the sexual contact and perhaps even instigated it, combined with the offender's coersion, create a great deal of shame and self-blame in the victim. Gail Wyatt and Michael Newcomb found that psychological coercion correlated with self-blame. The more the victim is manipulated into the abuse, the more she will take on responsibility for what occurred. They point out also that even years later, the victim will have difficulty in assigning blame to the perpetrator and will fail to see the coercion and manipulation in words such as, "If you have sex with me, I won't tell your mother that you seduced me." The child in this instance will likely believe that she did in fact seduce the perpetrator and thus is unlikely to disclose, as to do so would be to admit to her own responsibility.[54]

It is important to note that just as this serves as a methodology for seducing the child, the offender also uses it as a way to convince himself that the child is a willing participant. Carolyn Hartley studied the thought processes offenders use to decrease their own inhibitions about abusing. One of the four main distortions of thought was reducing responsibility. Offenders in the study convinced themselves that the children wanted or even invited the abuse, "It, it seemed like ... she really wanted me to do it. It really seemed that way." [55]

The abusers in this study were convinced that were t e child to express displeasure, they would end the abuse. However, in the Elliott et al. study, only 26 percent said that they would stop the abuse if the child said no; 49 percent said they were not concerned about the child's distress and 25

percent said that they would continue the abuse even if it caused the child great distress.[56] This is important to keep in mind when judging responsibility for abuse and in critically analyzing offender statements. Perpetrators convince themselves that the child is an equal partner in the abuse and may convince others of the same. At least one in five perpetrators uses victim blame to deny culpability.[57]

Incarcerated offenders admit that they cause the children to respond as though they invite the abuse. "When they refused, he would act angry, 'sulk' and leave the room. Two of the girls just ignored his reactions. The daughter he offended more seriously felt sorry for him and re-engaged him."

> **R:** "She came back and she felt sorry that I was down ..., 'Don't feel bad, dad. Don't feel down. It's okay.' And I can remember her saying that several times through the times I touched her. She didn't want me to do it ... And every time I had something that I did to her, almost every time, it was that she came back. That was my doing, that wasn't hers. I finagled her into that ... I knew she would ... I manipulated her into those [behaviours]." [58]

Another negative effect of victim blame is the exploitation of sexual arousal. Jan Hindman found that children who experience sexual arousal during the abuse are more likely to experience more severe long-term consequences of the abuse. The sexual arousal is interpreted by the offender as the child's experiencing the abuse as pleasurable. The child internalizes this and blames herself for the abuse.[59] Salter states that offenders will use the child's physical responsiveness to justify the abuse. "Because she is responding physically, she must really be enjoying it, therefore what I am doing is not wrong." While this is a normal response to physical stimulation, the child is likely to internalize it as wanting the abuse and is likely to feel shame for the arousal.[60] As adults, the victims may continue to feel shame for their physical reactions and feel that they were to blame for the abuse.[61]

The children are told that to talk about the abuse would tear the family apart and cause the involvement of the authorities. "If you tell, you're going to get into trouble ... They're going to throw you in jail. You'll never see each other again. The whole family will end up in jail, not just me." [62] Thus, the child is convinced that she is as much to blame for the abuse as the abuser and if she were to speak, she would wreak havoc on the entire family. So, not only is she to blame for the abuse itself, but if she were to speak of it, she would be to blame for the break-up of the family.

Groomed for Amnesia

Her reality has been altered, her trust betrayed, her voice muted and her words disbelieved. The perpetrator has methodically conditioned his victim to endure the abuse in silence. All of these factors decrease the likelihood that she will disclose the abuse to another person. Therefore it is unlikely she will get assistance from anyone else in reappraising the events.

Perpetrators use the grooming process to confuse the child, to desensitize her, to normalize the abuse and to create a bond of silence. This directly interferes with the child's ability to know what is real and what is not and does not allow her to assign a coherent narrative to the abuse. Since she is also likely to be punished or disbelieved upon disclosure, or at least has been convinced by the perpetrator that bad things would happen were she to speak, she is unlikely to share what is happening. In not sharing, in not assigning a narrative to the abusive events, according to shareability theory, the information is likely to remain dynamic and sensory in nature and thus less accessible and retrievable.[63] In other words, the events are stored in the mind not as words, not as stories, but as fragments — dynamic, sensory fragments that cannot be easily spoken or shared. As the events are not shareable, they are also not knowable.

According to Salter, "Grooming presents enormous difficulties for survivors. At the heart of it lies the engagement, manipulation and betrayal of the child's trust. The depth of the betrayal is often much worse than the formal relationship with the offender would suggest, because he has used that formal relationship as a springboard to emotionally seduce the youngster in a much deeper way. The relationship with the offender is often not just a relationship, but a relationship of persuasive warmth." [64]

As mentioned earlier, the closer the perpetrator is to the victim, the less likely she is to be believed if she discloses the abuse.[65] If she is also dependent upon him for survival (physical or emotional), she may need to remain unaware of the abusive aspects of the relationship in order to stay in relationship with him, according to Betrayal Trauma Theory.[66] Because the perpetrator has worked so hard to create a relationship of love and trust, to remain aware of the betrayal would cause the victim to disengage and risk losing a vital relationship. She thus is likely to inhibit recollection of the negative aspects of the relationship and cling to the positive aspects.

The offender seems to work hard to create confusion and self-mistrust in the child and to cause the child to grow increasingly dependent not only

upon the abuser himself, but also on the abuser's version of reality. The child thus loses any trace of what is really occurring and is likely to "forget" the abuse. The perpetrator benefits when the child loses awareness of the abuse, as he can then continue to abuse her and other children without fear. In listening to the words of the perpetrators and in studying their methods for grooming and abusing children, it sometimes seems as though they engineer the entire process to implant amnesia of abuse in the child.

DARVO

> *I think that one of the biggest traits among child molesters is the fact that they lie.*
>
> — Douglas Pryor[67]

Freyd proposed DARVO as a model of what happens when offenders are confronted with their abuses. DARVO stands for (1) Deny, (2) Attack, (3) Reverse Victim-Offender and fits in well with the methods offenders use to silence their victims. Just as offenders demand silence of their child victims, they demand continued silence as the child becomes an adult.[68]

(1) Deny

As discussed earlier, perpetrators deny that they are abusing the child throughout the abuse itself. They deny to the child over and over that what is occurring is abusive; they deny their own culpability; they deny that the abuse is harmful; and they deny any control over what is occurring. This denial continues even after the abuse is disclosed. Through his work with sexual offenders, Gordon Hall has found six ways in which the perpetrators deny their actions after disclosure.

• *Outright denial*: Completely denies any responsibility and denies any truth to the allegations.

• *Amnesia*: Denies any recollection of its happening due to the passage of time, the use of drugs or alcohol and/or being asleep at the time.

• *Minimization*: Admits to some inappropriate behaviour, such as fondling, or states that the abuse occurred only once. Denies that penetration occurs or that it occurred over a longer duration. Also may

minimize effects to victim and denies that any violence occurred or that it had any negative consequences.

+ *Projection*: Places culpability with the victim, or may blame drugs or alcohol or sexual addiction.

+ *Redefinition*: May admit to being aggressive and having trouble with anger and states that this causes the sexual aggression.

+ *Conversion*: Confesses to the violence, but states that he has been reformed and will never do it again or that he has suffered enough from his own guilt and depression.[69]

Elizabeth Mertz and Kimberly Lonsway call these types of denial "language games." An example they use is of a perpetrator who states, "I accidentally touched her when helping her into her pajamas." [70] This statement could of course be true. However, accidental touch is an early stage of desensitization in the grooming process and therefore touch such as this could be "accidentally on purpose," and a precursor to intensified sexual activities. Salter notes that children who disclose abuse while they are being groomed are at a particular disadvantage.[71] Although they may experience the contact or attentions as unwanted and uncomfortable, the actions are ambiguous and thus can easily be dismissed by the perpetrator or by non-offending adults. The perpetrator statement could also be an example of minimization on the part of the offender who, when confronted, minimizes the intentionality of the action: "It was just an accident." [72]

(2) Attack

Offenders blame their victims for the abuse. They state that the child seduced them, that she wanted the abuse, that she needed it for her sexual education or that she deserved it. This blaming and attacking often continues when the adult discloses and may be blamed for "tearing the family apart."

She may be "diagnosed" (often without an actual examination) as having a "syndrome" or "disorder" that serves to locate her memories in the realm of a mental illness.[73] Mertz and Lonsway cite an offender who attacks his victim and her mother by calling them "overly sensitive, neurotic [and] angry." [74] Thus, she remembers or speaks of abuse because there is something wrong with her. If she seeks therapy because of her memories of abuse, the therapist is then attacked, because the therapy then

results in "shattered families and lawsuits ... Given their entrenched belief in recovered memories, they are perfectly capable of rationalizing away the palpable pain and bewilderment of the accused parents." [75]

(3) Reverse Victim/Offender

> R: "In this country, we're puritanical when it comes to sex. Others don't look at it like we do. Like in Sweden, eleven is legal, eleven or older. I don't know about other countries. It's looked on differently elsewhere ... If a twelve and fourteen-year old boy jack off [together], it's okay. But if I do it with them, then I should go to jail or be put in an institution." [76]

This quote is particularly interesting as it exemplifies the last two pieces of DARVO. The offender attacks society and its conventions by claiming that we are too "puritanical" in our views of sex. Then he calls himself the true victim of such a society and states that if he were to engage in "normal" sexual behaviour with boys, he would be punished.

By denying, attacking and reversing perpetrators into victims, reality gets even more confusing and unspeakable for the real victim. The victims' ability to perceive reality is distorted, removing the events and experiences even further from language. These perpetrator reactions increase the need for betrayal blindness. If the victim does speak out and gets this level of attack, she quickly gets the idea that silence is safer.

Sociocultural Contributions to Abuse and Unawareness

We believe that there are cultural beliefs and values that allow the continued perpetration of sexual abuse and that deny the victim the right to a voice. Some of these abuse-supporting beliefs include:

• Parents, especially fathers, have the right to do whatever they please with their children.

• Family matters should be kept private.

• Adults are to be believed over children; their memories and perceptions are accurate.

• Child abuse happens, but after a certain age, the victim should just "get over it."

+ There is great tolerance for acts committed while under the influence of drugs and alcohol.[77]

+ Talking about violence and abuse is worse than the acts themselves.[78]

+ Society is tolerant of sexual interest in children,[79] and believes that children have sexual desires and the ability to consent or not to sexual activities.

+ Men tend to sexualize,[80] and cannot control themselves.

+ Once a woman is sexual, she is tainted and any further sex cannot be considered rape.

+ Children and women who allege abuse are themselves disordered.

+ Memory, especially children's and women's memory and/or memory for abuse, is implicitly untrustworthy.[81]

Together these beliefs help bystanders support perpetrators of abuse. Individuals and larger social groups, who hold some or all of these beliefs, may not perpetuate abuse directly, but may nonetheless contribute to the perpetuation of abuse and to the continuation of silence.

Talking as an Adult

Awareness of the existence of sexual abuse of children is too painful and too threatening to encounter unmediated; hence, fully understanding responses include shrinking away from it or flatly denying its existence.

— Lynn Henderson[82]

Intriguingly, just as a child who speaks of sexual abuse encounters resistance, blame and denial, the adult may find herself faced with similar disbelief. An adult who speaks of sexual abuse may also be told that she must "get over it," that she is confabulating or just trying to gain attention by fabricating trauma narratives. The results of Heriot's 1996 study on maternal protectiveness[83] offer insights into adult disclosure. Mothers are less likely to believe and protect if the offender is someone trusted and also less likely to believe and protect if the abuse includes penetration; perhaps this same pattern occurs when the victim grows up and talks about the abuse. If a woman describes fondling by a stranger, is she more likely to be believed than if she describes forced penetration by her father? If she describes abuse by someone no one trusts, as opposed to abuse by the "pillar of the community," does this alter how we as a society judge her

reliability? Take, for example, the documented abuse case of a seven-year-old girl who was strapped to a torture wheel, beaten and shown a sexually explicit film. The abuse was discovered accidentally when police investigated the drowning death of a three-year-old girl (whose autopsy indicated that she had been sexually abused).[84] Had the seven-year-old purposely disclosed the abuse, would she have been believed?

Given what we understand about the propensity of non-offending parents to disbelieve abuse disclosures when they involve severe abuse, it is likely that she would have been dismissed as confabulating. Had she come in and described scenes of torture, being strapped to a wheel, had she described the "sadomasochistic dungeon filled with whips, leather masks, a coffin and a guillotine," [85] would the adults to whom she disclosed have taken her seriously? Would they have labelled her crazy or desperate for attention? Or might it have been suggested that the memories had been implanted by an unscrupulous therapist or a vengeful mother? And what will happen when she speaks of this when she is an adult?

Again and again women are ostracized for speaking of the abuse. Silence is reinforced; speaking is punished. Why is it that the act of speaking is more threatening than the act of sexual violence against women and children? A woman who disclosed the abuse to her mother describes her mother's reaction: "She told me that I had ruined her life." [86] The abuser did not ruin the mother's life; the daughter, by merely speaking the truth, did. Jon R. Conte describes the difficulty in empathizing with victims of sexual abuse:

"Many of us, when viewing the adult members of our families and communities who abuse their own children and noting the resemblances between those adults and ourselves, tend to overidentify with the offender and thereby minimize what they do. As a result, we connect not with the pain of the victims or the needs of the adult sexual offenders to be helped to control their own behaviour, but rather with what it would be like if we were removed from our homes, lost contact with our family or had to experience the other logistical and emotional problems that the incest offender faces when the abuse is disclosed." [87]

This stance is well explicated by the words used to describe the boys accused of raping a young women in the Glen Ridge, New Jersey, gang-rape trial: "They're such clean-cut boys ... it's such a shame ... I'm a mother and I have such compassion for what they're going through." [88] Despite the fact that the boys did not deny raping the young woman, the

town rallied around them and insistently defended their actions and blamed the young woman. This overidentification with the perpetrator is alarming and unfortunately common.

Adults who speak of early traumas are blamed for infecting the culture with their narratives. They are told that their stories spread "'over the landscape like a stain' infecting the culture with a mixture of sorrow, depression and impotent rage." [89] The descriptions of abuse cause others to feel helpless; they force the culture to become aware of the traumas children endure and render the listener impotent to effect change. Women and girls finally begin to speak of the violences in their lives, finally feel as though they have a right to safety and a right to control their own bodies, and they are at once discredited and blamed for speaking. Fine et al. note that it is not the actual abuse or violence that causes society to fragment, but the act of speaking of the abuse or violence: "We watch the girl/woman wither as she sees her story be denied, denigrated, reconstituted or respectfully discarded ... Her demands for male accountability, once voiced, are considered shrill, partial and vengeful if repeated." [90] Is there a right way and a wrong way to speak of trauma? To criticize the manner in which women talk about the abuses they have experienced may serve to deny their experience and their right to discuss it.

Further Explorations

Many of the issues that we have raised in this chapter regarding abuse, awareness, communication and perpetrator dynamics deserve further exploration. It may also be fruitful to draw parallels to related bodies of literature. For instance, culturally based denials of interpersonal violence and abuse and culturally based criticisms of those who speak about this violence and abuse are topics that feminists have explored in great detail over the past few decades. These topics have also been explored with a specific focus on incest and sexual abuse. A next step may be to connect these analyses by focusing on the ways perpetrators take advantage of the victims' needs to remain unaware and take advantage of society's complicity in that unawareness.

There is also a compelling similarity between the grooming process outlined in this paper and grooming techniques used to support other forms of violence such as political torture, preparation for war, domestic violence and rape.[91] This holds implications for further study into memory disturbances

and effects on processing in a variety of violent acts where the victim is slowly groomed for dependence upon the abuser and where the violent and abusive behaviours are normalized.

There also may be parallels between the grooming process in child sexual abuse and the victim's subsequent difficulty with understanding what is and isn't violent or abusive in later relationships. Perhaps "normalizing" past abuse leads the victim to ignore signs of abuse in other relationships and causes her to remain unaware and silent when violence is perpetrated against her in future relationships.

While more questions may have been raised than answered in this article, we have sought to shed light on issues that are of deep importance to humankind. Our particular goal has been to extend and bridge previous work on victim awareness, the role of communication and perpetrator dynamics. Much research remains to be completed. We have raised questions that beg empirical research. In other cases, clinical wisdom and conceptual consideration will be most valuable. We believe that the precision and rigor of scientific and scholarly approaches, combined with compassion and attention to lived experience, offer great promise for the study of abuse and individual and collective awareness for that abuse.

Endnotes

1. Hanan Ashrawi, in Sapphire, *American Dreams* (New York: Vintage Books, 1996), p. ix.

2. The preparation of this manuscript was supported in part by grants to Jennifer Freyd from the University of Oregon Center for the Study of Women in Society and a Summer Research Award from the University of Oregon. We are grateful to Ken Pope, Grant Fair, Louise Armstrong, Anna Salter, Cheryl Capek and Diana Cook.

3. Kasi Lemmons, *Eve's Bayou* (Trimark Home Video, 1997).

4. Jennifer J. Freyd, *Betrayal Trauma: The Logic of Forgetting Abuse* (Cambridge, MA: Harvard University Press, 1996).

5. Jennifer J. Freyd, "Science in the Memory Debate," *Ethics & Behavior* 8, 2 (1998), p. 8.

6. Jennifer J. Freyd, "Betrayal Trauma: Traumatic Amnesia as an Adaptive Response to Childhood Abuse," *Ethics & Behavior* 4 (1994), pp. 307-329; Freyd (1996); Jennifer J. Freyd, "Violations of Power, Adaptive Blindness, and Betrayal Trauma Theory," *Feminism & Psychology* 7 (1997), pp. 22-32; and Jennifer J. Freyd, "Memory for Trauma: Separating the Contributions of Fear from Betrayal," invited chapter for Jon R. Conte (ed.), *Child Sexual Abuse: Knowns and Unknowns — A Volume in Honor of Roland Summit* (Thousand Oaks, CA: Sage, in press).

7. Freyd (in press).

8. Freyd (1994; 1996; in press).

9. Jennifer J. Freyd, "Shareability: the Social Psychology of Epistemology," *Cognitive Science* 7 (1983), pp. 191-210; and Freyd (1994; 1996; 1997; in press).

10. Freyd (1997).

11. Gail S. Goodman, Jodi A. Quas, Jennifer M. Batternam-Faunce, M. M. Riddlesberger & Jerald Kuhn, "Predictors of Accurate and Inaccurate Memories of Traumatic Events Experienced in Childhood," in Kathy Pezdek & William P. Banks (eds.), *The Recovered Memory / False Memory Debate*, (San Diego: Academic Press, 1994), pp. 3-28.

12. Kathy Pezdek & Chantal Roe, "The Suggestibility of Children's Memory for Being Touched: Planting, Erasing and Changing Memories," *Law and Human Behavior* 21, 1 (1997), pp. 95-105.

13. Elizabeth L. Loftus, *Memory: Surprising New Insights into How We Remember and Why We Forget* (Reading, MA: Addison-Wesley, 1980).

14. Jessica Heriot, "Maternal Protectiveness Following the Disclosure of Intrafamilial Child Sexual Abuse," *Journal of Interpersonal Violence* 11, 2 (1996), pp. 181-194.

15. Pezdek & Roe (1997).

16. Freyd (1996).

17. Pezdek & Roe (1997).

18. Ibid.

19. Curtis McMillen & Susan Zuravin, "Attributions of Blame and Responsibility for Child Sexual Abuse and Adult Adjustment," *Journal of Interpersonal Violence* 12, 1 (1997), pp. 30-48.

20. Ibid.

21. Patricia Coffey, Harold Leitenberg, Kris Henning, Tonia Turner & Robert T. Bennett, "Mediators of the Long-term Impact of Child Sexual Abuse: Perceived Stigma, Betrayal, Powerlessness and Self-blame," *Child Abuse and Neglect* 20, 5 (1996), pp. 447-455.

22. Heriot (1996).

23. Mary deYoung, "Immediate Maternal Reactions to the Disclosure or Discovery of Incest," *Journal of Family Violence* 9, 1 (1994), pp. 21-33.

24. Freyd (1996).

25. Leda Cosmides & John Tooby, "Cognitive Adaptations for Social Exchange," in J. H. Barkow, L. Cosmides, & J. Tooby (eds.), *The Adapted Mind: Evolutionary Psychology and the Generation of Culture* (New York: Oxford University Press, 1992), pp. 163-228.

26. Such as Ross Cheit's case, as discussed in: Freyd (1996).

27. Michele Elliott, Kevin Browne & Jennifer Kilcoyne, "Child Sexual Abuse Prevention: What Offenders Tell Us," *Child Abuse and Neglect* 19, 5 (1995), pp. 579-594.

28. Ibid., p. 584.

29. Anna C. Salter, *Transforming Trauma: A Guide to Understanding and Treating Adult Survivors of Child Sexual Abuse* (Thousand Oaks, CA: Sage, 1995).

30. Elliott, Browne & Kilcoyne (1995).

31. Salter (1995).

32. Elliott, Browne & Kilcoyne (1995).

33. For more discussion, see: Kathleen Monahan, "Crocodile Talk: Attributions of Incestuously Abused and Nonabused Sisters," *Child Abuse and Neglect* 21, 1 (1997), pp. 19-34.

34. Susan Forward & Craig Buck, *Betrayal of Innocence: Incest and its Devastation* (New York: Penguin, 1979).

35. Thomas A. Roesler & Tiffany Weissman Wind, "Telling the Secret: Adult Women Describe Their Disclosures of Incest," *Journal of Interpersonal Violence* 9, 3 (1994), pp. 327-338.

36. Elliott, Browne & Kilcoyne (1995), p. 584.

37. Salter (1995), p. 75.

38. Elliott, Browne & Kilcoyne (1995).

39. Freyd (1996).

40. Lucy Berliner & Jon R. Conte, "The Process of Victimization: The Victim's Perspective," *Child Abuse and Neglect* 14 (1990), pp. 29-40.

41. Salter (1995), p. 88.

42. Elliott, Browne & Kilcoyne (1995).

43. Salter (1995), p. 68.

44. Ibid., p. 80.

45. Anna C. Salter, "Truth, Lies, and Sex Offenders" [Videotape No. 81492 of the series *Listening to Sex Offenders*] (Thousand Oaks, CA: Sage Video Productions, 1997).

46. Ibid.

47. Inara Verzemnieks, "Girl's Family Defends Man Accused of Raping 12-year-old," *The Oregonian* (August 21, 1997), p. B6.

48. Salter (1997).

49. Gilead Nachmani, "Discussion: Reconstructing the Methods of Victimization," in Richard Gartner (ed.), *Memories of Sexual Betrayal: Truth, Fantasy, Repression and Dissociation* (Northvale, NJ: Janson Aronson, 1997). p. 202.

50. Elliott, Browne & Kilcoyne (1995).

51. Ibid.

52. Ibid.

53. Ibid, p. 590.

54. Gail E. Wyatt & Michael Newcomb, "Internal and External Mediators of Women's Sexual Abuse in Childhood," *Journal of Consulting and Clinical Psychology* 58, 6 (1990), pp. 758-767.

55. Carolyn Copps Hartley, "How Incest Offenders Overcome Internal Inhibitions Through the Use of Cognitions and Cognitive Distortions," *Journal of Interpersonal*

Violence 13, 1 (1998), p. 35.

56. Elliott, Browne & Kilcoyne (1995).

57. Nathan L. Pollock & Judith M. Hashmall, "The Excuses of Child Molesters," in Gordon C. Nagayama Hall, *Theory-based Assessment, Treatment, and Prevention of Sexual Aggression* (New York: Oxford University Press, 1996), p. 98.

58. Douglas W. Pryor, *Unspeakable Acts: Why Men Sexually Abuse Children* (New York: New York University Press, 1996), p. 141.

59. Jan Hindman, *Just Before Dawn: From the Shadows of Tradition to New Reflections in Trauma Assessment and Treatment of Sexual Victims* (Ontario, OR: AlexAndria Associates, 1989).

60. Salter (1995).

61. Hindman (1989).

62. Salter (1995), p. 90.

63. Freyd (1983; 1996).

64. Salter (1995), p. 81.

65. Heriot (1996).

66. Freyd (1996).

67. Pryor (1996), p. 27.

68. Freyd (1997).

69. Hall (1996).

70. Elizabeth Mertz & Kimberly A. Lonsway, "The Power of Denial: Individual and Cultural Constructions of Child Sexual Abuse," *Northwestern University Law Review* (in press).

71. Salter (1995).

72. For a thorough discussion of the denial tactics of offenders, see: Mertz & Lonsway (in press).

73. Kenneth S. Pope, "Science as Careful Questioning: Are Claims of a False Memory Syndrome Epidemic Based on Empirical Evidence?", *American Psychologist* 52 (1997), pp. 997-1006; and Kenneth S. Pope, "Memory, Abuse and Science: Questioning Claims about the False Memory Syndrome Epidemic," *American Psychologist* 51, 9 (1996), pp. 957-974.

74. Mertz & Lonsway (in press).

75. Mark Pendergrast, *Victims of Memory: Incest Accusation and Shattered Lives* (Hinesburg, VT: Upper Access, 1996), p. 197.

76. Pryor (1996), p. 182.

77. Hartley (1998).

78. Michelle Fine, Toni Genovese, Sarah Ingersoll, Pat Macpherson & Rosemarie Roberts, "Insisting on Innocence: Accountability by Abusive Men," in Brinton Lykes, Ali Banuazizi, Ramsay Liem & Michael Morris (eds.), *Myths about the Powerless: Contesting Social Inequalities* (Philadelphia: Temple University Press, 1996), pp. 128-158.

79. Hartley (1998).

80. Ibid.

81. Sue Campbell, "Women, 'False' Memory and Personal Identity," *Hypatia* 12, 2 (1997), pp. 50-82.

82. Lynn Henderson, "Without Narrative: Child Sexual Abuse," *Virginia Journal of Social Policy & the Law* 4, 2 (1997), p. 481.

83. Heriot (1996).

84. Melanie Burney, "Cops Probe Drowning, Find Dungeon," Associated Press (May 29, 1988, 20:42 EDT).

85. Ibid.

86. Fine, Genovese, Ingersoll, Macpherson & Roberts (1996).

87. Jon R. Conte, "The Incest Offender: An Overview and Introduction," in Anne L. Horton, Barry L. Johnson, Lynn M. Roundy & Doran Williams (eds.), *The Incest Perpetrator: A Family Member No One Wants to Treat* (Newbury Park, CA: Sage, 1990) pp. 19-27.

88. Fine, Genovese, Ingersoll, Macpherson & Roberts (1996).

89. Charles Baxter, in Will Hermes, "Too Many Stories: Are We Getting Paralyzed by Narrative Overload?", *Utne Reader* (October 1997), p. 41.

90. Fine, Genovese, Ingersoll, Macpherson & Roberts (1996).

91. For more information, see: Judith L. Herman, *Trauma and Recovery* (New York: Basic Books, 1992).

RE-VIEWING THE MEMORY WARS

Some Feminist Philosophical Reflections

Shelley Park

Questions concerning the accuracy of memory are both frustrating and important to consider. They are frustrating because it is often difficult to determine when memory can and cannot be trusted. They are important because often our accumulated memories are fundamental to our sense of who we are. As individuals, our personal memories are integral to our sense of personal identity. As members of groups, our collective memories help define our shared identities, for example as members of a particular family, profession, culture or gender.

Because memory is fallible, discrepancies in our accounts of the past frequently arise. In some cases, differing perceptions of past events can be overlooked. When the stakes are higher and serious disagreements arise concerning our accounts of the past — as they do concerning women's incest recollections — such disagreements symbolize a deeper conflict. At stake here is our conception of ourselves, not merely as truth-tellers, but as persons who have experienced certain events or as communities shaped by a shared history.

Current debates over the accuracy of women's delayed recollections of childhood sexual abuse are not simply disagreements over whose testimony is a more accurate rendering of the past. Being accepted as a reliable witness to the past is very important for the abuse survivor. Indeed, seeing ourselves as reliable witnesses to the past is important for all women in a society that has too often depicted us as less credible than men. But more than our status as witnesses is also at stake here. Debates between those who believe and those who do not believe women's memories of abuse also signify conflicts over core identity beliefs. In particular, accusations of widespread abuse of female children by fathers (and other adults entrusted to protect them) threaten core beliefs about the safety of the nuclear family, the equality of women and men, and the protection of human rights. The allegations of false memories protect these core beliefs by threatening women's identities as survivors and as healers, while maintaining stereotypes of women as gullible and manipulative.

Also at stake in these debates are notions concerning the objectivity and truth of science. Indeed, the personal and political significance of current debates over the accuracy of memory often involves questions of empirical evidence and scientific theory. The first section of this article "The Memory Wars" provides a brief overview of the current scientific debates in which science has become an ideological tool for holding core patriarchal beliefs and practices in place. The second section outlines feminist considerations that arise from current debates about abuse and memory. The third section describes some of the various ways that definitions of truth are utilized in these debates. Here I suggest that we need a more flexible definition of truth than that utilized by the empirical psychologists who have argued that abuse memories are false. Finally, in the last section, I describe what I see as the cultural truth revealed by women's collective memories of childhood abuse, namely, that they have been individually and culturally victimized by patriarchy. Ironically, as I suggest here, patriarchy itself has contributed to revealing this truth.

The Memory Wars

False memory syndrome, a phrase coined by the False Memory Syndrome Foundation (FMSF), is not (yet) an officially recognized diagnostic category. (It is not listed in the most recent edition of the American Psychiatric Association's *Diagnostic and Statistical Manual* (DSM-IV).) However,

the FMSF has drawn so much publicity that political rhetoric has become confused with medical diagnosis. Both the FMSF and its supporters assert that many adult memories of childhood abuse are fabricated imaginary experiences. This contention is based on a series of experiments conducted by experimental psychologists, including Elizabeth Loftus, Jean-Roch Laurence and others. These experiments aim to demonstrate that "false" memories — or, less oxymoronically, pseudomemories — can be created when experimental subjects are given misleading information concerning an allegedly witnessed event or episode that did not, in fact, occur. For example, a subject may be misled, by erroneous narrative, into believing that he saw a yield sign instead of a stop sign in a series of slides depicting a traffic accident. In all of these experiments, misled subjects performed more poorly than control subjects on test questions concerning the critical items. Loftus et al. have interpreted this as evidence of the malleability of memory.

A series of studies conducted by experimental psychologists Campbell Perry and his colleagues provides another interpretation of false trauma memories retrieved in therapy, especially when such memories are retrieved under hypnosis.[1] In a typical study, highly hypnotizable subjects chose a recent night during which they did not recall wakening or dreaming, were age-regressed to the night in question, and given the suggestion that they were awakened by loud noises. Post-hypnotically, nearly half the subjects responded that they had been awakened that night and many remained certain even after the details of the experiment were revealed to them.

According to the FMSF, these and related experiments suggest that pseudomemory creation is relatively easy. Experimental psychologists have further suggested that such experiments reveal a host of variables that may be related to memory creation. The profile of subjects most likely to exhibit pseudomemories that can be gleaned from these experiments includes subjects who are highly hypnotizable, imaginative, task-motivated and confident about their ability to retrieve memories.

Whether these research results lend credence to the claims of the false memory movement has become a subject of heated academic debate. According to the FMSF, overzealous therapists have encouraged clients' false memories by suggesting that childhood sexual abuse may be the cause of their present psychological difficulties and by emphasizing the need to recover their memories of these events if they are to be cured. According to Richard Ofshe, an academic member of the organization's

advisory board, "in effect, therapists prep these victims-in-training for key turning points of the therapy drama." [2] Therapists take a depressed or anxiety-ridden client and educate her about the prevalence of child abuse, the probability of repression of such episodes, and the correlation between past victimization and present symptoms. They spend numerous sessions encouraging her to try to remember childhood episodes. According to critics of recovered memory therapy, this approach to treatment takes advantage of clients who fit the profile of subjects most likely to exhibit pseudomemories. Moreover, these critics claim that a variety of suggestive techniques are used in helping the client to remember, including hypnosis, free association tasks, guesswork, guided fantasy, group therapy with other survivors, and reading of popular self-help books. According to sociologist Richard Ofshe and journalist Ethan Watters, the net result of all of this is that:

> "Clients become sufficiently knowledgeable of the therapy's plot-line that they can improvise their way through the next scene ... Clients discover that playing the sexual abuse victim is both a demanding and engaging role ... they will eventually become committed to the role of victim and will emote. Whatever doubts they may have are subordinated to the therapist's judgement, the images they have fantasized, the stories they have confabulated, and the identity they have developed through participation in ... this process." [3]

The use of the phrase "false memory syndrome" accurately depicts three sceptical views: first, that false memories of childhood abuse are common; second, that false memories of childhood abuse have a typical cause or reason; and third, that it is possible to provide a profile of the character type most likely to manifest pseudomemories.

In response to these conclusions, clinical psychologists and therapists have argued that the experimental and therapeutic situations do not closely correspond. Most notably, the two situations differ in the amount and importance of material forgotten and subsequently reconstructed. For example, as critics have noted, the Loftus subjects erred regarding a singular detail of a witnessed event that was otherwise recalled accurately. Thus, the terminology "false memory" in Loftus and others' studies may itself be misleading.

While it is plausible that an experimental subject could be led to misremember a stop sign as a yield sign or to misremember having slept through the night, it seems less plausible that a person would systematically

misremember a happy and uneventful childhood as a traumatic one characterized by ongoing abuse. In the former case, the error concerns a momentary incident of little personal consequence, while in the latter case, the alleged error typically concerns a long-term pattern of immense personal significance. As Swiss psychoanalyst Alice Miller[4] and others have suggested, it seems unreasonable to suggest that trauma memories could be implanted with the ease that the FMSF supporters claim. Of course, the terms of this debate blur a range of traumatic experiences. "Sexual abuse" covers a wide range of violations, some of which are one-time events and some of which do not involve family members. The differences from the experimental situations will be greater in cases of long-term incestuous abuse.

In response to criticisms of her work, Loftus has more recently attempted to buttress the arguments of the FMSF by experiments designed to implant a trauma memory that is entirely false. In these more recent experiments, parents of experimental subjects asked their adult children to "remember the time" they were lost in a shopping mall (no such event, in fact, occurred). When their children initially claimed to be unable to recall this, the parents prompted the recall by "recollecting" their own fright at losing the children — and their subsequent relief when a stranger reunited them. The results of this experiment paralleled those of earlier studies: a significant portion of the subjects, although initially having no memory for the fictional episode, eventually began to (mis)recall it, expanding on the fabricated incident by adding details of physical environment and emotional state not offered in the original parental version.[5]

Although these results provide additional support for the false memory movement's claims, further differences between the experimental and therapeutic contexts remain, including duration, resolution, severity and personal significance of the respective traumas. Clearly, there is an important difference between temporarily losing a loved one — even when the loss is through that person's neglect — and being subjected by a loved one to systematic, long term and willful violation of personal integrity. These differences between experimental and therapeutic contexts are unavoidable, insofar as ethical considerations make it impossible to inflict trauma on experimental subjects.

There is also an important distinction to be made between experimental and therapeutic aims. While Loftus and her colleagues were deliberately attempting to confuse their subjects, clinical therapists hope to

enlighten their clients. This difference largely explains the two-sided nature of these current debates. Experimental psychologists and others who seek recall errors — and devise methods and strategies to produce such — are apt to find memory malleable. On the other hand, clinical therapists and others who seek autobiographical truths — and devise methods and strategies for producing such — are apt to find memory reliable.

Research concerning child abuse suggests that 12 to 38 percent of girls in the U.S. (and 3 to 16 percent of boys) are the victims of sexual abuse. Yet less than one-half of these abuses are reported to police.[6] Reasons for not reporting abuse include sympathy for the abuser, a desire to forget the incident, fear concerning disruption of the family, and doubt that the abuse actually occurred. These rationales indicate that many unreported cases may involve perpetrators in the family.[7] One might also speculate that these same reasons might cause the incest victims themselves to repress their memories of abuse.

While experimental psychologists have interpreted studies concerning the malleability of memory as evidence against the theory of repression, recent clinical studies indicate that a significant portion of abuse survivors may be unable consciously to recall their abuse. Researchers utilizing clinical samples of women in treatment report that 28 to 59 percent of survivors fail to remember their childhood abuse at some time during their lives.[8] And a longitudinal study of 200 women, who reported sexual abuse as children in the early 1970s, found that more than one-third of these women failed to remember the abuse, the report and the (documented) hospital visit.[9] That experimental researchers studying memory have largely ignored such findings strongly suggests motivations stemming from "personal biases, such as distrust of therapists, desire to support male perpetrators, denial that 'nice' men can molest children, enjoyment of the recognition provided by groups that rally around men who are allegedly falsely accused, prior experience with one or more unfounded (not untrue, but unprovable legally) cases, and need to stand by a previously expressed position." [10] This suggestion contradicts our culturally received notion of a scientist as a completely impartial observer. Nonetheless, given conflicting bodies of scientific research, the belief that "science proves" the possibility (or even probability) of widespread and systematically false memories of childhood sexual abuse strongly indicates a predisposition to disbelieve sexual abuse reports.

From a Feminist Perspective

The publicizing of false memory syndrome should alarm feminists for a number of reasons. First and most obviously, the notion that false memories of abuse are commonplace casts suspicion on *all* women's and children's testimonials of abuse, thus silencing voices that have only recently begun to be heard. Prior to the 1980s, both therapists and the lay public discounted claims of child sexual abuse and "concluded that it rarely, if ever, occurred." [11] This prevalent disbelief negatively impacted abused children's ability to heal from the abuse. Most adult survivors claim they "gave up trying to get someone to help them and instead adopted coping strategies to protect themselves." [12]

The growing belief in children's reports of abuse was undoubtedly responsible for the sharp increase in reported child abuse in the mid- to late 1980s. [13] Yet, many victims still fear that no one will believe them and that their testimony will be dismissed as a fabrication or exaggeration. [14] Current publicity surrounding false suspicions, reports, and even memories of abuse threatens once again to silence abuse victims by further encouraging this distrust of others and even promoting self-doubt. Moreover, such publicity has effectively shifted public attention from the prevalence of child abuse and its under-reporting to the alleged prevalence of false accusations and the alleged over-reporting of abuse.

Clearly, the primary purpose of false memory allegations is to protect men accused of sexual abuse by devaluing children's and women's testimony. False memory allegations uphold patriarchy's core beliefs about the nature of men as protectors of women and children. The discounting of victims' memories of abuse often proceeds by utilizing well-known stereotypes of women as "evil" or "sick." Women who report abuse where (allegedly) no abuse occurred may be depicted as active and malicious — in short, as liars.

This is a common depiction of mothers who file false reports of abuse against their children in order, it is often suggested, to exact revenge upon a spouse or lover. Fathers accused of abuse by their minor children and threatened with losing custody may accuse mothers of poisoning the child's mind as some sort of revenge. While this accusation is nothing new, it has now received scientific credibility through the invention of the label "parental alienation syndrome." While no credible body of research supports the claim that such a syndrome exists, many psychologists and judges appear ready to accept the idea that children's reluctance to visit their

fathers is caused by undue maternal influence. Not surprisingly, some of the people promoting the existence of parental alienation syndrome are also involved in the FMSF.[15]

Alternatively, women may be depicted as well-intentioned, but passive and gullible. This is the stereotype of the victim of false memory syndrome. Her false reports of abuse, and the subsequent tearing apart of her family, are not viewed as her fault. She is, according to prevalent scholarly and public opinion, merely the unwitting pawn of her therapist, who has "brainwashed" her with therapeutic "propaganda." This is certainly the image of recovered memory clients put forth by Richard Ofshe and Ethan Watters, who depict clients as "blank canvasses on which the therapists paint." Those who seek therapy, they suggest, are "completely ignorant" and hence "exceedingly vulnerable to influence." [16]

The notion that therapists (wittingly or unwittingly) implant false memories of abuse is yet another indicator of anti-feminist backlash. Current discussions of false memory serve to devalue "women's work," in addition to devaluing women's testimony. Psychotherapy, and in particular recovered memory therapy, is women's work in two senses. First, it is one of the few places within the fields of psychology and psychiatry where female practitioners are well-represented.[17] Secondly, the style and fundamental presuppositions of such therapy exemplify methods and values commonly perceived as feminine. The therapeutic process relies heavily on establishing a relationship of trust between the client and practitioner, since it is only within the safety of such a caring relationship that the client will be able to find her voice, share her secrets and get in touch with her feelings.

The publicity surrounding false memory syndrome has cast suspicion on this therapeutic practice and its practitioners. Outside observers refer to recovered memory therapy as "quackery," its practitioners as "reckless" and its consequences as "dangerous." [18] In response to these charges, insiders have responded by attempting to distinguish between competent therapists (themselves) and "others," arguing for higher admission standards to professional organizations.[19] This advice to raise admission standards to exclude those who are contaminating the profession is both cause and consequence of devaluing women and other therapists who adopt a feminine style. Indeed, this movement to "professionalize" clinical psychology is reminiscent of the movement that professionalized physiological medicine a century ago. Just as the earlier movement led to the rise of (male) obstetricians and the demise of (female) midwives, this movement

seeks to raise the status of (male) psychologists and devalue the work of (female) therapists.

The blurring of the lines between professional and personal relationships that characterizes psychotherapy is characteristic of much of women's work. For psychotherapists, just as for secretaries, teachers, nurses, stewardesses, social workers and prostitutes, personal care-giving is inextricably intertwined with carrying out one's professional duties. Simply put, one cannot take care of business without caring for — and at least successfully pretending to care about — individual people. Yet, it is this appearance of emotional involvement (whether real or illusory) that codes these tasks as unprofessional.

Elizabeth Loftus sums up her (and the scientific community's) code of professional ethics succinctly: "I've trained myself to be wary of emotions, which can distort and twist reality, and to be as objective as possible ... [one must stay] detached and dispassionate." [20] In light of these professional and widely shared (masculine) norms, feminists should be wary of proposals to "regulate better" therapeutic practice and to "restrict access" to scientific programs. The subtext of these proposals is an injunction to draw professional boundaries that will — intentionally or unintentionally — exclude the feminine.

Finally, feminists need to respond to the allegations of false memory syndrome because these allegations directly affect the public image and valuation of feminism itself. First, consider the demographic profile of a typical victim of "false memory syndrome": a single, white, middle-class, college educated, aged 25 to 45, economically independent, professionally employed female.[21] This is the poster child for (bourgeois, white) feminism. Women who fit this description are women who have "made it" according to our culture's concept of success. The notion, disseminated by the false memory movement, that these women are also those most apt to confuse fantasy with reality strongly suggests a conservative backlash against feminism. This backlash is further indicated by the recurrent and familiar refrain that such women are responsible for the breakdown of their families.[22]

Scholars and journalists also more explicitly scapegoat feminism, claiming that "[b]road concerns about child protection and feminist thought have contributed to" and "provide the muscle behind" the institutionalization of recovered memory therapy.[23] In an interesting — but disturbing — reversal, the false memory movement has depicted feminists and child advocates as creating a "hysterical" cultural climate akin to the

Salem witch hunts.[24] The import of this analogy is clear: feminism is a dogmatic religion, psychotherapy is brainwashing, children's and adults' testimony of abuse is made up, and the accused are innocent victims of a modern-day inquisition.

The dissemination of the ideas of the FMSF among the general populace simultaneously marginalizes the biologically female, the culturally feminine and the politically feminist. Those ideas, therefore, clearly require a feminist response. Among the issues that need to be addressed are the selective interpretation and use of experimental research results. One wonders why, for example, research demonstrating the malleability of human memory has not been used to explain the less than credible — indeed, often inconsistent — memory reports of agents involved in events surrounding the Kennedy assassination, Watergate or the Iran-Contra affair.[25] For that matter, one wonders why research demonstrating the malleability of human memory is not used, in the debates under consideration and in courts of law, to explain, and render less credible, the apparently sincere testimony of some men who deny accusations of sexual abuse and those who corroborate their denials.

If memory is a *human* phenomenon, then how does false memory syndrome become a *women's* disease? Clearly we need a political analysis of patriarchy in order to understand the prevailing applications and interpretations, as well as origins, of the present scientific research on memory. In addition, we need an analysis of the ways in which ageism, racism, classism, heterosexism and other forms of oppression intersect with patriarchy. False memories of childhood abuse are not, after all, depicted simply as a (any) *woman's* problem, but are more specifically depicted as a widespread problem for *young, white, middle-class women.* In a society characterized by multiple forms of oppression, methods of suppressing abuse testimony will vary.

To see this, we need only consider the ways in which age, race, class and other variables intersect the therapeutic, psychiatric, social service and legal communities. To begin with, few women can afford to avail themselves of these services. Cultural differences may also render these services less than beneficial to many women whose needs, expectations and styles of communication diverge from those that professionals are trained to anticipate. Moreover, both within and outside of these professional communities, stereotypes pertaining to age, ethnicity and poverty serve to devalue some women's testimony independently of invoking false memory explanations. Women of colour, poor women, elderly women and

lesbian women — familiar with the cultural biases and stereotypes ena-
bling a hasty dismissal of their testimony — may be reluctant to offer
public testimony to the media, a jury, a social service agency or even a
private therapist.

Of course, factors such as race, ethnicity and poverty may — despite
a variety of cultural mechanisms for devaluing the testimony of marginal-
ized women — lead to reduced scepticism regarding their sexual abuse
accusations. Yet, women of colour, poor women, rural women and others
may also harbour concerns that their testimony, if believed, could be used
to strengthen already prevalent negative stereotypes of families of colour,
poor families and rural families. Thus, in the current debates over the
credibility of women's abuse testimony, the erasure of many women's
voices is already ensured.

These considerations suggest that while sexual abuse is not culturally
confined, it is largely the abuse testimony of young, educated, profes-
sional, white women that threatens patriarchy. Such women have the
financial and social resources to make themselves heard. Related to this,
they are the women most likely to be deemed credible in public forums.
And they do not risk racist, classist and other forms of backlash in going
public.

Privileged women do risk anti-feminist backlash, however, and this is
precisely what women who have spoken about their childhood abuse, their
therapists and other supporters have encountered. The FMSF has filed
lawsuits against therapists and authors whose actions, they contend, lead
people falsely to believe they were sexually abused. They have picketed
therapists' offices; they have advocated following children to therapists'
offices, prying information from children's confidants, hiring private
detectives, and pretending to be an abuse survivor in order to expose
therapists' incompetency. They have, moreover, stereotyped women who
claim to be abuse survivors as gullible, angry, hostile, and paranoid, and
ridiculed them as "whiners." [26] These techniques are fairly crude, how-
ever, and have the disadvantage — especially when applied to educated,
professional, white women — of appearing reactionary and coercive. It is
no surprise, therefore, that science has become the primary tool for
silencing privileged women's reports of incest. In its guise of objectivity,
science perpetuates scepticism regarding women's memory itself, thus
maintaining the patriarchal status quo while enjoying the presumption of
political innocence.

What is a Valid Memory?

How can we, as feminists, respond effectively to the backlash against women's testimony of abuse? One way is to attempt to "prove" the truth of individual abuse claims by providing evidence to support survivor's testimony. Relevant evidence here, suggested by some therapists themselves, includes three types: evidence arising from the client's testimony in court, evidence about the client (her childhood, her behaviour and her current psychological profile), and evidence pertaining to the event(s) remembered. Unfortunately, none of these types of evidence is likely to be conclusive. In effect, the truthfulness of a trauma memory may often be less than proven by available evidence.

In addition, the FMSF has been successful at undermining any abuse survivor's testimony. To the extent that a woman's memory fails to match the public record, on the one hand, the content of that memory is suspect. To the extent that her memory does match the public record, on the other hand, the status of her beliefs as memory is suspect. Compounding the difficulties faced by survivors, sexual abuse almost always occurs in the absence of witnesses. Therefore, holding women up to the public standards of evidence will effectively silence them about abuse in the private sphere.

Given the difficulties involved in providing clear and unambiguous evidence for women's abuse claims, feminists might simply accept women's abuse testimony on faith. Some might argue that those who listen to testimony have a general responsibility to believe survivor's claims about the past. Indeed, it seems odd to suggest that a third party might be in a better position to validate autobiographical events than the first-person narrator. It seems easier to believe that the bearer of abuse memories would be in the best position to validate her own autobiographical past. Hence, it seems presumptuous to challenge her memories of her own experience.

There are two ways to support therapy clients regarding their accounts of the past — and those retrieving memories of an abusive past outside of therapy. One is to uphold women's memories as subjectively true (an accurate depiction of her internal psychic reality); the other is to uphold women's memories as objectively true (an accurate depiction of external, historical reality).

For many therapists interested in psychodynamics, the only reality of therapeutic interest and utility is the client's subjective reality. With this approach, a client's memories are always (subjectively) true, insofar as the reality she remembers is her own reality and nobody else's. Unfortunately,

this subjective definition of knowledge secures the truth of women's individual narratives at the price of accepting a belief that truth is relative; a belief that goes against feminist purposes. This strategy shields women's testimony of abuse from criticism, but simultaneously trivializes it and renders it politically ineffective. If feminists want to criticize certain patriarchal beliefs (such as the belief that recovered memories are always false) and have these criticisms regarded legitimate, we cannot simply abandon the notion of objective truth. Moreover, as feminist philosopher Lorraine Code argues, a more robust form of realism is necessary if we are to be responsible knowers. "An intellectually virtuous person," according to Code, "would value knowing and understanding how things 'really' are, to the extent that this is possible, renouncing both the temptation to live with partial explanations when fuller ones are attainable, and the temptation to live in fantasy or illusion." [27]

For many therapists who treat abuse survivors, the reality of therapeutic interest is the client's actual, historical past. In this approach, a client's abuse memories are interpreted as mirroring objective reality. Indeed, the goal of survivor therapies that focus on retrieving abuse memories is to enable the client to understand how things "really" were, renouncing her temptation to forget, repress, deny, gloss over, or otherwise avoid painful truths about her past. Unfortunately, some therapists — and feminists — who work with survivors refuse to acknowledge that feminist therapeutic communities, like the consciousness-raising groups of the 1970s on which they are modelled, participate in the creation and not merely the discovery of knowledge. Thus, they also fail to acknowledge the possibility that therapeutic communities may be implicated in memory creation. This is ultimately unpersuasive.

Despite the conservative rhetoric of the false memory movement, experimental evidence suggests that pseudomemories (including memories of limited traumas) can be created when subjects are exposed to misinformation by a trusted authority figure. Anecdotal evidence offered by therapists themselves, moreover, supports this contention. The malleability of human memory raises serious philosophical questions with which feminists must be prepared to grapple.

Feminist reluctance to acknowledge the possibility of false memories stems from multiple sources. On a psychological level, none of us wants to believe that we could be so easily and dangerously manipulated. Even less do we want to believe that we might so easily and dangerously manipulate others. Therapy clients may have invested a significant amount

of time, energy and money to therapy and may be emotionally attached to
— even dependent on — their therapists.

Therapists who treat abuse survivors have a professional investment
to protect and a public image to uphold. Voicing any doubts publicly could
well result in professional ostracism by their colleagues and legal charges
by their enemies. Nonetheless as clinical psychologists Kenneth Pope and
Laura Brown note, "the reality of abusive psychotherapy makes it doubly
important that complaints about improper handling of recovered memo-
ries be taken seriously by individual therapists and mental health profes-
sions as a whole." [28] In keeping with Code's injunction to renounce the
temptation to live with partial answers, Pope and Brown suggest that even
where therapists have meant well and done their best, they should "repeat-
edly and seriously" ask themselves the following question:

> "'Despite all other factors, is it possible that I have done something
> wrong for which I should be honest and responsible?' The answer that
> comes from within may be the most difficult news that the therapist
> has ever had to endure. Temptations to shunt it aside are likely
> numerous (e.g., 'No one will ever really know,' 'I can prove it never
> happened,' 'The client doesn't know how to tell that what I did was
> wrong,' 'I'll never get any more referrals if I admit I did something
> like this,' 'I'll lose my job'). To disclose such an answer to others can
> be all but impossible, but can in fact have quite positive consequences
> in the long run, preserving the therapist's self-image as a healer." [29]

Similar considerations pertain to feminists who are not professional
therapists. We must frequently examine our beliefs and practices and ask
difficult questions of ourselves, if we are to preserve our self-image as
persons who support, empower and liberate other women.

Such honest self-examination would, of course, be easier were we, as
abuse victims, therapists, activists and scholars, accorded the social
authority to make knowledge claims. In the case of survivors' testimony
of abuse, abuse survivors are held to high standards of legal evidence and
listeners are encouraged to act as if they were adjudicating a criminal
proceeding. In the case of clinical theory and practice, therapists and other
mental health practitioners are held to high standards of empirical evi-
dence and listeners are encouraged to act as scientific critics. In both cases,
the burden of proof imposed is considerably higher than that typically
required outside of courts of law and scholarly journals. And, in both cases,
the burden of proof is placed solely on the shoulders of survivors and
witnesses of abuse.

Here, as elsewhere, feminist theories of knowledge, as marginalized discourses, develop in a context in which they are constantly threatened by the forces of epistemological imperialism. The epistemological imperialist, as defined by Code, takes little responsibility for his own knowledge claims, believing that "a person or situation is summed up" by a stereotype or conjecture.[30] Clearly this is the position of Ofshe and Watters, who stereotype women in positions of authority as pushy and manipulative and women in positions of need as passive and gullible, thus "summing up" the therapist-client relationship and "proving" the probability of false memories of sexual abuse.[31] Epistemic imperialism is also manifested by experimental psychologists who would label clinical psychology as a pseudoscience and thereby claim to have shown its potential danger. Similarly, epistemic imperialism is manifested by academic scholars who harbour stereotypes of feminists as dogmatic, thus dismissing the possibility of feminist objectivity.

Given these and other all-too-familiar stereotypes, it is no surprise that we, as clients, therapists, activists and scholars, may be reluctant to admit the potential shortcomings of our theories or practices. Yet if we are to uphold our private and public image, we must acknowledge and attempt to remedy such shortcomings where they truly exist. This means, with regard to the present issue, that we should not close ourselves off to the possibility of some false memories.

Part of the difficulty in sorting out true from false memories is that:

"The use of the terms 'false memory' and 'true memory' [is] problematic in light of research and theory about memory. Most paradigms seem to suggest that 'true' and 'false' are naïve or misleading labels when applied to memory, which tends toward a mixture of the accurate and the inaccurate." [32]

Indeed, Loftus' own paradigm of memory as socially reconstructed itself suggests that memory is a mixture of truth and falsity. As we have seen, many of the experiments performed by Loftus and others demonstrate the possibility of partially (not entirely) false memories. The exception is the "lost in the mall" experiment. But even there, closer examination of the differences between those who were and those who were not misled by their parents' false stories, might reveal an element of truth in these implanted memories. Perhaps, for example, the misled subjects had experienced being lost on other occasions, or perhaps their childhood experiences contained elements of minor parental oversights that rendered this story plausible and hence internalizable for them.

Loftus uses her experiments to disparage the theory of repression, claiming it absurd to believe that memories, inaccessible to consciousness for many years, could be later retrieved in their original form. In response, some psychologists have suggested that memories of traumatic experiences, especially when these experiences involve betrayal by a trusted caregiver, can be rendered inaccessible to consciousness until such time as it is safe to remember.[33] Discussions of "false memories" often make it sound as if these theories are incompatible. But they need not be. Experiments demonstrating the malleability of memory show that it is implausible to suggest that memories can be replayed in their original, unadulterated form, but they have little bearing on the claim that certain memories may be isolated from consciousness for some period of time. Conversely, although some advocates of repression theory may imply that memory flashbacks are accurate in every detail, this is not a necessary part of this model of memory.

Loftus and others criticize all models of memory that include a repression mechanism by calling those models a "videotape theory of memory." Ironically, this phrase may suggest precisely the richness that is needed to explain why memories can rarely be termed either "true" or "false." Indeed, the metaphor of a videotape captures historian Donna Haraway's notion of situated knowledge,[34] suggesting new concepts for objectivity. According to Haraway, attaining objectivity is not a matter of achieving a disembodied ("pure science") point of view, but of accepting partial perspectives and being accountable for how and what we learn.[35] The responsible knower here is one who, in Haraway's terms, does not eclipse the perspectives of others but instead learns to see in multiple ways, like a travelling lens rather than a stationary, passive mirror. The videotape theory of memory invites us to acknowledge the fallibility of memory by allowing for its fading, editing and perspective distortions. At the same time, it mandates that we continue to listen to, and sympathize with, survivors's narratives because autobiographical memory originates in perceptions of real events and thus contains partial, but nonetheless historical, truth.

A Cultural Analysis of Incest Memories

Unfortunately, the videotape metaphor of memory may fail to offer much help to the individuals (the victim, the accused, the therapist, the juror, the

friend) who want to know what actually happened in a particular case. Here, the lines between historical (material) and narrative (psychic) truth begin to blur. As one feminist philosopher, Stephanie Nelson, has suggested, perhaps the current phenomenon of women remembering childhood abuse should simply be read as a "collective cultural spitting-up of patriarchy." [36]

On first encountering this interpretation, I (like Nelson herself) worried that such a suggestion risked typing women as both the victims and the perpetrators of yet another "hysteria." These are, of course, precisely the stereotypes of women perpetuated by members of the false memory movement. Nevertheless, if we are to take responsibility for our knowledge claims, such private musings must finally be voiced — although we may want to be cautious concerning how, where, when and to whom we voice these concerns.

We might want to begin, in the feminist community itself, to develop a cultural critique of false memories similar to feminist philosopher and cultural theorist Susan Bordo's interpretation of anorexia nervosa.[37] Such an account of the recovered memory phenomenon has, I think, several advantages. Among them are its potential to explain why recovered trauma memories seem most prevalent among young, white, educated, middle-class single women. Like the anorexic — also young, single and middle-class — the bearer of false memories might be viewed as rebelling against cultural expectations for her to become wife and mother.[38] While we might anticipate that a woman's protest against adult domesticity would manifest itself most clearly when her childhood experience of family was traumatic, economically privileged, educated women might protest this expectation independently of such a history.

A second advantage of this account is its potential to explain the bodily symptoms preceding and accompanying recovered memories of abuse. Like the anorexic's protest, the recovered memory client's protest against the patriarchal family may be "written on [her] body ... not embraced as a conscious politics." [39] Indeed, the hysterical symptoms of the woman who is recovering traumatic memories are often interpreted as alien and beyond her control: memories flood over her, abdominal pains disrupt her sexual relations, panic attacks overwhelm her while shopping. This phenomenology of the abuse survivor closely parallels that of the anorexic who experiences her body and its appetites as an enemy, an "alien invader, marching to the tune of its own seemingly arbitrary whims, disconnected from any normal self-regulating mechanisms." [40]

The most prevalent example of this is the phenomenon of dissociation in which rape and incest victims "other" their body in order to insulate the "self" from violation or (mis)perceived complicity in moral vice. Decades later, women subjected to childhood incest or rape may continue to experience sexual appetite and fantasies as "alien" and disconnected from the self.[41] They may likewise be numbed to their other physical and emotional desires and needs. Survivors may also consciously or unconsciously punish their bodies by self-starvation, binging and purging, drug or alcohol abuse, or skin-carving.

The phenomenon of "othering" the body is not, however, unique to the incest survivor. As Bordo suggests, there is a peculiarly contemporary obsession with control over the body linked to a need for "self mastery in an increasingly unmanageable culture." [42] Viewed in this light, the incest survivor's focus on controlling her body through self-starvation, sexual abstinence, body carving and other measures may simply be the extreme end of a continuum characterized by the beauty rituals, diet regimens and exercise routines that preoccupy most contemporary women (and increasingly many men) in contemporary post-industrialized cultures.

For women recollecting childhood abuse, however, the body is not the only locus of attempts at self-control. Centrally important here is the attempt to control memory and, hence, self-definition itself. That the incest victim will exert control over her memories via repression — a pushing away of surfacing incest memories — is a common presumption of much psychotherapeutic work. Less noted, but just as important, however, is the need for control signified by the deliberate undertaking of memory work. Although the sexual abuse survivor undertakes memory recovery work in order to consciously reconstruct her history and hence herself, she retains a view of memory as alien to self and thus attempts to subject it to her will.

Spontaneous memories (flashbacks) are unwelcome. She does not wish to have memories "flood over her," but instead to "retrieve" memories at will via learned techniques. Such techniques may include such things as imagining that one is watching a video-tape of one's past, so that one may view it in slow-motion, fast-forward it, reverse it, adjust the volume and clarity, or shut it off when needed.[43] That a woman wishes assurances of safety in exploring a traumatic past is hardly surprising. The notion, however, that we can so readily control our memories — turning them on and off at will like a TV program — signifies a desire not only for safety, but a desire to micromanage the self that is endemic to modern culture.

As critics of incest survivor therapies are quick to point out, most contemporary women and men can find themselves in the symptomatic profile of the incest victim. Who, for example, hasn't been afraid of being alone, had nightmares, or failed to take proper care of her body? Who hasn't had headaches, feared losing control, felt the need to be perfect, taken too many or too few risks, felt nervous about being watched or felt different? This is a virtual profile of the ordinary citizen — or more accurately the ordinary middle-class citizen — in contemporary post-industrialized society. We all too typically feel overworked, micromanaged, dislocated from our families, isolated within our communities and generally "stressed out."

It is women, however, who are most likely to discover themselves in the symptomatic profile of the incest victim. There are several reasons for this. First, and most obviously, women are more likely to *be* incest victims. It is important to note, however, that although incest is a crime typically perpetrated against girls and young women by male family members, boys and young men may also be the victims of childhood sexual abuse. Cultural norms of masculinity, however, mitigate against male admissions to feeling out of control. Moreover, to the extent that men can admit such feelings to themselves or to others, they are much more likely to attribute their stress to workplace issues than to a history of sexual abuse. Patriarchy cannot countenance an image of men as sexual victims.

For women, however, quite the opposite is the case. Patriarchal norms of femininity easily encompass a portrait of women as weak, nervous, frightened and powerless, making it relatively easy for women to find themselves suffering the above listed symptoms. They may also experience fear of entrapment, feelings of suffocation, poor body image, gynaecological disorders, the need for privacy, eating disorders, depression, inability to express anger, humourlessness, the need for security, trust issues, boundary issues, guilt, shame, low self-esteem and an inability to say "no." [44] These symptoms of an incestuous past are all "utterly continuous with a dominant element of the experience of being female in this culture." [45] They are also fairly consistent with dominant stereotypes of femininity under patriarchy.

Ironically, it appears that patriarchal expectations themselves may contribute to increased reporting of incest and other sexual crimes against women. Despite the fact that patriarchy cannot countenance the notion of widespread incest, it can usefully depict a social reality that includes isolated cases of incest and other forms of sexual abuse. This is especially

so within a context of feminist consciousness-raising. As some women become increasingly discontent with their societal position, it becomes imperative for patriarchy to insist that their negative reactions are pathologies attributable to unfortunate, but (allegedly) anomalous, personal circumstances. Both implicit resistance to patriarchy (depression) and explicit resistance to patriarchy (fear of, or hostility towards, men) are thus usefully explained as pathologies resulting from early betrayal by one's father (or another trusted male figure).

For this explanation to be serviceable to patriarchy, however, it is imperative that such dysfunctional (abnormal) families be starkly contrasted with "normal" childhood circumstances. This technique for stabilizing patriarchy in the face of feminist resistance thus backfires, as women's distress becomes more widespread and increasingly more women find themselves depicted in the medical profile of the incest survivor. At this point, patriarchal science has to invent a new explanation that discounts the possibility of widespread incest. Diagnoses of false memory syndrome provide just such an explanation.

In labelling women as suffering from "false memory syndrome," the FMSF and its supporters perpetuate the notion of middle-class women as prone to hysteria. My own analysis runs a similar risk. Unlike traditional analyses of hysteria, however, an analysis of women as regurgitating patriarchy avoids labelling individual women as "sick," and instead interprets their behaviours as intelligible manifestations of cultural sickness. At the same time, unlike accounts of women suffering (solely) from "recovered memory syndrome," it does not subscribe to the hypothesis that the negative circumstances in question must be circumstances of childhood sexual abuse.

In many cases, it may be impossible to determine the complete historical truth of a woman's or child's specific memories of childhood abuse. The current analysis, however, invites us to overcome our obsession with this question. As Bordo notes, the problem for the anorexic is not merely that she incorrectly believes that she is too fat, but that she is so obsessed with staying thin that it "render[s] any other ideas or life projects meaningless." [46] Similarly, the problem for the bearer of abuse memories occurs not merely — perhaps not even — when her memories are false, but when she becomes so obsessed with those memories that she cannot enjoy the present or plan for the future.

Certain forms of therapy may disempower women even when the recovered memories are true. This happens when questions concerning the

validity of a woman's memories are reduced to questions concerning the factual accuracy of those memories without critical reflection concerning how her present circumstances may shape her interpretations of the past and its relevance to her future. To focus exclusively on whether the content of memories accurately captures the historical facts, as the current debate encourages us to do, risks perpetuating a woman's obsession with discovering the details of her past to the detriment of the client's present and future well-being. To counteract the client's tendency to subordinate all other endeavours to the pursuit of discovering historical truth, those who care about her may need, ultimately, to shift their own focus.

I am not suggesting that we abandon truth. What I am suggesting is that we may need to broaden our horizons on this issue to include a focus on metaphorical, as well as factual, truth, and on practical, as well as assertable, knowledge.[47] While the literal truth of a woman's beliefs (when this can be discovered) may be relevant to her well-being, questions concerning the validity of a woman's memories cannot be reduced to questions concerning the factual accuracy of those memories and her reluctance to take responsibility for the ways she re-enacts them in her present-day life.

A primary difficulty with both sides of the false memory debate, as currently constructed, is the assumption of client passivity and the subsequent failure to hold the client responsible for her beliefs, feelings or behaviours. As we have seen, the false memory movement typically depicts the bearer of false memories as simply the passive, ignorant and gullible victim of therapeutic interventions. While advocates of recovered memories deny that women are so easily brainwashed by their therapists, they too may risk depicting adult women as passive, ignorant victims. This occurs when, in an effort to avoid "blaming the victim," therapists and others portray the present attitudes and behaviours of adult women as determined by their past experiences, failing to acknowledge women's participation in the recollection, interpretation and use of those experiences.

Conclusions

What is a responsible feminist viewpoint on this issue? One simple response might be to acknowledge that in some (but not all) cases, women's experiences of "remembering" may be misleading and therapist-induced, but that in other (but not all) cases, the experiences are genuine

memories caused by earlier life events — although the catalyst for now recalling those previously repressed episodes is, in part, the therapeutic technique. Thus, memories must be considered on an individual basis, paying close attention to the myriad details of a given case. Such a response avoids the politically destructive effects of global scepticism concerning women's testimony of abuse while acknowledging grounds for local scepticism in at least some cases.

A more promising approach, I believe, is to view all memories as containing elements of truth and falsity. The question is not *whether* women's incest memories are true; rather, it is *how* they are true. To discern this, we must look to empirical evidence that pertains to a woman's past and present. We must also be sensitive to issues raised by science concerning the malleability of memory. But neither historical nor scientific evidence will be adequate for determining the overall significance and truth of a woman's memories. To determine the truth(s) of women's recollections of abuse, we will need to adopt also the interpretive techniques of a cultural critic, examining these memories in their appropriate personal, social and political contexts.

Middle-class white women living in post-industrial societies share a cultural context that makes it plausible to view their incest memories as signifying a rejection of contemporary patriarchal values and practices. I do not mean to imply that these memories are literally false; indeed, in many cases these memories may also contain personally significant, historical truth. Yet, even when recollections of incest contain elements of historical inaccuracy, they may still reveal fundamental truths about the lives of women living under, and struggling against, patriarchy.

Of course, if the current phenomenon of women recovering incest memories signifies a cultural regurgitation of patriarchy, then feminism, as well as patriarchy, is implicated in this cultural phenomenon. One part of the shared cultural context of educated, middle-class women is feminist consciousness-raising regarding women's oppression and victimization.

As feminists faced with backlash, we may be hesitant to acknowledge this. Yet, as feminists, we must consider how this shared social context shapes our own private and public responses to this issue. In addition, we must consider how our sometimes diverse political and intellectual allegiances, as well as our personal positions, may affect how we perceive the present issue. For my own part, my reflections here are grounded in the experiences of a white, middle-class feminist with traditional analytic philosophical training. My openness to the complexities of memory has

been influenced by a friend who engaged in the painful process of retrieving abuse memories, but has since rejected these memories as literally false. It might be difficult to accept ambiguity in accounts of a traumatic past, except for my experiences with this friend. These and numerous other factors (my own happy childhood, my trust in the father of my own daughters, my never having been a therapy client myself, and so on) no doubt influence my perspective on the present issue. Therefore, I do not claim to have offered the definitive approach to this issue. My aim here has been merely to offer some tentative suggestions concerning how we might approach questions concerning truth in women's incest memories. I hope these suggestions prove useful in our continued efforts to reshape the public dialogue about abuse memories, with positive consequences for the women directly and indirectly affected by this dialogue. And I trust that others occupying vantage points different from my own will correct my vision where it has been unduly myopic.

Endnotes

1. For example, see: Jean-Roch Laurence & Campbell Perry, "Hypnotically Created Memory among Highly Hypnotizable Subjects," *Science* 222 (1983), pp. 523-524; and Louise Labelle & Campbell Perry, "Pseudomemory Creation in Hypnosis," paper presented at the 94th Annual Convention of the American Psychological Association, (Washington, D.C.: August, 1986).

2. Richard Ofshe & Ethan Watters, "Making Monsters," *Society* (March/April 1993), p. 10.

3. Ibid., pp. 9-10.

4. Alice Miller, *Banishing Knowledge*, translation by Leila Vennewitz (New York: Doubleday, 1990).

5. Elizabeth Loftus, "Repressed Memory and the Law," presented at the Fourth Annual Conference on Mental Health and the Law (Orlando, FL: September 15, 1995).

6. Debra Whitcomb, *When the Victim is a Child*, 2nd Edition (U.S. Department of Justice, Office of Justice Programs, National Institute of Justice, 1992), pp. 2-4.

7. Ibid., p. 4.

8. John Briere & Jon R. Conte, "Self-reported Amnesia for Abuse in Adults Molested as Children," *Journal of Traumatic Stress* 6 (1993), pp. 21-31; and Judith Herman & Emily Schatzow, "Recovery and Verification of Memories of Childhood Sexual Trauma, *Psychoanalytic Psychology* 4 (1987), pp. 1-4.

9. Linda Meyer Williams, "Recall of Sexual Trauma: A Prospective Study of Memories of Child Sexual Abuse," *Journal of Consulting and Clinical Psychology* 62, 6 (1994), pp. 1167-1177.

10. Ibid., p. 85.

11. Lenore E. Walker, *Abused Women and Survivor Therapy* (Washington, D.C.: American Psychological Association, 1994), p. 82.

12. Ibid., p. 104.

13. Whitcomb (1992), p. 5.

14. Walker (1994), p. 240.

15. See: Richard A. Gardner, *The Parental Alienation Syndrome and the Differentiation between Fabricated and Genuine Child Sexual Abuse* (Cresskill, NJ: Creative Therapeutics, 1987); and Walker (1994).

16. Ofshe & Watters (1993), p. 9.

17. Ilene J. Philipson, *On the Shoulders of Women: The Feminization of Psychotherapy* (New York: Guildford, 1993).

18. Ofshe & Watters (1993).

19. Michael D. Yapko, "Suggestibility and Repressed Memories of Abuse: A Survey of Psychotherapists' Beliefs," *American Journal of Clinical Hypnosis* 36, 3 (1994), p. 163-171; and Melvin A. Gravitz, "Are the Right People Being Trained to Use Hypnosis?" *American Journal of Clinical Hypnosis* 36, 3 (January 1994), pp. 179-182.

20. Elizabeth F. Loftus & Katherine Ketcham, *Witness for the Defense: The Accused, the Eyewitness, and the Expert who puts Memory on Trial* (New York: St. Martin's, 1991), p. 278.

21. Carol McHugh, "Suits Claiming Childhood Sex Abuse on Rise: Lawyers, Experts Question 'Recovered Memories'," *Chicago Daily Law Bulletin* (September 22, 1993).

22. Ofshe & Watters (1993), pp. 4 & 11.

23. Ofshe & Watters (1993), p. 11.

24. See, for example: Gravitz (1994), p. 181; Loftus (1991), pp. 141-142; Ofshe & Watters (1993), pp. 13-14; James Selkin, *The Child Sexual Abuse Case in the Courtroom*, 2nd Edition, Ch. 1 (Denver, CO: self-published,1991); and Paul McHugh, quoted in Lenore C. Terr, *Unchained Memories: True Stories of Traumatic Memories, Lost and Found* (New York: Basic Books, 1994), p. 161.

25. Kate Lindemann (personal communication).

26. Kenneth S. Pope & Laura S. Brown, *Recovered Memories of Abuse: Assessment, Therapy, Forensics* (Washington, D.C.: American Psychological Association, 1996), pp. 96-105.

27. Lorraine Code, "Experience, Knowledge, and Responsibility," in Ann Garry & Marilyn Pearsall (eds.), *Women, Knowledge, and Reality: Explorations in Feminist Philosophy* (Boston: Unwin Hyman, 1989), p. 160-161.

28. Pope and Brown (1996), p. 234.

29. Ibid.

30. Lorraine Code (1989), p. 161.

31. Ofshe & Watters (1993).

32. Pope & Brown (1996), p. 11.

33. See, for example: Jennifer Freyd, *Betrayal Trauma: The Logic of Forgetting Child Abuse* (Cambridge, MA: Harvard University Press, 1996).

34. Donna Haraway, *Simians, Cyborgs, and Women: The Reinvention of Nature* (London: Free Association Books, 1991).

35. See also: Sandra Harding, *The Science Question in Feminism* (Ithaca, NY: Cornell University Press, 1986).

36. Stephanie Nelson (personal correspondence).

37. Susan Bordo, "Anexoria Nervosa: The Psychopathology of a Culture," *Philosophical Forum* 17, 2 (1985), pp. 73-103.

38. Ibid., p. 102-103.

39. Ibid., p. 105.

40. Ibid., p. 94.

41. For an example, see: Judith Herman, *Trauma and Recovery* (New York: Basic Books, 1992), p. 203.

42. Susan Bordo, *Unbearable Weight: Feminism, Western Culture and the Body* (Berkeley, CA: University of California Press, 1993), p. 153.

43. Herman (1992), p. 186.

44. For example, see checklists in: Briere (1992); and E. Sue Blume, *Secret Survivors: Uncovering Incest and Its Aftereffects in Women* (New York: John Wiley and Sons, 1990).

45. Bordo (1993), p. 57.

46. Bordo (1993), p. 105.

47. See: Vrinda Dalmiya & Linda Alcoff, "Are 'Old Wives Tales' Justified?" in Linda Alcoff & Elizabeth Potter (eds.), *Feminist Epistemologies* (New York: Routledge, 1993).

"SOMETHING HAPPENED"

The Repressed Memory Controversy and the Social Recognition of Victims

Elizabeth Wilson

In recent years, North America has been both fascinated and repelled by the vast numbers of women now coming forward to say they were sexually abused as children. These numbers are corroborated by studies indicating a far greater extent of sexual abuse, across all social strata, than previously imagined. The stories that have surfaced typically involve white middle-class women who claim to be incest victims and who say they *did not remember* the abuse until a certain moment in adulthood. The psychological concept of repressed (or dissociated) memory has been used to explain their sudden discovery.[1]

Dissociation refers to the mind's ability to "split off" or "space out" during experiences that are too overwhelming or threatening to bear. Once this occurs, the memories of that experience appear to be stored differently from other memories and remain, for some time, inaccessible to normal consciousness. Although dissociation is a recognized medical phenomenon, it is not the only psychological defence mobilized against trauma. However, the prominence given to it in self-help books for incest survivors

often goes so far as to suggest that it is the *typical* response to incest experiences. This has created a storm of controversy by planting seeds of doubt in the public mind as to the reliability of incest accounts that are based on repressed memories, especially when these are unable to be independently corroborated.

Ellen Bass' and Laura Davis' bestselling handbook for incest survivors, *The Courage to Heal*, has been at the centre of this acrimonious controversy. Near the beginning of the book, there is a section called "But I Don't Remember" that introduces the idea of dissociated memory: "Children often cope with abuse by forgetting it ever happened. As a result, you may have no conscious memory of being abused ... If you think you were abused and your life shows the symptoms, then you were."[2] This line from *The Courage to Heal* is frequently mentioned in hostile or sceptical media accounts, where it serves to suggest that the book encourages women to imagine or hypothesize abuse to explain their adult symptoms.

Harsh attacks by the False Memory Syndrome Foundation and others on the credibility of stories of sexual abuse based on recovered memories have understandably led feminist researchers and therapists to become defensive about *any* questions raised about the reliability of so-called repressed memories. Psychiatrist Judith Herman, who has been at the forefront of the movement to bring child sexual abuse to public attention, has said that raising suspicions about repressed memory claims serves "the mobilization of accused perpetrators and their defenders to take the spotlight off perpetrators of crimes and put it back on victims and their reliability."[3]

With the subsequent division of the field into true believers and cynical sceptics, the debate about recovered memories has taken an increasingly polarized form. Either sexual abuse happened exactly as stories of recovered memory claim or *nothing happened*, and these stories have been created out of thin air, by therapists' witting or unwitting suggestions and the clients' desperate need to "blame" their unhappiness on something outside themselves.

In any vexed controversy, it is as interesting to consider what unites participants, as well as what separates them. In this controversy about repressed memories, all sides generally concur that sexual abuse is the "worst" form of child abuse, the most heinous and the most devastating in its consequences. "Arguably," writes E. Sue Blume, author of *Secret Survivors*, "[incest] is ... the most serious of all types of child abuse," [4]

while the authors of *Confabulations: Creating False Memories, Destroying Families* declare, "Since the sexual abuse of a child is the worst crime we know of — to be falsely accused of such a crime is the worst thing that can happen to a person." [5] Without in any way trivializing the experience that sexual abuse survivors have endured, we should remember that one might "feel abused" after many powerful experiences, not all of which might be sexual in nature or involve physical contact or produce dissociative symptoms.

In this article, I argue that what is being lost in this furious debate about repressed memories is the fact that other forms of maltreatment are real and damaging forms of behaviour whose consequences can be comparable to those resulting from sexual abuse. First, I examine a story of repressed memories of sexual abuse — Betsy Petersen's *Dancing With Daddy* — in order to show that while other continuously remembered forms of maltreatment are included in the narrative, their role as potential causes of the author's symptoms is not fully explored. I argue that this emphasis is in keeping with the principles and approaches of incest-recovery literature. Then I show how, in the late 1980s and early 1990s, stories of victimization based on complex and pervasive forms of maltreatment — like growing up in a dysfunctional family — were ridiculed and dismissed by cultural commentators in books critical of the general "recovery movement." This helped to create a climate where only extreme stories would be credited as stories of genuine victimization.

Recovering Memories

Betsy Petersen's *Dancing with Daddy* retells a story of incestuous experience that is typical of those at the heart of the repressed memory debate.[6] White, middle-class, the daughter of a well-respected surgeon, Petersen never suspected that she was an incest victim until well into middle age when she pieced together the story of her abuse, partly through fictional reconstruction and partly through remembering. Petersen's narrative is among the most controversial types of recent incest revelations, since it apparently lacks a single corroborating piece of evidence. Her mother claimed not to know about the alleged abuse; her father and sister had both died before she remembered; and, despite her suspicions, she apparently did not find in her father's voluminous literary remains any mention, direct or indirect, of the abuse — any talk of "our little secret" or "don't you ever

tell." The plausibility of her narrative rests entirely on her adult symptoms, particularly her difficulty sleeping, her nightmares, her anger and her problems with her children.

The questions that a sceptical reader might raise of Petersen's story are evident just from the way the construction of the narrative is itself related, for it relies on the internal evidence of her symptoms and (repressed) memories as supported by her therapist.

Though Petersen says she doesn't remember exactly when remembering began, she writes, "in my mind [it] began with a box of letters my mother found in the basement of her house" [7] a few years after her father died. The letters were addressed to her from her father, with a note on the box saying they were to be given directly to her "without being opened. It [the box] contains no instructions, will, or other material of interest or value to anyone else, and some of the material is personal for the two of us." [8] During the weeks she waits for the box to arrive, she ruminates about its contents and becomes "more and more afraid that when I opened the box I would discover that my father had slept with my sister." [9] One day while she is jogging — still waiting for the box to arrive — the thought comes to her: "*I'm afraid my father did something to me.*" [10] Still before the box arrives, she "set about confronting my fear. If there was incest, when did it happen?" [11] She begins to do research, pulls out family records, writes a chronology of family events, where they lived, when they moved, what happened when. Poring over the material, she decides, "the most likely date for the incest — I hypothesized a single incident — was November 1945, when my father returned from the war. I was three. His autobiography told of his anxiety about the future ... So perhaps it had happened — if it had happened — in the apartment in San Francisco, when my father came back from the war." [12] She then constructs a written scene, a hypothesis, a "worst-case scenario," about what might have happened.

Her hypothesis is then confirmed by her therapist. She reads the scene aloud, saying that she doesn't know whether she made it up. The therapist tells her — and this intervention may have been crucial — "There was a good chance it had happened ... It was consistent with what I remembered about my father and my relationship with him, and with the dreams I had been having, and with the difficulties I had being close to my children, and also, she said, with the feelings I had during and after sex with my husband." [13] When Petersen asks, bewildered, "But how could I forget something so important?" the therapist explains the workings of dissociated

memory to her. When the box finally arrives, there is nothing in it to confirm her fears, so for six months, she abandons her quest, until the dreams begin again, "more specific and terrifying." 14 Then she goes back to her incest scene and starts to embellish it.

Petersen herself admits that she initially invents a great deal of the abuse which she eventually believes in. "I had no memory of what my father had done to me," Petersen writes, "so I tried to reconstruct it. I put all my skill — as reporter, novelist, scholar — to work making that reconstruction as accurate and vivid as possible. I used the memories I had to get to the memories I didn't have ..." [15]

Her imaginative effort is effective. She writes a story with the title "Surgeon's Hands," in the first-person, that describes her reactions at three when her father comes to her crib, licks his fingers and explores her genitalia, while instructing her in the names of her body parts: "Labia majora, big lips; labia minora, little lips. And this little bump is your clitoris." In her reconstruction, he then orgasms against the crib while masturbating her.[16] When she reads the story to herself, she began "to scream and curse and cry," wetting her pants just as she did in her reconstruction of the abuse. She comments: "the feelings that came up for me were so intense I felt they must be grounded in some reality. But my memories of the incident are nowhere near as organized and specific as the story ... [In the memory] I feel the terror and the shame, but not the sexual contact itself." [17]

Shortly after this, the therapist makes another crucial intervention, as she notes a "slip" in Petersen's language: " 'Are you aware,' [the therapist] said slowly, 'that you said, "The incest started when I was three"?' " [18] when Petersen thinks merely that she said, "The incest took place when I was three." It is at this point that she really and for the first time "remembers" the abuse. The actual memories come to her while she was trying to sleep during the daytime, "[l]ying on the sofa with the sun warming me like a blanket ... I sink into the welter of images, and there is a moment when one of them sharpens and I can see it clearly. Then it drifts out of focus again and disappears." [19]

Opponents of the incest-recovery movement would undoubtedly argue that the validity of Petersen's memories are suspect and point to the following factors as dubious: the lack of corroborating evidence, the therapist's crucial role in asserting that a sexual abuse history would explain Petersen's symptoms and in explaining the mechanism of dissociated memory, and the extensive efforts made by Petersen to imagine abuse before remembering it. One can almost hear the False Memory Syndrome

Foundation coming to the defence of Petersen's father (and here I am ventriloquizing according to the logic of the debate): "Here's an example of an obviously distraught woman, with severe difficulties in coping with normal circumstances (for example, her relationship with her children), who seizes on an idea that offers an explanation for her trouble and positively *creates* the memories. She ponders, analyzes, hypothesizes, does research, interprets dreams. She writes stories and then comes to believe they are true. Case closed."

What Counts as Abuse?

My approach to this narrative is somewhat different. The point of looking at Petersen's story is not to say that it couldn't have happened just as she recounts, but to look at which aspects of her past experiences she considers "causal" of her later difficulties and which she does not regard as having explanatory relevance. In other words, what does she present as "abuse" and what does she present as merely unhappy information about her family? The differentiation, perhaps not coincidentally, breaks down largely along the lines of a distinction between sexual abuse and forms of mistreatment that are mostly emotional in nature, if also sexualized. Ultimately, I think it can be asked in a supportive way whether the abuse that she remembers actually occurred as she remembers it (or reconstructs it) or whether it might be a metaphor for something that is painful, but also more invisible, diffuse, elusive, and (only from a certain perspective) equivocal than sexual abuse.

If this question seems apparently to "deny" the reality of the abuse, it would be important to explore why this is so. Why does the question of abuse so often come down to the question of "sexual abuse" versus "no abuse"? What is the origin of the assumption that if a girl is not forced to engage in sexual intercourse with her father, she cannot have been significantly damaged by her relationship with him?

In Petersen's case, it seems evident that her relationship with her father (wholly apart from the question of sexual contact) was eroticized and inappropriate. He joked about sex incessantly in front of her, behaved in an exhibitionistic fashion, showed her writing he kept secret from his wife, confessed his infidelities to her and wrote his autobiography in the form of a 193-page "Letter to Betsy" (the title). An event from her adolescence illustrates the enmeshed nature of their relationship.

The day after Petersen had sex with her college boyfriend — a decision discussed torturously with both parents — she felt "overcome with guilt." [20] Though her mother was absent, off visiting friends, Petersen "crept into my father's bed, snuggled up to his naked body as I had done on so many Sunday mornings as a child, and told him what I had done." [21] Her father tried to reassure her, but, Petersen notes, "his voice let me know I had betrayed him." [22] She leaves his bed, but then returns complaining of a stomachache and feeling bloated and asks her father if he can recommend anything. He suggests an enema, which she takes into the bathroom. Soon, she returns to the bedroom, nude, and tells her father she doesn't know how to work it. He offers to help and eventually gives Petersen the enema as she "kneeled naked on the bathroom floor." [23] The enema incident would turn out to be the first sexual abuse experience she confessed to her husband. She would be stricken with shame over it, over the inappropriateness of it, the violation of her boundaries, her apparent complicity and would later develop constipation as she is working through her memories.[24] Though the book does not make a connection between the constipation and the enema, it seems obvious.

To many therapists and survivors, the enema incident would no doubt show up as a red flag in the psychological history of the author. It would be relatively easy to see this incident as the iceberg's tip of many years of abuse, to which she had become so accommodated that letting her father insert a penetrative object would not seem unusual. It could even be argued that the enema incident itself (wholly apart from any repressed memories) makes Petersen a victim of sexual abuse, since the giving of an enema could be construed (the way that spanking on the bare bottom can be construed) as a pretext for sexualized contact, even though the contact itself is not ostensibly sexual.

But even though it *can* be read as sexual abuse, the enema incident is much more ambiguous and lends itself more easily to multiple interpretations than the other memories of sexual abuse that Petersen recovers. From her description, the extent of the father's sexual gratification is unclear. The incident could be an exertion of control, an act of infantilization, or a logical extension of the extremely blurred physical boundaries that existed among all the members of her family. The habits of the family's interaction made the casual display of nudity between father and daughter seem normal: "My parents slept in the nude and my sister and I would join them in bed on Sunday mornings to chat and clown around ... My sister walked around the house naked and sunbathed nude in the backyard." [25] It was, it

seems, a household where casual nudity was considered normal, even among outsiders although Petersen was never as comfortable with nudity as the other members of her family.

In raising questions about what "counts" as abuse in Petersen's story, I should stress that I am not interested in whether or not the physical sexual abuse "actually" occurred. It may well have. My interest is cultural, rather than clinical or legal. What are the assumptions about victimization that shape Petersen's interpretation of her past? If we subtract the recovered memories from her story, we are still left with a dismal picture; however, this picture does not add up to "abuse" in Petersen's mind. The question is, why not?

A closer look reveals many deficiencies in Petersen's family, in addition to those I have already mentioned. A short summary would include that both of her parents were alcoholics; her mother was distant, unavailable and prone to hostile outbursts; her father was crude, violent-tempered, sadistic in a petty way; both parents were exhibitionistic with their sexuality; the parents bickered and argued constantly in front of the children in ways that were extremely upsetting; the father, when enraged, used spanking on the bare bottom as a punishment; the mother was critical, angry and prone to blow up unpredictably over minor matters; the father took nude photographs of the older sister while standing outside her bedroom door; the sister, a half-sister, was deeply troubled by being abandoned by the mother to her grandparents until she was eight years old (where, by the way, she lived with two "crazy" relatives who were known child molesters).

My point here is *not* to suggest that Petersen is a troubled woman coming from a lovely home who, under the guidance of her therapist and her own creative initiative, is "making up" a story of abuse to explain her symptoms. It is rather to point out that there was a great deal about her family — remembered by her with no difficulty at all — that might have generated a disturbing atmosphere for her as a child. Yet until she became convinced that she had been sexually violated, none of this information, apparently, was considered sufficient to explain her adult symptoms.

Petersen's comments about her mother are especially suggestive. While it is typical for incest victims to be angry with their mothers for failing to protect them from the father's advances, Petersen's representation also suggests that her mother was emotionally neglectful and abusive in her own right, specifically that she was critical, angry and prone to blow up unpredictably over minor matters. In the chapter "Looking for

Mommy," Petersen recounts that several times as a young child, she was lost or abandoned, sometimes left alone in the car when her parents were in a bar. Judging from the relative amount of space devoted to it in the book, one of Petersen's most distressing symptoms was her tendency to rage at her own children in ways she found inappropriate. Though, eventually, she will attribute her anger towards her children, like much else, to her incest, in chapter one she represents it as her mother's legacy: "I remember how it felt to be on the receiving end of that quick rage ... My mother did it to me. And I did it to my children." [26]

Despite all the other deficiencies of her family, Petersen reserves the term of abuse for what her father did to her at night. Until she comes to believe that she was sexually abused by her father, she feels that her difficulties in caring for others did not make sense. "Before I knew my father had molested me," she would think, "If only my children weren't so demanding ... I wouldn't feel so crazy." [27]

Yet considerable recent psychological research into the nature of childhood attachments suggests that profound disruptions in caregiving to offspring can result from deprivations less sensational than the abuse Petersen ultimately claims. Animals that have been separated from their mothers early in life are much more likely to become abusive parents, capable of mutilating or even killing their offspring.[28] While a good deal of writing on child abuse, sexual and otherwise, assumes its intergenerational transmission, it appears that certain individuals, within every generation, will become child abusers without their having been "abused" as such. This is not to say that their experiences of childhood were optimal or even adequate. The authors of one study note, "An abusive parent may have suffered damaged self-esteem as a child due to lack of parental respect, affection, or pride. Parents who have been emotionally deprived as children are often consumed with their own needs, turn to their children to fulfill these needs, and become abusive when frustrated in these excessive expectations." [29] The children of "psychologically unavailable" mothers have been shown to suffer more "devastating" developmental consequences than physically abused or physically neglected children.[30] The absence of real care in Petersen's background, even apart from the sexual abuse, appears to have been great, but she herself does not find it adequate to explain her feelings of rage, of having unstable boundaries, of being unable to care.

A similar question raised by Petersen's narrative is whether her account of sexual abuse happened *literally* the way she recounts it or

whether it is a way of *literalizing* the inappropriate intimacy between father and daughter that seems to have occurred in this family. Though it is not illegal, it is certainly not considered normal in the culture from which Petersen comes for a father to give his 18-year-old daughter an enema, even if he is a doctor. The eroticized relation between Petersen and her father, her role as sexual confidante and wife-surrogate, gives the incident even greater significance. In her study *Father-Daughter Incest*, psychiatrist Judith Herman describes covertly incestuous behaviour as behaviour on the fathers' part "that was clearly sexually motivated, but which did not involve physical contact or a requirement for secrecy." This includes talking constantly about sex, confiding details of sexual exploits, interrogating their daughters about their sexual activities, leaving pornographic materials around the house, exhibiting themselves, spying on their daughters when they were undressing, engaging in courting behaviour, or buying romantic gifts (for example sexy underwear).[31]

None of these behaviours appears in sociologist Diana Russell's contemporary study of incest behaviour, *The Secret Trauma*, which defines incest as "*any kind of exploitive sexual contact or attempted contact that occurred between relatives, no matter how distant the relationship, before the victim turned eighteen years old.*"[32] This is an important omission, because as Russell herself admits, "verbal proposals can sometimes be more violating than some contact experiences."[33] Nor does her book address the kind of contact experience that Petersen describes in the enema incident — a potentially exploitive contact that is ambiguously sexual. As Herman argues, victims of covert incest may suffer severe psychological problems in later life, including major depression, conflicted self-image, and sexual dysfunction, though on the whole their symptoms are less severe than those of incest victims.[34] Russell herself seems to have had second thoughts about the nature of her definition of incest but dismisses them abruptly: "… perhaps we should have included distressing noncontact experiences. But we did not."[35]

Russell's definition of incest is directly relevant to Petersen's story, for the first incident concerning her father that Petersen tells publicly is the enema incident, which, she says, she had always considered "odd" but now began to think "was far more sinister, and shameful, than I had ever allowed myself to see."[36] After confessing this event to her husband and therapist, she reasons — on the basis of the definition of incest in Russell's book — that this event could not qualify as incestuous contact. She goes on to remark, "It took more than a year in therapy before I was able to

change this perception. Meanwhile I was beginning to realize that indeed my father ... had sexually abused me on many more occasions than I originally thought." [37]

It is interesting to consider what course her therapy might have taken if, in Russell's text, she had found exhibitionism, sexual innuendo and invasive boundary crossings included as behaviours having potentially detrimental emotional consequences. This is, of course, not to deny that the effects of 10 years of physically incestuous contact would be more likely to take a greater toll than the effects of emotional sexual abuse carried out over an equivalent time period. However, it is a distortion to believe, as Russell's criteria imply, that a woman who had her breasts fondled once by an uncle would be a victim by Russell's criteria, but a woman whose father had for years made her into a substitute for, and rival of, her mother, would not.

Because *The Courage to Heal* has been so helpful to so many survivors and at the same time been so pilloried in the media, it is difficult to raise questions about it, even sympathetically, without appearing to lend aid and comfort to the enemy. Yet it must be acknowledged that the book contains passages that encourage victims of non-physical forms of sexual abuse to interpret them as "signs" indicating physical sexual abuse. In a section entitled "But I Have No Memories," Bass and Davis write about a woman who was a victim of "emotional incest" and was "haunted" (her word) by her inability to possess solid data that she had been sexually violated by her father. Bass and Davis propose this woman as a model for other women who have no memories, quoting her words:

> "It's like you come home and your home has been robbed, and everything has been thrown in the middle of the room, and the window is open and the curtain is blowing in the wind, and the cat is gone. You know somebody robbed you, but you're never going to know who. So what are you going to do? Sit there and try to figure it out while your stuff lies around? No, you start to clean it up. You put bars on the windows. You assume somebody was there ..." [38]

As a result of this logic, the experience of emotional sexual abuse is being ignored or overridden by physical sexual abuse. When Bass and Davis write that women should trust their feelings of violation (in the absence of memories), they tend not to propose that emotional sexual abuse could be at the root of feelings of violation, although elsewhere in

the text they are willing to allow that emotional sexual abuse can have long-term consequences.[39]

We can easily see why incest-recovery literature is tempted to de-emphasize emotional sexual abuse. Russell defends her use of a relatively narrow definition of abuse by saying that she was trying to avoid the risk that including "distressing noncontact experiences" in the survey "might also be used to trivialize the problem." [40] To an extent, this fear seems justified. Social psychologist Carol Tavris, well-known critic of the "incest-survivor machine," cites the example of a woman who "didn't like the way her mother would plant a 'wet' kiss on her, look at her in ways that made her feel 'queasy' and walk in on her in the bathroom." [41] That this woman regarded herself as the victim of sexual abuse Tavris considers a "textbook example of the reconstructive nature of memory, showing how an adult belief can transform childhood experiences into 'memories' of trauma." While we could debate the accuracy of calling these experiences "traumatic," it would no doubt be very confusing and problematic for a daughter to grow up with a mother as seductive as this one sounds. One wonders, who is reconstructing what? That this kind of emotional sexual abuse is chronic, diffuse, suggestive and pervasive does not make it less *real* than physical sexual abuse or developmentally benign. But there is no doubt that it is less socially recognized as a victimization experience. As we shall see in the next section, in the late 1980s and early 1990s, when Petersen's story appeared, there was a general climate of ridicule surrounding stories of emotional abuse, whether sexual or not, a climate which continues to this day.

Who ARE the Victims?

Since social beliefs about victimization influence the reactions and the treatments victims receive, it is clear that the public debate about repressed memories must be understood in the context of a broad set of social assumptions about what victimization is and who can be called a victim. Emotional maltreatment is not mentioned in many laws dealing with child abuse, or it is mentioned only as a consequence of physical injury or in general terms that do not specify legal criteria.[42] Under the entry "emotional neglect," the authors of *The Encyclopedia of Child Abuse* write: "Despite the *potentially devastating effects* of emotional neglect, many areas do not specifically identify it as a condition to be reported to child

protection agencies. Legal definitions of neglect, when they exist, are often so vague as to be useless in a court of law. Further, while the results of emotional neglect can be observed, it is often difficult to prove that parental neglect, rather than other factors, was the cause." [43] Emotional maltreament is less likely than other forms of maltreatment to be reported to child protection services,[44] even when it is detected.

Lack of recognition of emotional maltreatment also affects the context for survivor stories. In the late 1980s and early 1990s, the recovery movement came under increasing criticism for being narcissistic, self-indulgent and self-pitying; and its key terms (for example, "12-steps," "co-dependency," "inner child," "grief work," "false self") proved easy to mock. Stanton Peele's *The Diseasing of America*, Charles Sykes' *A Nation of Victims*, Wendy Kaminer's *I'm Dysfunctional, You're Dysfunctional* and Stan J. Katz's *The Co-Dependency Conspiracy* are just a few of the books that criticized the recovery movement for being misguided and even silly.[45] These criticisms were prompted by an expansion in the categories of experience from which one might need to "recover"— from alcoholism to being the child of an alcoholic to being "co-dependent." What interests me here is not whether these criticisms are accurate, but how the critics draw the line between "real victims" and "pseudo-victims," between complaints about mistreatment that are considered "real suffering" and those that are dismissed as merely "whining." Not surprisingly, this line usually divides emotional forms of maltreatment from physical ones.

My comments in this section focus on the middle class, not because I am unconcerned with abuse occurring in families that are not middle class, but because the social critics I am discussing focus on claims of victimization coming from members of the middle class, suggesting that *these* stories are especially illegitimate because members of the middle class are, by definition, not victims. The legitimacy of middle-class stories of victimization is at the heart of the repressed memory controversy, since the bulk of families who have contacted the False Memory Syndrome Foundation are middle class, white and well-educated.[46] The texts I am about to discuss appeared just before the repressed memory controversy erupted in full-force and reveal, more clearly than later arguments about memory, the social assumptions about victimization that are presupposed by the controversy.

Many critics of the recovery movement and its concern with middle-class dysfunctionality comment on how the tendency to refer one's behaviour to past mistreatment and/or to pathologize it (calling it a disease)

constitutes a moral failing on the part of the middle class. The view of such commentators seems to be that membership in the middle class is enough to ensure that claims of being victimized are false or self-indulgent.

Interestingly, this position is taken by both left-wing and right-wing commentators. The right-wing commentator Charles Sykes interprets the recovery movement as reflecting a problem with the American character. His best-selling *Nation of Victims* argues that "the mantra of the victims is the same: *I am not responsible; it's not my fault.*" [47] Of course, Sykes does not go so far as to deny that victims exist and that they have certain claims upon society. But notice where he draws the line:

> "But our concern for the genuine victims of misfortune or injustice is sorely tested as the list of certifiable victims continues to grow; victim status is now claimed not only by members of minority groups *but increasingly by the middle class*, millionaire artists, students at Ivy League colleges, 'adult children,' the obese, code-pendents, victims of 'lookism' (bias against the unattractive), 'age-ism,' 'toxic parents,' and *the otherwise psychically scarred* — all of whom are now engaged in an elaborate game of victim one-upmanship" [italics added].[48]

The "middle class," juxtaposed with "millionaire artists," heads the list of patently absurd victims, whom Sykes eventually dismisses as merely "psychically scarred."

On the other hand, Wendy Kaminer, author of *I'm Dysfunctional, You're Dysfunctional*, is a left-liberal commentator who draws attention to the limitations of the recovery movement as compared with early feminism where "from the beginning, consciousness-raising was accompanied by political action." [49] Despite having a different political agenda than Sykes, she also complains that bad luck or bad character is now being reinterpreted and redefined as "illness," [50] with the result that people are being "encouraged to see themselves as victims of family life rather than self-determining participants." [51] Like Sykes, she worries that recovery ideology "provides an excuse" for personal difficulties more often than it points the way to a solution.[52]

In the chapter "In Step: Support Groups," Kaminer makes explicit her ideas about who has permission to claim victim status by comparing a support group for refugees from the Khmer Rouge with various American recovery support groups. Kaminer apparently feels that, with this comparison, she hits the recovery movement where it hurts:

"If some recovering codependents resent my comparing them to Cambodian refugees *whose sufferings they cannot match*, I'm making the comparison their movement has invited.

"I'm not suggesting that we should ignore all lesser degrees of suffering and care only about greater ones or that only torture victims and targets of genocide have reason to be unhappy and the right to be heard, but they do have more reason and perhaps we should afford them greater rights. Mostly, I offer this portrait of Cambodian women refugees as *a reality check*, a reminder of the difference between holocausts that happen *only metaphorically* and holocausts that happen in fact [italics added]." [53]

Kaminer insists on what we might call a "hierarchy of suffering," as if individual subjective experience could be "measured" against some "objective" external scale. She writes without taking account of the excruciating suffering that psychological problems like depression can cause.

There is increasing evidence that a wide range of childhood abuse and neglect experiences have detrimental consequences for children and may be associated with later psychiatric or behavioural problems.[54] Furthermore, child maltreatment occurs more frequently, even in the middle class, than previously thought. While it may seem clear that seeing your family murdered must be more traumatic than being raged at by an alcoholic parent, it does not follow that the latter is *not* traumatic, especially when it occurs to an immature and very malleable child.[55] The danger that children are exposed to in dysfunctional families is not "metaphorical." It is real.

It is therefore interesting to note that Kaminer's scepticism about the severity of middle-class reports of mistreatment is generally suspended when it comes to reports of sexual abuse. In the same chapter, while reporting on a disturbing (to her) acceptance of all claims of mistreatment as equally worthy of attention in 12-step groups, she comments, "The stories you hear range quickly from the trivial to the tragic. As soon as one woman finishes testifying to the ravages of PMS, another recalls being raped by her stepfather." [56] Later, she asks herself: "I wonder what testifiers mean by abuse. Were they sodomized by their mothers too or merely 'shamed,' deprived of self-esteem." [57] To Kaminer, the idea of a violation to the spirit is patently ridiculous.

The criticisms of Sykes and Kaminer and others like them contain the hidden assumption that middle-class families provide at least the minimal level of nurturance to allow an individual to develop into a functioning

human being. If you have problems after growing up in such an environ-
ment, it is *your fault* and you have to take responsibility for yourself. This
reasoning implies several assumptions that are worth making explicit.
First, members of the middle class are not justified in complaining about
their situation in life, since their material needs are taken care of. Secondly,
psychological pain is not real pain. Thirdly, victims can only come from
objectively designated victim-groups, since "real" abuse is not "merely"
emotional. Fourthly, claiming to be a victim is an abdication of personal
responsibility.

I would argue that we should not subscribe too quickly to these
assumptions, without at least realizing what their implications are. There
is plenty of evidence that the homes of alcoholics may be chaotic, violent
and unpredictable, even in the absence of sexual abuse. If Betsy Petersen
were not a victim of sexual abuse, she would still be the daughter of two
alcoholic and deeply flawed parents. Much of the current backlash against
the recent attention to dysfunctional families seems to suggest that we
should accept such families as constituting a "good-enough" environment
for children. Yet it seems likely that such environments can induce
symptoms that will, over the course of a lifetime, take an enormous
personal and economic toll.

Given the assumptions about victims detailed above, it is easy to see
how "incest" might function in the unconscious of middle-class women
beset by anxieties that the suffering caused by emotional maltreatment will
be ridiculed and dismissed as "metaphorical" because they are not starv-
ing, ill-clothed political refugees. After all, incest is silent, invisible — a
betrayal of the care of children, the fundamental promise of the family, an
invasion of privacy — a violation of one of the highest political values of
the class. It is possible that the belief that sexual abuse is at the root of most
significant forms of adult pathology is related to middle-class anxiety that
its suffering is not legitimate, given the relative material prosperity it
enjoys. How can you complain about being emotionally abused or ne-
glected by your parents if at the same time you had plenty of toys?

Broadening the Category

The tendency of incest-recovery discourse to downplay emotional sexual
abuse reveals the extent to which the discourse is being shaped by wider
social assumptions about victimization. Attempts to broaden the category

of sexual abuse to include non-physical forms have met with ridicule and rebuke and these forms are consequently de-emphasized in incest-recovery literature. Thanks to efforts of feminist researchers and the political momentum of the feminist movement, it is no longer considered acceptable to "blame" victims of sexual abuse for their fate. But the political impetus that feminism lends to the issue of child sexual abuse does not fully extend to emotional sexual abuse nor indeed to any other category of child maltreatment.

The beliefs about victimization I have described in this article reflect a general inability to conceptualize social or historical phenomena in anything other than material terms. Scratch the distinction between physical and emotional suffering and one often finds an objectionable contrast. Violations to the body are real; violations to the mind are not. This hierarchical relation has a self-evident quality, but is nonetheless problematic, given the fact that most non-fatal physical wounds heal long before psychological ones do.

These assumptions should be kept in mind during the recovery process. Contemporary survivor literature on child sexual abuse stresses that sexual abuse, as a violation of the physical boundaries of the body, has psychological consequences and interferes with the child's developing a sense of autonomy. Although not every culture recognizes psychological and physical boundaries in the same way, when a culture places a high priority on self-reliance and self-actualization, it makes sense that the violation of boundaries has detrimental psychological consequences. To the extent that this is true, there is no reason to assume that violations of *psychological* boundaries do not have the same effect. To the extent that Petersen's father imposed his sexuality, through confidences, jokes, innuendoes, exhibitionism, intrusive questions, her psychological boundaries were violated as well, whether or not he physically abused her.

It is therefore important for survivors who are sifting through their childhood histories to remember that childhood trauma does not have to be of the same nature or magnitude as adult trauma to have destructive consequences. Because of their physical and emotional vulnerabilities, children, especially infants, are virtually powerless to avoid harm and frequently feel overwhelmed, even terrified, by experiences that may be or seem life-threatening.

The social lack of recognition of emotional maltreatment as a legitimate victimization experience makes it difficult for survivors of emotional forms of maltreatment to name their experience accurately and to assess

its consequences. It is likely that they may need support in "owning" their individual stories, in all of their complexity and perhaps subtlety, and in not giving way to feelings that their pain is illegitimate. In this hostile climate of backlash and suspicion, incest might be seen — both by potential authors of such narratives and by potential members of the audience — as "counting" as real abuse, whereas emotional abuse or neglect, however documentable, might not. It is thus a way of proving that *something happened.*

In light of this, it is interesting to note that Petersen's process of narrative construction begins with the thought, "I'm afraid my father did something to me" — which is immediately interpreted as physical sexual violation — as if all the other things her father "did" to her that she remembers did not really count as doing *something.*

Endnotes

1. I am grateful to Rose Zoltek-Jick, Arthur Kleinman, Michael Meltsner, Mary Margaret Steedly and Elizabeth Hanson for their detailed and helpful commentary on this article.

2. Ellen Bass & Laura Davis, *The Courage to Heal: A Guide for Women Survivors of Child Sexual Abuse*, 2nd Edition (New York: Harper & Row, 1992), p. 22.

3. Quoted in: Susan Chira, "Sex Abuse: The Coil of Truth and Memory," *New York Times* (December 5, 1993).

4. E. Sue Blume, *Secret Survivors: Uncovering Incest and Its Aftereffects in Women* (New York: Ballantine, 1990), p. 1

5. Eleanor Goldstein, with Kevin Farmer, *Confabulations: Creating False Memories, Destroying Families* (Boca Raton, FL: Upton Books, 1994), p. 3.

6. Betsy Petersen, *Dancing With Daddy: A Childhood Lost and a Life Regained* (New York: Bantam, 1991).

7. Ibid., p. 60.

8. Ibid., p. 61.

9. Ibid., p. 61.

10. Ibid., p. 62.

11. Ibid., p. 62.

12. Ibid., p. 63.

13. Ibid., p. 64.

14. Ibid., p. 65.

15. Ibid., p. 65.

16. Ibid., p. 70.

17. Ibid., pp. 73-74.

18. Ibid., p. 74.

19. Ibid., p. 75.

20. Ibid., p. 49.

21. Ibid., p. 49.

22. Ibid., p. 50.

23. Ibid., p. 50.

24. Ibid., p. 151.

25. Ibid., p. 17.

26. Ibid., p. 8.

27. Ibid., p. 78.

28. S.J. Suomi & C. Ripp, "A History of Motherless Monkey Mothering at the University of Wisconsin Primate Laboratory," summarized in Bessel van der Kolk, *Psychological Trauma* (Washington, D.C.: American Psychiatric Press, 1987), pp. 38-39.

29. Ellen C. Herrenkohl, Roy C. Herrenkohl & Lori J. Toedter, "Perspectives on the Intergenerational Transmission of Abuse," in David Finkelhor, Richard Gelles, Gerald T. Hotaling & Murray A. Straus (eds.), *The Dark Side of Families: Current Family Violence Research* (Beverly Hills, CA: Sage, 1983), p. 306.

30. Bryon Egeland & Martha Farrell, "Psychologically Unavailable Caregiving," in Marla Brassard, Robert Germain & Stuart N. Hart (eds.), *Psychological Maltreatment of Children and Youth* (New York: Pergamon, 1987). See also: Julie L. Crouch & Joel S. Milner, "Effects of Child Neglect on Children," *Criminal Justice and Behavior* 20, 1 (1993), pp. 49-65.

31. Judith Herman, with Lisa Hirshman, *Father-Daughter Incest* (Cambridge, MA: Harvard University Press, 1981), p. 109.

32. Diana E. H. Russell, *The Secret Trauma: Incest in the Lives of Girls and Women* (New York: Basic Books, 1986), p. 41.

33. Ibid., 50.

34. Herman (1981), pp. 109-125.

35. Russell (1986), p. 53.

36. Peterson (1991), p. 80.

37. Ibid., p. 81.

38. Bass & Davis (1992), p. 82.

39. Ellen Bass & Laura Davis, *The Courage to Heal: A Guide for Women Survivors of Child Sexual Abuse*, 3rd Edition (New York: HarperPerennial, 1994), p. 14.

40. Russell (1986), p. 51.

41. Carol Tavris, "Beware the Incest-Survivor Machine," *New York Times Book Review* (January 3, 1993).

42. Robin E. Clark & Judith Freeman Clark, *The Encyclopedia of Child Abuse* (New York: Facts on File, 1989), p. 145.

43. Ibid., p. 59.

44. Jeanne Giovannoni, "Definitional Issues in Child Maltreatment," in Dante Cicchetti & Vicki Carlson (eds.), *Child Maltreatment: Theory and Research on the Causes and Consequences of Child Abuse and Neglect* (New York: Cambridge University Press, 1989), pp. 3-37.

45. Stanton Peele, *The Diseasing of America: Addiction Treatment Out of Control* (Lexington, MA: Lexington, 1989; Charles Sykes, *A Nation of Victims: The Decay of the American Character* (New York: St. Martin's, 1992); Wendy Kaminer, *I'm Dysfunctional, You're Dysfunctional: The Recovery Movement and Other Self-Help Fashions* (Reading, MA: Addison-Wesley, 1992); and Stan J. Katz, *The Co-Dependency Conspiracy: How to Break the Recovery Habit and Take Control of Your Life* (New York: Warner Books, 1991).

46. Pamela Freyd, "The False Memory Syndrome Foundation: Response to a Mental Health Problem" (unpublished manuscript).

47. Sykes (1992), p. 11.

48. Ibid., p. 12.

49. Kaminer (1992), p. 79.

50. Ibid., p. 10.

51. Ibid., p. 13.

52. Ibid., p. 14.

53. Ibid., p. 81.

54. See, for example: Robin Malinosky-Rummell & David J. Hansen, "Long-Term Consequences of Childhood Physical Abuse," *Psychological Bulletin* 114, 1 (1993), pp. 68-79.

55. Bruce D. Perry, "Incubated in Terror: Neurodevelopmental Factors in the 'Cycle of Violence'," in Joy D. Osofsky (ed.), *Children, Youth and Violence: Searching for Solutions* (New York: Guilford, 1996).

56. Kaminer (1992), p. 70.

57. Ibid., p. 79.

ABOUT THE CONTRIBUTORS

Kathryn Belicki, Ph.D, is a clinical psychologist and professor at Brock University who divides her time among writing, teaching, research and clinical practice. She has contributed to five books and published many articles on the topics of dreams, nightmares and the impact on adult functioning of childhood trauma and abuse. She has been a consulting editor and senior editor for the journal *Dreaming*, and an associate editor for the journal *Lucidity Letter*. A popular speaker, she has had frequent appearances on radio and television talk shows including the *Dini Petty Show*, the *Shirley Show* and CBC's *Morningside*.

E. B. Brownlie is a graduate student in developmental psychology at Simon Fraser University. She is currently researching the ways that young adults construct gender conformity and non-conformity.

Karen Busby, LLB, works as a researcher, teacher and lawyer on sex-equality law, especially laws relating to violence against women. She is employed at the University of Manitoba (Law) and she has had a long association as a volunteer with the Women's Legal Education and Action Fund (LEAF) and other anti-violence organizations, including three years as a rape-crisis counsellor. She was called to the Manitoba Bar in 1982.

Sue Campbell, Ph.D, is assistant professor of philosophy and women's studies at Dalhousie University. Her recent publications include "Women, 'False' Memory, and Personal Identity," *Hypatia* 12, 2; and *Interpreting the Personal: Expression and the Formation of Feelings* (Cornell University Press, 1997). She is currently co-editing *Racism and Philosophy* with Susan Babbitt (Cornell University Press, forthcoming).

Elly Danica is the award-winning author of *Don't: A Woman's Word* (gynergy books, 1988) and *Beyond Don't: Dreaming Past the Dark* (gynergy books, 1996). She is an extraordinarily gifted writer and visual artist whose work has been exhibited in Canada and Europe. Publication of *Don't: A Woman's Word* in 1988 catapulted her to the leading edge of the sexual-abuse survivors movement. She has toured extensively in North America and Europe, given hundreds of lectures and interviews and met thousands of survivors of child sexual abuse. Through her words, Elly Danica, herself a survivor of child sexual abuse, has become a leader and a symbol of hope and healing for survivors everywhere.

Gail Fisher-Taylor is a feminist psychotherapist and consultant in private practice in Toronto. She is a frequent conference and workshop presenter and has worked as a photographer, writer, editor and publisher, always with an interest in understanding context and interconnection in individual and social experience, creative expression and culture. She has studied and worked in a small Mexican village and has worked with Holocaust survivors, traumatized youth and adult survivors of childhood abuse. She has been awarded Canada Council and Ontario Arts Council grants, and in 1989 her CBC Ideas radio documentary "Family Secrets" received the ACTRA award for the Best Public Radio Program of the Year.

Mary Gail Frawley-O'Dea, Ph.D, is a clinical professor and supervisor at the Derner Institute of Adelphi University. She also is a faculty member of the Minnesota Institute of Contemporary Psychoanalysis and is on the continuing education faculty of the National Psychological Association for Psychoanalysis in Manhattan. Dr. Frawley-O'Dea is co-author with Jody Messler Davies, Ph.D, of *Treating the Adult Survivor of Childhood Sexual Abuse* (Basic Books, 1994). She is in psychoanalytic private practice in Nyack, New York.

Jennifer Freyd, Ph.D, is professor of psychology at the University of Oregon. She received her Ph.D in psychology from Stanford University in 1983. Freyd has received several prestigious honours for her research in cognitive psychology, including a John Simon Guggenheim Memorial Foundation Fellowship. She is a Fellow of the American Psychological Association, the American Psychological Society and the American Association for the Advancement of Science. Her current research includes experimental and clinical investigations of memory for trauma. Her recent teaching has included courses in psychology of gender, experimental psychology, cognition, trauma and feminist ethics. Freyd's book *Betrayal Trauma: The Logic of Forgetting Childhood Abuse* was published in 1996 by Harvard University Press and released in paperback in 1998. For *Betrayal Trauma*, Freyd received a 1997 Distinguished Publication Award from the Association for Women in Psychology and the 1997 Pierre Janet Award from the International Society for the Study of Dissociation.

Susan June Haslip recently graduated from the University of Ottawa common law program. She is working as a legal researcher with the Federal Court Trial Division and is looking forward to her call to the bar in February 2000. She has published on conditional sentencing, violence against women, conflict resolution and recovered memory. She has completed research for the Provincial Court, the Round Table to Achieve a Coordinated Criminal Justice System Response to End Violence Against Women and Equality for Gays and Lesbians Everywhere (EGALE). She recently compiled a statistical analysis of domestic violence files, a sentencing digest and casebooks for the new Domestic Violence Court in Ottawa.

Jennifer Hoult is a professional harpist whose schedule includes symphonic concerts, Broadway, recording sessions, solo appearances and teaching. She has also pursued a successful career as an artificial-intelligence software engineer, specializing in natural language processing and expert and diagnostic systems. Her volunteer efforts include legislative work at the state and federal level to end child abuse, and as a certified rape-crisis counsellor. In 1988, Jennifer Hoult filed what became a landmark civil suit against her father, a former MIT professor, for damages resulting from years of childhood sexual abuse and rape. After a week-long trial in 1993, the jury unanimously found in her favour. Their decision has been upheld in every appeal pursued by her father.

Katharine Kelly, Ph.D, is an associate professor of sociology at Carleton University. Her research interests include violence against women, women and the law and women's use of violence. She is co-author, with Walter Dekeseredy, of the Canada's first national study of dating violence. She has also written about women and policing, young offenders and women and the law.

Meredith Kimball, Ph.D, is a professor in the departments of women's studies and psychology at Simon Fraser University. She teaches in the areas of adult development and aging, female roles in contemporary society, history of western feminism and feminist psychoanalytic theories. Her research interests include women's friendships, caregiving, gender and math, women in science, moral theories and the history of women in psychology. She has begun a long-term project on the history of women in psychology and psychoanalysis. As a first step she has explored Bertha Pappenheim's (Anna O.) role in the development of psychoanalysis and German maternal feminisms.

Connie Kristiansen, Ph.D, is an associate professor of psychology at Carleton University, Ottawa, where she teaches and conducts research on the social-psychological factors associated with violence against women and children. This research has included studies of people's responses to partner abuse, the impact of prison on women survivors of child abuse and the socio-political factors sustaining the debate over the validity of recovered

memories of child abuse. As director of the Ottawa Survivors' Studies I and II, Connie Kristiansen has examined the nature of survivors' traumatic memories, the (in)validity of "False Memory Syndrome" (FMS) and the retraumatizing impact of the FMS debate on survivors of child abuse. Her most recent research concerns the long lasting effects of child and adult sexual assault and battering on older women. She has also been involved in grass roots activism, being a founding member of the Ottawa Recovered Memory Task Group and, most recently, doing research on behalf of sex-trade workers regarding their practical, psychological and physical health needs.

Shelley M. Park, Ph.D, is an associate professor of philosophy and director of the women's studies program at the University of Central Florida. Her teaching and research interests include feminist theory, epistemology and philosophy of psychology. She is especially interested in bringing these research interests to bear on issues of personal and political relevance. Her current research focuses on debates concerning transracial adoption and recovered abuse memories.

Anna C. Salter, Ph.D, SC, is in private practice in Madison, WI, and consults half-time to the Wisconsin Department of Corrections on sex offenders. Before moving to Madison in the fall of 1996, she was in private practice in Lebanon, NH, and on the adjunct faculty of Dartmouth Medical School. While full-time on the faculty of Dartmouth Medical School in psychiatry and pediatrics, she was director of psycho-social training for the pediatric residency program, director of child psychiatry consultation to the pediatric ward, co-director of the Parenting Clinic, assistant director of the Children-at-Risk Program and director of the Parents in Distress Program. Anna Salter is the author of two academic books: *Treating Child Sex Offenders and Victims: A Practical Guide* (Sage, 1988) and *Transforming Trauma: A Guide to Understanding and Treating Adult Survivors of Childhood Sexual Abuse* (Sage, 1995); and two forensic mysteries, *Shiny Water* (Pocket Books, 1997) and *Fault Lines* (Pocket Books, 1998). In 1997, she won the Significant Achievement Award from the Association for the Treatment of Sexual Abusers. She lectures and consults throughout the country and abroad.

Cindy Veldhuis is a graduate student in psychology at the University of Oregon. She has worked as an advisor for returning women students and also has done volunteer work in the areas of domestic violence and sexual assault. Her current research is on the role of information sharing in healing from trauma.

Susan M. Vella, BA (Hons.), LLB, is a partner with, and the co-ordinator of, the civil sexual assault and harassment group at the Toronto-based law firm of Goodman and Carr. She has extensive experience in sexual assault and fiduciary duty claims against various institutions including the government, religious institutions, hospitals, school boards and corporations, and individual perpetrators including priests, doctors, teachers and other professionals. Susan has lectured in the area of sexual assault and recovered traumatic memory at seminars sponsored by the Canadian Bar Association, Law Society of Upper Canada, Canadian Institute, Ontario Trial Lawyers Association, Advocates Society and other professional and community organizations. She has also published in legal periodicals and journals on issues related to institutional liability, recovered traumatic memory and other issues related to sexual assault. Susan has appeared as trial and appellate counsel before all levels of courts including two recent appearances before the Supreme Court of Canada on civil sexual assault matters, and as intervenor counsel in criminal sexual assault matters. Susan is a past president and a current member of the National Association of Women and the Law.

Elizabeth A. Wilson, Ph.D, is a visiting professor in gender studies and American studies at Humboldt University in Berlin, Germany. She worked as an assistant professor in the English department at Yale University before becoming a research fellow at the Bunting Institute at Harvard University, where she was also a fellow in the research training program in family violence at Children's Hospital. In addition, she was a Fulbright Scholar in American studies at Frankfurt University in Germany and has published on cultural, feminist and comparative issues in such journals as *Diacritics*. Her forthcoming book *Not in This House: The Recovered Memory Controversy and the White Middle-Class Family*, will be published by W W Norton.

ABOUT
THE EDITOR

Margo Rivera, Ph.D, is an assistant professor of psychiatry in the faculty of medicine at Queens University and director of the Personality Disorders Service at Kingston Psychiatric Hospital. She has worked for 30 years as a psychotherapist with adults and children who are survivors of abuse. She has published and lectured widely in Canada, the U.S. and Europe on trauma, psychotherapy and post-traumatic dissociation, including writing her book, *More Alike Than Different: Treating Severely Dissociative Trauma Survivors* (University of Toronto Press, 1996). She is one of the first theorists to integrate a feminist perspective into the professional discussion of dissociation.

BEST OF GYNERGY BOOKS

Don't: A Woman's Word, **Elly Danica**. "Tightly written to the point of poetry — as if each sentence has been boiled down to its essence — it tells the story of the unspeakable sexual invasion of a child ... Beautiful? Only in this way: Elly has triumphed over her past." Peter Gzowski, *Canadian Living Magazine*
ISBN 0-921881-05-3 $10.95

Beyond Don't: Dreaming Past the Dark, **Elly Danica**. With honesty and insight, Elly Danica continues her inspiring story of surviving and dealing with child sexual abuse. "A fluent, probing, reflective work on [Danica's] painful transition from victim to fighter." Michelle Landsberg, *Toronto Star*
ISBN 0-921881-40-1 $14.95

Consciousness Rising: Women's Stories of Connection and Transformation, **Cheryl Malmo & Toni Suzuki Laidlaw** (eds.). "By focusing on the deep connections that women have forged with themselves and others, editors Malmo and Laidlaw have created a collection that seamlessly weaves the personal and the political into a vision of feminism that will flourish into the next century." Jeri Wine, Ph.D, Psychologist
ISBN 0-921881-52-5 $19.95

An Unexpected Journey: Women's Voices of Hope After Breast Cancer, **Aniko Galambos**. "An Unexpected Journey resonates with the power of the tremendous personal journeys that all of the women have embarked upon after being diagnosed with breast cancer. *Quill & Quire*
ISBN 0-921881-49-5 $14.95

Patient No More: The Politics of Breast Cancer, **Sharon Batt**. "This book is a must for all women and should be compulsory reading for all health care professionals." *The Journal of Contemporary Health*
ISBN 0-921881-30-4 $19.95

gynergy books titles are available in quality bookstores everywhere. Ask for our books at your favourite local bookstore. Individual prepaid orders may be sent to: **gynergy books**, P.O. Box 2023, Charlottetown,PEI Canada C1A 7N7. Please add postage and handling ($3 for first book and $1 for each additional book) to your order. Payment may be made in U.S. or Canadian dollars. Canadian residents add 7% GST to the total amount. GST registration number R104383120.